ST 2010

00049751

D1577481

PERSISTENCE OF CRAFT

ST 2010

00049751

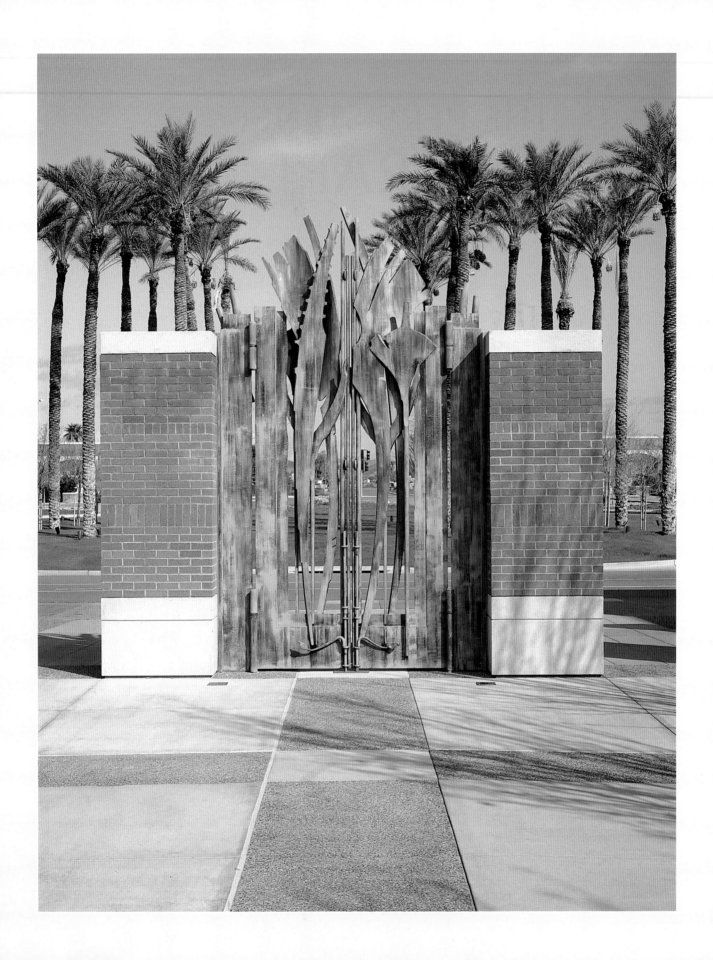

THE PERSISTENCE OF CRAFT

The Applied Arts Today

EDITED BY PAUL GREENHALGH

A & C Black • London

Rutgers University Press
New Brunswick • New Jersey

00049751
£10.99
745 GRE
ROBY
Short loan

DEDICATION

This book is dedicated to all my friends and former colleagues at the Victoria and Albert Museum, with whom I spent many happy years. And, of course, to Jack and Alex.

ACKNOWLEDGEMENTS

I would like to acknowledge help and support from a number of people through the long birth process of this volume. First and foremost, Linda Lambert, my editor and mentor at A&C Black, can take credit for originating the idea. No less important, she then gave crucial editorial and academic advice throughout its evolution. Keith Cummings encouraged me to do it. Rebecca Salter and Rupert Faulkner did the Japanese translations and helped in general. The following worked on picture research and editorial aspects of the book at one time or another between 1998 and 2002: Susan Barry, Melanie Brooks, Pete Clark, Lisa Hebden and Cal Lane. Susan McIntyre designed the book. Many others simply listened to and inspired me over a long period of time: Eli Avrahampour, Robert Bud, Linda Cameron, Garth Clark, Craig Clunas, the late Peter Dormer, Dame Elizabeth Esteve Coll, Jerry Ferguson, Aaron Fleischman, Sir Christopher Frayling, Belinda Greenhalgh, Tanya Harrod, Kenn Honeychurch, Ian Inkster, Jean Johnson, Mike Lee, Lin Lougheed, Charmaine Malet-Veale, Paul Mathieu, Bernadette MacDonald, Ralston Macdonnell, Enid MacLachlan, Gwyn Miles, Gillian Naylor, all the Staff and Students at NSCAD, Jennifer Opie, Jane Pavitt, Nigel Schooley, Chris Stevens, Sir Roy Strong, Victor Syperek, Eric Turner, Jan Van der Wateren, the late Clive Wainwright, Gabriel Weisberg, Mitchell Wolfson Jr, and Ghislaine Wood. Thank you one and all.

Frontispiece: Albert Paley; American; *Ceremonial Gate*; Arizona State University, Phoenix; formed and fabricated steel, polychrome; 1991

First published 2002 by A & C Black (Publishers) Ltd
37 Soho Square, London WC1D 3QZ
www.acblack.com

ISBN 0-7136-5001-X

Copyright © 2002 Paul Greenhalgh.

Published in the USA 2003 by Rutgers University Press
100 Joyce Kilmer Avenue, Piscataway, NJ 08854-8099

ISBN 0-8135-3264-7

The authors have asserted their rights under the Copyright, Designs and Patents Act 1988 to be identified as the authors of this work.

This book has been partially funded by the Crafts Council.

All rights reserved. No part of this publication may be reproduced in any form or by any means – graphic, electronic or mechanical, including photocopying, recording, taping or information storage and retrieval systems – without the prior permission in writing of the publishers.

A CIP catalogue record for this book is available from the British Library and the US Library of Congress.

Typeset in 10.5 on 13pt FBCalifornian.

Printed and bound in Italy by G. Canale & C. S.p.A., (Turin)

CONTENTS

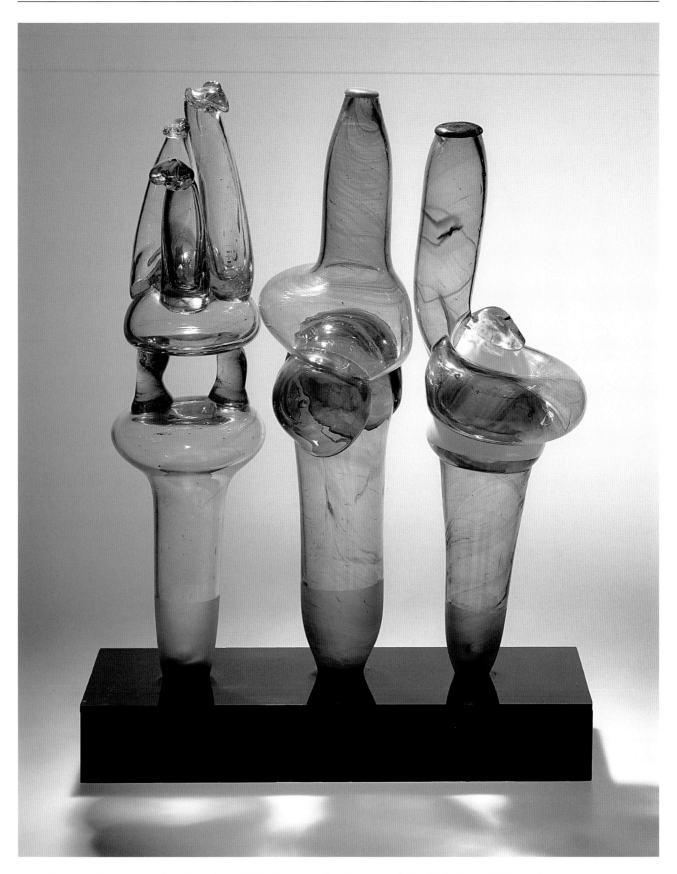

Sam Herman; American; *Glass Sculpture*; 1971; Courtesy the Trustees of the Victoria and Albert Museum

1 · INTRODUCTION CRAFT IN A CHANGING WORLD

Paul Greenhalgh

AFTER decades of deliberation it has become obvious what the crafts are. In late modern culture the crafts are a consortium of genres in the visual arts, genres that make sense collectively because for artistic, economic and institutional reasons, they have been deliberately placed together. At different times in the 20th century they have been forced together, have drifted towards one another in a more accidental fashion, or have volunteered to sit together. They have no intrinsic cohesion; they have no *a priori* relationship that makes them a permanently peculiar or special gathering; there could be fewer or more of them; they are together now, as we move into the next century, because the complex forces that brought them together, despite shifts in circumstance, hold them in proximity. This proximity is not stable and is certainly in a process of change. Nevertheless they are in consortium still.

Craft has always been a supremely messy word. For centuries it was normally used in contexts that had nothing to do with creative artistic practice of any kind, but when it is used in the context of art, its multifarious nomenclatic heritage has rendered it so ambivalent that many who are associated with it consider it a drawback. Those of us who have spent time in the field are at a stage, I am sure, at which earnest definitions and descriptions of craft as something which is (or is not) art, is (or is not) design, as technophobia, as an anthropological signifier, as a protector of apparent traditions, as old (or new) age lifestyle, as patriarchy, as airport trinket, as ethnic iconography, as communist Utopia, as eco-protest, as redundant technology, as aromatherapy, and most emphatically as victim of an unloving world, have ground us all down. There have been so many worthy agendas and maundering laments that we barely know what it is anymore and a lot of very sensible people no longer care.

This pejorative picture, of an arbitrary group of practices languishing together in an unloved condition is – of course – an overstatement. For while the crafts have certainly been corralled into a particular enclosure during the 20th century, and have developed some problems because of this, there is no doubt the confinement has resulted in the growth of ties and the recognition of correspondences. Alliances have been formed, affecting the way things have been made and consumed. Like a Roman legion forming a tortoise of shields, there have been times when the individual genres have successfully protected themselves as a collective. And while it is important not to fantasise or fetishise craft as *a thing in itself*, ultimately, it really doesn't matter how it all came together; the point is, it is together. What really matters at this juncture is where all these genres are going and how they are going to develop in the next period of years.

Craft is presented in this book as a fluid set of practices, propositions and positions that shift and develop, sometimes rapidly. This depiction is deliberate because in the past craft too often has been described in restrictive and defensive rather than in inclusive and expansive terms. Too often it has been a history and philosophy of excuses and apologies rather than a confident striding out of a vital part of visual culture.

Peter Fleming; Canadian; *Pelican Cabinet*; afrormosia, cast bronze and green slate;1996.

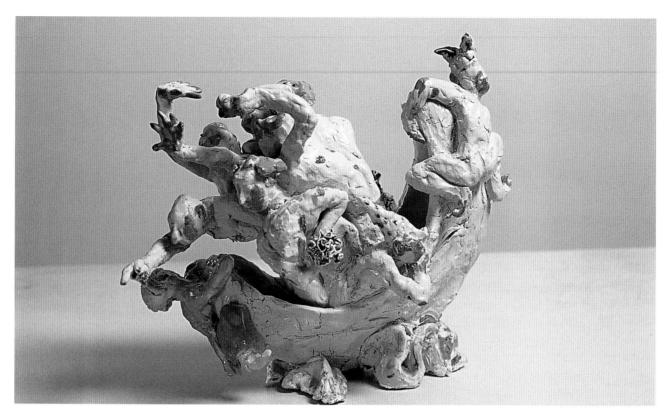

Michael Flynn; British; *Ship of Fools V*; salt-glaze porcelain;1996

The following chapters do not avoid the definitions and descriptions listed above (and debated less flippantly below). Rather, they use them as a starting point in order to outline the integrity of practice, the vitality of the object, and the ideas of makers and consumers, in the larger world of visual culture.

Three main aims provide the underlying agenda for this book. First, it explores the key issues, ideas and developments that have been current on the international scene over the last 15 or so years. Historical contexts, sometimes reaching back a century, are provided where necessary. It has been a turbulent period for the modern crafts and this turbulence needs to be described and explained. Second, a number of the chapters will explore the intellectual, social and economic context of practice, often making use of disciplines outside the immediate realm of craft or craft history. Third, and in some ways most important, the book summarises the intellectual and ideological condition of objects. The nature and role of cultural artefacts have been under question for some time. Issues surrounding both of these will be presented.

On a superficial level it is not difficult to characterise the way that the crafts have unfolded through the last three decades. The 1970s is for the most part seen as the decade in which a radical wave of activity sought to explore the meanings and roles of the various genres. The contemporary jewellery movement, the new ceramics, fibre art, the studio glass movement and book arts, for example, while they grew as experimental practices during the 1960s, were fully realised in the next decade. It might be best defined as the period in which, internationally, a consolidated avant-garde emerged in most media. It was when official crafts institutions were founded in many countries, courses were developed in leading colleges of art and design, and publications grew in number.

The 1980s carried on much of this activity, though the character of the craft world changed as the decade progressed. This was simultaneously the decade of voracious consumption and Post-Modern discourse; both affected the visual arts directly. On the material front, institutional life was squeezed all over the industrialised world. Consequently, fewer practitioners enjoyed the protection of salaried posts and commerce visited craft as it had never done before. In some countries private patronage developed dramatically. The number of private galleries selling craft, often integrated with the Fine Arts, steeply rose (although numbers fell away somewhat when the economy went into recession at the end of the decade). As public money shrunk, private enterprise became the key to survival. On the

intellectual front, the growth of interest in the histories of design, craft and decorative art among historians and practitioners led to the development of a fascinating eclecticism. The specific histories of ceramic, glass, furniture, jewellery and metalwork began to play a vital role, and the gestural abstraction of the 1970s receded significantly before a wave of figurines, cabrioles, rocialles, gold fittings, arches and tazzas. History became a key element in the revitalisation of narrative and symbolism. Irony became an important weapon. As one has to be ironic about something, the use of a wide range of historical imagery, became a necessary feature of much new work.

The 1990s are still too close to draw clear conclusions about, but several chapters identify trends that were highly significant. First of all, however, it is important to remember that the decades are not in any way hermetic. The developments of the 1970s and 1980s continued on in various forms in the 1990s. This is especially true of historical eclecticism, which reached an extraordinary pitch in the last decade.

An interesting aspect of the classification debate during the course of the 1990s has been a shift in emphasis from the ideology of negative complaint (*why am I not treated like an artist?*) to an integrationalist spirit (*what does it matter as long as I create and communicate?*). In this regard the 1990s could be best characterised as being to do with interdisciplinarity. The desire to set an intellectual agenda that crosses boundaries has been a key feature of

the humanities generally, and while it still has to yield significant results in most fields, there have been promising and provocative results within visual culture. The key to success has been found in the willingness to collaborate. Facilitated by high technology, co-operatives and companies are changing the way radical material culture is produced. These new companies and co-operatives have fused areas of art and craft practice with media, communication and interior design. Thus, if the previous 20 years had been fraught with anxiety about the status of craft in relation to the Fine Arts, the last ten years have witnessed the beginnings of a promising fusion of craft with everything else.

Small co-operative businesses in Britain and the European mainland have sprung up and occupied areas that straddle communication design, architecture, design and craft media. Jam (Britain), Tomato (Britain), Neissing (Germany) and Droog Design (Holland), for example, are driven by concepts, not processes, and operate across media. In some areas of the world, and most notably in Holland, Germany and the Nordic countries, designer craftsmen are employed directly by manufacturers to produce prototypes for batch-run production. Alternatively, individual craft practices have expanded in order to become industry-scale producers of large-scale works. Albert Paley and Dale Chihuly offer the most impressive examples of the trend. (See Chapter 9 and p.5) The avant-garde of the future will not be based on individuals, it seems, but individualised companies.

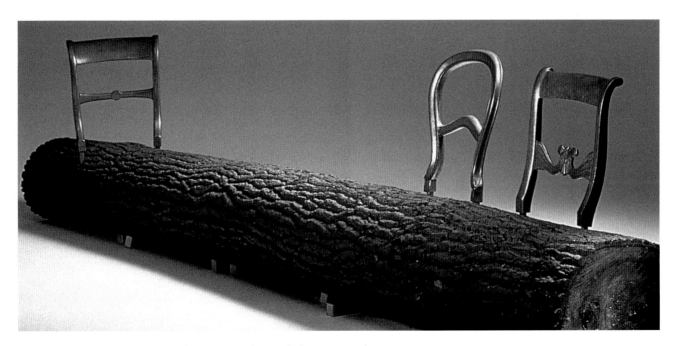

Jurgen Bey, Droog Design; Dutch; *Tree Trunk Bench*; bronze, trunk; 1999

An aspect of the last 30 years has been a steady shift in the geography of craft. While all nations enjoy solid craft production of one kind or another, radical Modernist developments have tended to be primarily associated with relatively few nations, the most regularly important of these being America, the Scandinavian nations, Japan and Britain. This can barely be sustained now. As the character of craft evolves, and especially as it interfaces more fully with other disciplines, other nations have come to the fore. Interestingly, a number of nations that enjoyed the status of being at the forefront of the avant-garde in the first half of the 20th century have increasingly returned to the fore in the last two decades. These include the Netherlands, Italy, Spain and the Czech Republic (see pp.3, 7 and 15). Nations that have rarely been positioned in the avant-garde spotlight are now confidently in the fore. Canada and Australia contain leading movements in ceramics, jewellery, textiles and furniture and have set powerful new intellectual agendas through publications and conferences.[1] Nations not usually associated with Modernist innovation, such as India, Mexico and Korea have entered strongly into the international arena (see pp.8, 9 and 11). The increasing number of international congresses on the crafts shows the shift to be less a chance emergence of a few new schools of thought, and more a general opening up, a de-centring of craft, as travel gets cheaper and the internet gets sharper.

Throughout the last 30 years there have been a variety of issues (some already alluded to) that have at one time or another come to the fore to worry us. I will list the most important:

1. Classification
2. Economy
3. Amateurism
4. Technology
5. Morality
6. Ethnicity
7. Place
8. Domesticity
9. Museology
10. Gender
11. History
12. Modernity
13. Quality

All of these are addressed by the various authors in this volume, and indeed, every one of them could and should be the subject of a book in its own right. For the rest of this introduction, I will identify the nature of the discussions and debates that have circled around these subjects.

Classification refers to the ongoing – and inevitable – struggle between the different types of practice at large within the visual arts. We classify our arts and, for one reason or another, we have always done so. Through much of the 20th century within the European and North American traditions, we have grouped the various genres under the headings, art, craft and design. While there is an historical and intellectual rationale for this arrangement, the structure has held principally for economic, institutional and political reasons. In short, the system is understood by (and benefits) the marketplace, galleries and government. The so called *art/craft* debate, whereby we wonder where exactly craft is situated in relation to the Fine Arts, has rolled on too long, and has accrued a full and very mixed literature.[2] Suffice it to say that the debate has until recently been dogged by the absence of a clear historiography. Craft has been depicted as a separate, self-contained entity, or alternatively as a part of the Fine Arts. The debate has also been wilfully ignorant of key social economic determinants, it has been Eurocentric, it has failed to deal with the gender issue and, unlike 19th century forebears, has openly ignored social class.[3]

Abstractions and theories to one side, at root, classification is to do with money. Kings are richer than peasants. On the contemporary art market, one can get considerably more decorative art for one's money than fine art. The very finest and greatest ancient Greek vase will cost a fraction of the allocated price of a modest minor Impressionist painting. There are tacitly agreed price levels and controls that effectively dictate what any genre, and any period of any genre, will cost at one time. Fluctuations in prices occur of course, and works by key craftspeople occasionally break out of the established framework, but on the whole, the modern age has established a financial pecking order which remains pretty well in place. Most art historians, theoreticians and critics have followed the money. Some will specialise in connoisseurship, some lean toward sociology, yet others politics and feminism. What they hold in common, however, is that they prefer to write about art that costs a lot.

This pared down analysis now needs some moderation. Artists, designers and craftspeople alike are driven not by economic considerations but by an incessant creative urge. It would be unfair to imply that they set themselves against one another as rival producers in the arts economy. They are all subjected to the established way of things and in the end relatively few of them significantly benefit from it. To depict fine artists in general as having cornered the market, for example, would be a very incomplete view. Few practitioners are able to sell

Dale Chihuly; American; *Installation*; glass;1994; Dallas Museum of Art; Photograph by Scott Hagar

their works at consistently high prices over the span of a career, and the majority struggle along on the edge of penury.

Nevertheless the *craft economy* is a particularly problematic area and has been for some time, not because it has been in some way deliberately attacked or marginalised by rivals, but because it at present sits in a very awkward place within the socio-economic infrastructure of the arts.

There are two ways to make money selling artefacts: through exclusivity or quantity. The fine artist classically makes a living by selling a small number of handmade objects very expensively. The designer makes a living by creating templates for objects that go into mass-production. The unit price in both spheres, quite without the manipulations of the market, has its logic in the mechanisms of production. Paintings need to be expensive and mass-produced products must be cheap. Marketing can make cheap things expensive, but the underlying principle remains unmoved. Straddled between an art and a design economy, craft often gets the worst of both worlds. It occupies an economic space where objects, though individually handmade, sell at mass-production prices. Lacking the prestige of high art or the reproductability of product design – both characteristics economically viable – the craftsperson frequently is obliged to sell unique works at mass prices.

Of course there are exceptions. 'High' designers have effectively entered into the art economy and many fine artists have found ways of reducing unit costs, usually by publishing, making prints or multiples, and some leading

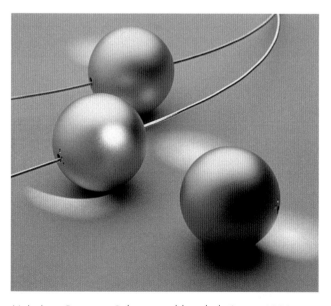

Neissing; German; *Spheres*; gold and platinum; 1998

craftspeople have risen into the economic stratosphere. But, the underlying depiction remains accurate: to survive, it is necessary either to make a lot of affordable things or a very few prestigious things. It is most important that these things are not mistaken for one another. In both instances, objects have to be convincingly sold. Each individual craftsperson has to position himself appropriately within this economic reality, or risk a life of anonymous financial hardship.

A central issue throughout the century, and one which is still vibrantly current, is that of the relationship of the professional with the vast numbers of amateur craftspeople. Understood as those groups who engage with some form of making on a part-time, non-specialist or hobbyist level, *amateurism* is an important element in all the arts. There is nothing pejorative in describing areas of practice amateur, of course. The enthusiasm and commitment of those who engage physically with the arts is vital to their maintenance and dissemination. But in many ways the amateur sphere in the crafts has come to symbolise the whole. Craft as a word does not immediately and automatically conjure up an image of works of high excellence displayed in marbled halls; it is as likely to materialise images of wooden stalls crammed with baskets, pots and jars of jam under a canvas awning. Craft has been imaged as a pleasurable way of filling time, or alternatively as a subsistence practice that is done alongside other things.

There are long-standing reasons why these images cling and often hold centre-stage. From the mid-19th century onwards, a consistent thread in craft theory had been the idea that craft is not to do with a single-minded striving for high excellence by individuals, but rather that the process of making was a key to a humane society. For a thinker like John Ruskin, every person in society could achieve the sense of being an individual through the medium of universally-practised, anonymous craft. The humane intent of the position is laudable, but it does present problems.

Surveys have shown that more people write poetry than read it. Poetry is a complex thing. A pattern of words configured to promote semiotic pregnancy; a medium that allows us to explore ourselves in a concise manner. Because it is not onerous to do, many of us write it; because it is so difficult to understand, few of us read it.

At the amateur level, the crafts are like that. Despite the given wisdom of our time, which tells us that we are all consumers but few of us are producers, the reality is really very different and in some ways less desirable. Many of us make things with creative intent, picturing ourselves as

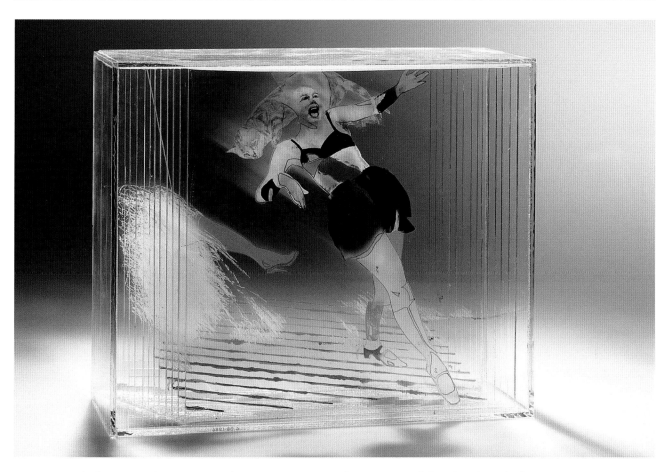

Dana Zamechnikova; Czech; *Two Cats*; glass; 1984; Courtesy the Trustees of the Victoria and Albert Museum

being on a special, self-exploratory quest. But often we don't look at, consume, absorb or contemplate the works of others to the same extent. Millions of people in the industrialised world are amateur craftspeople: the evening classes, DIY stores, garden sheds and basements of our cities are full of people making pots, baskets, embroideries, dresses, cupboards and watercolours, much of it of an extremely high technical quality. Statistics show – in Britain at least – that not nearly so many visit museums specifically to look at masterworks in these media. For example, many hundreds of thousands of Britons make pots and various forms of textile as amateurs at various levels, yet the ceramics and textiles study galleries of the Victoria and Albert Museum in London, which hold among the very finest and largest collections in the world, are visited by a tiny fraction of these. This considerable percentage of the British population are more interested in making their own craft objects than in looking at those of others. They want to make their own poetry not consume the poetry of others.

A key element of the idea of modern craft lies in these observations. In an affirmation of process over product,

amateur craft is to do with the need to physically engage with things in an overly pre-packaged world. It is a vital element in any healthy society, but it is not the same thing as the obsessive, intense search that is central to the professional sphere. The former is to do with the injection of the subjective self into objective phenomena, the latter is to do with the objectification of subjective impulses. The former strives for locality and the latter universality of consciousness. The real difference is in the way the work is situated, and in the research conducted. The great poets are the ones who read poetry.

Technology has had a decisive effect on the way the whole of visual culture has unfolded since the Renaissance. As the physical realisation of scientific advance, technology has been present at every level of artistic invention, facilitating the physical construction of innumerable quantities of things, and being responsible for the development of entirely new forms of practice. It is important to recognise this because, since the later 19th century, craft has continually been defined as being anti-technological, and as a corollary to this, anti-urban. Certainly, in the later 19th century, the period in which

craft formed itself as a lobby and a distinct zone of practice, hatred of technology was a major motivating force among various groups. A wave of Utopian activity across the industrialised nations hoped to save the world by marching backwards into an invented perfect past. Socialist Luddism – this term not being necessarily pejorative – has remained a fierce and loud force within the craft world and at its most aggressive has constituted a blind resistance to mechanical, electronic and mass-production technologies of all types, and the embracing of a rustic, mythologised vision of handmade objects.[4] This lobby is understood by many to represent the whole of craft, rather than a single thread within a far more complex fabric.

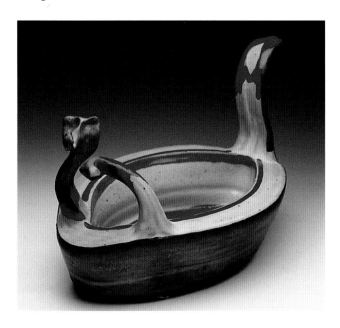

Kristine Michael; Indian; *Animal double-walled vessel*; wheel thrown and altered stoneware; 1998

Designer-craftspeople who have engaged with alternative technologies during the last several decades present a more constructive, albeit still Luddite, model. This has been at least partly in response to widespread disillusionment with science and technology as benchmarks of human progress. Some thinkers have even suggested that technology does not imply any form of progress,[5] while others have developed bio-technological models as alternatives to existing 'hard sciences'.[6] Environmental disasters, technological redundancy and the corruption of high capital have, since the 1970s, led to increasingly well-articulated and forceful protest against the uncontrolled advance of industrialism. Most of these have been committed to creating environmentally

responsive products than run in tandem with rather than against the eco-system.[7] Some have created designs specifically for Third World nations and for the poor in the larger industrial economies.[8] During the 1990s, many have engaged with the issue of recycling used products and raw materials.[9] This has taken the form, at one end of the spectrum, of designer-craftspeople incorporating old furniture, receptacles and industrial materials into objects, often with ironic or didactic intent. At the other end, materials have been broken down and recycled. Paper pulp and various forms of recycled plastic, for example, have been widely used for the creation of one-off and batch-produced furniture and jewellery. At root, these responses to technology are to do with lifestyle and the power of the individual to resist the imposition of an alien way of living.

The etymology of craft relates it to power. The power to control one's own pattern of life, its shape and speed, to resist through the process of making and designing. Many craftspeople have embraced new technology and exploited it brilliantly to achieve their ends; they perceive its primary function to be to add to the quality of life, not solely to the economic advancement of those who exploit it.

Throughout the modern period *morality* has been a constant issue. Many schools of thought have insisted that art cannot simply be about aesthetics or technics. But the aesthetic dimension never switches off. I pondered on this point one winter evening as I bounced and swayed my way out of London among several hundred others on an evening train. It was raining and as I stared out into the gloom my eyes flickered backwards and forwards between a dishevelled image of myself in the glass and the cityscape beyond. The two fused in front of me, achieving a simultaneity of subjective and objective visions. I was struck by my now automatic tendency to see the world through art, in this case a kind of Cubist or Futurist sensibility. But suddenly I was shaken out of my complacency by a quick, rat-like movement down in a street we drifted past. A horrendously broken man, stroboscopically lit with filthy yellow light, stirred and scuttled among trash cans. A typical south London street, unconsciously customised through decades to match the general detritus we recognise as a inevitable element of industrial culture; a street to lengthen the stride past, to piss on or be raped in. I wondered, as I stared at this pitiful sight, how that man felt about being part of my Cubo-Futurist vision.

The artist-craftsperson-designer has been invited to engage directly with the moral dimension of life throughout the modern period. The extreme position

was set out by John Ruskin, who effectively made art a moral reflection of the culture that produced it. Art Nouveau, De Stijl, Constructivism, Purism, the Bauhaus and the Studio Craft movement were all mediated by the perceived need to engage with the moral condition of society. While many practitioners and movements have doggedly maintained the right to disinterested thought – to art for art's sake – the rejection of the moral prerogative has been less successful in the crafts than elsewhere.

Timing is never coincidental. Over the last two centuries, whenever the industrial society appears to tip into an especially consumerist phase, real or imagined, and particularly when respected thinkers identify the age as decadent and greedy, craft and design are wont to reveal themselves as the forces of anti-Mammon. Practice has revealed itself capable of instantaneous change: the production of luxury goods and the styling of products to enhance saleability can seamlessly translate into a moral drive to conserve the material fabric of the world. The 1970s saw the publication of seminal texts on craft and design as vehicles for the improvement of society, but it was during the 1980s that the lobby was consolidated as a fierce resistance to the ethos of Ronald Reagan and Margaret Thatcher. It was in this period that the 'new age travellers', the disenfranchised urban youth of the industrial world, set off to live a life on the road, in defiance of the ideology of careerism. In many respects this activity was an earthen, Post-Modern version of the escape to rurality practised by adherents of the Arts and Crafts Movement a century before.

Work as a concept came under much scrutiny during the 1980s. For some thinkers, craft could be interpreted as no more than creative work, or the elevation of the necessary activities of life to the level of creative practice. Derived centrally from the social theory of William Morris, craft here became an entire means of living, whereby one engaged with all aspects of the material world and literally made one's own environment. Fiercely anti-consumerism, this vision of life would see most people working for much of the day in activities which directly related to their own comfort and survival, and, perhaps, the well-being of those immediately around them.[10]

While an attractive proposition in many respects, to define craft in terms of its social functionability, as a philosophy of making intrinsically tied to environment and lifestyle – to a politics of living – is extremely problematic. Oscar Wilde, among others, famously attacked the idea that any art form had to be socially responsible. As a socialist himself, he believed that society had to change in order to enjoy art, rather than art changing society or,

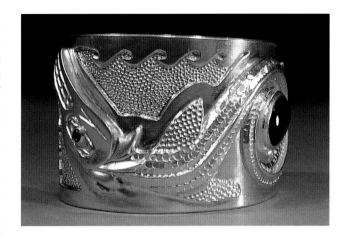

Rodney Sayers; Canadian, Lupacasath Nation; *Creation Myth*; silver; 2000

worse still, art changing itself to suit society. Art as an agent for change; art as the reward after change: throughout the 20th century these were – and remain – tensely opposed alternatives.

Ethnicity implies race, place and national identity. The role of ethnic traditions, customs, practices, local and vernacular approaches to art and life have become increasingly significant in the globalised atmosphere of late Modern culture, so much so that particular emphasis is laid on ethnic issues in this volume. The artistic iconographies and mannerisms of individual races have rarely been more important, providing not simply stylistic identity, but communal and political focus also. We must take care, however, not to see the forces of ethnicity as being simply in opposition to internationalism. Ethnic identity only becomes a self-conscious cultural issue when an international environment exists. It has been a condition of modernity from the Enlightenment onwards that the steady advance toward a global condition simultaneously leads to the positive appropriation and preservation of local difference and its artificial transmission to new geographic centres, as well as to the negative, and deliberate destruction of those cultures.[11]

Through much of the 20th century, craft was politicised by ethnic groups all over the world. It has been used as crude propaganda to exacerbate difference and tensions between peoples.

Hyun-Seok Sim; Korean; *Brooch*; sterling silver; 1998

Ethnicity has a natural and inevitable relationship with racism. But ethnic culture has not simply been about the struggles in and around this last spluttering of barbarism.[12] It has also given life and breadth to communities, inspiring some of the very best aspects of human civilisation.

Specific groups have consolidated and differentiated themselves in order to preserve and invigorate their cultural heritage. This is obviously the case with ethnic groups that feel themselves threatened or subsumed into larger dominant cultures: Canadian First Nations peoples, the Québecois, Bosnians, Bretons, Catalans and Scots resist the paralysing anonymity of internationalisation through their material culture. Ethnic minorities in the world's major cities, the millions of Greeks, Afro-Caribbeans, Slavs, Africans, Irish, Lebanese, Indians, Scandinavians, Chinese and many other peoples have developed hybrid forms based on a fusion of ancient heritage and modern environment.[13] Migrant craftspeople have deliberately fused several ethnic traditions. Typically, Japanese, Chinese and African artists living in Europe and America have manipulated several traditions. Less common but increasingly, American and European craftspeople and designers have moved to Asian countries in order to expand their vision.

We go on vacation to places making use of the fiscal and mechanical devices of international, industrial, capitalist culture; when we get there we hope to find an environment that has resisted all of these things. In a world in which globalisation has finally brought everything into involuntary proximity, *difference* has become an intrinsic part of the macro-politics of culture. We all wish to be ethnic in a global environment, we all wish to be simultaneously somewhere and everywhere.[14]

The idea of *place* – specific, unique spaces that we allow to accrue history and symbolic meaning – has great importance here. Anthropologists have discussed place at length over the last several decades, and examined the need we seem to have to create 'places' or, sites with a density and weight of symbolic meaning. A natural corollary to places are 'non-places', such as airports and motorway restaurants, where the desirable thing is to swiftly pass by without psychological attachment.[15] The crafts could be defined in this regard as being 'portable places'; objects that exude a sense of permanence, history and symbolic weight. A *space* filled with such objects has the potential to become a *place*. Those peoples who, for whatever reason, live away from the places that identify and give meaning to their cultural heritage, create places by surrounding themselves with

artefacts. The consumption and display of ornamental objects is to do with the creation of places, with profound memorabilia, and the places we tend to return to regularly, that we associate with our own cultural heritage, are premised on the idea of permanence. We expect not only our greatest cathedrals and squares but also our favourite pubs and restaurants to acquire a patina that is the result of a residual, ongoing presence. That is not to dismiss impermanence; transience is a most important quality in any vital and healthy society; but we need also a conception of permanence. We need cathedrals as well as bike sheds, ceramic cups as well as paper ones, and books as well as newspapers. A significant amount of activity within the crafts can be characterised, through the use of specific technologies and imagery, as deliberately setting out to deal with the idea of permanence.[16]

Most obviously, permanence is a vital ingredient in the formulation of collective cultural memory. Things that last through generations pass on a core of values and encoded narratives, which succeeding generations reinterpret and embellish. Things that last are intrinsically bound up with the idea of memory, of memory recorded through tactile senses.[17] To engage with many of the craft practices directly is literally to be touching history. To take an example, when a piece of ceramic is held it conveys through the inherent symbolism of its materiality, ten thousand years of activity, of things being made, substances being stored and consumed. The act of human hands clasping a clay body, of skin and clay lips meeting, is automatically and unavoidably endowed with the archaic depth of an act endlessly repeated back into antiquity. The clay vessels that survive imbue contemporary clay vessels with the concept of age. Innovation in ceramic practice is invariably achieved against the symbolic backdrop of unimaginable antiquity. The same can be said of most practice in the crafts. For all practitioners in these genres, from radical innovators to the celebrators of tradition, permanence is a central quality that constantly has to be mediated. Undoubtedly, acceptance or rejection of the idea of permanence sharply divides types of practice and practitioner in the visual arts.

The construction of places and the idea of permanence implies another major theme, one that will become evermore significant in the next decades: *domesticity*. As high technology begins to undermine the external workplace as a necessity, domestic space comes to the fore in a way that it has not been for much of the last two centuries. Clearly, the need for places of work external to

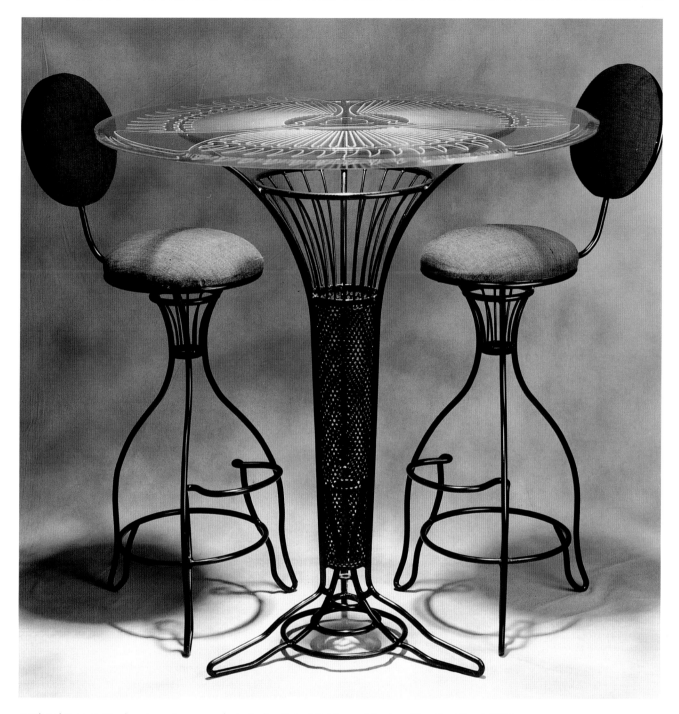

Michael Jansen Studio; American, made in India; *Jiubei Table and Jiuping Ping Bar Stool*; 1996

the home will remain a functional given in various areas of production, but the proportion of the population who will have no need to leave their immediate habitat except for purposes of social interaction will rise steadily. We already maintain office blocks, depots and educational centres of various types that do not actually need to exist in practical terms at all. We acknowledge the reality that the workplace is where we meet most of our friends, our role models and our sexual partners; it is the vital social centre of the modern age. But as the workplace gets replaced by the home as a site of productivity, the function of public and private spaces in relation to art will also change.[18]

The *museology* of craft is problematic. Through much of the last two centuries, the status of most art forms was established in official arenas of public display, that

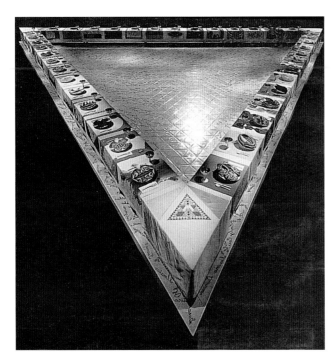

Judy Chicago; American; *Dinner Party*; china-paint on porcelain and needlework; 1979

is, museums and galleries. The inherent problems of identity in craft practice are exacerbated once they are projected into an institutional environment. Torn between being signifiers of defiant ethnic groups, representatives of tradition, functional artefacts, exercises in technique and disinterested art, the modern crafts have not sat nicely or even logically in gallery space.[19] Unlike the various forms of large-scale painting and sculpture and the ornamental arts associated with architecture, the majority of the genres associated with the crafts were not invented for display in galleries, museums and other public spaces and are intrinsically unsuited to them. We prefer to drink out of glasses rather than look at them; jewellery looks better when jangled on a dance floor; pottery is best when held. The scale, symbolism and practical function of these things was often intended for private consumption in informal places.

There is no intrinsic reason, of course, why a domestic or informal setting should be exclusive to crafted artefacts. In 1982 I went to a large exhibition of Georges Braques Papiers Collés at the Centre Georges Pompidou in Paris.[20] The collage works of the great Cubist from 1909-1914 remain one of the milestones in 20th century culture, and for me personally have always constituted one of the most intense experiences that any art form could offer. One can only wonder at the precociousness of a 26 year old who could create an idiom and a set of images that have the delicacy of Vermeer, the structure of a Gothic cathedral and the wit of Chaplin. But as I stood in front of these small, dark works, lined up like postage stamps on a giant white flat envelope of a wall, I made a sudden and discordant discovery. I realised that these works failed to function in this environment. Friends and students I was with, particularly those without prior experience of the works, felt that they looked sad, tired, lonely and confused. It was a matter of museology; this tube-embraced barn-of-a-place had destroyed their scale; and the fact that they were lined up *en serie*, like a row of trophy heads in some weird clubhouse, had neutered them. The gallery space – so vital in its provision of context and status to so much late Modern practice – here was the nemesis of art. The problem lay in the origins of these works. Braque, Picasso and Gris were the dealer Daniel Henry Kahnweiler's key artists. Kahnweiler did not so much have a gallery as a room, and he encouraged his artists to make small-scale works that could stand alone in the beautiful, complex clutter of the fin de siècle interior. Braque loved this idiom. He was a quiet, complex and subtle man, who saw his work as an abstracted, re-formed rhythmic depiction of the interiors his contemporaries lived in. Wallpaper, wood panelling, tables, textiles, glasses, newspapers, musical instruments, books, swirling around smoky, compartmentalised spaces. Any one of these collages, if placed over a fireplace in a lived-in, period space, would converse with its surroundings, make comment on the architecture, make jokes at the expense of the fixtures and fittings, and make claims for alternative ways of seeing the world. On this wall, in 1982, only two contexts remained: the tired formalism of self-referential art historical discourse, and the educational acumen of the visitor. In the absence of either, all meaning was lost.

This is not to say, of course, that a new context cannot be created, or that the original context of a work of art is the only one in which it can be enjoyed. But when an object enters into a museum, its context automatically changes. It may well still remain a great work of art, but it won't be the same, and in some cases – notably most of the crafts – it my well lose something vital. All too often, the public spaces we put works into shift them from being living, vibrant manifestations of poetry and humanity to being mere pieces of evidence that poetry and humanity once existed here. Millions of visitors trail around the world's museums and galleries each year, mutely acknowledging the importance of art without ever experiencing it, because, in reality, the art is no

longer there. Works of art are not objects; works of art are relationships between people and objects. If the relationship does not exist, neither does the work of art. Context and environment are important. They should remain in consideration when any work is presented.[21] Art is primarily an idea. Remove the idea, and only social class and economics remain.

Museums and art galleries have come to play an ever more important role; they are the world's foremost citadels of sophisticated pleasure. The crafts need to have a distinct and effective presence in these citadels, while recognising that they operate at an optimum in private space. In this regard, the crafts can only stand to gain from the development of 'on-line museums' and web based galleries. The actual objects can then return to the domestic milieu without disappearing from sight.

Gender has played a key role in the crafts over the last decades in three main ways. First, various of the crafts have been used to explore ideas of gender. Feminists have politicised their practice in order to change perceptions of the role of women. Most famously perhaps, Judy Chicago created her *Dinner Party* in 1979, an installation consisting of a giant triangular table with places set for the important women of history. The place settings, including ceramic, textile and metalwork were designed around the personalities of the individual women, and a tiled floor identified other women of historical importance.[22] Jewellers, textile artists and ceramists also used their art to address the women's issue.[23]

The second way in which the gender issue has come to the fore concerns the way in which theoreticians, historians and makers have begun to explore the way that craft objects of various types carry gender connotations. This has been widely discussed throughout the realm of women's studies, centring on sociology and psychology, and the power of both to confer a sexual identity on intrinsically ungendered objects.[24] For a considerable period through the modern European tradition, women have been denied a role as cultural producer. On the other hand, over the last century, the consumption of luxury goods, including the crafts, has been made into a naturalised practice of women. So certain types of produce – and certain environments – have likewise been naturalised into being to do with women. The domestic environment has become the woman's realm. Over the past several decades, this stereotyping, whereby women have their role ideologically subscribed in advance of any form of lifestyle choice, has been challenged.

The third issue that impinges heavily on gender concerns the numbers of women practising within the

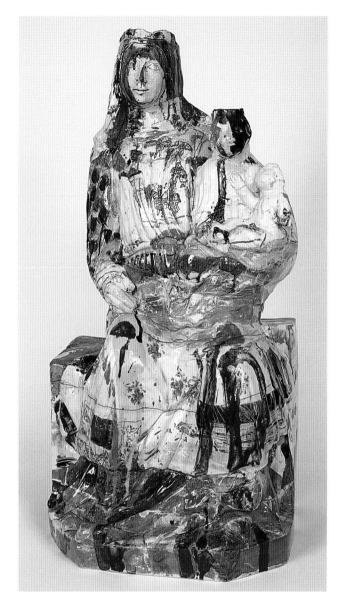

Philip Eglin; British; *St Anne, Virgin and Child*; ceramic; 1999; Photograph by Andrew Pritchard

individual genres. For a considerable period and for myriad reasons, women have been associated with the textile arts. In some cultures, women have long been associated with ceramic production.[25] However, in the last two decades, the demographic trends in some countries have seen a powerful shift whereby women have come to dominate certain practices. In Britain, for example, ceramics and jewellery immediately stand out as practices that are dominated at the training and professional levels by women. Interestingly, the disciplines of art and design history have also seen powerful numerical shifts toward women. The reasons behind these demographic shifts are complex and vary across nations.

For much of the 20th century, *history* has been positioned as being in opposition to *modernity*. The Modernist project across the visual arts largely rejected the use of historical forms for anything other than ironic use. At the same time the use of decoration or ornament – the main vehicles for the conveyance of historical narrative – was rejected as being no more than engagement with reactionary signifiers.[26] When the past was used, it was usually for the appropriation of forms and ideas that bolstered a progressivist stance. When the ancients showed themselves able to provide patterns and ideas that could function as precedents for modern experimentation, they were acceptable. Otherwise, they were to remain inside the museum. Anti-historicism in the crafts has tended toward the use of minimal, geometric and gestural abstraction, often accompanied by overt focus on the function of the object being made.

As noted earlier, the position began to change from the later 1970s, reaching a high point in the later 1980s and 1990s, when craftspeople and designers all over the industrial world began to make use of an unprecedented range of historical sources. Much of this usage was part of the general ironic atmosphere of Post-Modern culture. Some of it, however, was concerned with the disinterested use of languages at work in the craft genres and the relationship of those to modern society.

The desire to use history was bound up with a considered return to relativist values. Relativism, while questioning the essentialist values underpinning the more extreme forms of design modernism, was not – and is not – anti-Modern in itself. Rather, the simultaneous contextualisation of practice in the contemporary environment and in the ongoing continuum of genre-history has enabled the crafts to engage with the processes of change at large in the world.[27]

Underlying all these issues is the persistent problem of *quality*. Philosophically, quality has been bound up since the Enlightenment with the search for absolute values – values that allow us to identify and even measure aesthetic truths. Many thinkers have described the work of art not through its immediate physical properties or its social role, but as an abstract, sublime essence; some have developed this to the point at which art of the right quality becomes immutable and timeless.[28] This notion of quality implied a standard of excellence that was objective and universal.

Current debates on quality stem from the prolonged Modernist tradition. For many practitioners within the Modern movement in design, the quality of a work of art was tied to a value system that implied an ahistorical continuity of absolute taste. For these adherents of what became known as the International Style, the quality of a thing, when it was perceived to be of sufficient weight, was believed to transcend time and place. Under the control of advocates less able than the grand pioneer generation of architects and designers, the Modernist canon ultimately deteriorated into a dogmatic stylistic formula that made claims to immortality. Modernist objects of 'universal quality' had the uncanny likelihood of being made by white European men, and for many others, they become synonymous with elitism and bigotry.

This was certainly how such absolutism was viewed through the first phase of Post-Modernity, when relativism came to the fore in most areas of intellectual life. The development of relativist approaches to culture effectively put an end to the Modernist value system. Anthropological and sociological studies demonstrated the fallacy of immutable value; theoreticians, historians and practitioners acquired the habit of automatically exploring the social context of an object and its local meanings, as part of the assessment of its worth.[29] There came to be 'qualities' rather than 'quality', no single, unchanging idea of how things are in a complex environment in which value systems gently shift on the tides of demography, geography and economy.

However, as soon as the relativist, contextual approach to the work of art acquired widespread legitimacy, by the mid-1980s, questions were raised about an apparent collapse in standards in all areas of visual culture. Leading cultural thinkers worried about the decline of literature, drama, painting, architecture and sculpture at one end of the spectrum, and television programming, journalism, pop music and fashion at the other. By the late 1980s a critical and theoretical war about the value of things and the nature of quality raged across the international art press.

When attention was given to the crafts, the version of the debate became particularly viperous. A sense of decline in standards was promulgated; the idea was abroad that craftspeople across the media had somehow lost the plot, that they had feebly given up a higher heritage in order to wallow in one of several lower ones. Writers railed on about the need to 'return to' or 're-discover' quality in technique and idea.[30] Two evil places were identified as the abodes of failing craftspeople: the *abyss of commercialism*, in which makers sacrificed all to make a living; and (worse) the *ghetto of bourgeois individualism*, where they gave up the specific heritage of their disciplines to embrace a generalised and debased form of Fine Art practice.

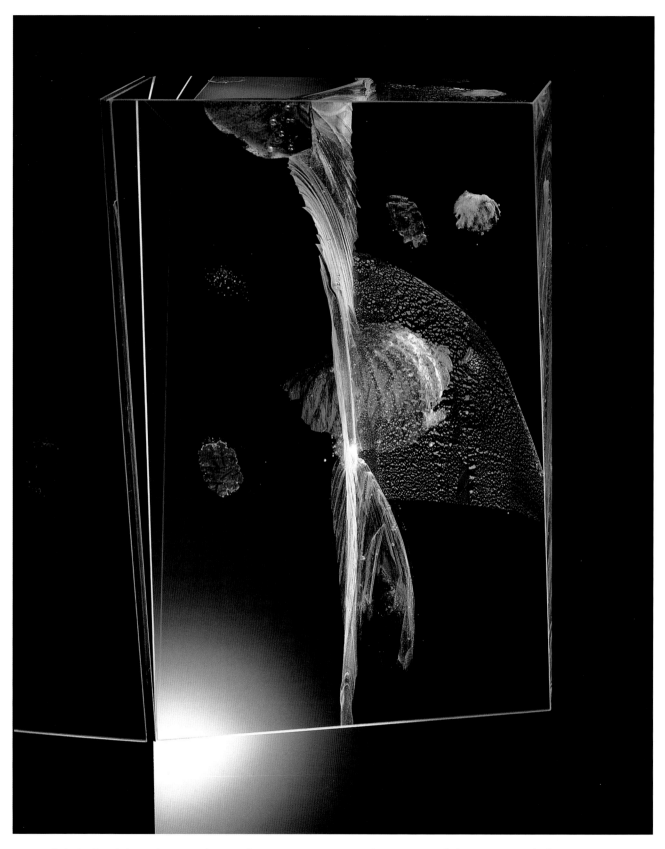

Yan Zoritchak; Czech/French; *Cast Glass Sculpture*; 1998; Courtesy the Trustees of the Victoria and Albert Museum

Skill was – and is – associated with the idea of quality. Skill has had a very mixed press within Modernist culture. Often interpreted as the perfection of mechanical techniques, it has been derided as limiting the potential of the mind to generate a truly liberated poetic vision. Skill has been associated with the measurable aspects of visual culture, a thing invented by academics and guilds to provide benchmarks and standards. While many defenders of the notion of skill in the visual arts have denied these limiting definitions, it remains a phenomenon marginalised by its apparent anti-cerebral intent. Craft and skill have often been used as interchangeable terms and this has undoubtedly undermined the status of craft as a Modernist activity.[31]

Quality is not to do with immutable models of value. It simply implies that any fabricated phenomenon, any thought, object, physical action, speech, or any other thing that is made, has the potential to be in a better or a worse condition. Quality denotes the constituency of a thing and confirms that it has this propensity, rather than being merely *different* from other things or its own previous condition. Quality is an *a priori* condition of art. Art is the realisation that material has the potential to be raised into a higher state. None of us should tolerate the absence of quality. None of us should tolerate the sophist verbiage that allows those who are against standards for political and economic reasons to equalise the world out into a cheap, uniform mediocrity.

Craft is like any other word. It has no sacred right to exist, and the word may well fade in the coming decades. What will not fade away are the genres the word represents. At present various of these are combining, melting and dissembling into one another, while others intensify around a set of principles and practices pushing to ever higher levels of poetic exactitude. As the following pages in this book show, this gaggle of methodologies and ideologies – the crafts – has never been in a healthier condition. It has never been more vibrant. It has persisted; it is poised for a radical new phase.

COPYRIGHT © 2002 PAUL GREENHALGH.

NOTES

1 See, for example, the journal *Ceramics Art and Perception* (Australia); Norris Ioannou (ed.) *Craft in Society: An Anthology of Perspectives* (1992, Western Australia, F.A.C.P.); Norris Ioannou *Masters of their Craft: Tradition and Innovation in the Australian Contemporary Decorative Arts* (1997, Sydney, Craftsman House); Peter Fuller *The Australian Scapegoat* (1986, Perth, University of Western Australia); G.A. Hickey (ed.) *Making and Metaphor: A Discussion of Meaning in Contemporary Craft* (1994, Ottawa, Canadian Museum of Civilization and the Institute for Contemporary Canadian Craft); Morrison Fleming and Warner Keene (eds) *Common Ground: Contemporary Craft, Architecture and Decorative Art* (1998, Ottawa, CMOC and ICCC); Jean Johnson and R. Bishop (eds) *William Morris Yesterday and Today* (1996, Toronto, Harbourfront); Anne Barros *Ornament and Object: Canadian Jewellery and Metal Art* (1997, Toronto, Stoddart); Gail Crawford *A Fine Line: Studio Crafts in Ontario from 1930 to the Present* (1998, Toronto, Durdurn).

2 See, for example, R.G. Collingwood *The Principles of Art* (1938, Oxford); Peter Dormer (ed.) *The Culture of Craft* (1997, Manchester , M.U.P.); Paul Greenhalgh 'Art and Craft: a Dichotomy of Falsehood', *Ceramic Review*, March/April 1989); Indra Kagis McEwen *Socrates Ancestor: An Essay in Architectural Beginnings* (1993, MIT); David McFadden *Defining Craft* (2000, New York, American Craft Museum); Lee Nordness *Objects USA* (1970, New York, Viking); Sue Rowley *Craft and Contemporary Theory* (1997, NSW, Australia Council, Allen & Unwin); M. Vickers and D. Gill *Artful Crafts: Ancient Greek Silverware and Pottery* (1994, Oxford, OUP).

3 See, for example, Walter Crane *The Claims of Decorative Art* (1892, London, Lawrence & Bullen).

4 See Paul Greenhalgh 'The Progress of Captain Ludd' in Dormer (1997).

5 See Jean Gimpel *The End of the Future: The Waning of the High-Tech World* (1995, Connecticut, Praeger); John Horgan *The End of Science* (1996, London, Abacus).

6 Lewis Thomas *The Fragile Species* (1992, New York, Robert Stewart); Jeremy Rifkin and Ted Howard *Entropy: A New World View* (1985, London, Paladin).

7 See, for example, Dorothy MacKenzie *Green Design: Design for the Environment* (1991, London, Lawrence King); W.J. van den Brink and K.J.A. de Waal *Procedures of the Second European Conference on Environmental Technology* (1987, Amsterdam, Martinous Nijhoff).

8 Victor Papanek *Design for the Real World* (1979, London, Paladin) and *The Green Imperative: Ecology and Ethics in Design and Architecture* (1987, London, Thames & Hudson); International Organisation of Consumers Unions *Consumerism: The Green Factor* (1993, IOCU).

9 Louise Taylor *Recycled* (1997, Rotterdam, 010 Publishers); Ed

van Hinte and Conny Bakker *Trespasses: Inspirations for a Co-efficient Design* (1999, Rotterdam, 010 Publishers).

[10] By far the best example in recent times has been Roger Coleman *The Art of Work: An Epitaph to Skill* (1988, London, Pluto); see also Tim Dant *Material Culture in the Social World* (1999, Buckingham, Open UP).

[11] The debates around Edward Said's seminal text *Orientalism* (1979, London) are of interest here. See, for example, John MacKenzie *Orientalism* (1996, Manchester, MUP).

[12] See J. Hutchinson and A.D. Smith (eds) *Ethnicity* (1996, Oxford, OUP).

[13] See, for a discussion of these issues, Arjun Appadurai *Modernity at Large* (1997, Univ. Minnesota Press); J. Hutchinson and A.D. Smith (eds) *Ethnicity* (1996, Oxford, OUP).

[14] See, for example, F. Jameson and M. Masao (eds) *The Cultures of Globalisation* (1999, Duke University Press); S. Herman and R.W. McChesney *The Global Media* (1997, London and Washington, Cassell).

[15] Marc Auge *Non-Places: Introduction to an Anthropology of Supramodernity* (1995, London, 1992, Paris, Verso).

[16] Key discussions of these issues can be found in Jean Paul Sartre *The Psychology of Imagination* (1940, London, Methuen); Hannah Arendt *The Human Condition* (1958, Chicago, CUP).

[17] M. Kwint, C. Breward and J. Aynsley *Material Memories: Design and Evocation* (1999, Oxford, Berg).

[18] See, for example, Manuel Castells *The Rise of Network Society Volume 1* (1996, Oxford, Blackwells).

[19] There is a substantial literature dealing with this range of problems. See Peter Vergo (ed.) *The New Museology* (1989, London, Reaktion); J. Elsner and R. Cardinal *The Cultures of Collecting* (1997, London, Reaktion); Robert Lumley *The Museum Time Machine* (1990, London, Routledge).

[20] Centre Georges Pompidou *Georges Braque: Les Papiers Collés* (1982, Paris, CGP).

[21] Ray Crozier and Paul Greenhalgh 'Beyond Relativisim and Formalism: The Empathy Principle' *Leonardo*, Vol. 25, No. 1, 1992); Ray Crozier and Paul Greenhalgh 'The Empathy Principle: Towards a Model for the Psychology of Art' *Journal for the Theory of Social Behaviour*, Vol. 22, No. 1, March 1992).

[22] See Judy Chicago *Through the Flower* (1982, California, Benicia); Judy Chicago *The Second Decade 1973-1983* (1984, New York, ACA Galleries); Judy Chicago and Edward Lucie Smith *Women and Art: Contested Territory* (1999, Weidenfeld and Nicolson).

[23] See, for example, Rozsika Parker *The Subversive Stitch: Embroidery and the Making of the Feminine* (1984, London, Women's Press); H.W. English Drutt and Peter Dormer *Jewelry of Our Time* (1995, London, Thames & Hudson); Liz McQuiston *Women in Design: A Contemporry View* (1988, London, Trefoil).

[24] See, for example, Elinor , Richardson, Scott, Thomas and Walker *Women and Craft* (1987, London, Virago); Penny Sparke *As Long as its Pink: The Sexual Politics of Taste* (1995, London, Pandora); Victoria de Grazia and Ellen Furlough *The Sex of Things: Gender and Consumption in Historical Perspective* (1996, Berkeley, California UP); Attfield and Kirkham (eds) *A View from the Interior: Feminism, Women and Design* (1989, London, The Women's Press).

[25] Moira Vincentelli *Women and Ceramics: Gendered Vessels* (2000, Manchester, MUP).

[26] See, for example, any manifesto of the Modern movement in design; Le Corbusier *The Decorative Art of Today* (1924, Paris); Hitchcock and Johnson *The International Style* (1929, New York).

[27] See Tanya Harrod (ed.) *Obscure Objects of Desire: Reviewing the Crafts in the Twentieth Century* (1997, London, Crafts Council); Paul Greenhalgh 'Discourse and Decoration: The Struggle for Historical Space, *American Ceramics*, Vol. 11, No. 1, 1993).

[28] See, for example, R.G. Collingwood *The Principles of Art* (1938, Oxford); Richard Wollheim *Art and its Objects* (1980, Cambridge, CUP).

[29] See Hal Foster *Post-modernism* (1983, London, Pluto); John Thackeray *Design after Modernism* (1988, London, Thames & Hudson); Perhaps the best exploration and 'proof' of relativist ideas can be found in Pierre Bourdieu *Distinction* (1985, London, RKP); Mark Poster (ed.) *Selected Writings: Jean Baudrillard* (1988, Cambridge, Polity); Adrian Forty *Objects of Desire* (1986, London, Thames & Hudson); Roland Barthes *Mythologies* (1968, Paris, Gallimard).

[30] The best example can be found in Peter Fuller *Images of God* (1984, London, Chatto).

[31] The famous definition of craft along these lines is in Collingwood above. Seminal recent texts include Peter Dormer *The Art of the Maker* (1994, London, Thames & Hudson); Christopher Frayling (ed.) *Beyond the Dovetail: Craft, Skill and Imagination* (1991, London, Crafts Council).

2 · THE GENRE

Paul Greenhalgh

I HAVE a jug by the British potter Michael Casson. It is a tall, eccentric-looking piece, one of a pair I own, with a slight shoulder, large neck and tiny handle. It is swathed in a lush salt glaze that is patterned by vertical curves pulled through the once wet surface. It is a beautiful thing. I like to hold it while contemplating its confident formalism. But I know that I am doing some-

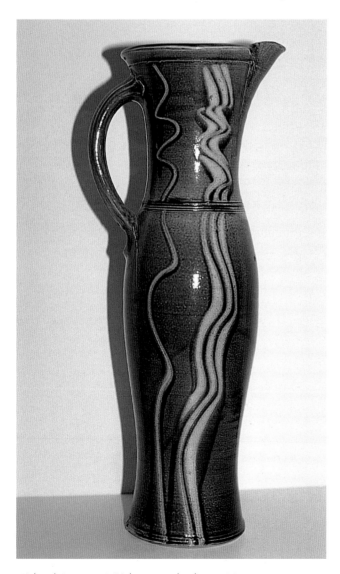

Michael Casson; British; *Jug*; salt glaze;1988

thing else as well when I do this. I am also taking part in an immense discourse fed into the object by the maker, which ranges through centuries of ceramic activity. The glaze, invented probably in Germany and imported to Britain five centuries ago, occupies an interesting space between the aristocracy of high art, the ignominy of peasant wares and the alienation of sewage pipes. The curves of the shape are pure Europe, with a height acknowledging Medieval Britain and a deliberate stiffness that is faintly Mycenaean. The fluidity of the pattern feels Korean, with a hint of ancient Crete, a taste of Bernard Leach and a modicum of Modernist abstraction. It could actually work as a jug, but it doesn't want to; it is a swan, not a duck, a protected species fabricated to be observed, not used.

Then the subjective comes to play. The actions of the maker transmit directly to me through this thing, his preferences, choices and eccentricities. In this case, as it is so often between artist and patron, I enjoy a personal friendship with Michael Casson and so can push beyond the objective recognition of his sources into the subjective realm of his tastes and affections. And so I position myself in his world.

The way we make things is fantastically revealing of the human condition. As individuals we all use various types of material to make objects of all kinds for numerous roles and functions. These constructive skills are essentially what differentiate us as a species. Going beyond this, and following the logic first fully articulated by Karl Marx, we can see that the way we make things underpins the structure of society. And as soon as we make things for sale to others, the world becomes a different place. Commodities of any kind, their production and consumption, shape the human universe.

I want to discuss here the major mechanism that guides the production of cultural artefacts: the genre. The genre is best defined as a way of working; an established way of making particular products using a set of technologies, processes and materials. The fully developed genre has provided the principal method for the creation of things of artistic quality. Some genres – ceramics, furniture making,

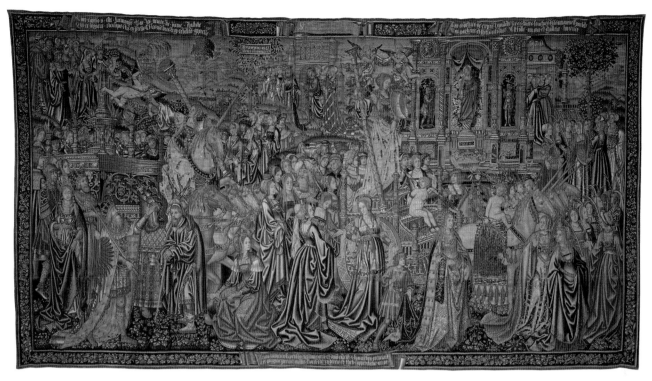

Tapestry illustrating Petrarch's *Triumph of Chastity over Love*; Flemish; 16th century; Courtesy the Trustees of the Victoria and Albert Museum

glassmaking, jewellery, metalsmithing, painting, sculpture, tapestry, for example – are recognised as being at the core of the Western artistic tradition. All these, in the forms in which we now understand them, have moved through history, adapting, twisting, changing, accumulating and surviving extraordinary upheavals within the fabric of the societies they reside in. They have functioned more or less effectively for over five centuries, but for around the past one hundred and fifty years a questioning of the role, status and meaning of the genre has been in continuous progess. We might recognise this questioning as part of the generic phenomenon of modernity.

In late Modern culture the crafts are defined as a consortium of genres, a group of practices peopled by individuals engaged in genre-based activities who have consciously chosen to express themselves through a set of established practices and principles. It would be a mistake, however, to see the genre simply as a set of techniques and materials for the production of artefacts; it has roles that have little to do with the workbench. It functions in the marketplace, mediating and stabilising commodity values; it is the main vehicle for the creating of hierarchies between types of produce; it gives identity to ethnic and class-based groups. In this way it straddles the economic, political and social worlds.

As the mechanism that results in the production of expensive and socially important objects, the genre has always been organised into socio-economic structures that protect the interests of those who subscribe to it. And when the object enters the marketplace, or when it is deemed worthy to represent important institutions and official bodies, further power structures mediate its role and value. These power structures also play a role in the rise of new genres and determine when, if ever, genrehood can be conferred. Throughout history, guilds, unions and societies have protected the interests of the genre, academies have consolidated its methods, the marketplace has monitored its distribution, the stock exchange has fixed its price, scholars have maintained its status and museums have preserved its heritage.

All of these entities and their successors are still active in the process of genre creation and preservation. The genre benefits or suffers from the way they function within what is an immensely complex cultural infrastructure. Adding to the complication, the entities are acutely aware of one another and work to preserve (or undermine) each other's interests. When the cultural infrastructure works to particular effect, the genre can acquire great power. Over time it can make itself inviolable and changing it might be a very tricky business. It can create a cultural closed shop, in which set practices and practitioners provide an unbreakable code of principles. It is capable of

coming to represent entire communities and even nations. Thus, the actual *making* of beautiful objects is only one aspect of the success or failure of a genre.

But a genre can also lose its position within the cultural hierarchy. Many of them were originated to produce objects that were vehicles of communication or prosaically utilitarian. When technology or economy renders these roles redundant, such objects survive for other, usually symbolic or cultural reasons, and these might simply not be good enough. Some, despite being practised and consumed only sporadically, are deemed worthy of life. These are often dependent for survival on government agencies designed to protect endangered genres. Arts and crafts councils, heritage societies and craft museums, are, at root, cultural preserves for near extinct, ailing and geriatric genres. These bodies collectively fight to prevent the terminal fade of once crucial practices. Thus, basket making, letter cutting, repoussé and macramé limp on as protected species.

As a cultural phenomenon the genre can be observed to have gone through a paradigm shift since the onset of modernity proper. In the first part of the 18th century, as Enlightenment humanism gained meritocratic and materialist dimensions, formal institutions were founded with the express purpose of improving, promoting and standardising genre creation. These academies of art were followed in the 19th century by training institutions that covered all rather than simply the high genres. The so-called Schools of Design, Schools of Arts and Crafts, and Colleges of Art and Design placed the genre firmly under the control of appointed educators.

A parallel transformation occurred alongside the one in training. The display of genres in the public and private spheres was a vital factor in the development of the whole of visual culture in the second half of the 19th century. Especially important was the growth of the museum sector. Large-scale world's fairs, trade fairs, private galleries and salons, department stores and auction houses also changed forever the cultural landscape of the industrialised nations. Books, magazines, journals, posters, catalogues proliferated and made local genre activity internationally known.

Thus the whole machinery of production and consumption that we associate with the modernisation of the world came to bear on the visual arts. The genre was speeded up,

Christopher Dresser; British; *Drinks Set*; red stoneware; c.1881; Courtesy the Trustees of the Victoria and Albert Museum

cosmopolitanised and intellectualised. It is important to remember also that the genre is a living thing and new ones do come into being. When new technologies become available and when audiences demand new sensations, new genres develop and consolidate themselves. Photography and various forms of printmaking are obvious examples of technologies that grew into complex cultural phenomena.

It is also important to remember that the genre is not the only thing. The obsessional focus historians and dealers have placed on the history of painting has led us to see the history of art as almost exclusively genre-based. But not all creative practice has been structured in this way. Much design activity has not been premised on single genres but on their orchestration into finished works. Architecture is not a genre as such and neither is interior design. Classically, the key differences between craftspeople and designers is that the former engage in a single genre, while the latter are concerned with problem-solving that might move across a diverse range. The success of the great designers of the last two centuries is usually found in their ability to find novel solutions to problems by moving between materials and technologies. Christopher Dresser, Henri Van de Velde and Norman Bel Geddes were orchestrators. George Ohr, Maurice Marinot and Charles Rohlfs were craftspeople.

Among the myriad approaches and ideas that constitute the story of visual culture during the 20th century, we can now discern many patterns that reveal the ideological and technological strains of the period. The most striking one in the current context, and certainly a most important one for the crafts, reveals itself as a divide at the heart of the visual arts as a whole, marking out a fundamental difference in approaches to practice itself.

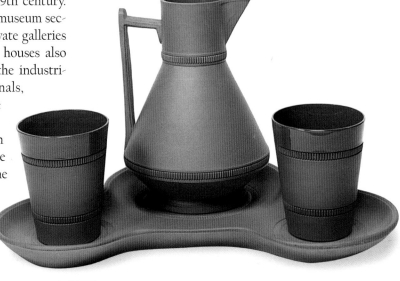

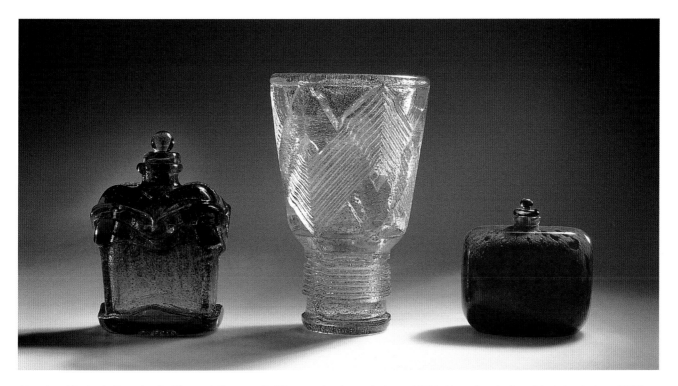

Maurice Marinot; French; *Bottle and Stopper* (left); cased coloured glass; 1930; *Vase* (centre); acid etched glass;1932; *Flask and Stopper* (right); glass with coloured enclosures, acid etched; 1929; Courtesy the Trustees of the Victoria and Albert Museum

This division separates what I will call positivist and ironic practice. While these two approaches can be iden- tified far back into the European tradition, and in all the arts and humanities, the phenomenon I am describing here is somewhat different, and only has real significance and meaning when understood as a functional element within the machinery of Modernist practice.

I am stretching the conventional meaning of both terms in order to describe the phenomenon. The positivist approach is on one level simple and innocent: it is about pushing an art form as far as it will go as a vehicle of aesthetic expression, while accepting its established parameters. It involves those practitioners in all the visual arts who have sought to aesthetically complete their cho- sen field. By ironic practice more or less the opposite is implied. Irony is essentially to do with critique. Ironic practice uses art as a vehicle to intensify and improve human experience by questioning the role and purpose of things. It is to do with intellectual deconstruction, with deliberately undermining established or normative values in order to assert the new.

One can play instructive and amusing games dividing modern visual culture down the positivist-ironic line, and examples give a good indication of what is being pro- posed. Modern movements are easy to characterise: the

Arts and Crafts movement, Fauvism, Constructivism, De Stijl, Art Deco, Abstract Expressionism, and the Studio Glass Movement were positivist. Dada, Surrealism, Arte Povera, Neo-Dada, Pop (mostly), Happenings, the New Jewellery (mostly), Art and Language and the Brit Pack are ironic. Individual makers in all disciplines can also be sorted out without too much difficulty. For example, Alexander Calder, Dale Chihuly, Philip Guston (p.22), René Lalique, Bernard Leach, Mies Van der Rohe (p.24), Piet Mondrian (p.23), Issey Miyake, Kinpei Nakamura (p.193), Albert Paley, David Pye, Wendy Ramshaw (p.25) and Peter Voulkos are (and were) positivists; Robert Arneson, Gijs Bakker (p.115), Marcel Duchamp, Gerald Ferguson, Dan Friedman, Otto Künzli, René Magritte, Michael Marriot (p.64), Robert Rauschenberg, Richard Slee (pp.27 and 192), Cindy Sherman and Ettore Sottsass live in the world of irony. Many of them may well have had phases on the 'other side' and all are capable of change, but the broad location of their oeuvres is clear enough.

The practitioners and movements listed don't describe the fact that the two approaches were in poise at key moments in the Modernist story. Between the Wars the International Style in design and architecture and related groups of abstract painters and sculptors were firmly positivist; at the same time, Surrealism was

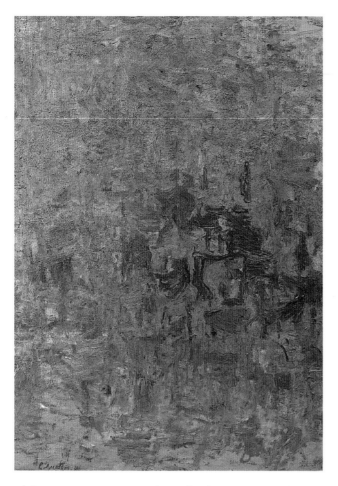

Philip Guston; American; *The Bell*; oil on canvas; 46″x 40″; 1952; Collection of Aaron I. Fleischman

to say that it now constitutes normative practice. Positivist approaches are seen at this time as somewhat peripheral, of a previous phase, and are overly caricatured as determinist.

Differences in style and content are implied by the positivist-ironic divide. Most (but not all) forms of abstraction have been powerfully positivist, in the sense that individual practitioners and theorists, and the schools they represented, saw the goal of art as being a search for the sublime, of the perfection of itself. Irony tends toward commentary, and therefore emerges via language and narrative. Ironic practice, because of its critical dimension, inhabits the world to comment on it; it is an art of engagement. Positivism has often insisted on transformation of the world or alternatively absents itself from it; it lives in the aesthetic dimension. Positivists think in terms of permanence. In their use of materials and techniques and even in their selection of subject matters, they tend to remain loyal to what has proven itself over time. Ironic practitioners have little time for such loyalty. They use the best material to hand for the effect sought; in their subject matter they often ridicule the very idea of permanence.

There is something of greater significance for the crafts here. The acceptance or denial of the genre in the 20th century has been largely bound up in the discourses that have surrounded the positivist-ironic divide, and its survival as a vehicle for creative expression is partly dependent on how that discourse unfolds. As a consortium of genres, this affects directly the position of the crafts.

At this point we should distinguish between modernity and Modernism. By modernity we imply the ongoing process of cultural modernisation that has been in train for several centuries, and continues to shape the way we are. Modernism is far more focused and refers to the successive waves of self-conscious and even aggressive attempts to transform the cultural world, dating from the 1890s. The genre sits more comfortably with modernity than Modernism.

Thousands of practitioners have shown a commitment to modernity through a single genre. Painters, sculptors, potters, jewellers, furniture designers have pushed their media to the highest form of expression through the reification of the means of the genre. As already implied, for centuries there have been forms of positivism and irony operating within the arts. Turner and Friedrich struggled toward their respective notions of the sublime, and alternatively Goya and Hogarth revealed the debauched nature of the world to us. These artists continually stretched the boundaries of their

the critique-driven ironic response to the condition of the world. Both were aware of the nature of the space between them, while recognising that they were also both part of the grand project of modernity. Over the last two decades, Post-Modernism is widely understood to be a relativist (ironic) reaction to absolutist (positivist) approaches to culture. It is important to remember of course that the term Post-Modernism is deceptive in that it implies that modernism as such has finished. This is not the case. Post-Modernism has simply witnessed a dramatic shift in the discourses of modernity. The complex fabric of history, the tumultuous variables of socio-political context and the value systems of the consumer have all been added to the mix in order that the next phase of humanist development does not make some of the tragic mistakes of the last. The project rolls on in revised form. Nevertheless, Post-Modernism has witnessed a distinct shift away from the previous condition of poise. Irony has come powerfully to the fore in key areas, so much so that it would be fair

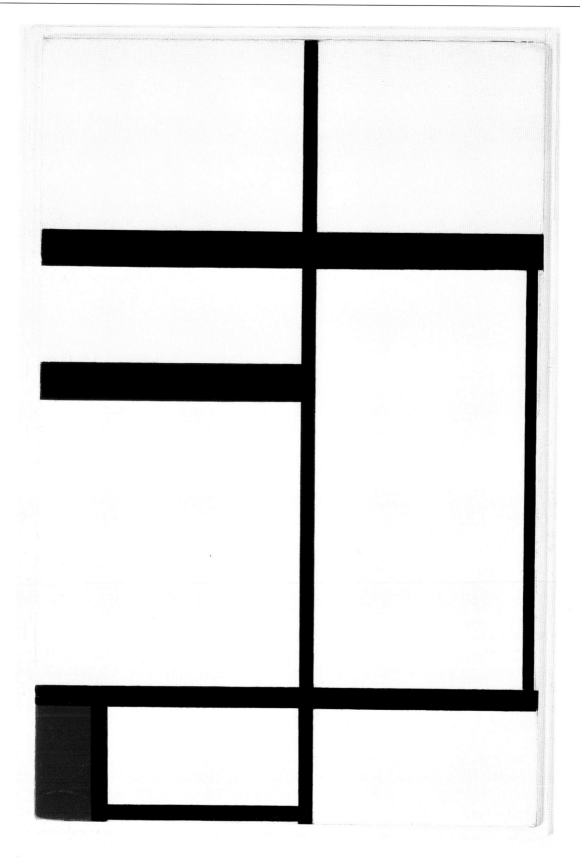

Piet Mondrian; Dutch; *Composition with Red, Black & White*; oil on canvas; 32½″ x 21½″; 1931; Collection of Aaron I. Fleischman

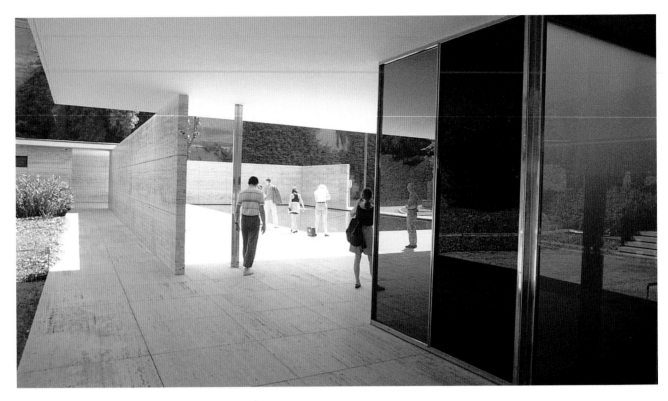

Mies Van der Rohe; German; *Barcelona Pavilion*; 1929

chosen genres. In the same way in the 20th century, a wide band of those existing within the rubric of Modernism have seen their practice as a quest to explore and push the genre to its upper limit. The classic Modernist painters Georges Braque and Henri Matisse, for example, while they extended the boundaries of normative practice, consciously remained within genre. They can be seen as individualist obsessives relentlessly pushing at their medium. Similarly Anselm Kiefer and Leon Golub have much biting ironic comment to make on the world from within the boundaries of their chosen idiom. But many Modernists were not content to accept or to extend the parameters of the genre. Modernism is not simply about forms and subject matters.

The genre has been systematically surpassed or rejected by some within Modernist culture. Movements and makers split dramatically into groups along ideological lines. When allied to progress, positivism led to the aggressive and single-minded search for new forms that went beyond genre-based activity. It was believed that buildings, chairs, tables, light fittings, receptacles could be transformed into something ethically and aesthetically higher and better. New materials and products rendered much established genre activity marginal and eccentric. Modernist artist-architect-designers such as Le Corbusier had an almost mystical dimension to their positivism,

whereby perfectability was at the end of the process of progress. For him, the 'decorative art of today' was not premised on genre but on socio-cultural prerogatives. Artists and designers associated with movements such as Purism, Constructivism and De Stijl believed that art was intrinsically linked to the metaphysical condition of the world, and sought to achieve the sublime in order to engage with this. In this spirit, Piet Mondrian remained a painter, but the implication of his practice, and those of his associates in De Stijl, implied the end of the genre. The asymmetrical infinities generated by his grids could be applied to any idiom, and in due course they were.

Ironic Modernists have focused on the critique of the practice of art itself. This aspect of ironic practice was largely initiated by the Dadaists in the years running up to the Great War. Marcel Duchamp, through his invention of the 'Ready made', dispensed with established principles for making art. The skills, histories, symbologies and hierarchies of painting and sculpture were dropped and replaced by the artist's determination to identify art in new and entirely cerebral terms. The Surrealists railed against accepted canons of skill. The genre was of no use to those wishing to dispense with stable or established idioms. Critique – irony – became a weapon to achieve freedom, and freedom was understood to be outside of the genre.

From Surrealism to the many developed forms of 'art as critique' of the 1960s and 1970s, and finally into the current generation of film-makers, performance and installation artists, the ironic dimension has continued on. Tracy Emin, Hans Haacke, Damien Hirst and Jeff Koons, for example, testify to the ongoing nature of the project.

Back to the crafts. The craft world can be characterised as predominantly positivist. This is because a genre can only do certain things. It can endlessly radicalise its language and develop its aesthetic resonance as long as this is done from within, but it has accepted parameters and if these are denied then the genre ceases to be a genre. By definition, a ceramic vessel or figurine is made of clay. If a decision is made to reject clay, then the resultant objects are not ceramic. Conversely, the internal logic of the genre needs to be understood and recognised at some level. Because an object is made out of fired clay it does not mean it is ceramic. This is because a genre is not premised simply on materials and technologies, some derive their inner cohesion from a set of iconographies, histories, utilitarian functions and social roles. This is very much the case with jewellery and furniture.

Having said this, one of the most interesting and important aspects of the Post-Modern decades has been the development of a powerful presence in the crafts of those who engage in critique. This has entailed either the direct use of imagery which comments upon socio-political issues, or an eclectic exploration of the history and meaning of the genre itself, in an attempt to expand and complicate its boundaries. But by definition all this work has been ironic within genre.

Genre-based objects that deliberately try to be ironic against genre tend to appear confused, awkward, contradictory and even hypocritical, as do those that attempt to occupy the space of other genres. To work within a genre is to do a specific thing, albeit that the specific thing has an inordinate amount of flexibility within it. Given that at this point in the Modernist project there is infinite, legitimised space outside the genre to orchestrate material in any way in order to create art, there would seem to be little point in deliberately sitting inside a genre in order to manipulate it into self-destruction. It is important to stress that the positivist-ironic divide is not value laden and is not a tool for the judgment of practice. It simply describes an aspect of the machinery of modernity.

At this point in time, the genre has become, within the totality of object production in industrialised society, a minority rather than a majority practice. But it is still popularly recognised as the most direct means of self-

Wendy Ramshaw; British; *Rings and stand*; mixed media; 1997

expression. Paintings remain by far the most popular museum exhibits in the Western world because painting is a stridently direct vehicle of self-expression: you have a surface, you do something to it to tell the world you are there. And while you are doing this, you are simultaneously engaging in the heritage of a thousand years. In the crafts, self-expression, or the direct intervention of the maker in the material process, is a key to its continued cultural usefulness. From this perspective, craft as we have it now is largely a result of intellectual developments at the end of the 19th century. The ideas of, among others, Eugene Emanuel Viollet le Duc and Gottfried Semper (largely formulated in the mid-century) were powerfully in the foreground. Both advocated the creation of a modern style through the honest and undisguised use of materials and technologies. When combined, in the last quarter of the century, with the rising tide of individualism, promoted by such eminences as Walter Pater and Oscar Wilde, powerful credence was given to the notion that the greatest art was achieved by individual artists working in a direct and honest way with materials. Craft effectively became to do with the direct intervention of the self in the material world, a means of asserting personal control, and this spirit remains at its core.

Gerald Ferguson; Canadian; *One Million Pennies*;
Installation at the National Gallery of Canada; 1979

Related to these observations, the personality of the maker can be seen to be a key factor in the formation of the positivist-irony divide. There are those among us who prefer to exist in ambivalence with regard to the macro-structures of life, and deal with it in an ironic way; others sense a consistent shape and direction to things, and construct positive scenarios for existence. Many of us flip from one condition to the other depending on how context interferes with us.

There is an intrinsic link between the individual and collective. The localised, subjective visions of the one cohere and play a central role in the formation of the objectivised, social pattern of the other. The modern genre ties larger histories of distant civilisations to local histories and immediate actions. A commemoration of artists, patrons, places made possible through acts of making, collecting, displaying. The genre is the mechanism we have designed for fusing the giant fabric of history with the forgettable actions of our own lives. An example might demonstrate this.

Hortus Testudinei by Walter Ostrom is a compendium of representations of the history of ceramic functions and styles. The form could be a giant food cover or an inverted tureen. The figurative nature of the form ties it to the French faience and English porcelain factories of the 18th century; the use of narrative echoes 19th century Staffordshire wares; more than anything there is a powerful sense of the grand phase of Italian maiolica, somewhere in there hangs a hint of China; the architectural scale of the piece relates to the Grotesque ornamentation of Baroque gardens. The surfaces could not have existed before Abstract Expressionism and the gentle absurdity of the subject and its scale of treatment looks back to the narrative games of Surrealism. This eclecticism is deployed to position the object in a larger world of visual poetry that expands and complicates the initial subject matter: the artist's pet tortoise. This fusion of the universal and the personal is the central function of the genre in late Modern culture and a key to the persistence of craft.

We have come to invent ourselves around genres. We accept what many of the genres do and we act upon this knowledge; there is no need for us to distinguish ceramic from glass when we drink hot or cold liquids, or to adorn ourselves with a repertoire of metal contrivances – medals and rings – to show affection or status. We do these things to tie ourselves into the larger fabric of our culture and the genre is one of the vehicles that gives us access to this fabric. We tend to change how we do these things when the genre changes, and the genre changes when there is a shift in the complex web of interdependent relationships between people and things.

Perhaps ultimately the genre is also to do with power. 'Power' is the most interesting meaning that attaches to the nomenclature of craft. It is still the

Rene Lalique; French; *Glass Lamp*; *c.*1925; Courtesy the Trustees of the Victoria and Albert Museum

meaning of the word in some languages. In the most direct sense this stems back to the social, economic and political power associated with the skill-based guilds of the medieval period, and their successors in the following centuries. There is another type of power at work however, that only manifests itself in the presence of an object fabricated within the parameters of a genre.

The power of the genre is in the easy, accrued knowledge that effervesces from successful objects, those works of art that comfortably take part in the millennia of history without losing sight of the present: works of art that engage with all of us while remaining faithful to the discourses of their own kind. We enjoy the arts on many levels, but perhaps the deepest empathy only comes when one feels oneself to be inside the culture of the genre itself, engaging with the language of that particular idiom. And perhaps we can only engage at the most profound levels with new idioms once we have mentally configured them as genres. It is then that they resonate.

The creation of new genres and the collapse of old ones is a dynamic process alive and well in the contemporary world. Non-genre-based, and even anti-genre, activity is capable of settling into an established way of doing things. New approaches to sculpture over the last several decades have formed into patterns that effectively make them genres. Performance and installation art use a range of strategies, are distinct and even predictable. Digital technology has created the potential for numerous genres to consolidate. The process is dynamic. Genres form, legitimise and present cultural forms. They gather hinterlands of patrons, dealers and writers around them. Once established, they are usually attacked from forces without; they then re-invent themselves or they disappear, to be replaced by new

Richard Slee; British; *Surfing Heart*; ceramic; 1998

established forms. A genre is capable of resisting collapse through considerable periods of time if it has an appropriate economic and social base. Indeed they are rarely destroyed by new technology, but are forced by it to change identity and emphasis. Genres only disappear when no one feels they need to look or to pay.

Imagine modernity as a giant, gaseous field of millions of active particles, alternately bouncing off or adhering to one another to form new compounds. Floating in this creative mayhem, the genres are those entities that hold onto particles and ultimately complete themselves. They are not the catalysts, but stable elements that change slowly and ultimately characterise and identify the field as a whole. They render the constantly transforming flux that is modernity into comprehensible reference points, summations, statements of quality. They fix the processes of modernity in time and store them for future use. They are vital for allowing us to see exactly what it is that we are doing.

The status and meaning of the genre is central to the development of the visual arts. Genres are in the process of consolidation, collapse, transformation and re-invention at this time, and the outcome of these various processes of change will determine the types of art we will enjoy in the next several decades. The genre has persisted and remains strong as a structured form of activity, as a stabiliser, despite the fact that many of them have become peripheral activities, languishing nobly at the edges of the emergent world. But it is important that we acknowledge our genres; that we continually question them; that we occasionally terminate them; and that we consolidate new ones.

Walter Ostrom; Canadian; *Hortus Testudinei*; earthenware; 2000

Copyright © 2002 Paul Greenhalgh.

3 · STUDIO CRAFT AND CRAFTICAL FORMATION

Kaneko Kenji

Two of the most important outcomes of the 20th century have been the development of modern design as an independent discipline and the institution of the making of crafts as individualistic works of art[1].

The theoretical and practical foundations of modern design were laid when the decorative arts philosophy of William Morris and the Arts and Crafts Movement was transmitted to Continental Europe and developed by the Deutscher Werkbund and the Bauhaus. The rise of individualistic crafts occurred almost simultaneously in Japan and Britain when, during the 1920s, Tomimoto Kenkichi (1886-1963) and Bernard Leach pioneered new approaches to the making of ceramics. These developments led to the expansion of the concept of modern art that had been formulated in the West to include both the applied arts and individualistic crafts.

Kenkichi Tomimoto; Japanese; *White Porcelain Jar*; 1936

Craftsmanly qualities and the characteristics of materials were not the focus of particular concern in the world of modern design, but were aspects among many that required consideration. The demise of the Bauhaus ceramic workshop is evidence of this, as is the fact that in the postwar period the idea of limiting activity to specific materials became largely meaningless to industrial designers. In the case of craft as art, on the other hand, the more mature and established this became, the greater the emphasis that was placed on originality and universality. A point of no return was reached in the 1950s when makers working in media hitherto defined in terms of their practical applications began to produce works that served no obviously useful purpose. The proposition that crafts were a vehicle for individualistic expression resulted in an inevitable clash with traditional concerns about utility and function. Viewed with hindsight, the assimilation of the crafts into the realm of fine art was not unproblematic. Using the work of contemporary ceramics as my main example, I will explore issues relating to the meaning and purpose of craft over the past few decades.

In the United States ceramic makers, such as Peter Voulkos, John Mason, James Melchert and Henry Takemoto, sought to incorporate the avant-garde spirit of Abstract Expressionism, seen in the work of Jackson Pollock and his New York contemporaries, into the field of ceramics. Cutting, joining and beating clay in a manner akin to action painting, they succeeded in creating a substantial body of work imbued with a dynamism realisable only through the manipulation of clay. Examples include Voulkos's series of massive clay sculptures, Mason's 'Vertical Sculpture' series and Takemoto's 'Big Vases'. It could be argued that these endeavours were relatively short-lived, however, that little of what was produced in the 1960s remained fundamentally integral to the ceramic medium. Voulkos subsequently started to work more sculpturally and in

metal, Melchert became a Funk artist, Mason became involved in the Primary Structures movement and Takemoto abandoned the making of one-off works to become a ceramic designer.

This generation sought to elevate ceramics into a form of contemporary art. Having achieved their aim, however, they quickly turned their attention towards other areas of creative practice. The result was that ceramics were left to occupy themselves with traditional issues of function and utility or, in reaction to the attempt to brand them as a form of contemporary art, to play with the concept of the vessel or indulge in extravagant figuration. Much of what was produced during this period was amateurish at best.

The problem was that many makers working in this spirit used clay and clay-working techniques without ever properly engaging with the inherent potential of the medium. They were involved in the traditional ceramic processes of throwing, forming, drying, glazing, firing and finishing, but never stopped to reflect on the deeper significance of these things. Many were unaware of the fundamental contradiction arising from limiting themselves to working in clay while at the same time claiming to be part of a contemporary art scene in which clay, as only one of a multitude of potential media, lost its absolute status (hence 'material relevance'[2]). This is the principal reason why American makers of this period produced so little work of consequence.

Prior to what took place in America the question of material relevance had already raised itself as an issue in Europe, when figures such as Bernard Leach and William Staite Murray pioneered the making of individualistic ceramics during the 1920s (see Chapters 5, 14 and 17).

Staite Murray developed the concept of ceramics as a kind of abstract sculpture whose circularity of form derived from the use of the potter's wheel. 'The fine art pot' describes the artistic nature of his ceramics and the major break they represented from mainstream industrial products.[3] However, even if one allows for limitations of language and the conditions of the period, there is no evidence that Staite Murray distinguished between the condition of crafts and the constraints imposed by the use of particular materials and that of sculpture and its essentially pluralistic attitude towards media. In this sense his position was somewhat contradictory.

Bernard Leach, in contrast, promoted the ideal of what has been termed 'the ethical pot'.[4] The 'studio', from the term 'studio ceramics', used to describe individualistic ceramics, has the sense of 'anti-industry'. In

Peter Voulkos; American; *Untitled Plate*; stoneware and porcelain; about 1975-8; Courtesy the Trustees of the Victoria and Albert Museum

asserting that utility was an essential feature of ceramics, Leach also placed ceramics in an 'anti-fine art' position. Leach believed that the making of ceramics belonged in the space between these two 'antis'.

For practitioners seeking self-expression through the making of ceramics within a Western theoretical framework constructed around the categories of fine art, applied art and craft, there were no other options. Leach's world was marked by vacillation and a lack of resolve, however, while Staite Murray's recasting of ceramics as Fine Art resulted in a discrepancy between material specific approaches to making and sculpting for the sake of sculpting. The situation presaged what subsequently occurred in 1950s America.

The British ceramist and critic Alison Britton has questioned why crafts continue to have a place in modern industrial societies where everyday utensils can be manufactured so quickly and cheaply by mechanical means. In addressing this issue she has written:

I think that a common thread could be seen to be that many people choose to work in the crafts because close involvement with a material brings a set of limitations that are stimulating to work with. I

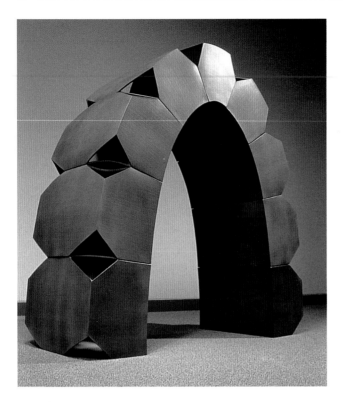

Masahiro Kiyomizu; Japanese; *Space Receptor 98-B;* 1998

would suggest that pleasure in limitations is a characteristic that distinguishes craft practice from that of fine art or design.[5]

But this is a deceptive argument. To talk about the limitations of materials in practices which are in advance defined in terms of the limited materials they employ is to argue in circles. The issue, rather, is what can be achieved by working with and through the limitations imposed by particular materials.

As exemplified by what happened with the Bauhaus ceramic workshop, the crafts have suffered from the tendency in the West to equate individualistic expression with Fine Art, and utility and mass production with industrial design. This has resulted in a lack of attention being paid to the significance of the processes unique to the making of ceramics. Clay, whether used to produce ceramics or to make Fine Art, is regarded as no more than one among a range of creative media.

Such an outmoded and simplistic concept does not allow distinctions to be made between materials in the context of crafts and materials in the context of Fine Art – a single undifferentiated view operates in both arenas. The creation of Fine Art sculpture through adherence to the limitations of clay is, however one looks at it, an impossibility. If, despite this, a maker perseveres in this course, the

objection is made that clay is 'an extremely inappropriate material for the making of fine art'.[6] This leaves the maker with no choice but to return to traditional concerns with vessel production. If the aim then becomes the pursuit of an individualistic artistic agenda through the creation of vessels that are different from industrial products, the maker ends up in a backwater where the highest aspiration is to indulge in the 'pleasure of limitations'.

The making of so-called 'avant-garde' ceramics by members of the Modern Art Association of Japan and the Shikkai foundered for similar reasons.

Yoshimichi Fujimoto(1919–1992) and other ceramists belonging to the Modern Art Association tried to apply the concept of 'Spatial Formation' then fashionable among sculptors to the making of ceramics. Much of what they produced adhered closely to the sculptural principles advocated by their peers. As Fujimoto stated:

> Taken to its logical conclusion, three-dimensional objects could have been thought of as sculpture, and two-dimensional objects as painting. In which case there was no reason for me to make such an issue over working in ceramics. But this meant that what I was doing was full of contradictions – for by that time I was already too deeply steeped in ceramics to be able to work with anything else.[7]

Being a type of sculpture, 'Spatial Formation' involved all kinds of media and bore no relation to disciplines that put the processes required for the manipulation of particular materials at the centre of their practice. The prevalence in Japan of the sort of undifferentiated view of materials discussed earlier explains why Fujimoto tried to employ ceramic making processes in the creation of works whose starting point lay elsewhere. The impossibility of his position led him to abandon his sculptural interests and to redirect his passion for clay towards the making of vessels. Fujimoto's situation, the outcome of a view of materials comparable to that espoused by Alison Britton, was similar to that in which his American contemporaries found themselves. The situation was the same for artists belonging to the Shikkai.

In Britain a number of steps have recently been taken to address the problems facing the crafts. There have been attempts, for example, to re-examine the history of the philosophy of the crafts in order to establish new concepts in keeping with the changed circumstances of the late 20th century. The recent publication of *The Culture of Craft: Status and Future*, edited by the late craft historian Peter Dormer, is of particular interest in this respect.[8] It

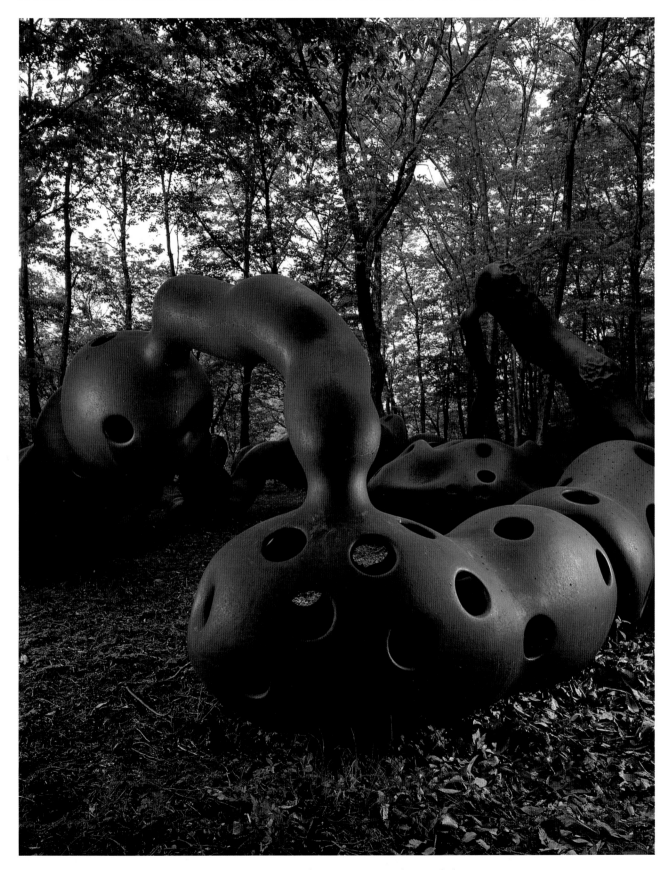

Masayuki Hashimoto; Japanese; *Orchard – Sunlight within Fruit, Fruit within Sunlight*; 1978-98

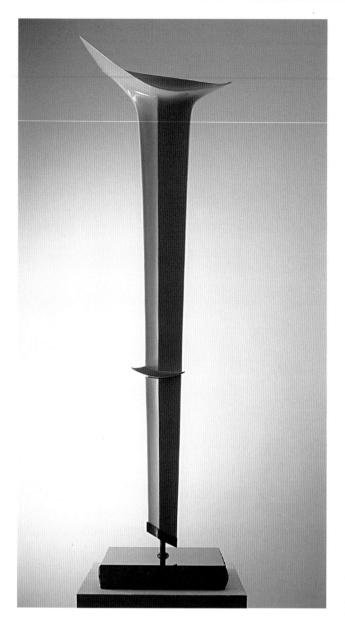

Sueharu Fukami; Japanese; *Distant Scene 'Descrying'*; 1994;
Collection of The National Museum of Modern Art, Tokyo

Writing retrospectively about the early years of the Sōdeisha, Yagi explained:

> Unlike in sculpture and painting, where ideas preceded the choice of materials and techniques, the starting point in ceramics was the medium itself.... Our work didn't begin so much from the consideration of form but was led by the nature of clay and the processes used to fashion it. This was rather different from what happened in fine art. It was more a question of integrating the ceramic making process with one's own artistic impulses.[9]

This adoption of a position firmly situated between Fine Art and the crafts as they had traditionally been understood was a solution to the problems posed by material relevance. It offered a means towards self-expression that, whether in a spirit of acceptance or rejection, was based on a recognition of the autonomy of ceramics and the processes of clay-working. This new approach to the making of ceramics is what I have termed 'the crafting of form'.

The origins of these ideas can be traced back to Kenkichi Tomimoto, mentioned earlier as the pioneer of individualistic ceramics in Japan. He had formulated a philosophy of ceramics around the use of the potter's wheel in the making of jars, at which he excelled. His theory was based on the idea of the 'battle of the profile':

> If you work at the wheel with the shape of a jar in your mind's eye, the soft clay moves in and out in a myriad of profiles. I call this the 'battle of the profile'. (1914)[10]

What Tomimoto meant was that the final form of the jar came about through a process of negotiation between the shape intended by the artist and the shape dictated by the clay itself.

Tomimoto subsequently developed this idea into a broader concept of ceramics as 'the making of solid forms within space'[11] (1926–40). Then, arguing that 'ceramics represent the ultimate in abstracted forms', he posited that 'ceramics are little different from abstract sculpture'[12] (1926–40). While this sounds similar to the assertion made by Staite Murray, it is more a reflection of the limits of language and thinking that prevailed at the time and their inability to go beyond the equating of three-dimensional forms with sculpture. With Tomimoto, unlike Staite Murray, there was a logic and consistency in how he limited himself to, and worked exclusively with, ceramics.

Tomimoto's achievement lay in the fundamental shift he made from using clay to produce vessels dictated by the

includes important essays by Paul Greenhalgh and Peter Dormer entitled, respectively, 'The History of Craft' and 'The Language and Practical Philosophy of Craft'.

In Japan the Sōdeisha, a Kyoto-based group of ceramists established in 1948 by Kazuo Yagi (1918–1979) and others, played a central role in negotiating the parameters of the crafts at both a theoretical and practical level. Unlike the Shikōkai, the Sōdeisha was extremely thorough in its deconstruction and analysis of the different stages of the ceramic making process – throwing, forming, drying, glazing, firing and finishing – and the technical skills that each entailed.

traditions of ceramics to the creation of new forms that grew out of the process of throwing on the wheel. These ideas were taken up by Shōji Kamoda (1933–1983) and then developed by Kazuo Yagi into his 'new concept of creating form'. Further sophistication has continued to this day:

> To be able to limit oneself to one material and its associated techniques is to have the freedom to reject freedom. The issue is whether or not one can make the logic of materials implied by adherence to a set of limitations the starting point for the realisation of one's creative ambitions.[13]

Written by Masayuki Hashimoto (b.1950; see p.31) in 1996, this proposes that choosing to work with a particular material is in itself a first step in the creative act, the 'logic of materials' being to proceed step by step to produce forms that can only arise from the symbiosis between materials and the techniques needed to process them. This notion of the logic of materials is an important step forward in the conceptualisation of ceramic practice, and represents a major furthering of the ideas developed by Yagi.

Contrasted with what might be described as a rather defeatist notion of 'pleasure in limitations', Hashimoto's logic of materials offers a positive and constructive way forward. In Alison Britton's thinking, limitations resulting from a lack of alternatives are regarded as the characteristic of working in the crafts. I have already explained that this derives from the undifferentiated

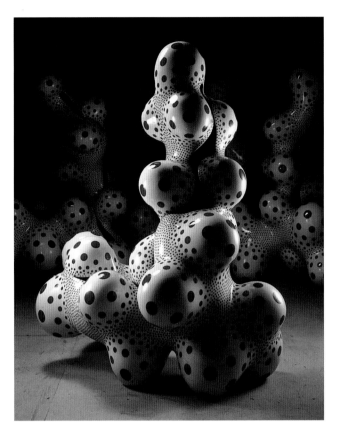

Harumi Nakajima; Japanese; *Hard Struggle V-1*; 1995; Collection of The National Museum of Modern Art, Tokyo

view of materials originating in the Fine Art position that all media are potential candidates for creative manipulation. This idea of 'limitations' is based on the Fine Art view of materials, the only options are to work within the confines of a particular medium – which effectively means making vessels – or to reject this completely and operate as a Fine Artist.

Hashimoto's proposition is different from this. His 'logic of materials' and its positive embracing of the limitations of materials as the starting point for creative practice renegotiates the space between the crafts and Fine Art. While Hashimoto uses the materials, techniques and processes traditionally associated with metal forging, what motivates him is the same concern for self-expression found among Fine Art practitioners. His work occupies a middle ground between the crafts and contemporary art, having aspects of both but being neither one nor the other. His clearly articulated philosophy represents a new approach to making of the sort I have called 'the crafting of form'.

The crafting of form is the focus of much attention in contemporary Japan and has given rise to a great deal of recent experimentation, especially in the field of

Yō Akiyama; Japanese; *Peneplain 872*; Collection of The Museum of Modern Ceramic Art, Gifu

Hideo Matsumoto; Japanese; *Enclosure and Appreciation IX*; 1991; Collection of The National Museum of Modern Art, Tokyo

Ayumi Shigematsu; Japanese; *Bone Ear '96-1'*; 1996

ceramics. The work of Sueharu Fukami (b.1947; see p.32) involves the creative adaptation of slip-casting techniques used for the mass production of tableware. This choice of technique and his preference for porcelain are the outcome of a search for a means of producing forms that leave no physical trace of the artist's involvement in the making process. The polished edges and simple but richly-modulated faceting of his forms have a pure and ethereal quality to them.

Harumi Nakajima (b.1950; see p.33) is an example of an artist whose long-standing involvement with Fine Art practice has led him to re-evaluate the processes unique to ceramics. He makes cylindrical forms from which circular sections are cut away and filled with spheres of clay. His forms evolve naturally from his engagement with the clay, sometimes resulting in the addition of further cylinders out of which subsequent spheres emerge. They have a compelling sense of being the inevitable outcome of the interaction between clay and artist. Both powerful and monumental, they rise upwards with a remarkable dynamism.

Again, in the case of Yō Akiyama (b.1953; see p.33), his search for a means by which to explore the innate qualities of the ceramic medium has resulted in a series of experiments revolving around the fissuring of clay through exposure to extreme heat. His massive forms are born out of a desire to give physical shape to the power of clay and its latent capacity to rupture and split.

The recent work of Hideo Matsumoto (b.1951; see p.34), which explores the theme of 'enclosure and appreciation', has developed from his observation of the similarity between fashioning clay and the workings of the natural world. His forms and their enclosed spaces come about through the harmonisation of his shifting spiritual state with the rhythmic process of transforming clay into ceramics. Matsumoto's work is a prime example of the approach to clay defined by Kazuo Yagi as the 'new concept of creating form'.

Masahiro Kiyomizu (b.1954; see p.30) incorporates his experience as a student of architecture into his ceramics. He makes composite works consisting of slab-built boxes whose surfaces are cut through and caused to slump during firing. This slumping is Kiyomizu's particular means of engaging with clay. He is also interested, however, in creating architectural structures that have the capacity to envelop and contain.

The work of Ayumi Shigematsu (b.1958; see p.34) seeks to give concrete expression to sensory perceptions, particularly aural sensations as felt through the human bone structure. Operating at the limits of what is possible with clay, she creates organic forms distantly suggestive of animate existence.

The theoretical point of departure for these various endeavours is the same as that proposed by Hashimoto and his 'logic of materials'. This basic principle is the key to recent Japanese ceramics and the crafting of form as a whole. Japan is currently witnessing the emergence of a new generation of ceramic makers. Foremost among them are Toshiju Saitō (b.1963), Akito Morino (b.1969), Mariko Shibata (b.1957), Tsuyoshi Maeda (b.1964), Kaoru Ojio (b.1969) and Junko Hasegawa (b.1964). The crafting of form in which they are engaged is carrying the 'new concept of creating form' to ever greater heights. The outlook for the future is bright.

COPYRIGHT © 2002 KANEKO KENJI. TRANSLATION COPYRIGHT ©2002 RUPERT FAULKNER.

Toshiju Saito; Japanese; *Steam Explosion*; 1998; Collection of The Museum of Modern Ceramic Art, Gifu

NOTES

[1] See also Kaneko Kenji, 'William Morris and Studio Crafts', in *William Morris, The Father of Modern Design* (exhibition catalogue), Tokyo: The National Museum of Modern Art, Tokyo, 1997; Kaneko Kenji, 'Japonisme in the Crafts and the Contemporary Crafting of Form', in *Japonisme in the Crafts* (exhibition catalogue), 1998; Kaneko Kenji et al., *The History of World Ceramics*, Bijutsu Shuppansha, 1999.

[2] See also Kaneko Kenji, 'Abakanowicz – The Studio Crafts Movement – Masayuki Hashimoto: Development and Overcoming of the Material Relativism (sic),' *Bulletin of The National Museum of Modern Art, Tokyo*, no. 5, 1996; Kaneko Kenji, 'The Crafting of Form and the Basic Principles of the Lausanne International Tapestry Biennial', *Minzoku Geijutsu*, no. 14, Minzoku Geijutsu Gakkai, 1998.

[3] See Oliver Watson, *British Studio Pottery*, Oxford: Phaidon Christie's, 1990; Garth Clark, *The Potter's Art*, London: Phaidon, 1995.

[4] Ibid.

[5] Alison Britton, 'Craft: Sustaining Alternatives', in Martina Margetts (ed.), *International Crafts*, London: Thames and Hudson, 1991.

[6] As expressed, for example, by Helmut Ricke in connection with studio glass: 'Group Discussion: An Exploration of the Directions and Possibilities of Contemporary Glass', in *The 4th World Contemporary Glass Exhibition* (exhibition catalogue), 1991.

[7] Fujimoto Yoshimichi, 'Interview with Hayashiya Seiz', in *Collected Works of Fujimoto Yoshimichi*, Tokyo: Kodansha, 1986.

[8] Peter Dormer (ed.), *The Culture of Craft*, Manchester and New York: Manchester University Press, 1997.

[9] Group Discussion, 'Pioneers of Avant-Garde Ceramics', in *Contemporary Ceramics*, no. 12, Tokyo: Kodansha, 1976.

[10] *The Collected Works of Tomimoto Kenkichi*, Satsuki Shob, 1981.

[11] Ibid.

[12] Ibid.

[13] Hashimoto Masayuki, 'A Flight with Materiality - Theories on Materials as Related by Artists,' vol. 1, *ART & CRAFT FORUM*, no. 4, 1996.

4 · ART MANUFACTURERS OF THE 21ST CENTURY

Karen Livingstone

THE end of one century and the beginning of the next is a natural time for both reflection and prediction, as Walter Crane, key spokesperson of the Arts and Crafts movement, reminds us in his 1905 publication, *Ideals in Art*. Here, he points out how:

> It seems strange that ... – what I was going to call our machine made-century should be characterised by a revival of the handicrafts; yet of the reality of that revival there can be no manner of doubt, from whatever point we date its beginnings, or to whomsoever we may trace its initiation.[1]

Now we are standing on the threshold of a new millennium, with all its associated hype, we find ourselves in the similar and equally strange position of looking back at a century characterised by a revival of handicrafts. However, whereas the heart of the 19th century revivalism lay in a deep seated political commitment and set of core philosophies, the range of practices and approaches in the 20th century will not, I would argue, represent any serious contribution to ways of thinking or doing that will leave a valuable legacy for practitioners in the 21st century.

The crafts in the 20th century were characterised by an obsession with the 'mark of the hand', angst over whether 'craft' can be 'art', the relationship of the maker to the material and the made object, and a desire to recapture an ideological social position which did not exist in the first place. I will contend here that these are not the values that should continue to define 'craft' in the 21st century and that the one-off, hand-crafted ideal of the craft practitioner is being, and should be, vigorously challenged by a new 'craft' relationship with batch production, and a re-discovery of craft as part of the much wider culture of design.

Craft does not have an easily recognisable position within contemporary culture. Endless self analysis, determined self-isolation, and a self-conscious anti-

Walter Crane; English; *Design for a printed textile*; c.1900; Courtesy the Trustees of the Victoria and Albert Museum

W.A.S. Benson; English; *Oil Table Lamp*; brass and copper; *c.*1890; Courtesy the Trustees of the Victoria and Albert Museum

modern approach to material discipline, has had a damaging and confusing effect on its status and perception, and on the ability of the numerous disciplines within the woolly boundaries of craft to remain wholly relevant to society. The influential and innovative practitioners at the end of the 20th century did, in fact, have a closer relationship with their progenitors in the last three decades of the 19th century than with much of what has occurred in craft since the First World War. In the latter part of the 19th century, the designers of 'Art Manufactures' and the key practitioners of the Arts and Crafts Movement had parallel interests and their work shared many characteristics. As the 20th century progressed, however, 'craft' was shaped into very different and distinct set of practices from any other genre. One dominant, and, I would argue, largely destructive, model of craft discourse in the 20th century was a widely adopted attitude to hand craft and technology.

This model of 'craft' is based on assumptions about the mechanisation of the old craft industries, yet mechanisation in the production of the decorative arts was far from universal by the end of the 19th century. With the exception perhaps of most textile production, the

large majority of decorative arts had some element of hand crafting or finishing in their creation. Craftsmanship and production – or the application of 'handicraft' to manufactured decorative objects – were never totally distinct activities, and workshop production was still as common as factory production at the end of the 19th century. The key figures associated with the Arts and Crafts Movement, including William Morris and C.R. Ashbee, were not professional, skilled craftspeople but were, for the most part, trained architects and painters. They were, therefore, theorists and designers rather than makers. Walter Crane, leading figure in the Arts and Crafts Movement, for example, was a painter who also worked as an illustrator, designer, writer and teacher. The prime motivation of these leading figures was the shared critical Romantic vision of Britain as set out by the quasi-mediaeval anti-industrial stance of John Ruskin in his key writings,[2] and the plea of William Morris for a world in which there was enjoyment in labour through the regeneration of handicraft. They favoured workshop practice, aimed to raise the condition of ordinary workers and the quality of ordinary workmen through training, to eliminate the division of labour, and to encourage the craftsman to engage in creative expression during the making process. Adam Smith had provided the model they loathed, and they set out to provide an opposition to it. However sincerely motivated this ideal was, practice and philosophy were more usually kept separate for economic reasons.

Thus, major misunderstandings about craft practice lie in the ideas that a crafted object is made by only one person, that the making process does not involve the use of any machine or machine-operated tool and that 'handmade' means 'rough-finish'. The artistic products we associate with the period from about 1870–1900 were made in a variety of situations and many different methods of manufacture, and in both workshop and factory situations.

The designer W.A.S. Benson, who is most commonly associated with his innovative solutions for lamps and light fixtures which furnished some of the most important Arts and Crafts interiors in England, set up his own workshop in Hammersmith, west London, in 1880 specialising in metalwork. In just two years he established a foundry in Chiswick, also in West London, and a new factory in Hammersmith which was equipped with advanced machinery to make domestic objects of the highest quality in copper, brass and electroplate. Benson sold his designs which were labelled 'Art Metal', at his own two London showrooms, and through Morris & Co.'s showrooms, and

Ernest Gimson; English; Candle sconces; brass; c.1910; Courtesy the Trustees of the Victoria and Albert Museum; Photograph by Daniel McGrath

they were exhibited at Siegfried Bing's Maison de l'Art Nouveau in Paris. As one of the most versatile of the Arts and Crafts designers, Benson also designed furniture, fireplaces and grates and wallpapers.

Benson's organisation was perhaps rare among art manufacturers for the extent to which he employed mechanical techniques, but the use of machinery and tools and, more importantly, the division of labour, was common workshop practice even in the most experimental Arts and Crafts situations such as C.R. Ashbee's Guild of Handicraft, and in the workshops of William Morris's business, Morris & Co., which were both staffed by a network of professional trade craftsmen. Similarly, designer-makers, such as C.F.A. Voysey, A. H. Mackmurdo, and Ernest Gimson, understood traditional craft skills by studying techniques, but they made little if anything themselves. Gimson, for example, learned wood turning and rush seating from local skilled workers but he staffed his workshops with a team of craft workmen, as well as commissioning a traditional blacksmith, Alfred Bucknell, to make sconces and firedogs to his designs.

Benson was a founder member of the Art Workers Guild in 1884, and was involved with the Arts and Crafts Exhibition Society which was founded in 1888. Its founding president was Walter Crane. The Arts and Crafts Exhibition Society organised annual exhibitions which encouraged a sense of unity in presentation reflected in the diversity of the exhibitors. Among the exhibitors were not only individual craftspeople and designers, but also enlightened manufacturers. This kind of forum helped to promote the work of the Arts and Crafts designers, whose success led to commissions from the large numbers of both new and established factories who produced art manufactures.

The textile manufacturers of Britain were innovative and forward looking in their use of designs purchased from many of the key designers of the period. The innovative retailer Liberty commissioned ranges of artistic wares from leading art manufacturers and design studios, including art pottery and tableware from the Moorcroft Pottery, furnishing fabrics from the Silver Studios and a range of pewter made in Birmingham. This block printed silk bedcover, probably sold through Liberty, was designed by Voysey and produced by London textile printers G.P & J. Baker in about 1895. By the 1880s and 1890s, art manufacture was the norm and this new breed of artist-designer was flourishing.

C.F.A. Voysey; English; *Bedcover*; printed silk; 1893;
Courtesy the Trustees of the Victoria and Albert Museum

In 1892, after several years of working on individual commissions for stained glass, Louis Comfort Tiffany established the Tiffany Glass and Decorating Company in Corona, New York for the production of a range of art glass which successfully captured the imagination of the domestic and then international markets. The workshops were at first dedicated to the production of the leaded glass lamps which, although produced in multiples by teams of craftsmen, are readily identifiable as the work of a single guiding spirit. As many of his lamps were designed for electric light, Tiffany demonstrated an understanding of how light is transmitted, softening the harshness of the electric light with the colours of the glass. Function was also given consideration in electric lamps, which had armatures to alter the focus and shades which were interchangeable. In addition, new ranges of experimental art glass, jewellery, ceramics and metalwork could be introduced as a result of the commercial success of the lamps, including the favrile glass which was hand blown from designs by Tiffany or other designers in the firm's studios. In France, Emile Gallé, at his glassworks in Nancy, achieved similar aims of producing art works for a broad audience as well as unique pieces. Despite the individual power of many of the objects, Gallé himself was exclusively the designer and did not engage in the making process.

In Denmark at the end of the 19th century an attitude to craftsmanship, production and design promoting the co-operation between designer and makers was nurtured and, significantly, remains characteristic to this day. The Danish silver designer Georg Jensen and the English Arts and Crafts reformer C.R. Ashbee were almost exact contemporaries. Unlike Ashbee or his predecessor William Morris, however, Jensen was not intent on promoting a social message or moral philosophy. Before establishing his own business in Copenhagen in 1904, however, he did work in the silver workshops of Mögens Ballin, which were founded on Morrisian principles. Here Jensen was encouraged to develop his own designs and remarkably, to exhibit jewellery under his own name. He took a similar approach with the people that worked for him in his own workshop, allowing them artistic freedom and encouraging their independent work. Jensen also collaborated with other artists, buying designs from his associates. Jensen silver jewellery and hollowware was produced by silversmiths partly by machine and then finished off by skilled hands. (See p.42.) The workshops expanded due to the company's success, and until 1915 Georg Jensen designed all the objects except those that were bought in, directed the work and supervised the making of each piece of silver. It was this open-minded approach to design and Jensen's dedication to preserving a high standard of craftsmanship which established a model for design excellence.

There was, however, a contradiction implicit in the aims of the Arts and Crafts Exhibition Society which has had long-lasting implications. One reason it was formed as an organisation in the first place followed an act of refusal to exhibit with the Royal Academicians. By establishing a parallel organisation in retaliation, the idea of 'the other' was established. It was then perpetuated by a damaging shift in attitude and approach in the early years of the 20th century. The collaboration of the Arts and Crafts Exhibition Society with a broad range of

manufacturers and individual makers stopped in about 1913 when any relationship previously held with industry was consciously terminated in favour of a purist approach to hand craft. The committee members of the Arts and Crafts Exhibition Society, with the surprising support of the president, Walter Crane, voted firmly against commerce following a report written by the stained glass artist Christopher Whall.[3]

Almost simultaneously the society greatly increased its (amateur) female membership. The continued promotion through most of the 20th century of craft as an amateur or, at best semi-professional, pursuit has left us with a paradoxical vision of craft far removed from the political and philosophical commitments of William Morris and the pioneers of the Arts and Crafts Movement.

One of the incertitudes of the Crafts movement from the end of the First World War has been the insistence of both makers and critics on limiting the scope of the genre through materials-based self-isolation.[4]

Where contemporary art trends had privileged ideas over materials and were increasingly interdisciplinary, the ascendancy of the importance of materials and the increasing specialisation of craft practitioners, was taken to the extreme in 20th century crafts. In fact, the Morris ideal of one craftsman designing and making an object from raw material to finished piece, while a fantasy in the 19th century, was adopted as the principle and defining characteristic of a 20th century craft practitioner. Bernard Leach came to provide the archetypal, and perhaps most important, example when he published *A Potter's Book* in 1940. He powerfully presented the idea of the individual craftsperson working in one material as the inheritor of the 'anti-industrial' values of William Morris. To have restricted the vision and potential of the designer-maker in this way exemplifies the serious and fundamental assault of this 20th century crafts ethic on creative practice that cannot continue into the 21st century. (See Chapter 5.)

Crafts – or rather crafted objects – have a new, fashionable audience at the beginning of the 21st century. Crafted decorative art objects are as likely today to feature on the pages of *British Vogue* and *Elle Decor* as they are in specialised, professionalised, magazines. In London, they are as likely to be sold in Selfridges (currently developing a line of bed linen and hand painted bedcovers with textile artist Kate Blee) and fashion-orientated spaces such as Egg, in the Knightsbridge area of London (featuring the ceramics of Edmund de Waal and Rupert Spira) or as part of the Nicole Farhi Home range (thick brown pottery and wobbly white plates), as

Emile Gallé; French; *Vase*; glass, wheel-cut, acid-etched, with applied cabochons of glass, *c.*1903; Courtesy the Trustees of the Victoria and Albert Museum; Photograph by Daniel McGrath

they are in the crafts gallery Contemporary Applied Arts (which changed its name from the British Craft Centre and then re-located to the heart of London's advertising and media world).

Designer-makers associated with the world of fashion have their own 'craft' tradition in the unique, hand-crafted objects of haute couture. Smaller scale objects and accessories such as bags by Lulu Guinness and Natalie Hambro, and the hand spun copper and aluminium leather-covered bowls and luxury handbags by Bill Amberg, are exquisitely hand-crafted. Amberg trained as a leatherworker and now runs a small bespoke company. Lulu Guinness works with a small team of people who make her bags for either limited edition ranges or her more commercial diffusion range for customers who include the UK department store Debenhams. Natalie Hambro meticulously crafts each bag herself, for sale and exhibition. (See p.43.) The emphasis tends to be on the innovative use of materials, technology or a combination of both. Fashion designer Alexander McQueen said of his

Spring/Summer 1999 Women's Wear collection that it was 'inspired by the Arts and Crafts Movement, and the way in which man relates to machine as we approach the end of this century'.[5]

The collection of hand-crafted wooden skirts and collars, and prosthetic body pieces combined craft techniques with the hard edge of the technology of fabrics. Tradition and innovation can, it seems, meld successfully. This is where the future of 'craft' lies – rather than as a pastiche, or as obsessive individualism, or a failed reinvention of the past.

The challenges and scope of new technologies have been embraced with particular success by many textile artists. The application of new technologies, combined with or informed by traditional techniques, to the making of contemporary textiles has produced some of the most creative and forward-looking work. The possibilities presented by advanced materials, and the application of computers to reduce the time spent on previously labour-intensive techniques, have opened up new challenges and perspectives for textile artists. In Japan, for example, traditional craft techniques are central to the development of new 'techno' textiles. The University of Crafts and Textiles was founded in Kyoto in 1989 with the specific aim of nurturing the combination of textile

traditions with advanced technologies. The result is that the traditional and the new are worked together in the innovative manufacture of performance textiles, protective clothing and textiles for interiors or fashion.

Fashion designer Issey Miyake, noted for his creative use of textiles and reinterpretation of fashion, became interested in traditional weaving and dyeing techniques when he was a student. Along with his design team he visited many small workshops across Japan to study the techniques practised in the workshops. His interest has informed his work as a designer, but he is also equally interested in industrial techniques and 'the joint power of technology and manual work [which] enables us to revive the warmth of the human hand, in other words, to come close to the value inherent in artisanal work'.[6]

Textile designer Makiko Minagawa is part of the long established team in Issey Miyake's design studio, which also includes designer Naoki Takizawa. The collaboration between the designers is so close that it is difficult to discuss their work independently, yet Minagawa's inventiveness and innovations 'rooted deep in the tradition of a long line of Japanese weavers',[7] even before the cloth is translated into fashion, are remarkable.

Since she joined forces with Miyake in 1972, Minagawa's work has focused on creating fabrics using

Georg Jenson, Danish, *Coffee-pot, creamer and ladle*; silver; c. 1909-14; Courtesy the Trustees of the Victoria and Albert Museum

Natalie Hambro; British; *Handbag*; stainless steel and leather mesh; 1997; Courtesy the Trustees of the Victoria and Albert Museum

Alexander McQueen; British; *Prosthetic body piece*; Fashion in Motion; 1999; Courtesy the Trustees of the Victoria and Albert Museum

techniques that may not have been previously thought possible or appropriate to apply to a textile. Minagawa has replaced the traditional, artisanal techniques of making, with modern methods of production to create the look of traditional Japanese textiles, but using more practical and efficient methods to bring down the cost of production and to allow for large quantities of a new fabric to be made. In this way craft techniques such as traditional quilting for peasant wear in primary colours and geometric patterns (sashiko) or resist dyeing techniques (shibori) are kept alive but re-interpreted for modern use, bringing new life to old ideas. Minagawa gives untraditional looks to traditional fabrics, using synthetics for their aesthetic properties, or combines processes to create a contrast. In one piece a transparent nylon thread was jacquard-woven to create a floating or raised pattern. Nylon was mixed with the matt texture of the cotton background to add tension and lustre to the fabric. The textiles that are produced are vivid examples of what technology allows the Miyake design team to achieve, but for Miyake the overriding factor is to show that technology is not the most important thing:

> it is our brains, our thoughts, our hands, our bodies which express the most essential things ... I subsequently spent a lot of time thinking mainly about materials. Now I feel it is important to come back to human beings.[8]

Another Japanese company with a similar approach to craft and tradition, Nuno Corporation, operates on a different scale from the Miyake design team. Nuno (which means fabric in Japanese) is a small company occupying the space they describe as the middle ground 'between factory and cottage'. The Tokyo based, ten person team was established in 1984 as a commercial venture dealing with all stages of the development, creation and sale of innovative textiles which combine traditional aesthetics with the latest computer and synthetics technologies. Their medium-output production of fabrics for interiors and a small range of garments is organised to be accessible and affordable in a competitive contemporary market, but remains flexible enough to encourage innovation and experimentation.

Reiko Sudo, Nuno's director, co-founder and main designer, experiments freely with different combinations and techniques to produce fabrics which are totally original and bear little relation to the past. The Nuno textiles are characterised by a soft muted palette, the main interest lying in their spatial, structural, tactile or material qualities. The raw materials range from the

traditional Okinawan banana fibre, to the use of stainless steel, rust, polyester and recycled waste plastic. Finishing treatments include the application of chemicals or heat moulding techniques. These are fabrics that can only be made in the present.

Dismissing any allegations that industry and hand weaving represent irreconcilable opposites, Nuno's extensive range of woven textiles offer reinterpretations of traditional fabrics. Constructed on computer-assisted jacquard looms, the textiles maintain qualities also associated with hand woven products, such as the exploration of the unique characteristics and interaction of the yarns and the fabric's inherent qualities. *Ripple Reed* is a silk and nylon woven fabric produced by Nuno in 1997. Here, they have used a loom with rippled reeds (normally they are flat) which gives the woven fabric a natural lilting horizontal wave pattern. This technique was formerly used to make lightweight summer kimonos and sashes, and only a few craftspeople in Japan still maintain the skills to produce this finely detailed work and fewer still who know how to make the reeds required for the looms. Nuno hopes that in some way that they are helping to preserve this endangered art. They describe their own fabrics as 'tradition in the present sense', through the process of taking ideas from the past and readapting them for the present and the future. Their fabrics benefit from the technological advantages of the present while maintaining the integrity of the past.

London based textile designer Rebecca Earley is one of a successful group who initially worked with experimental techniques, as concerned with the nature of a fabric as with its end form in fashion. Earley is more interested in context and concept than product or process, using technology for motivation and inspiration, over and above materials and techniques. She will experiment with the latest dyes, fabrics and printing techniques, developing the processes to meet her own needs. Some of the dyes she has used, for example, have included newly developed inks such as 'retroflective' ink which, as its name suggests, reflects light back to its source. Its more widespread use by its manufacturers is to make special tape for protective and safety clothing. Earley has been responsible for developing the now much imitated, 'heat photogram' technique, which she first investigated as a student at Loughborough College and Central St Martins School of Art and Design. Heat pressing is a common process in textile manufacturing, used to transfer paper patterns on to fabric, but Earley's take on the process uses objects and materials such as pins or lace as templates, not paper patterns. Heat-sensitive dyes are used to print ghost-like images of these

on to microfibre fabrics, resulting in exciting visual puns and optical illusions, like the pins and lace fabric and its references to dressmaking and the illusion of the normally transparent qualities of lace. Recent commissions include radiotherapy gowns for patients at the Queen Elizabeth Centre for the Treatment of Cancer in Birmingham, which are sensitively printed with images of a range of healing plants which are used in complementary medicine.

New products for interiors which are carefully handcrafted and produced in limited series can also be seen to evolve from a commitment to experimentation with ideas and materials. Typical products demonstrate a deliberate reversal of roles – the revival of traditional forms using new techniques, or the use of old techniques (or crafts) to form new and unexpected results. Marcel Wanders' *Knotted Chair* of 1996 for Droog was born of a marriage between handicraft and technology. Using macramé-knotting techniques the rope (aramid braid with a carbon centre) is formed into a chair, treated with epoxy, hung in a frame and left to dry. The final form is the work of gravity as the ropes dry – an element of surprise, unexpected finish or uniqueness will characterise each chair. Sometimes, the ephemeral aspect of an object will come to the fore more than the physical. The idea behind the *Vermehla* chair by Brazilian designers Humberto and Fernando Campana, originated from a desire to create a birds nest, an idea which became translated into real form when they began to create a structure out of cotton cords spread over their work bench. (See pp.122 and 126.) The driving force behind their work is the material and its colour and physical properties which determine the form and often the title of a piece. In this case the *Vermehla* chair is named after its colour.

Glass was never an isolated craft practice, but has always been created in a factory environment. The Finnish company Ittala, founded in 1881, offers a good example of practice which effectively eliminates barriers between design and craft. Early in the 20th century they were in the middle of the Scandinavian Modernist effort, employing such designers as Timo Sarpaneva, Tapio Wirkkala and Alvar Aalto. They continue on, using the highest quality of material and technique, with designers such as Kati Tuominen-Niittlyä, Tiina Nordström and Kerttu Nurminen. (See p.46.)

The most innovative practitioners today actually prefer not to be restricted to one particular material or genre, and, as was the practice in the 19th century, are focusing on forming new relationships between materials and ideas to actually get their pieces made. Shifts in recent practice and, indeed in what is acknowledged as

Rebecca Earley; British; *Pins and gloves*; heat photogram printed fabric; 1995

'craft' in an ever widening field of definition, demonstrate that the relationship between materials and the intellectual aspect of making is becoming more important than the relationship of the designer to the making process, except, perhaps, through prototyping and careful quality control.

The London-based design and communications company, Jam, has formed relationships with some of the UK's biggest manufacturing companies to make products combining elements of both nostalgia and futurism, and inspired by a combination of commitment to recycling and search for relevance in an industrial age. The designers at Jam are motivated to look for manufacturing companies with a product that they can reposition and use to make an installation or object for use or display. They do not seek to change the processes, materials or techniques of manufacturing so, for example, when working with household giants Philips they have used their light bulbs and Whirlpool washing machines to make new objects.

Gitta Gschwendtner, a young German-born designer based in London, is interested in using a range of different materials and making different products. She has a certain sensibility and approach to objects which go beyond pure function, and which form a kind of hybrid between craft techniques, design and batch production.

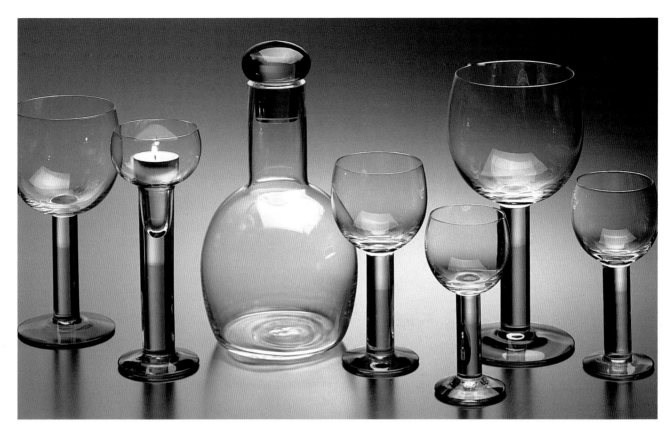

Kerttu Nurminen; Finnish; *Mondo*; Ittala glass; 1997; Photograph by Markku Alatalo

Established for a relatively short period of time (she graduated from the Royal College of Art in 1998) she has already developed an exciting range of products and established an impressive list of working relationships with manufacturers in Germany, Italy and the UK, although she says that getting people to manufacture her products is probably the most difficult aspect of her work either because of the scale and quality at which they need to be produced or, more simply, because there are so many other designers all trying to get their work made. Usually, she will make the prototype of her designs herself, or enlist the help, for example, of a friend who can slip-cast her 'ripple bowl' or a sub-contractor for her 'cast iron wedges'. Quality of production is always key, and this is relatively easier to achieve on a smaller scale.

Strangled Light originated from thinking about the visual impact of the electric cable in a standard electric light fitting, and how the cable itself could be used to change the shape of the shade. Gschwendtner began with a slip-cast earthenware shade which she manipulated with her fingers until she found the shape that she wanted. This then became the master copy from which batches are made. The light is manufactured and distributed in batches of about 500 by Galery Artificial in Germany.

The overriding factor or value which defines these new ranges of practice is the maintenance of high standards of quality in both ideas and production. Shin and Tomoko Azumi's *table-chest* (see p.48), designed in 1995, is made from birch veneered MDF and solid birch and in the UK is manufactured by Frank E. Bailey of Swaton, a small company which specialises in small batch production and which allows Azumi to control the quantity and the quality of the pieces sold. At the time of writing, Azumi have to date produced 35 *table-chests* for UK buyers. The first three pieces to be made were acquired for institutional collections – the Geffrye Museum, which acquired the prototype, followed by the Crafts Council and the Victoria and Albert Museum, the remainder going to private collectors, architects, design-conscious consumers and personal friends of the Azumis. Shin Azumi attributes the relatively small number of sales largely to the cost of the *table-chest* which in 1999 sold at £770. Ideally, Azumi say they would like to sell in the lower range of £200–£300, but the precision and quality required in the production of each item, with 5% angles and the placement and accuracy required of the joints for the design to function successfully and without compromise, makes this impossible.

Gitta Gschwendtner; German; *Chair/Chest of drawers*; American cherry veneer, plywood, felt; 1998

Gitta Gschwendtner; German; *Strangled Light*; ceramics; 1999

Gitta Gschwendtner; German; *Magazine Rug;* goat skin, fibre glass, felt; 1999

Tomoko Azumi; *Table=Chest*; made by Frank E. Bailey, cabinet makers;1995; Courtesy the Trustees of the Victoria and Albert Museum

The Japanese firm, Abode, has bought a licence to produce and distribute the 'table=chest' to the domestic Japanese market, and does so at the competitive price of £500. However, Abode also has full rights on the quantity and quality of the product in Japan, thus in order to reach a wider market, Azumi have had to release the aspect of quality control which is vital to their products made in the UK under their own supervision.

The vision behind Azumi's 'table=chest' is the design of furniture for small spaces, in this instance inspired by the stacking units of a Japanese lunch box. When folded open and used as a table, it is reminiscent of the traditional low tables used for eating in Japanese homes. Perhaps not surprisingly, therefore, Japan, where the majority of living spaces are small and where there is some recognisable design precedent, offers a potentially very different market for this piece of furniture.

Essentially, therefore, I would argue that attitudes to craftsmanship, production and design can and should change if the constituency and intellectual profile of 'craft' is to survive in the 21st century and to make a significant contribution to the visual culture of the future. Although the direction and assured quality of the 'art manufactures' of the present (identified in small-scale production and semi-industrial circumstances) do not rely on a return to historic values and practices, it can be predicted, through current trends, that they will redefine the values and organisational structures of 'craft' as we have known it in the 20th century. In fact, far from advocating a return to the historic or revivalist values and political motivation of the artist-architect-designers from the end of the 19th century, I would, however, suggest that the most innovative work is likely to emerge from the variety of situations and different methods of making and manufacture, ranging from workshop to factory, that was the reality of 19th century production. The 20th century organisational structures and material based disciplines of 'craft', as defined by Bernard Leach and his followers, are already being challenged by work which appeals to a much broader audience, yet continues to maintain a high standard of craftsmanship in production. Ultimately, this work is no less ethical. These are the equivalent art manufactures of the 21st century. The defining factors that will clearly distinguish a modern or future approach to 'art manufactures', will certainly be that the practitioners of the present and future will not be so ideologically motivated, or determined to reject technology, or keen to remain in the position of 'other', or obsessed with individualism, if they are to have any relevance in the 21st century.

Copyright © 2002 Karen Livingstone.

NOTES

1 Walter Crane, *Ideals in Art*, George Bell & Son, 1905, p. 1.
2 John Ruskin, *The Seven Lamps of Architecture* (London, 1849) and *The Stones of Venice* (London, 1851).
3 Tanya Harrod, *The Crafts in Britain in the 20th Century*, London, Yale University Press, 1999, p. 22.
4 See Chapter One.
5 McQueen press release, *Women's Wear Collection Spring/Summer 1999*.
6 Herve Chandes (ed.), *Issey Miyake: making things 1st*, Paris, Scalo ed. Fondation Cartier pour l'art contemporain, 1999, p. 55.
7 Makiki Minagawa and Keiichi Tahara, *Texture*, Tokyo, Kodansha, 1988, p. 20.
8 Chandes, op. cit., p. 105.

5 · RE-INVENTING THE WHEEL – THE ORIGINS OF STUDIO POTTERY

Julian Stair

Among professional artists there is ... a vague idea that a man can still remain a gentleman if he paints bad pictures, but must forfeit the conventional right to his Esquire if he makes good pots or serviceable furniture.[1] Roger Fry, 1910

The shifting of interest away from the "fine" arts towards the so-called "applied" arts is one of the significant features of the post-war period in England, and nowhere are its effects more readily seen than in pottery.[2] Bernard Rackham, 1925

In 1910, the critic and painter Roger Fry attended a meeting of the Society of Arts where a 'vigorous' discussion took place on the relationship between the Fine and Applied Arts, a subject still debated in contemporary craft today. Fry wrote soon afterwards of the 'implied contempt' for the Applied Arts and the association of utilitarian work with 'a lower kind of faculty'. Fifteen years later, a major change had taken place in the crafts; Bernard Rackham's words reflect a movement full of self-belief, confident enough to be dismissive of the 'fine' arts. As Keeper of Ceramics at the Victoria & Albert Museum, his comments were part of a chorus of voices which heralded pottery in particular as a new and radical art form. From the first appearance of the term 'studio pottery' in a trade journal in 1923,[3] up to the beginning of the Second World War, handmade pottery, and the wider studio crafts, were re-invented in a period of remarkable optimism. With this, the era of the amateur or gentleman ended along with Fry's worries about forfeiting one's right to the 'Esquire'.

The complex threads which account for this transformation of the crafts can be traced through the early critical writing of what is now called 'studio ceramics'. The factors

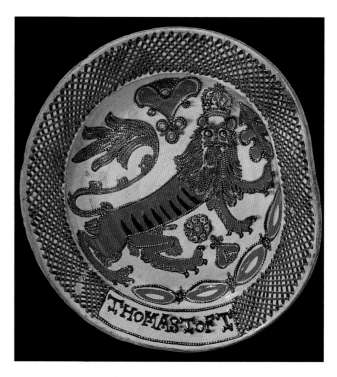

Thomas Toft; British; *Charger*; slip trailed earthenware; 1671-89; Courtesy the Trustees of the Victoria and Albert Museum

that shaped the interwar years owed much to the urban environment of London's avant-garde and two of that century's most important art critics, Roger Fry and Herbert Read, who were instrumental in shaping this emergent discipline. In just a few decades, studio pottery moved from a crusade of moralism (with its maxim of 'truth to materials') to Modernism. A new critical agenda emerged in which Formalism evolved into ideas of abstraction through the discovery of English vernacular earthenware and an unlikely marriage with early Chinese stoneware.

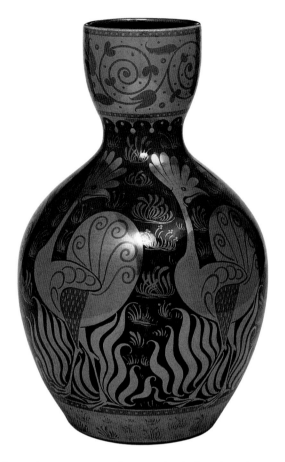

William de Morgan; British; *Vase*; lead-glazed earthenware, painted lustre; 1889-98; Courtesy the Trustees of the Victoria and Albert Museum

The context in which these changes took place was less than auspicious. By 1910, the 'utopian' work of the Arts and Crafts Exhibition Society was being widely questioned as one of its most prominent figures, W.R. Lethaby, declared in a lecture to the Royal Institute of British Architects

> However desirable it may be to continue in the old ways or to revert to past issues, it is, I feel ... impossible. We have passed into a scientific age, and the old practical arts, produced instinctively, belong to an entirely different era.[4]

If this was a period of uncertainty for the crafts in general, it was a time of crisis for pottery, which was unable to achieve the success of other Arts and Crafts media such as woodwork, textiles, metalwork and bookbinding. Pottery had been dependent upon William De Morgan for its identity, and was in a vacuum after the closure of his factory in 1908. Although De Morgan

achieved success with his various tile products, by his own admission, pottery came low on his list of priorities. In the order of their importance:

1 Decorative painted panels.
2 Stove tiles and other patterned tiles for various purposes.
3 Plain coloured tiles.
4 Miscellaneous decorated pots – good for wedding presents and the like, but of no use except to put flowers in when they do not run – as indeed now and then they do not. It is very possible that a little further evolution of this work might have really satisfactory results.[5]

Art Pottery, the industrial equivalent of Arts and Crafts pottery, also came in for criticism in the 1910s for its reliance on obsolete Victorian glaze effects and superfluous decorative treatments. In a review of the British entry at an International Exhibition in Turin, the pottery (in this case Bernard Moore's) was criticised for allowing technical virtuosity to take precedence over artistic skill: 'it is deplorable to see prints of village churches and the Grand Canal underlying splendid *sang de boeuf* glaze.'[6]

The creation of the Design Industries Association in 1915 led to key figures in the Arts and Crafts Movement realigning themselves to industry, and small-scale pottery production was marginalised further. Even the ceramic work produced by the short-lived Omega Studios (1913–1919) did not produce a lasting influence and references to contemporary pottery in the press and major art journals were scarce.

In 1924, however, the studio pottery movement was propelled into the critical limelight through the first references to pottery and abstraction, and within the span of a few years, studio pottery came to epitomise avant-garde concepts of abstract art. Although these ideas were seen to be embodied in contemporary work, they arose from a re-evaluation of historical ceramics in the key ceramic text of the interwar period, *English Pottery*, which was published in 1924 by Herbert Read and Bernard Rackham. Read had joined Rackham in the ceramics department of the Victoria & Albert Museum in 1922, and their collaboration on *English Pottery* proved to be a successful union of skills and ideas. Rackham's scholarly knowledge of ceramics complemented Read's interest in Modernist poetry and art. But it was Read's Modernist disposition which introduced a new and radical set of

criteria and elevated ceramics into the centre of innovative debate. Read claimed that as pottery forms were free from figurative associations they were 'plastic art in its most abstract form'.[7] In re-appraising historical pottery and creating a critical agenda that could evaluate it, but could also apply to modern pottery, Read and Rackham equipped critics and potters with the means to frame contemporary developments. Reviews of *English Pottery* were quick to point this out: 'English pottery has emerged from this cloud of classicism, and a much more healthy outlook as to what constitutes fine pottery quality is now prevalent.'[8]

R. L. Hobson, curator of ceramics at the British Museum concurred.

> The true canons of the potters' art, as conceived by our authors, are clearly explained in the introduction, and they are kept constantly in view in the admirable criticisms which run through the book.[9]

Within months of publishing *English Pottery* Rackham used abstraction as a theme to discuss William Staite Murray's first solo exhibition at Paterson's Gallery in Old Bond Street, claiming that 'Pottery can indeed be plastic sculpture in a purely abstract form'.[10] Five months later Staite Murray reinforced this in 'Pottery from the Artist's Point of View'. 'The forms are abstractions and as such readily contemplated as pure form.'[11] In the same year, Rackham widened his artistic net to include the pottery of Reginald Wells 'in its truest forms – [it] may rightly be classed as abstract sculpture.'[12] (See p.53.)

This proto-movement grew quickly, attracting other critics who came to regard pottery as the link between painting and sculpture. *The Observer* art critic, P.G. Konody, stressed the unity of these three disciplines in a catalogue essay for an exhibition which included Staite Murray and Reginald Wells, Paul Nash and Jacob Epstein – 'the modern movement in art is based on a broad foundation',[13] – while the owner of Beaux Arts Gallery, Frank Lessore, described pottery 'as high as any other branch of sculpture, of which it may justly be considered the most abstract form'.[14]

In the 1920s and 1930s studio pottery received remarkable coverage by today's standards, in the *Observer, The Sunday Times*, the *Manchester Guardian*, and *The Morning Post*, and in leading journals of the day, *The Spectator, Apollo, Artwork, Burlington Magazine, Sphere, The Studio, The Listener,*

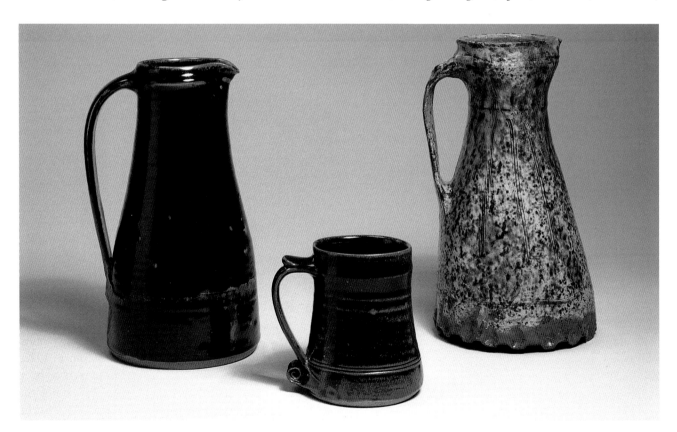

Leach standard ware and mediaeval jug; *tenmoku* glaze; 1949; Courtesy the Trustees of the Victoria and Albert Museum

among many others. Charles Marriot, the art critic of *The Times*, joined this consensus in 1926, and promoted studio pottery over the next decade, spreading the mantra of 'pottery as abstract art' in over 40 reviews and championing Staite Murray above all others. A review of 1927 opened

> The difficulty in discussing the stoneware pottery by Mr W. Staite Murray ... is to avoid superlatives ... the works of Mr Murray represent a fusion of painting and sculpture, and the technical beauty of the results goes a long way to show in what direction abstract aims are legitimate.[15]

Between 1924 and 1930, studio pottery consolidated this position at the core of Modernist critical developments in the Fine Arts, breaking most of its associations with Arts and Crafts ideology. While Reginald Wells disappeared from view, Staite Murray went on to show with leading artists of the era, notably Christopher Wood, and Winifred and Ben Nicholson, whom H.S. Ede (the founder of Kettle's Yard) described as 'a most interesting trinity'.[16] (See pp.52 and 54.)

Through Nicholson's introduction, Staite Murray became a member of the notorious Seven & Five Society of Artists and the only potter to exhibit in their annual shows. During this period Herbert Read developed his ideas on pottery and abstraction further and in 1931 published *The Meaning of Art*, which included his famous maxim that 'Pottery is pure art; it is art freed from any imitative intention ...'.[17]

Significantly, the entire section was first published anonymously in the catalogue introduction to Staite Murray's first solo exhibition at the Lefevre Galleries in 1930.

The compelling marriage of Read, the young critic and Rackham, an established curator, which had produced *English Pottery* established new canons of ceramic appreciation and revealed many previously unappreciated qualities of English ceramics. However, close reading of Rackham and Read's ideas and language reveals a precedent in Roger Fry's Formalism and the renaissance of interest in early English and Chinese pottery of the preceding decade.

At the end of the 19th century ceramics collectors had become interested in vernacular English pottery, in particular early slipware. This spawned a few publications such as Charles Lomax's *Quaint Old English Pottery* of 1909, which Leach copied pots from while in Japan. Reginald Wells, the pioneer of the modern revival, started making slipware around 1900 in the old pottery town

William Staite Murray; British; *Bowl and vase*; stoneware, grey glaze, purple decoration; 1924 and 1927; Courtesy the Trustees of the Victoria and Albert Museum

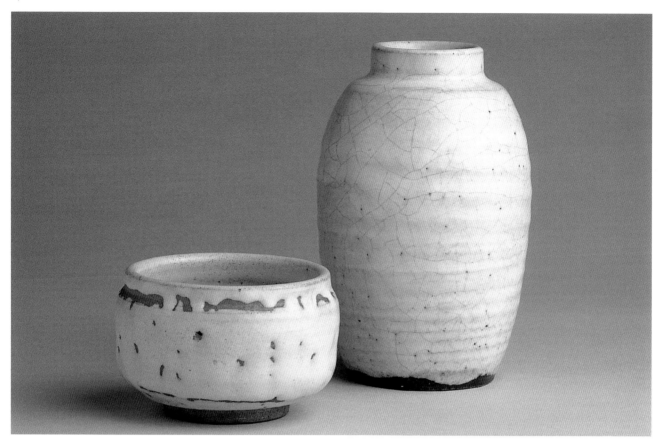

Reginald Wells; British; *Bowl and vase,* bowl inscribed 'SOON'; stoneware, opaque white glaze; 1925 and 1924; Courtesy the Trustees of the Victoria and Albert Museum

of Wrotham, Kent, but abandoned it in 1910 in favour of higher temperature stoneware. The vernacular revival was established in 1914 with the seminal exhibition Early English Earthenware at the Burlington Fine Arts Club. However, this interest in slipware did not extend to appreciating the aesthetic value of mediaeval pottery which was perceived as 'crockery of simple form ... [and] crude designs'. Lomax saw such pottery as simply a precursor to the more decorative slipware.

> ... at length we find the potters assuming more elegant shapes, and attempts being made to relieve plainness by applying ornaments of various kinds and the more frequent use of coloured slips.[18]

Similarly, the catalogue for the Burlington Fine Arts Club exhibition of Early English Earthenware quickly passed over the medieval and slipware pottery, categorising it as unsophisticated and rural 'a purely native product, a rustic craft, home grown and racy of the soil' in favour of later cosmopolitan pottery.[19]

Critical interest in the vernacular amongst museum curators was slow to develop. A younger Rackham, without the counterbalance of Herbert Read, compared mediaeval pottery unfavourably with the universally admired mediaeval encaustic floor tiles and relegated it to fulfilling 'the everyday needs of humble folk'.[20]

He was also dismissive of Leach's later attempts at a revival:

> Any attempt to revive ... the use of the actual materials of the 18th century is likely to end in failure ... study of bygone wares will certainly be helpful, but only if the aim of such study is to stimulate the student to fresh ideas of his own, not to save him the trouble of thinking for himself.[21]

The first critic to appreciate medieval earthenware pottery was Roger Fry. Fry judged mediaeval pottery on the grounds of form, texture and expressiveness, using new analytical terms such as 'austere rhythm ... structural design ... relation of planes ... inherent unity'.[22]

He argued for the work's great refinement of taste and, in the ultimate accolade, compared it to Tang

William Staite Murray; British; *Madonna*; vase, stoneware, incised decoration, copper red painting; 1930; Courtesy the Trustees of the Victoria and Albert Museum

dynasty pottery, 'the greatest ceramics in existence'. Crucially, Fry appreciated mediaeval pottery for its purity of form and understated decoration and valued it above the decorative slipware of Ralph Wood and Thomas Toft which he saw as degenerate, a really crude, barbaric and brutally clownish idea of deformation, devoid of a structural sense and vital rhythm, expressive only of a beery jocularity.[23]

This was a distinction that Herbert Read would reinforce a decade later in *English Pottery: An Aesthetic Survey*[24] where he also classified mediaeval earthenware with

Tang and Sung Dynasty pottery. Through the validation of medieval earthenware pottery, Roger Fry paved the way for the later revival of English pottery effectively launching 'the English recovery', one of the defining movements within English studio ceramics. He provided the critical references that enabled this previously neglected work to rise above the level of curiosity and become representative of a modern movement. Although these ideas were published well before the studio pottery movement's rapid expansion in the 1920s they provided the critical foundation for much of *English Pottery*. Ironically, the slipware revival popularised by Leach and Cardew in the 1920s was built on the historic English pottery Fry and Read dismissed. The 'beery jocularity' of Staffordshire slipware and the 'clownish fancies' of English slipware were to become embedded in the psyche of British studio pottery despite the low opinion of the two critics who were instrumental in launching the movement.

The other great theme of the interwar period was 'Orientalism'. Less critically charged than the revival of vernacular pottery or the development of abstraction there was still confusion over the means of its introduction to Britain. Chinese pottery in the first decades of the 20th century was little known, for 'the number of genuine pieces in English or indeed in Western collections generally might be almost counted on the fingers'.[25]

Curatorial discussion had been limited to authenticating the few available examples in the West through obscure Chinese literary references. The opening up of China to the West after the Boxer Rebellion in 1900 and the cutting of embankments during the building of railways disturbed grave sites and new archaeological finds provided keen scholars with access to this rare pottery for the first time. In response to this enthusiasm the Burlington Fine Arts Club organised an exhibition of Early Chinese Pottery and Porcelain in 1910 and the *Burlington Magazine* published a comprehensive series of articles on Tang and Sung dynasty pottery by the British Museum curator R. L. Hobson. The exhibition was highly influential in showing this very rare work for the first time and in helping curators and collectors to establish its chronology and provenance. 'It may be safely said that until the last two or three years it would have been absolutely impossible to bring together a collection of this character.'[26]

Within the next decade the pottery of China became the subject of intense interest with exhibitions, articles and reviews. There was a wide interest in Chinese philosophy and *The T'ao Shuo* – an anthology of ceramic literature first published in China in 1774 – was trans-

lated while Bernard Rackham published 'The Literature of Chinese Pottery: A Brief Survey and Review'.[27]

This scholarly interest was soon translated into contemporary debate, as the new type of pottery exhibited at the Burlington Fine Arts Club was seen to reflect a change in aesthetic and critical values, 'taste that tends more and more to favour the simpler and ruder early wares'. The Chinoiserie of the 18th century and Japonism of the 19th century was superseded by a new wave of Orientalism more appropriate to the emerging Modernism. An editorial of 1910 in the *Burlington Magazine* summed up this mood:

> There are signs that the present rapidly increasing preoccupation with Oriental art will be more intense, and produce a profounder impression on our views, than any previous phase of Orientalism ... To us the art of the East presents the hope of discovering a more spiritual, more expressive idea of design.[28]

The critical agenda of this early phase of Orientalism in studio pottery was shaped by the debates that framed abstraction and the vernacular revival, ideas that were a product of a wider agenda, before a 'craft' ethic had permeated studio pottery. Again, Fry's role in establishing a link between Orientalism and avant-garde concepts was pivotal. In an article on the art collector Mr R. Kelelian, Fry revealed how Kelelian's sensibility to modern developments was fashioned by ancient art:

> His long familiarity with early Oriental art has trained his taste in the search for what is really significant ... in his choice of modern work... a man who has handled so many Fayum portraits was not likely to miss the qualities in a head by Matisse.[29]

Oriental art was felt to embody the aspirations of the modern movement and pottery was seen as an integral element. Wyndham Lewis's inclusion of work by the great Japanese potter Koetsu in *Blast*, the publication which launched the Vorticist manifesto, was evidence of the avant-garde movement's interest. Hamada, as the first potter to exhibit in Bond Street, represented the living embodiment of this new phase of Orientalism and his exhibitions were soon followed by Staite Murray's Orientally-inspired abstract pottery and Reginald Wells's 'Soon Pottery'. The new material of stoneware clay, reductive forms, monochrome glazes, sober colours and controlled decoration were discussed in terms of expressiveness and artistic integrity. Hamada's first

Bernard Leach; British; *Vase*; stoneware, white glaze, painted decoration; 1931; Courtesy the Trustees of the Victoria and Albert Museum

exhibition was praised for allowing 'the individuality of the potter to assert itself'.[30]

From Fry's comparison of English mediaeval pottery with Tang and Sung pottery – 'some of the greatest ceramics in existence'[31] – early Chinese pottery became the universal benchmark of ceramic excellence. By the end of the decade the critic W.A. Thorpe wrote: 'It is said that a man cannot paint who has not studied the Italians; no more can a potter pot who is unversed in Sung.'[32]

The 1920s saw widely differing interpretations of Orientalism by individual potters. The adoption of the

'Sung Standard', the ultimate canon of ceramic integrity, is widely credited to Bernard Leach but, as with the rising interest in slipware, his arrival in Britain in 1920 was fortuitous. The prevailing climate of interest was already established, as he acknowledged: 'Upon my return to England I found the basis of criticism of pottery had shifted. America and Europe had become familiar with earlier work.'[33]

Leach's return to Britain from Japan in 1920 may have been timely given the rising tide of interest in Orientalism, but he suffered from a lack of critical recognition, for his interpretation of Orientalism was at odds with the wider consensus. Although Leach's Japanese credentials automatically prefaced every public mention of him, his self-portrayal as a conduit between East and West, and emphasis on tradition seemed parochial in contrast to the more radical ideas which presented Sung and Tang dynasty pottery as icons of modernity. From the very first reference to him in the press which expressed his desire to promote 'hand work rather than machine craft'[34], Leach effectively allied himself to a Morrisonian concept of craft as opposed to that of the Modernist potter, creating individual artworks. Leach's choice to locate his pottery in Cornwall under the patronage of the St Ives Handicraft Guild and his ambition to 'turn out more than a couple of thousand pieces per annum for the first year or two' reinforced this image.

While the critical landscape was developing rapidly, in the early days of studio pottery Leach became marginalised. Abstraction was never linked to his pots although it was a key factor in the appreciation of Staite Murray, Wells and even his pupils Nora Braden and Katherine Pleydell-Bouverie; Leach only made one passing reference to abstraction in an article on Tomimoto in 1931. While Wells, Staite Murray and his 'assistant' Hamada were exhibiting in Bond Street, Leach was struggling commercially with exhibitions at less prestigious galleries. Prompted by worsening financial problems Leach attempted to balance his artistic aspirations with commercial practice but this fraught strategy collapsed in 1927. *The Studio* announced the 'very interesting experiment'[35] of two simultaneous exhibitions of 'collectors' pottery' in Leach's first Bond Street exhibition at

Sung pottery; Chinese Chun ware vase, stoneware, blue glaze, Sung Dynasty; 9th-11th century; Courtesy the Trustees of the Victoria and Albert Museum

Paterson's Gallery and 'English Slipware ... ordinary household utensils' at the Three Shields in the less fashionable Holland Park. Leach's attempts to straddle artistic and commercial markets was unsuccessful, the slipware sold badly and whether his artistic credibility was damaged is difficult to gauge, but he never exhibited at Paterson's Gallery again. After this failure Leach adopted a different tactic and started to show in the emerging specialist craft venues such as The New Handworker's and The Little Gallery. He also began to publish polemical articles which were instrumental in altering the direction of studio pottery. In the same year that Staite Murray was being heralded by Marriot as one of Europe's leading artists, Leach issued a statement:

> There is a need to escape from the atmosphere of the over-precious; and not only have the new craftsmen to prove that they can be creative, but as 'artist craftsmen' they must, if only for the sake of their art, contribute to national life. A growing public wants to enjoy the use of its crockery, and that can only be if it is inseparably practical and beautiful. ... There is a profound and urgent need for attempting to bridge that gulf soon.[36]

It is difficult to separate the aggrieved tone of Leach's view of 'over precious' studio pottery from his own commercial problems. Up to this stage in the development of studio pottery, the critical agenda had been firmly placed in the domain of radical Modernist ideas with little attention devoted to vestigial Arts and Crafts ideals. The new radical movement of studio pottery was seen as an adjunct of the Fine Arts, with an economic identity based on the patronage of Bond Street – one that Leach had previously accepted and aspired to. Until this point, the 'gulf' that Leach identified had not existed, as the making of studio pottery and 'crockery' were accepted as separate activities. Leach was disingenuous in advocating utility as a prime motive, for he survived the early years through a mixed practice of exhibiting stoneware 'museum pieces', producing slipware pottery and making raku for the tourist trade. He also struggled with practical matters as Frank Rutter, a leading critic and member of the Design Industries Association revealed in a thinly veiled criticism:

> We have been suffering from a teapot with a defective spout. It is most versatile and will shed its contents anywhere besides into a cup. It was bought at a small pottery in the West Country. We were attracted by a

Bernard Leach; British; *Dish*; sliptrailed earthenware; 1923; Courtesy the Trustees of the Victoria and Albert Museum

pleasantly mottled colour and the fact that the maker incises his name on every piece with the place of origin. This, we thought, should be a guarantee of general excellence, and we still think it should.[37]

The following year Leach published *A Potter's Outlook*, a diatribe on the condition of contemporary pottery – the same year that Staite Murray exhibited with Winifred and Ben Nicolson at the prestigious Le Fevre Gallery.

> What have the artist potters being doing all this while? Working by hand to please ourselves as artists first and therefore producing only limited and expensive pieces, we have been supported by collectors, purists, cranks, or 'arty' people, rather than by the normal man or woman ... and consequently most of our pots have been still-born: they have not had the breath of reality in them: it has been a game.[38]

Critical response to Leach's pottery and studio pottery in general started to change after these public expressions of his disillusionment. A year later *The Studio Year Book* coined the new term 'domestic wares' to describe Leach's pottery and approved of the change in direction of his work which was formerly only 'within reach of the collector' but became pottery 'within reasonable reach of the person of taste'.[39]

Leach's critical isolation of the early and mid-1920s was boosted by the visit of Soetsu Yanagi in 1929, the leader of the Mingei movement and exhibitions from three of its prominent potters, Hamada, Kawai and Tomimoto, over the next few years. The momentum Leach gained from Hamada's two exhibitions at Paterson's Gallery in 1929 and 1931 and his joint exhibition with Tomimoto was invaluable as they generated publicity he had been starved of and confirmed his oriental 'authenticity'. But the main benefit to Leach was the critical support he received from Yanagi with his unbending moral advocacy of utility, and desire to move pottery 'from the parlour to the living-room and the kitchen'.[40]

By the early 1930s the tone of critical writing in the media had changed and the new and fragile edifice of studio pottery started to develop cracks. The response of Charles Marriot, a very public, but less than independently minded critic, reveals this transformation. Having assiduously championed the autonomy of studio potters during the 1920s, believing they should work independently of industry in 'cloistered virtues', Marriot reported in 1930 that Leach's essay, *A Potter's Outlook*, 'inspires confidence by facing facts and conditions [in] linking up studio and factory pottery'.[41]

Reviewing Leach's exhibition at the Little Gallery in the following year Marriot wrote approvingly:

> The special point of this exhibition is that the articles in it – pots for flowers, jugs, vases, grapefruit and other bowls, ash trays, covered pots for preserves, and pots planted with Japanese dwarf trees – are mostly small, and all of them intended for everyday use and are inexpensive. As a rule, and for good reasons, questions of price do not come into notices of art exhibitions, but in this case price is a definite factor.[42]

Marriot saw Leach's work as pushing individual pottery towards commercial production, approving this on the grounds of its advantages to 'lean purses' and a departure from 'the individual potter stood aloof with museum pieces'.[43]

By the mid-1930s studio pottery's high critical standing went into decline. An industrial or 'machine' aesthetic, the antithesis of a craft sensibility, emerged out of reconstructed industrial production. The Wall Street crash and Depression had profound economic and social consequences and new movements in art developed with radically different conceptual rationales, notably Dada and Surrealism, which undermined studio pottery's reliance on formal appreciation. As Clive Bell wrote:

The first movement of the twentieth century, the movement sometimes called 'Abstract', at one moment 'Cubist', and best fitted, I think, with that … purely chronological label, 'post-Impressionist', has, unless I mistake, run its course. It is complete.[44]

But these factors do not account wholly for the demise of studio pottery as a viable movement within British art. By the mid-1930s it was receiving minimal critical coverage from either the broadsheets or the major journals. It is difficult to separate the introduction of Leach's petulant and prosaic agenda with its resultant emphasis on pragmatic factors such as costs and commercial production from the freefall that took place in critical writing about it in the early 1930s. In the space of a few short years studio pottery moved from being discussed as a radical new art form and the interface between painting and sculpture to an adjunct of industry where quality was governed by price. The dynamism of Fry's Formalism or Read's ideas of pottery and abstraction which were able to re-contextualise historic precedents within a contemporary Modernist agenda were replaced by Leach's hectoring and moralising tone, originally derived from the writing of Ruskin but mediated through the Japanese Mingei movement. The consequence of this was the demotion of pottery as a viable avenue for artistic practice to a commercial enterprise with bolt-on aesthetics. Whereas it once had a clearly defined position in the art world it was now compromised, hovering somewhere between the gallery and department store. 'The steady working down to common use is wholly welcome, for potting however you may look at it, is a domestic art.'[45]

Pottery now had an ambiguous identity and its audience was unsure of its new position. In one of the last articles of the 1930s Jan Gordon of the *Observer* concluded with an opinion which is still applicable today:

> Thus potting has contrived to straddle branches, appertaining to Fine Art on the one side and to Craft-Art on the other… though potters always lay claim to be craftsmen, the high art of potting, that is, the production of rare pieces with unique glazes, belongs to the most high-brow of Fine Arts … Much pottery is abstract Fine Art camouflaged in the sheep's clothing of a humble craft.[46]

As a result of this repositioning, critical coverage of studio pottery in the national press and art journals fell dramatically away and where it did continue it was less

enthusiastic. While Leach's career benefitted from this revision of criteria that now defined pottery as a practical craft, and by the emergence of a group of gifted pupils – Michael Cardew, Nora Braden and Katherine Pleydell-Bouverie – who were producing technically competent work at significantly lower prices, the general esteem of pottery fell. Marriot complained of the 'smug bucolic roughness which is the mark of so much modern pottery'.[47]

After his vociferous championing of studio pottery during the late 1920s he even lost interest in Staite Murray, writing in 1932: 'In his enthusiasm for form and colour in the abstract, he has lately been in danger of forgetting that a pot is after all a pot.'

Apollo magazine echoed these criticisms: 'his hands are in the clay but his head is surely in the clouds'[49] and condemned his last show: 'And can he really reconcile the labelling of his pottery, ... with the abstract significance of form on which he once so much insisted? A pot's a pot for a' that'.[50]

The fall of studio pottery's critical approval was sudden and dramatic but the movement did not disappear, it simply relocated to a new position within the arts, one which is familiar today and loosely titled the 'crafts'. Although outlets such as Muriel Rose's Little Gallery emerged selling studio pottery and imported ethnic folk crafts, this was little compensation for the loss of such galleries as Le Fevre or Paterson's. The closing remarks of a review of a contemporary Japanese crafts show organised by Leach at the Little Gallery reveal the retail arena into which studio pottery had settled, 'Practising artists will find the exhibition exciting, and the brushes and papers on sale irresistible'.[51]

In the course of a decade, studio pottery which had been seen to fulfil the progressive criteria of early British Modernism and burst into the closed sanctity of the Fine Arts with a momentum that defined itself as a valid new movement was now concerned with the prosaic, of 'representing shillings instead of pounds'.[52]

From occupying a central position in national newspapers and the major art journals, studio pottery coverage moved from the review sections to the Home pages. The last article to feature ceramics in *The Times* (Leach, Cardew and Pleydell-Bouverie) before the outbreak of war was a homily on the virtues of slow cooking, 'Attractive Fireproof Ware'.

Katherine Pleydell-Bouverie; British; *Roc's Egg*; vase, stoneware, ash glaze; 1929-30; Courtesy the Trustees of the Victoria and Albert Museum

The modern housewife who can usually cook as well as order an attractive meal to-day knows that casseroles in fireproof ware are a necessity for the making of certain dishes.[53]

After a decade of lively debate, with nothing new to offer, studio pottery fell from critical grace and in the process moved from Bond Street to the High Street.

Copyright © 2002 Julian Stair.

NOTES

1. Roger Fry, 'A Modern Jeweller', *The Burlington Magazine*, No. LXXXVII, Vol. XVII, June 1910.

2. Bernard Rackham, 'The Pottery of Mr Reginald Wells', *The Studio*, Vol. 90, Dec 1925.

3. Anon, 'The Late Robert Wallace Martin', *The Pottery Gazette and Glass Trade Review*, Sept 1923.

4. W.R. Lethaby, Royal Institute of Architects, 1910.

5. May Morris, 'Willliam De Morgan', *The Burlington Magazine*, No. CLXXIII, Vol. XXXI, Aug 1917.

6. 'Applied Art At Turin', *Burlington*, No. CV, Vol. XX, Dec 1911.

7. Bernard Rackham and Herbert Read: *English Pottery: Its Development from Early Times to the End of the Eighteenth Century*, London, Ernest Benn Ltd, 1924.

8. Gordon Forsyth, Book Review, *Artwork*, No. 5, Oct-Dec 1925, p. 68.

9. R.L. Hobson, Book Review, *Burlington*, Vol. XLV, No. CCLVII, Aug 1924.

10. Bernard Rackham, 'Mr W.F. Murray's Flambé Stoneware', *The Studio*, Vol. 88, Dec. 1924.

11. W, Staite Murray, 'Pottery from the Artist's Point of View', *Artwork*, Vol. 1, No. 4, May-Aug 1925.

12. Bernard Rackham, 'The Pottery of Mr Reginald F. Wells', *The Studio*, Vol. 90, Dec 1925.

13. P.G. Konody, *Catalogue of Pictures, Sculptures and Pottery by Some British Artists of To-day*, London, Leferve Galleries, Feb 1926.

14. F. Lessore, 'The Art of Reginald F. Wells Sculptor and Potter', *Artwork*, Vol. 2, No. 8, Dec 1926.

15. Charles Marriot, 'Mr W. Staite Murray', *The Times*, Nov 11, 1927.

16. H.S. Ede, *Foreward to Paintings by Ben & Winifred Nicholson and Pottery by Staite Murray*, London, The Leferve Galleries, July 1928.

17. Herbert Read, *The Meaning of Art*, London, Faber and Faber, 1931, p. 23.

18. Charles J. Lomax, *Quaint Old English Pottery*, Manchester, Sherratt and Hughes, 1909, p. 4.

19. *Catalogue of Early English Earthware*, Burlington Fine Arts Club, London, 1914, p. xvii.

20. Bernard Rackham, 'English Earthenware at the Burlington Fine Arts Club', *The Burlington*, No. CXXXI, Vol. XXIV, Feb 1914, p. 265.

21. Bernard Rackham, 'Domestic Pottery of the Past', *"The Studio" Year-Book of Decorative Art*, London, 1922, p. 10.

22. Roger Fry, 'The Art of Pottery in England', *The Burlington*, No. CXXXI, Vol. XXIV, Mar 1914.

23. Ibid.

24. Herbert Read, 'English Pottery: An Aesthetic Survey', *Apollo*, Vol. II, No. 12, Dec 1925.

25. Edward Dillon, 'Chinese Pottery and Porcelain at the Burlington Fine Arts Club', *The Burlington*, No. LXXXVII, Vol. XVII, July 1910, p. 210.

26. Ibid. p. 211.

27. Bernard Rackham, 'The Literature of Chinese Pottery: A Brief Survey and Review', *The Burlington*, Vol. XXX, No. CLXVI, 1917.

28. 'Oriental Art', *The Burlington Magazine*, No. LXXXV, Vol. XVII, April 1910.

29. Roger Fry, 'Modern Paintings in a Collection of Ancient Art', *The Burlington*, No. XXXVII, No. CCXIII, Dec 1920, p. 304.

30. W. McCance, 'The Pottery of Mr Shoji Hamada', *The Spectator*, May 26, 1923.

31. Roger Fry, 'The Art of Pottery in England', *The Burlington*, No. CXXXII, Vol. XXIV, Mar 1914, p. 330.

32. Thorpe, 1930.

33. Bernard Leach, 'From the Hand of the Potter', *Homes and Gardens*, Nov 1929, p. 225.

34. 'An Art Pottery in Cornwall', specially contributed, *The Pottery Gazette and Glass Trade Review*, Dec 1, 1920, p. 1661.

35. *The Studio*, Vol. 93, March 1927, p. 200.

36. 'Bernard Leach on Crockery', *The Arts and Crafts*, Vol. 2, No. 2, June 1927, p. 14.

37. Frank Rutter, 'In Quest of a Teapot, The Work of the Studio Potter', *Birmingham Post*, Dec 9 1925.

38. Bernard Leach, 'A Potter's Outlook', *Handworker's Pamphlets*, No. 3, New Handworkers Gallery, 1928.

39. 'Pottery and Glassware', *The Studio Year Book*, 1929, p. 151.

40. M. Yanagi, 'The Pottery of Shoji Hamada', *Catalogue of Shoji Hamada*, Paterson's Gallery, 1931.

41. Charles Marriott, 'Stoneware Pottery', *The Times*, March 31, 1930.

42. Charles Marriott, 'Stoneware Pottery', *The Times*, Oct 29, 1931.

43. Charles Marriott, 'Mr Bernard Leach', *The Times*, Dec 5, 1933.

44. Clive Bell, 'What Next in Art?', *The Studio*, Vol. CIX, No. 505, April 1935.

45. Charles Marriott, 'Stoneware Pottery', *The Times*, May 23, 1932.

46. Bernard Leach and Jan Gordon, 'The Rise of Potting', *The Observer*, May 3, 1936.

47. Charles Marriott, 'Mr Staite Murray', *The Times*, April 26, 1934.

48. Charles Marriott, 'Leferve Galleries', *The Times*, Nov 7, 1932.

49. 'Art News and Notes', *Apollo*, Dec 1935.

50. 'Art News and Notes', *Apollo*, Dec 1936.

51. Hugh Gordon Porteus, 'Contemporary Japanese Crafts', *The New English Weekly*, May 21, 1936.

52. Charles Marriott, 'Leach Pottery', *The Times*, Mar 23, 1927.

53. Anon, 'Attractive Fireproof Ware', *The Times*, Oct 19, 1938.

6 · CREATING LASTING VALUES

Gareth Williams

In order to retain relevance in the modern world, craft must engage with contemporary concerns. One of the most pressing issues today is the impact of production, consumption and disposal of goods upon the earth's resources and ecological balance. The crafts are defined by the intrinsic value of the handmade object above the mass-produced commodity and the integrity of the maker and his or her relationship to material and technique. Politicised by an engagement with environmental issues, the crafts have striven to become more relevant to the needs of modern society. The crafts are themselves exempt from charges of pollution or over-consumption, by their very nature as small production or one-off objects, often made by hand or with low technology. However, a traditional definition of craft has been the production of functional or utilitarian objects. Although contemporary practice also favours the production of decorative, non-functional or metaphorical objects, the crafts share a common root with the industrial production of commodities. Unlike the Fine Arts, therefore, craft can uniquely contribute to the 'green' debate.

Many traditional and contemporary crafts are characterised by the use of natural materials – wood, clay, silk – or by ancient compounds, for example glass. It is easy to assume these are ecologically-friendly materials as they originate in nature. But the production of any material in quantity or intensity unbalances ecologies and can be detrimental. For example, plantation forestry does not sustain the diversity of ecosystems that mixed forests do, even if the timber produced is more affordable. Exotic hardwood trees are felled for use in furniture, often with little management of resources and few legislative controls. Tentative steps have been made to develop international standards of marking timbers harvested from sustainable, managed forests. Byproducts of glass and ceramic production can be toxic if they are produced in significant enough quantities. It is misleading, therefore, to believe that working with natural materials is necessarily 'greener' than

using synthetics, or that traditional practice, such as furniture making, does not contribute to global issues of resource management.

An assessment of furniture makers' approaches to recycling and sustainability serves as a model for other craft practice. Furthermore, recycling has become a focus for other debates, for example the relationship of the crafts to industrial production, conceptual art, and political and social programmes. Moreover, recycling can take many forms and should not be merely limited to the re-use of materials. As a practice it can also include the recycling (or regeneration) of ideas, traditions and symbols to retain relevance in contemporary society. This concurs with David Walker's taxonomy which includes Brutalism (the use of found materials, as in Tord Boontje's blanket upholstery), Animism (the use of found forms, such as the work of Michael Marriot) and cannibalism (the use of found objects, as with tranSglass' use of old bottles).[1]

In various ways, therefore, the crafts exist to promote lasting value, increasing the meaning and physical quality of objects.

The term 'lasting value' is open to several interpretations. It can mean the use of high quality materials and techniques to ensure the longevity of an object. It can mean finding an afterlife for materials or components that would otherwise be discarded, because they no longer fulfil their original function or have become obsolete. But it can also mean the perpetuation of traditions and conventions valued in the past, now threatened by social, economic or other changes. Similarly, the phrase can pertain to the spiritual or symbolic meanings inherent in objects, such as their emotional associations or individual characteristics. For a discussion of craft, it must also mean the added value in a handmade object that we preserve and respect above mass-produced commodities.

Throughout this examination the troubled relationship between craft and industrial production will be a

John Makepeace; British; *Column of Drawers*; 1978;
Courtesy the Trustees of the Victoria and Albert Museum

the decade. Ivan Illich called for 'convivial' societies, in which people will live harmoniously with one another and with nature, and James Lovelock wrote of Gaia, a vision of the earth as a living organism.[2]

With Victor Papanek, whose *Design for the Real World* was first published in 1971, a growing body of writing emerged in response to this 'earth first' philosophy, proposing radically new ways of designing and making objects. A respect for global cultures (and a disrespect for corporate, first world dominated economics) characterises this writing, acknowledging the lessons to be learned from, for example, African and South Asian contemporary craft practice. In Milan's Domus Academy, Ezio Manzini explored the meanings and metaphors of objects, and the ways in which we use them, in a search for new forms of consumption. Sustainability of production, consumption and disposal became an important issue, whether achieved through least use of resources, recycling or designing out in-built obsolescence. In poorer parts of the world this holistic approach was, and remains, a necessity, but in the West, the response of craftspeople to the 'green' imperative in the 1970s was to return to traditional, rural methods of manufacture, comparable in attitude to that of Morris a century earlier.

In Britain several craftspeople have been influential over a generation of makers. The furniture of John Makepeace is well known, and perhaps seems out place in this context. We can place his furniture as a type of modernised tradition, building on and updating conventional craft skills for the late 20th century. He celebrates the process of manufacture, the idiosyncrasies of timber and detailing of construction. Made until 2001 in his Parnham House, Dorset, workshop, founded in 1976, Makepeace furniture retains a ruralism at odds with the prevalent urban character of contemporary younger makers. In 1982 Makepeace extended the Parnham project, which also included a school of woodcraftsmanship alongside the production workshop, by opening Hooke Park. He opened this woodland estate as a research and development training centre to explore possibilities of sustainable forestry in manufactured goods and architecture. It is here, rather than in his own furniture, that Makepeace has undoubtedly been an emissary of the sustainable movement in design. Hooke Park, which closed in 2000, used thinnings as raw materials, taken from its own woodlands in a cycle that not only reduced the environmental impact of production but positively enhanced the health of the managed forest.[3]

recurring theme. Similarly, as boundaries between disciplines slip and blur, the contrary relationship of craft makers to artists and industrial designers becomes apparent. The connecting principle in all this work is an approach to production incorporating a concern for recycling, appropriation, sustainability and longevity, to create lasting value in objects.

We can date the modern engagement with 'green' design to the 1962 publication of *Silent Spring*. In this book Rachel Carson detailed the toxic effects of pesticides on natural ecosystems, focusing attention on the impact of human systems upon the earth and prefiguring the return to nature of the hippy movement later in

Like Makepeace, David Colwell has proven that sustainable forest management and furniture production

are compatible. In the 1960s, as a student at the Royal College of Art, Colwell experimented with acrylic to make Pop furniture, later working for ICI. Like many in his generation, however, Colwell retreated to the countryside to found Trannon Furniture, first in Wales in 1977, moving to Wiltshire in 1992. He was also a design tutor at Hooke Park until 1990. The precept of Trannon is to use thinnings from sustainable, managed woodlands to construct modern furniture. He describes this as 'non-ascendent technology' and describes his work as post-industrial rather than pre-industrial.[4]

Colwell's furniture is not as 'crafted' as Makepeace's, in the sense that he designs it to be mass-produced as multiples, using mechanised processes. Chief among these is steam-bending, a process economical on energy, that doubly seasons and shapes the sapling wood. Trannon stands at the crossroad of craft and production furniture. Its character is natural, ruralist and non-specifically traditional, yet the design is rational, using minimum resources and energy to construct.

Makepeace and Colwell are from the previous generation of sustainable craft makers. Both have re-invigorated traditional rural industries of forestry and furniture making, creating lasting value where previously these skills and assets were falling out of use. Makepeace maintains the tradition of spectacular, one-off furniture and cabinet-making, while also teaching and influencing younger generations to think and make sustainable furniture. Colwell has rationally applied traditional rural wisdom to making furniture appropriate to this age.

Makers such as Colwell and Makepeace defined British craft furniture until the 1990s. Since this time, however, the influential new generation of makers are urban, reflected in the character of their work. Timber from managed forests close to their workshops has not been the natural material for these makers, who have taken inspiration from the cities around them. Sustainable design takes the form of recycling and appropriation.

It is a complex process to make new materials from existing waste, often beyond the means, if not the imagination, of the craft maker. Simpler to achieve, yet no less apparent in execution, is to appropriate materials and components from one source and employ them in a different context. Post-Modern theory of the equal validity of all materials is effective here, as are notions of memory, individualism, customisation and symbolism. Appropriation was legitimised in Fine Art by Duchamp's urinal and other Dada 'readymades' in the interwar years, and through surrealism briefly influenced design, though mostly in terms of appropriated forms rather than components (for example, Dali's 'Mae West Lips' sofa). Should the current wave of crafts using appropriation be judged, therefore, as artistic production rather than functional design? The obvious use of discarded waste to create decorative or utilitarian new objects draws attention to the original material and invests it with new value, and also places the object in the terms of reference applied to 'readymade' art. The vexed question of the crafts' relationship to Fine Art spans all craft production, not only that discussed here, but it is reasonable to conclude that acceptance of avant-garde art predisposes consumers to accept similar approaches applied to craft. Artists such as Sarah Lucas work in a related manner today. We understand Duchamp's urinal and the works of Lucas; we therefore comprehend the aims of Michael Marriot and others.

Appropriation does not only arise from knowledge of avant-garde art. Mike Press has pointed out that cuts in government funding of design and art education since

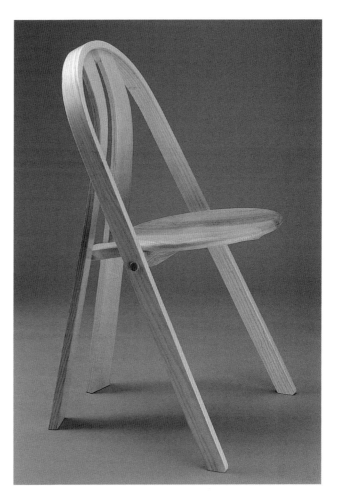

David Colwell; British; *C3 Stacking Chair*; 1989

the 1980s has forced students and teachers to experiment with salvaged materials.[5]

Economic necessity demands resourceful use of materials close to hand by contemporary, urban, craftspeople. For many, the raw materials of creativity are the cheap or free detritus of modern life. Arguably, personal expediency drives appropriation and recycling in craft as much as political, theoretical or ideological imperatives. In this respect Western craft makers are similar to contemporary makers in Africa and elsewhere. A strong tradition of manufacture has arisen in which discarded metal advertising hoardings, oil cans, and even telephone cable, are transformed into bags, toys, boxes and baskets. Anthropologists see continuous patterns of manufacture, use and design between these artefacts and the traditional practices of, for example, West African craft makers, the principle difference being that now the materials are reclaimed industrial commodities. These makers ascribe their own, local, meaning to their

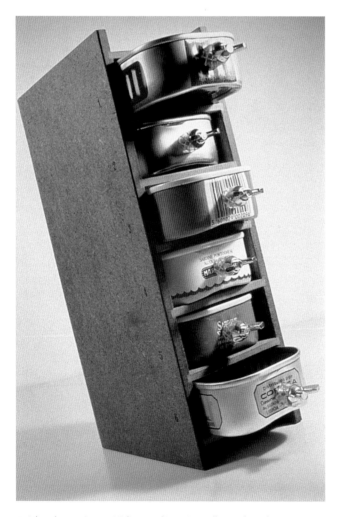

Michael Marriot; British; *Sardine Tin Collector's Cabinet*; 1989

objects that are as valid and cogent as Western debates about the potency of the readymade or the ideology of recycling. For them, recycling makes economic sense and is therefore legitimised.

It is appropriate to cite two exhibitions which have examined the role of recycling in craft and design. 'Recycling', an exhibition organised by Craftspace Touring in 1996, showcased diverse work by 27 makers.[6]

It confined itself to handmade one-off or batch-produced work, but muddied the issues surrounding the validity of recycling in contemporary work by failing to differentiate between different approaches. Prototypes for industrially-manufactured goods were shown alongside the purely decorative and ephemeral. The overbearing impression was that recycling and appropriation were fashionable in craft production, rather than considered approaches to real issues. 'Refuse', (combining 'reuse' and 'refuse' by crossing through the letter 'f') also in 1996, organised by the Orango Design Foundation in Miami, divided work into a taxonomy that differentiated between traditional recycling (for example quilting), one-off hand work and industrial applications.[7]

By broadening the debate to include both traditional and industrial work alongside contemporary craft practice the exhibition succeeded in contextualising the recycling debate. Much of the work appears to be 'gimmicky', for example Christine Desforges' teabag tapestry, and the industrial products have remained as prototypes, or experienced limited commercial success (for example Philippe Starck's sawdust-derived Jim Nature television for Saba). Perhaps the economics of recycling still do not equate with mass-production. In short, neither exhibition provided objective criticism of the issue and, while preaching to the converted, they unquestioningly included any and all recycled objects, regardless of their validity.

Michael Marriot, whose work was included in the 'Recycling' exhibition, has become a chief exponent of appropriation in craft and design. Yet he does not identify himself as a craftsman at all, though he has designed and batch-made his own work since the 1980s. He perceives his work 'more as a commentary on the "over design" of products and overabundance'. 'We don't have to surround ourselves with opulent remakes. We should be satisfied with what we have.'[8]

Although Marriot is known for re-using materials and components, both post-consumer waste and appropriated elements from other sources, he sees recycling as incidental to his work. Unlike Jane Atfield (see pp.67–8), who is actively political in her use of recycled plastic, for

Marriot, resourcefulness is more important than recycling. He re-interprets the materials of his London environment. The hardware shop is a valid source to Marriot, just as a sculptor may use a quarry, or a traditional basket maker sources bulrushes. Despite distancing himself from the recycling movement in design, Marriot fervently believes in sustainable design and consumption. For him Thonet's bentwood chairs were the archetypes of 'green' furniture, economically employing material, manufacture and distribution. Recycling is merely pragmatism, to Marriot.

> Using found and recycled elements in my furniture is to do with a way of working which is about observation and lateral thinking, an awareness of everything in the world. There is a great wealth of resources surrounding us and I approach them all in the same way whether it is a sheet of plywood, a length of steel tube, a hinge or any other piece of hardware, a glass lemon juice squeezer or an empty sardine tin.[9]

Marriot has made his influential sardine tin chests of drawers in batches since 1989, housing re-used food packaging in a carcase of MDF. Marriot is sure its 'cuteness', meaning its accessibility and whimsy, gets in the way of understanding the object. He believes it has a political dimension that can be read as a critique of consumerism. However, the celebration of the sardine tins' bold graphics, colours and functional moulding appeals most to Marriot. He admits there is more crafting in the tool-making for the tins than there is in his construction of the carcase now containing them. This admission reveals an appreciation, rather than rejection of, industrial processes that defines much contemporary craft practice. This dichotomy between the traditional extremes of production – hand and machine – is creatively explored and embraced. Marriot believes to make a difference you have to work within the culture and industry, witnessed by his honest use of industrial components, and his increasing design consultancy work.[10]

Marriot's absorption in the inherent beauty of everyday objects is apparent in the detailing of the drawer handles. Constructed simply from wing-nuts and industrial hose, the tiny handles suggest the bodies of the fish once contained in the tins. In essence this work promotes lasting values by celebrating the overlooked qualities of everyday materials and objects. It is symbolic, rather than economic that the sardine tin chest of drawers contains reused materials. Marriot wants people to reassess what they have around them.

Peter van der Jagt; Dutch; Droog Design; *Bottom's up Doorbell*; 1994

Consequently a lampshade he designed is simply a bucket turned upside down. The craftsmanship, such as there is any handwork at all, is limited to securing the electrical fitting.

The Dutch foundation Droog (meaning Dry) Design parallels Marriot's approach. A loose affiliation of designers, theorists and makers founded by the art historian Remy Ramakers and the designer Gijs Bakker, Droog has been internationally influential since their foundation in 1993 (see pp.67 and 115). One member, Tejo Remy, once made stools from upturned buckets, similar in concept to Marriot's lampshade. Droog members have experimented with appropriating materials from one source for alternative uses, such as Hella Jongerius's polyurethane soft vases and bathroom fittings. Components have also been appropriated, as in Peter van der Jagt's 1994 'Bottoms Up' doorbell comprising chiming wine glasses. Remy made a series of chests of drawers out of reclaimed drawers from diverse discarded furniture, bound together into a loose, sculptural, de-constructed whole. The memory of each original object (and of its users) lives on in a new piece of furniture. Droog has actively worked with manufacturers to develop new systems for making familiar objects, such as experiments using high-technology ceramics conducted with the German company Rosenthal. Central to the

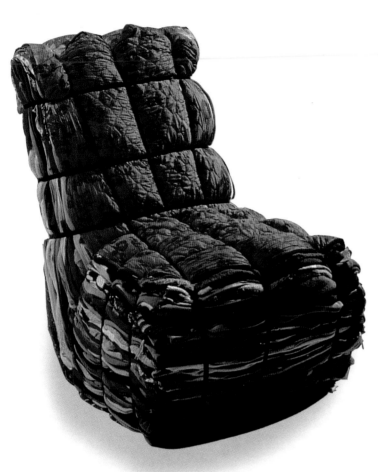

Tejo Remy; Dutch; Droog Design; *Rag Chair*; 1991

bottles, using reclaimed packaging as a raw material.[12]

Similarly, ducting for the construction industry and the manufacture of dustbin liners, also employ an element of recycled material. What is different about Atfield's plastic board, marketed by her own company Made of Waste, is that it completely comprises recycled plastic. Moreover, the particular composition of each board forms its individual character. After the summer, when a higher than average proportion of discarded suntan lotion bottles are collected, the board can take on the characteristic orange hues of those bottles. The compression of the loose chippings also defines the finish and pattern of each board, as the colours smear and radiate from the centre of the press towards the edges. It is as if the material is a latter-day marble, or burr-wood, self-patterned by its own construction. Consequently, it has structural and decorative uses.

Atfield's furniture design (included, like Marriot's work, in the 'Recycling' exhibition) allows the quality of the plastic to speak for itself. Her design is architectonic, influenced by modernists like Gerrit Rietveld, derived from planes and right-angles. The understated form of her RCP2 chair is the perfect foil for the exuberance of the multi-coloured plastic board from which it is made. (Atfield contracted out each batch of chairs, and is not a maker herself. This division of activity is apparently contrary to craft doctrine but is increasingly prevalent.) Atfield admits that, in the early 1990s, makers were specific about their use of recycled materials, drawing attention to their credentials as advocates of sustainability.[13]

She saw this as a transitional period, during which makers, consumers and industry would learn the necessity of recycling. She predicted that reclaimed materials and sustainable systems would become integrated into the manufacture of objects, disappearing from the surface. Wearing green credentials so obviously would no longer be necessary. Atfield experimented with other source plastics, including vending machine coffee cups, telephone cables, and metallic plastic snack food packaging, to create a range of subtle finishes. This was post-consumer waste but Atfield made other boards from post-industrial waste: the offcuts and rejects of the plastics industries. They were less apparently recycled than the original board made of bottles. This bears out her belief that recycling can become integral to manufacture without remaining obvious.

Clearly Atfield's work is as pertinent to industrial manufacture as it is to craft. She is political in her ambitions to teach both producers and consumers the value of

Droog philosophy is a reductive design process, celebrating the ordinariness of materials and functions, and the decorative possibilities of the simplest shapes and materials. Sustainability derives from rejecting voguish fashion in favour of pure principles, whether they are found in recycled materials or perpetuated archetypal forms.[11]

In the 1990s Jane Atfield made furniture entirely of recycled plastic board and, in David Walker's terms, her work is cannibalistic. Whereas appropriated forms (Walker's animism) reveal their undisguised sources, Atfield transformed the original commodity into a wholly new material with its own distinct character. To create this board requires complex industrial and distribution processes. High-density polythene from used shampoo and washing-up liquid bottles is salvaged from community reclamation schemes, sorted, cleaned, chipped and formed into board in redundant plywood presses.

Atfield did not initiate the process of reclaiming plastic. Companies such as Procter and Gamble have developed systems of reusing plastic to make new

Gijs Bakker; Dutch; Droog Design, manufactured by Rosenthal; *High-Tech Accent*, porcelain;1997

These chairs are all comparable forms, and are endlessly repeatable. Yet each model is individual, dependent on the nature and quantity of packaging used to make it. They demonstrate a realistic way for the re-use of large quantities of waste to make durable furniture. In addition they suggest how mass or batch-produced objects can be customised in production to retain individualities. Industrial designers are experimenting with customisation of mass-produced commodities too, to penetrate consumer markets with more personalised objects. In form, Bär and Knell's chairs relate to the experimental design of Gaetano Pesce in New York, who has made furniture and other objects from draped and melted synthetic materials, and has explored the possibilities of individualised mass-production.

Bär and Knell chairs are functional, but are more important as manifestos of 'green' consciousness. The recycled material is apparent, but transformed, and their organic shapes appear to have grown from the landfill site.

sustainable design – unlike Marriot, recycling is not incidental to her work. Yet craft is an important arena for Atfield, who believes that one-off and small batch-produced objects such as hers are provocative statements. The crafts, therefore, cannot resolve all the issues pertinent to industrial production, but exist as exemplars, or possibilities. Atfield feels that many so-called craft objects are in fact unresolved prototypes for industrial production (as witnessed by the selection of objects for 'Refuse' discussed previously), returning us to the relationship between craft makers and industrial design.

Not only did Atfield re-use material, but her reductive design makes the best use of resources. No embellishments, then, on her furniture, which also includes shelves simply formed from fabric slings within a standard wooden clothes drier, and cupboards with stretched canvas doors. She enjoys the evocative use of everyday materials and components, appropriating their emotional content.

In Germany, Bär and Knell Design have also developed furniture from recycled plastic. The company comprises the designers Hartmut Knell, and Gerhard and Beata Bär, who claim: 'We see our work as a challenge to treat plastic in both a sensible and artistic manner. We want to put an end to the throwaway mentality and save valuable resources for the long term.'[14]

Although, like Jane Atfield, they use plastic chips to form sheets and boards, they have also created chairs by melting and draping plastic packaging over moulds.

Jane Atfield; British; *RCP2 Chair*, recycled materials; 1994; Courtesy the Trustees of the Victoria and Albert Museum

Jane Atfield; British; *Soft Shelves*; 1995

The tension between the 'perfect' forms of the mass-produced original packaging and the distorted, organic, arbitrary recycled results, alludes to the unbalanced value we ascribe to disposable, ephemeral commodities and environmental sustainability. Without compromise, they expose the problem of over-consumption and excessive disposal of waste, while simultaneously transforming waste into objects of lasting value and meaning.

Atfield and Bär and Knell transform waste into new material, in both cases using plastic packaging as a source. Both makers exist within the craft parameters of small-scale batch production. Equally, however, they propose radical industrial solutions to achieving sustainable production and consumption systems. However, this work is a rebuke of over-consumption in society, rather than a realisable proposal for large-scale change. Ironically, the chairs of both makers could not exist without the over-consumption of packaging that provides the raw material.

Jane Atfield realises the green movement in craft and design has a long way to go before it can effect real change. She perceives a stalemate in environmentally-aware crafts since the early 1990s. In other areas the sustainable argument is winning ground, and she cites the increase in mass-market organic food as an example of environmentalism becoming mainstream. In time, she hopes, the sustainable message, and practical reality, contained in craft work may enter the mainstream of design[15]

Dutch-born Tord Boontje, who lives and works in London, transforms discarded and unvalued materials into objects of utility and contemplation. His design does not overtly intervene between the past life of the material and its present incarnation. The work is anti-aesthetic, as it is often brutal in its uncompromising rawness. By reordering our traditional hierarchy of materials, and conventional notions of technical virtuosity, Boontje proposes a new order of objects more suited to the ways in which we live today. From Victor Papanek to Ezio Manzini, theorists have conceived a new aesthetic for sustainable design – perhaps influencing Tord Boontje's approach. A practising industrial designer, it is important that Boontje also engages with small-scale batch production and debates about craft. 'I am an industrial designer thinking through the crafts. A lot of the time I am thinking through my hands.'[16] For Boontje, therefore, engagement with craft allows him freedom to experiment.

Boontje founded tranSglass in 1997 with Emma Woffenden, a sculptor in glass, to batch-produce tableware entirely from recycled bottles. They retrieve these from massive dumps of post-consumer glass in Dagenham, Essex. Their method is to cut slices through the bottles to create vases or drinking vessels. Some designs fuse the bodies of two bottles to create new forms. The cuts are generally polished and the bodies are often sandblasted, but the origin of the vases as utilitarian wine bottles is still apparent and celebrated. Like Michael Marriot, who appropriates materials and components for the love of their individual characters, tranSglass tableware draws attention to the pure beauty of a bottle, normally overlooked. However, the production of the finished tableware undeniably requires much energy, both in power and craftsmanship. Boontje believes it is the attitude towards the creation – and the consumption – of the tableware that matters more than the economics. TranSglass products cannot dent the mountains of reclaimed glass in Dagenham and elsewhere. However, the conspicuous use of the discarded bottles, given an afterlife as something useful and attractive, shows a concern for, and appreciation of, the 'green' imperative. TranSglass, therefore, is politicised craft. It is the production of a limited range of comparatively expensive objects, for an elite, discerning market, which consumes objects because it understands the ideological reasoning underlying them.

Bär & Knell; German; Recycled plastic chairs; 1997

The materials of Boontje's furniture are less mediated than the bottles used for tranSglass products. Titled 'Rough and Ready', the range comprises a table, a chair, a light and a cabinet that are conspicuously unfinished. Boontje states: 'I find it hard to relate to the prevalent plastic slickness and preciousness. With this furniture I want to develop my ideas about objects we live with. Ideas about a utilitarian approach towards the environment we live in.'[17]

The solution, for Boontje, is to design simplified, unfinished, sparely constructed, unpretentious furniture, which he describes as 'brutal and civilized'.[18]

These act as archetypes for contemporary furniture, made of the raw materials of the urban building site. Boontje constructs the frames of untreated timbers, simply screwed together, and other elements may be of reclaimed plasterboard or polythene sheet. For the chair's upholstery he employs folded blankets, lashed to the frame with industrial binding. Conceptually a chair is only a raised platform with padding for comfort, and this chair delivers little else. Boontje ignores traditional notions of beauty, and conventions of virtuoso technique or craftsmanship. Brutal in its lack of pretence, the furniture nevertheless has elegance derived from balanced proportions. This is an anti-aesthetic formed from a wilful rejection of expectations about quality, materials and manufacturing standards, akin to Arte Povera and contemporary work by artists such as Sarah Lucas. We return, again, to Duchamp.

However, Boontje's furniture is not only conceptual; 'I don't like objects which don't work, or which work badly'.[19]

He designs objects for use and their unfinished nature is a virtue allowing customisation and aging, unlike the 'precious', highly-finished synthetic furniture he despises. This adaptability, combined with the archetypal character of the furniture, gives each piece a longevity beyond the cycle of fashion, according to the principles propounded by the 'Eternally Yours', a Dutch foundation, organised with the Netherlands Design Institute, to explore issues of sustainable design, by designing objects that are more durable. Like other contemporary Dutch design, Boontje's furniture tinges ascetiscm with irony in response to the excesses of modern, particularly urban, existence. 'Offering alternatives is the thing I can do', says Boontje, who also sees craft products as 'philosophical products, not designed with function in the first place'.[20]

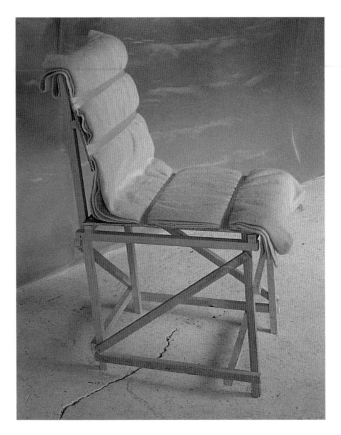

Tord Boontje; Dutch; *Rough and Ready Chair*; 1998

This work is metaphorical for possibilities yet untried. Boontje's furniture and tranSglass products are craft in that they engage with the debate about form and meaning in handmade objects. Yet, simultaneously, they offer new possibilities for industrialised production and types of consumption on a scale unachievable by rarefied craft practice.

The Netherlands Design Institute drove 1990s innovation in practice and theory. Recent research there has promoted different approaches to sustainability – of materials, resources but also traditions, differences and individuality. Two examples will serve to show sustainability in craft and design can mean more than merely re-using materials and components.

The *Connecting* project, which developed from the Design Institute, staged an exhibition of work in a satellite venue of the Milan Furniture Fair in 1998. Designer Peik Suyling formulated *Cabinets of Cultures* as an attempt to meld traditional crafts from the non-Western world with the rationalism of Western industrial production. In the context of this discussion, I mean craft as indigenous hand-skills, redolent of local customs of making, symbolism and use. *Cabinets of Cultures* sought to recycle

these traditions themselves, rather than the materials from which they are made.

Suyling devised a simple, industrially-produced aluminium framework to create shelf and cupboard units. A collaboration with craftspeople in Morocco and India using traditional techniques individualised the neutral, characterless products with the addition of local decoration. The results were a compromise of contemporary and traditional; international and vernacular; north and south; 'first' and 'third' worlds. Precisely because the results were a compromise, or amalgamation of traditions, their meanings were dissipated, but the project served to show the validity of traditional practice in the face of prevailing industrial production. Importantly, it provided a means for local traditions and techniques, so easily swept away by industrialisation and globalism, to be assimilated to preserve indigenous culture. Moreover, the project produced prototypes of simplified industrial products customised to suit the local requirements of different communities. Lasting value is created if products and individual objects are fitted to the specific of their local environment. If local customs – of decoration and manufacture – can prevail, lasting value endures.

We can be critical of *Connecting* on two accounts. First, for the tone in which Peik Suyling approached the craft communities of India and Morocco, which was arguably imperialist. Second, for the lack of ambition to create a variety of object forms equally relevant to both collaborators: the Dutch instigators and the local craftspeople. The project did not consider the relevance of the shelving units *per se* for the communities who made them, emphasising instead the manner of their embellishment. As commodities for export these products may be powerful agents for their makers, but this is dangerously close to tourist art, and was not in the brief for the project. An example of recycling as tourist art could be the toys and autonoma made in Africa from discarded tin cans for foreign visitors. These bear radically different meanings for their makers, and their first-world consumers. *Connecting* does not relate to the re-use of materials. Yet, in a discussion of lasting value, the project succeeds by extending the validity of ideas and traditions, assimilating them to contemporary practices and expectations. It is the tradition recycled here, along with the local cultural meaning and imperative tied up in its creation.

Eternally Yours acknowledged the relevance and importance of recycling, but proposed more radical means to maintain sustainable consumption. It is not enough to re-use the materials and products of everyday

life, like the work of several craft-makers in this chapter. Recycling is only an engagement with the symptoms of overproduction, not the root problems. Rather, *Eternally Yours* proposed attaching a new set of values to the objects and services of everyday life. It suggested that we re-appraise the emotional and physical relationship we have with objects, in a search for more enduring attachments. Thus, makers have a duty to create objects that will continue to function physically much longer than those we buy today, which have built-in obsolescence as a standard feature. Furthermore, as consumers we must learn to appreciate our possessions for longer, allowing attachments to last, rather than replacing objects as fashions and changes in style dictate. The underlying principle is to make objects with longevity – physical, emotional and psychological – that will be 'eternally yours'. By consuming less, we need to make and dispose of less. Longevity is the lasting value, and becomes the principal quality of any object.

Clearly we can criticise the project for both its romanticism and for failing to address the cataclysmic economic slowdown that would accompany a large-scale reduction in the consumption of goods. However, *Eternally Yours* tried to see the problem of sustainability as a larger problem, intellectually and materially, than the proponents of recycling have attempted. To date, few, if any, craftmakers are responding to the challenge of producing objects addressing durability and longevity. Tord Boontje intends his furniture to age with dignity, changing as we interact with it. Of the makers mentioned in this chapter, his attitude comes closest to the precepts of *Eternally Yours*.

Ezio Manzini addresses the extent of the problem facing anyone, whether consumer, theorist – or craftmaker – who engages with sustainability:

Sustainability, in its strongest sense, implies such a deep transformation of production and consumption activities that it implies a 'systemic discontinuity': a change so formidable that it cannot be imagined as the result of the incremental innovation of technologies in use or as a partial modification of the existing non-sustainable way in which industrial societies produce and consume. Therefore, achieving sustainability has to be

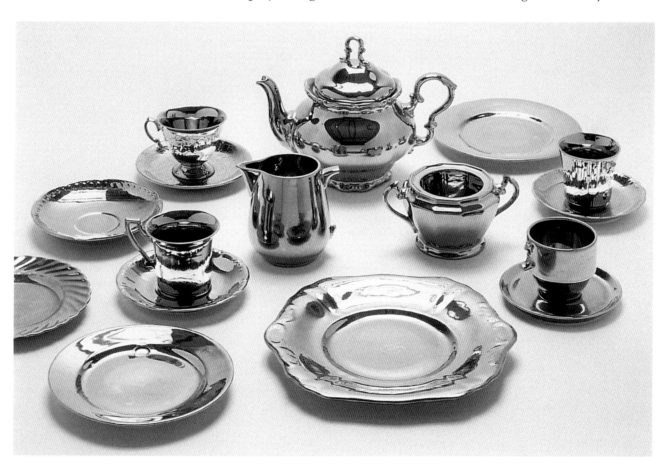

Jürgen Bey, Dutch; *Broken Family,* 1998

considered a transition towards nothing less than a new economy and a new culture, in the way that it is most acceptable to society: assuring both production continuity and social democracy.[21]

Craft may be politicised, and involved with both aesthetic and social concerns. However, can it be the revolutionary force required to drive Manzini's 'systemic discontinuity'? Makers are addressing aspects of sustainable design and consumption, but by concentrating on recycling and appropriation, they only focus on the symptoms. Yet craft makers work outside the conventional restraints of industrial design and can experiment without the risks or responsibilities of economic viability. Perhaps their position as outsiders, commenting and reflecting upon broad industrial and social issues, is their greatest strength. They cannot solve the larger problem, but they can show possibilities. These craft makers nurture lasting value, but sustainable systems require action by all of us, not just the avant-garde.

COPYRIGHT © 2002 GARETH WILLIAMS.

NOTES

[1] Walker, D., 'The ABC of design', *Co-Design Journal*, 1994, vol.1, no.1. Quoted by Press, M., 'All that is solid melts into craft: crafting a sustainable future from today's waste', *Recycling*, Birmingham: 1996, pp.12-17, p.14.

[2] Illich, Ivan, *Tools for Conviviality*, London, 1973; Lovelock, James, *The Ages of Gaia*, XXX, 19XX.

[3] For a fuller description of Parnham College and Hooke Park, see Myerson, J., *Makepeace, A Spirit of Adventure in Craft and Design*, London, 1995

[4] Bignell, E., 'Economy meets ecology in quality', *Furniture*, no.2, 1993, pp.10-13.

[5] Press, M., op.cit., p.13.

[6] *Recycling*, op.cit.

[7] *Refuse, good everyday design from reused and recycled materials*, Miami, 1996

[8] Interview with the author, 6 November 1998.

[9] *Recycling*, op. cit., p.68.

[10] Interview with the author, op.cit.

[11] See Ram, R. and Bakker, G. (eds) *Droog Design: Spirit of the Nineties*, Rotterdam, 1998; van Zijl, I., *Droog Design 1991-1996*, Utrecht, 1997.

[12] Mackenzie, D., *Green Design, Design for the Environment*, London: 1991, pp.110-11.

[13] Interview with the author, 12 November 1998.

[14] Gerhard Bär, quoted in 'A recycling café to relax in', press release issued by Deutsche Gesellschaft für Kunststoff-Recycling mbH, Cologne: January 1996.

[15] Interview with the author, op. cit.

[16] Interview with the author, 11 November 1998.

[17] Boontje, T., unpublished notes written in preparation for the Crafts Council exhibition *No Picnic*, where the 'Rough and Ready' furniture was first shown. The exhibition, for which Boontje was also an advisor, also included work by tranSglass.

[18] Boontje, T., quoted in *No Picnic* exhibition catalogue, London: 1998, section 02.

[19] Interview with the author, op. cit.

[20] Ibid.

[21] Manzini, E., 'Leapfrog Strategies', in van Hinte, E. (Ed), *Eternally Yours*, Rotterdam, 1997, p.208.

7 · GLASS MAKING AND THE EVOLUTION OF THE CRAFT PROCESS

Keith Cummings

MUCH is made of the uniqueness of glass as a material and while it does occupy a singular position in scientific terms (it is the fourth state of matter, the glassy state), the products made from it should not enjoy the same isolation. All objects must be seen against their cultural and critical background if they are to be fully appreciated, and regrettably, contemporary glass artefacts have often been viewed as somehow apart from the mainstream by both makers and public. This isolation is not only critically unhelpful, it is also historically inaccurate, for any study of the material shows that it flourishes only within aesthetically and technologically well-developed societies. It is not by accident that the high points of glass development and design have occurred within peaks of artistic and economic achievement – Rennaissance Venice or 18th century England, for example. It is also a basic fact that glass cannot be made (it is a synthetic) without the support of a wide range of materials and their associated technologies.

The evolution of glass as a contemporary craft medium is also totally bound up with the practice and theory of other craft-manipulated materials, and increasingly with mainline practice. Any attempt to explore and define its role within 20th century craft must take into consideration the wider movements to which it clearly belongs. Its special qualities, exploited by brilliant individuals, have helped to make major contributions to 19th and 20th century stylistic movements. It is hard to envisage Art Nouveau or Art Deco without the particular contributions of Gallé, Tiffany or Lalique.

In the same way, it would be impossible to imagine the contemporary craft movement without the contribution and presence of its major glass practitioners. The Modern movement, centred on individual making, dates from the early 1960s and is currently only three generations deep. It includes still vigorous pioneers such as Dale Chihuly (p.5) and Marvin Lipofsky; young artists like Clare Henshaw (p.75) and Keiko Mukaide (p.78); and large numbers of students enrolled on glass courses, a reality that would have been unthinkable 40 years ago. Each generation has built fast on the discoveries and achievements of their teachers and predecessors, ratcheting up the quality at the same time.

In this essay I will concentrate my attention on a single model of practice. The exploitation of glass as an expressive medium by individuals who have chosen to combine concept and realisation by working the material themselves. I am aware that other models continue to flourish but these have been well-described elsewhere, and I have chosen one which is unique to our era and which is now old enough to have established a tradition worth discussing and a future worth speculating about.

In 1970 Marvin Lipofsky was invited to be a visiting artist at Royal Leerdam. Lipofsky had graduated in 1964 as one of Harvey Littleton's first glass students at Wisconsin and had quickly built a reputation for his sculptural glass forms. He was invited to, in his own words, 'do what Americans do – work by myself. But I saw an opportunity to try what Europeans did. I was given an opportunity to work with the glass master Van der Linden.' This split between designing and making ran counter to the spirit of both Harvey Littleton's teaching and the American post-war craft movement with their emphasis on the total integration of concept and production. Lipofsky found that he had to produce drawings of his desired object to have it made for him by Van der Linden. The drawings were loose and expressive and Lipofsky found that Van der Linden interpreted them absolutely literally, reproducing every mark in the glass. Totally new, unambiguous drawings had to be produced

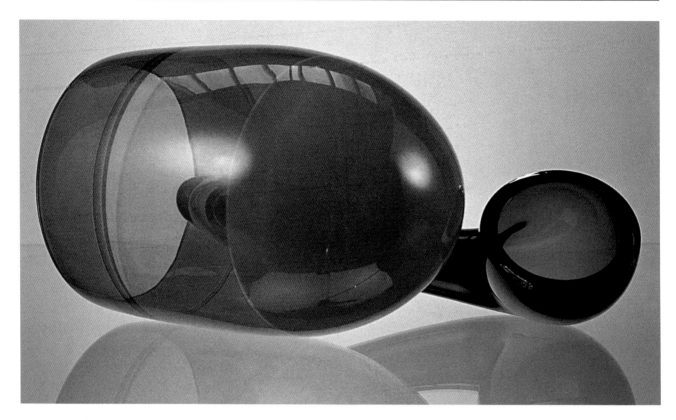

Marvin Lipofsky; American; *Leerdam Colour Series*; mixed media; 1970; Photograph by M. Lee Fatherlee

and the resulting collaborative pieces were radically different to the work conceived and made by Lipofsky.

This story illustrates one of the main tenets of the contemporary glass movement and its difference from historical practice. In 1888 C.R. Ashbee dedicated his translation of Benvenuto Cellini's treatise on Goldsmithing to 'all those who seek to link the work of their hands to their reason for existence'.[1] Ashbee's statement was an aesthetic, intellectual, middle-class view of craft activity in the lee of the Industrial Revolution. Central to this view was making – the actual operation of craft, skills and processes to shape materials personally – bridging the gap between designer and maker and forging the important links between hand and brain that have dominated the crafts ever since. One of the key elements that made craft activities so attractive to Ashbee and his circle was in fact totally new – choice.

In common with other media glassmaking, as opposed to glass designing, had been a predominantly anonymous and low status activity until the late 19th century when it became a material of choice for individuals who sought to harness its unique qualities to their personal, creative endeavours. In such an equation, choice and ego are paramount, both alien to craftmakers prior to our own era. In a system where idea and production are in the hands of the same individual, the medium, with its own vocabulary of techniques, processes and material qualities, is of prime importance. It is no accident that 'truth to materials' has become a 20th century mantra.

It is possible to disagree profoundly with the notion that some forming processes are 'truer' than others while accepting the importance of the concept in the late 19th and early 20th centuries. Ruskin (in *Stones of Venice*) railed against glass cutting as a means of decorating because it was somehow alien to the material's inherently viscous nature, altering its form after it had been shaped by fire.

The term designer-maker is often used to describe an individual who combines both roles. In many ways it is unhelpful and misleading. It was created by pushing the words for two separate activities together and the result still contains the idea that making is distinct from designing and simply the result of it. The true relationship that exists between the two, where both are combined in one individual, is much closer. The end product is the result of a dialogue between idea, material and making process, with, creatively, many feedback loops between them rather than a single, linear progression.

It is significant that, integral to the development of

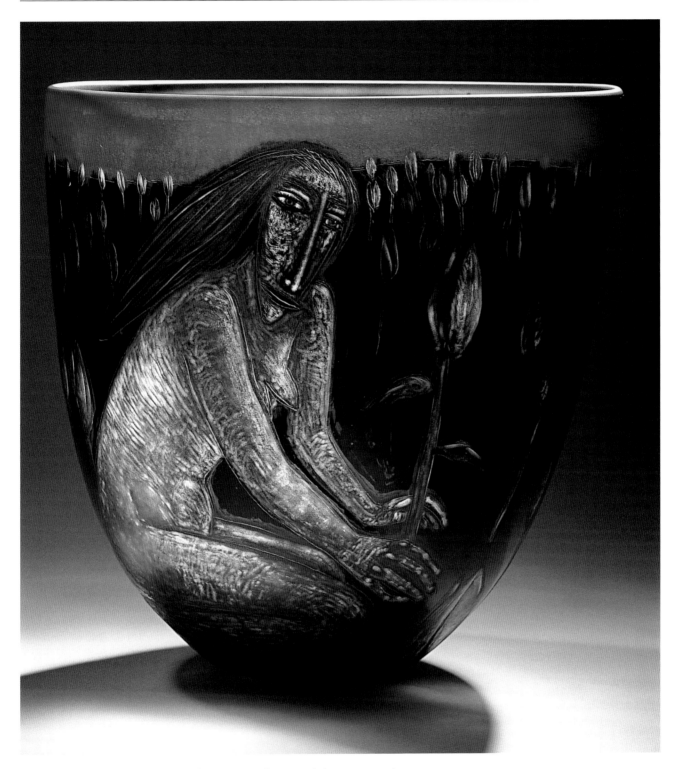

Clare Henshaw; British; *Bridget*; glass; 1990; Photograph by Brian Nash

studio glass over the past 100 years is a core of discovery, renaissance and improvement in material terms, as each individual has sought to negotiate their own personal deal with it. This represents an attempt to invent, identify or develop a particular way of shaping glass that is part of their creative identities, and which distinguishes their objects. This search has remained remarkably constant and is as much a feature of the work and development of major practitioners now as it was of Henri Cros a century ago.

Far from slowing down it is increasing in complexity

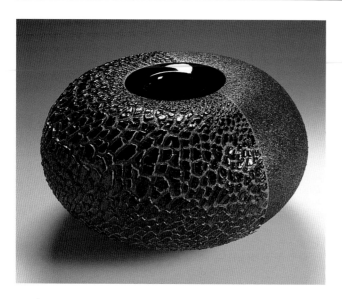

Mieke Groot; Dutch; *Blown form*; 1997; Photograph by Ron Zylstra

and sophistication as each newcomer has to look harder for a new, idiosyncratic angle to his making. The need to establish an individual, creative signature embedded within the end product has led to an increasingly dominant role for the material, its shaping methods and their joint histories. The four thousand year history of glass is dominated by its range of forming processes but, crucially, until our own era, one group of processes has always been pre-eminent, usually to the exclusion of all others. It is a major feature of our era that, for the first time, all major glass processes exist at the same time. The period from 1850 to the present has seen all historical processes revived by, and for use by, individuals.

Minor variations of processes or even single techniques have been exploited to yield idiosyncratic results and it is no surprise that most successful glass practitioners have become associated with a particular, often narrow, way of making.

The technique of pate-de-verre is a particular case in point. The technique centres round the fusing of crushed glass fragments inside a supporting refractory mould to create a single, homogenous form. It was developed by a group of French artists, among them Henri Cros, Argy-Rousseau and Decorchement, in the last quarter of the 19th and first quarter of the 20th centuries. It was inspired by access to, and a study of, ancient glass artefacts, predominantly Egyptian, and made by similar methods, but the version developed by these pioneers was more specific and sophisticated than the original on which it was based. However, despite the fact that the outline process was shared, each named practitioner

developed a variant that suited their particular creative personality. The quality of a piece by Argy-Rousseau, and its difference from a piece by Dammouse is at least as much to do with their preferred method of filling and firing their moulds. This model of practice has become established in the 20th century, and varies dramatically from mainstream glass practice.

The importance of access to glass artefacts from the full historical range cannot be overstated as an influence on the development of the contemporary glass movement. Not only the fact, but also the method, of their availability has been of importance and worthy of note. The establishment of collections, publications and increasing access has meant that, for the first time, creative individuals drawn to the material have been presented with what amounts to a complete vocabulary of glass to inspire and instruct them. Instead of being chronologically separate, as they were in reality, objects made by different methods at different times are now presented for viewing simultaneously alongside each other. The added fact that these objects, often made to serve entirely different functions and within different value systems (basic, repetitive, functional vessels, next to rare symbolic artefacts) are together in a closed showcase that denies all but visual access, gives another twist to their influence.

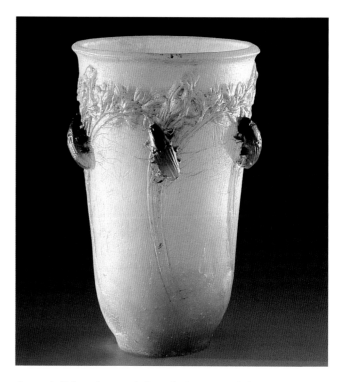

Francois Décorchemont; French; *Vase*; paté de Verre; 1912; Courtesy Museum des Arts Decoratifs, Paris; Photograph by L. Sully-Jaulmes

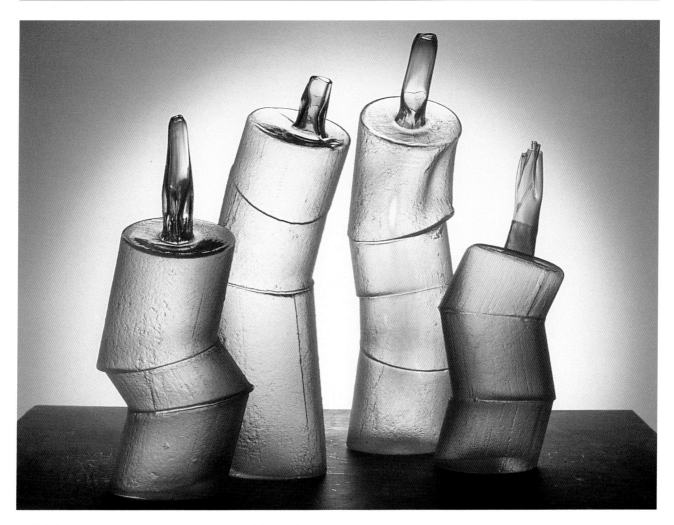

Joel Philip Myers; American; *Dialogue no. 8*; blown glass; 1997

Such presentation stresses their formal, material and technical aspects and gives further encouragement to the development of glass objects that also stress and demonstrate these same qualities. Tiffany, Gallé and Lalique were all inspired by their encounters with important historical collections. Tiffany, for instance, was so captivated by the natural iridescent erosion on ancient Persian glass that he sought to develop a controlled production version that became synonymous with his glass.

As J.L. Fairbanks says 'craft persons usually identify themselves with their medium, wood-worker, metal-smith, glass-blower'.[2] A similar situation exists within glass with practitioners identifying (and becoming) identified with a particular way of forming or decorating glass. This is also compounded by the way university courses and art schools offer materially designated courses – Ceramics, Wood, Metal, Glass. This encourages the student to make an early commitment to a particular material and thereby places that material in a prime position when questions of creative output arise.

The basic fact that the vast majority of glass artists in the 20th century have insisted on physically making their own objects, represents a profound break with the material's history, and is an extraordinary position, given the traditional lowly status of handwork within the hierarchy of Western society. As P. Hunter-Stiebel puts it 'the distance the individual could place between such activities and himself often marked the level of his rise in his community'.[3] Prior to the Industrial Revolution, craft was merely the most efficient system by which society supplied its everyday needs. The Revolution not only removed the predominant reasons for the low status of craft activities, but also effectively reversed the system itself. Prior to 1850 the need for the end product justified the lifestyle associated with it, repetitive manual labour, low pay and status. The exact reverse is true in our own era when a free choice is made to dedicate one's life to the

Keiko Mukaide; British; *Curved Glass Walls*; Installation at Hill House garden, Scotland; 2001; slumped and laminated glass; h. 160-200 cm, w. 222-280 cm; supported by Scottish Arts Council

for form. From my experience this is also the main reason why students are drawn to craft activity and the main reason why they stay with it. In such a model of practice the end product is the means by which the activity is supported, but this does not mean that the end product is less important in such a system; it does offer a more deterministic role for the material.

The choice of glass as a primary medium is only part of the equation, the choice of forming method has arguably an even more important role. Glass-blowing, the best known process, is ideally suited to a model of practice based on individual recognition. This is perhaps one reason why glass-blowing was the focus of the early experiments of individuals such as Harvey Littleton and Dominic Labino. Its performance value, where an object emerges as the result of a real-time dialogue between maker and material, is extremely attractive and seems in many ways to epitomise the designer-maker ethos. Many glassmakers, e.g. Dale Chihuly, are as well-known for their public, bravura glassmaking sessions as for the products that emerge from them. The object that results from this process carries with it the actions of its making in a direct way. However, glass-blowing, despite its high profile, is only one of a wide and disparate range of glass processes. Many of these are much less immediate and dramatic than manipulating molten glass with tools that are extensions of hands, fingers and lungs. A blown object can be made in minutes (although it takes years to acquire the skill to do this). On the other hand, a piece of kiln-cast glass can take many weeks to make using indirect proxy methods: models, moulds, kiln firings and finishing. The slow, episodic and incremental nature of kiln forming could not contrast more dramatically with the immediate nature of hot glassmaking, despite the fact that they both share a common material. Perhaps it is because it is a synthetic, capable of almost infinite variations, that its nature and shaping methods vary more, in my opinion, than any other material. The impact of its process routes on the eventual nature and visual properties of its end products is correspondingly large. Even a minor variation of, say, temperature during manufacture can affect the composition and appearance of the material.

It is tempting to say that there is no such thing as a characteristic of glass that is innate to it, so contradictory are its manifestations. We have as a society merely become accustomed to encountering it as fragile, transparent and displaying a hard, shiny surface. This is because we have chosen to utilise and exploit only a small part of its possible range. It is no more typical of glass to be opaque, hollow, solid, weak, strong, rigid or

practice of a craft from a position of privilege and education. Here it is the choice of the lifestyle that justifies and necessitates the end product. As the artist Frank Stella says 'the modern artist is self employed, occupied with the creation of their own space',[4] a view that would be shared by many contemporary craftmakers.

For them the rhythm, pace and procedures of their craft are crucial reasons for their choice, and major determining factors of their products. This was achieved by rejecting the traditional model and re-stating it as an intellectually-based search for individual expression that offered a totality of experience; a fusion of hand, heart, brain and ego into a single creatively meaningful activity. Such aims fed William Morris's socialism and Ashbee's Cotswold dream, as much as Littleton's search

Bert Frijns; Dutch; *Dish on Stone*; slumped glass, bluestone; 1990

flexible. Each society has historically defined glass according to the products it has wished to fashion from it. The pressure on contemporary craft practitioners has fuelled this search for new variants of glass through manipulation of basic composition and forming procedures. This need for each practitioner's products to display a marketable individual signature stamp has created a contemporary glass movement which uses a wider range of processes and techniques than have existed throughout its entire history.

The visual vocabulary of glass is fuller and richer as a result and with little sign of new potential avenues of enquiry drying up. The popularity of glass as a medium may well owe something to its visual range, allied to its seemingly endless store of individual process riches.

In this context the exact nature of craft manufacture needs some amplification. The importance of direct physical control over the making process seems basic craft-defined activity in our era. In glass-forming the precise nature of that control varies widely according to the process route selected. Physical control has an obvious association with the hand-driven skills of glass-blowing and hot glass manipulation. However it is harder to discern in the case of a kiln-former who shapes glass by using control that is staged intermediate, and governed more by experience and prediction than craft skills. Moulds, lost-wax techniques and firing cycles are clearly not the same as manual dexterity.

I would argue nonetheless that they share the same relationship to creativity and production, in that they all lie within the control of the same individual, and constitute a method of working in which creative decision-making is continuous rather than split between designing and making. Svetlana Alpers' description of Rembrandt's working method, 'his habit was not to work out his inventions in advance through drawings but rather to invent paintings in the course of their execution',[5] is an amazingly accurate description of the preferred method of many contemporary practitioners over three centuries later. On reflection it is not surprising as they are both using the Western model of Fine, High or Beaux Art practice that Rembrandt came to embody; one which places

Colin Rennie; British; *Primal Animal;* (*Active*); 1997

the practitioner's individual use of material at the centre of the process of invention.

In his seminal work *The Nature and Art of Workmanship*, David Pye defined two types of workmanship – risk and certainty – relative to the extent to which the maker uses hand skills (risk) or mechanical aids, jigs or machines (certainty). Both definitions presume a certainty of end product that exists prior to the making process. Such a model of practice is usually described as goal-oriented, and the process of achieving the goal as one of 'matching and making' to use Gombrich's term. Prior to our own era, the skills and knowledge of the glassmaker were dominated by matching and making. During the making process the emerging object was constantly judged by its similarity to an existing prescription of that object and adjusted accordingly. This prescription could take the form of a design drawing or a traditionally evolved object. Glassmakers, along with other craft practitioners now 'study their metier in Universities and Art schools', and among the aspirations of the graduates of these courses is to be taken seriously, and preferably on the same terms as Fine Artists.

The reasons are easy to see – the potential status and value of Fine Art objects is high, and the position of the individual and its expression are enshrined in the activity. Art status allows the maker to explore and inhabit terrain previously held exclusively by Fine Artists, and through this to escape the formal limits of a past dominated by essentially practical forms. This process began with individuals such as Maurice Marinot and was developed into a more formal movement in America in the post-war years.

Thanks to their work a tradition of contemporary glassmaking has become established, with yesterday's pioneers becoming today's elder statesmen and women.

The importance of the dialogue between maker and material was, and is, central to the development of expressive glass craftwork. Although the making, presentation, and consumption of objects defined by this means is by now a well-established aspect of contemporary culture, the system is clearly in a state of continuous transition. For example, its formal language is moving from a past dominated by function to, if present trends continue, an increasingly expressive and sculptural future.

The frequency with which echoes of, or direct quotations from, the practical history of glass occur in contemporary practice indicates a major aspect of this transition. References to redundant functional forms create a shared format between maker and public. The use of a common form, be it jug, vase or dish, allows the maker to demonstrate their creative language in the same way as a jazz musician might use a simple, universally-known tune. This use and extension of traditional formats also helps to keep a link with the history of the materials and helps to negotiate a firm base for such personal experiment. Such objects, domestic in nature and scale, have the effect of toning down the radicalism of purely individual expression.

Many glass-forming processes were invented and developed in the way they were in order to facilitate the production of practical artefacts. Glass-blowing is (literally) centred on the production of a container bubble, and forms the basis for all of the container forms made from this premise.

Much of the 20th-century glass odyssey has been dominated by the creative need to extend this traditional language and to graft on, or supplant it with, more mainstream Fine Art sculptural vocabulary with varying degrees of success.

At its worst it has been little more than a risk-free matching activity in which largely experimental objects (natural outcomes of glassmaking procedures) have been simply presented as bona fide examples of the type of sculpture they most closely resemble, with Brancusi suffering more than most. It can, perhaps, be argued that this 'search for form' to use Littleton's phrase, was a necessary part of the re-definition of glass as a medium, but it is at heart a sterile process. At its best, however, it can be a real attempt to re-interpret glass as a medium using the concepts underlying 20th-century sculpture rather than merely apeing its surface appearances.

Rick Mills; American; *Vanitas*; Blown glass, cast bronze; 78"x48"x24"; Photograph by Brad Goda

Keith Cummings; British; *Stem*; cast glass and bronze; 1998

Underlying this is a large question. How far can such a movement go, and, ultimately, can such glass objects successfully cross the binary line that still exists between the Fine and Applied Arts? Are there any signs in the short- or long-term that this has, or may happen. Despite over a hundred years of creative endeavour by talented and creative individuals the demarcation seems as strong as ever, at least in the Western hemisphere. For what it is worth, I believe that there does exist a profound and radical difference between Craft and Fine Art practice as they are at present defined. Seamus Heaney characterises a work of art as possessing a threshold which the viewer/reader is taken 'through and beyond'.[7] By contrast a craft object, especially one made from a seductive material like glass, acts more as a destination; its properties hold the viewer firmly within its spatial remit and aura. It is, of course, impossible to prove but for me explains a fundamental difference which, if accepted, accounts for and celebrates the differences between them. Studio glass production became a world-wide activity in the 1960s when the work of Littleton and Eisch, and the movement associated with them, spread into mainstream education. Since then there has been a constant escalation of control and skill in the handling of glass. This has resulted in increasingly sophisticated objects, with those of today making those produced only a few years ago seem naïve, crudely-produced and predominantly experimental in nature.

This is consistent with a model of practice that places material and process at its centre. It can also be argued that during an equivalent period mainstream Fine Art has seen a lessening of interest in the traditional skills of painting and sculpture, their formats and materials, in favour of more conceptual and cerebral modes. This has created an opening for craft objects to be taken seriously on their own terms, while allowing them to take over some of the more decorative and domestic functions of art works. This is particularly true of glass objects that are often collected and displayed in this manner.

The only confident prediction that can be made about the future is that the dramatic rate of change that has characterised the past 40 years will continue. Especially so as the same period has seen an equivalent expansion in the sheer numbers of craft makers. Hopefully, like society at large, old rigid hierarchies will erode, to be replaced by estimation based on judgements of the quality of enterprise and product rather than high or low art classifications.

If, despite this erosion of differences, Craft and Fine Art remain distinct from each other, the reason must surely reside in the practitioner. As Schwitters puts it 'if an artist spits, it's good', the medium being subservient to the artist. The studio glassmaker by choosing to work with a medium that is difficult to shape but which offers such a rich material language, operates from a basis of at least equal partnership. Combined with the lack of identifiable, useful end products, this constitutes a new way of approaching a material that already has a four thousand year history, and one that is unique to our era. During its development over the last hundred years, it has made a major contribution to the world-wide Craft movement of which it is clearly an important part. Dedicated individuals have, through their work, laid the practical and theoretical foundations of a genuine movement.

COPYRIGHT © 2002 KEITH CUMMINGS.

Dana Zamechnikova; Czech; *'without a word'*; glass; 200x500x250; 1996

NOTES

1. C.R. Ashbee, Introduction to his translation of Benvenuto Cellini's *Treatise on Goldsmithing* , 1888.
2. Johnathan L. Fairbanks, 'Crafts and American Art Museums,' *The Eloquent Object*, Tulsa, Philbrook Museum of Art, 1987.
3. Penelope Hunter-Stiebel, 'The Craft Object in Western Culture,' *The Eloquent Object*, Tulsa, Philbrook Museum of Art, 1987.
4. Frank Stella, *Working Space*, Harvard, 1986.
5. Svetlana Alpers, *Rembrandt's Enterprise*, London, 1988.
6. John Perreault, 'Notes on Crafts, on Art, on Criticism,' *The Eloquent Object*, Tulsa, Philbrook Museum of Art, 1987.
7. Seamus Heaney, *The Government of the Tongue*, London, Faber & Faber, 1986.

8 · MAJOR THEMES IN CONTEMPORARY CERAMIC ART

Ronald A. Kuchta

As a curator and art museum director for over 30 years and now as editor of an art magazine, my usual habit in confronting any art work is to place it in an historical context and to categorise the work according to its content, material, period and place of origin. It's therefore my position to consider all forms of art, including ceramics, in the same way assuming all art works can basically be described by investigating three major elements – the art work's idea or content; its form or shape; and its technique or craft.

How modern ceramics, my topic here, got placed in the crafts category and figures so prominently in the history of the Arts and Crafts Movement in the late 19th and early 20th centuries is not a subject that I intend to elucidate on now. However, the endless debate between artists and curators and critics as to defining ceramics as art or as craft seems to persist in the background of every conference or symposium I attend. And, it seems to me that the various designations of museums and galleries concerning the decorative arts, the applied arts, the crafts and design persist also at this point in time, when almost anything made by man or animal can be considered art, only serve the vested interests of those institutions and professions holding them in place. Curators of decorative arts are too often uninformed or uninterested in contemporary ceramics, and curators of contemporary art are usually disdainful of anything associated with the word 'craft' as are many but not all art galleries.

The ceramics I was interested in as an art museum director and those I'm interested in as an art magazine editor all have the same basic components for criticism and analysis as painting and sculpture – the previously mentioned elements of form, technique and content. Yet, the discussion of ceramics too often, for my interest as a non-practitioner, seems to devolve into a description of ceramics' craft – how the ceramic work was made – which admittedly, I guess, is somewhat more mysterious to the ordinary observer, since it involves more of the forces of nature in firing clay, than is the practice of applying paint to a canvas in painting for instance.

American Ceramics, the magazine of which I am Editor, was founded as a quarterly art magazine about 15 years ago in New York to present ceramics as art both through the publication's design, photography and writing. The need for art critics to address ceramics and to think about this contemporary art form critically and analytically not just descriptively, historically and technically as so many other ceramic magazines seemed to do up till then was apparent to *American Ceramics'* founding publisher, Mr. Harry Dennis in 1982. That is still the case in terms of this magazine's point of view although its perspective has enlarged, and although its name has not changed the magazine now concerns itself with ceramics internationally in keeping with the globalisation of almost everything in the information age in which we now live.

Ceramics has certainly flourished and gained in prestige in the past decade. It has been well-served by many relatively stable, specialised galleries, museums, publications, member organisations, workshops, art centres, conferences and symposia. Hardly a week goes by that I'm not invited to an opening of a ceramic artist's work by a gallery, nor does a month go by without an invitation to a symposium or conference or jury somewhere in the world. From my perspective in New York and in travels in America, Europe and Asia I have seen a great deal of impressive new ceramic art recently. Ceramic sculpture has grown in scale and adventurous sophistication. The vessel form has been explored in depth by

Claudi Casanovas; Spanish; *Circular Plate*; stoneware and mixed media; 1994

Torbjorn Kvasbo; Norwegian; *Form*; ceramic; 1999

Elena Karina; American; *Pita Urn*; ceramic form

hundreds of artists with great inventiveness and a seemingly inexhaustible variety of self-expression and technical virtuosity. And, of late, even a preciosity unparalleled in modern history.

For me the current contemporary ceramic art scene and its aesthetic production can be surveyed and described thematically in the following five basic categories of artistic intent (although with many variations and mixtures):

1 *The archaic category* – forms inspired by the past, the archaic or antique, the mythological, archaeological or historical. Many works in this category I see as 'forlorn objects', elegiac in feeling as in a mournful or melancholy poem – full of pathos or reverie.

2 *The organic category* – an organicism or biomorphism as the subject – forms inspired by a fundamental curiosity about the geological origins of the earth or of living things on this planet or in space. I also refer to this category as 'the primordial' – defined as existing in the very beginning as in biology – formed first in the course of development – original, elementary.

3 *The modern category* – Modernism connoting an interest in a formal purism, as in abstract forms, a quest for a sublime beauty through superb geometrical design and exquisite technique or Modernism in the vein of surrealism with dream-like content and aberrational or exaggerated forms juxtaposed irrationally.

4 *The pop category* – works derived and inspired by popular expression, advertising, common objects of everyday use, kitsch or ornamental ceramics whose ordinariness or garishness inspires irony – works full of idiosyncratic personal expression or social commentary.

5 *The traditional category* – ceramics of particular ethnic, national or local character, maintaining or refining a regional or national tradition, full of respect for method and a continuity of form and design. For instance: H'Sing ware in China; Shigaraki or Bizen ware in Japan; Talavera ware in Spain; Tonala ware in Mexico; Iznik ware in Turkey; Pueblo pottery in the Southwestern USA; Maiolica ware in Italy, and interpretations and variations on other folk and regional traditions too numerous to mention – including works by foreign potters or ceramists who strongly emulate the traditional techniques and forms of many of these noted regional styles and well-recognised cultural expressions.

Critically, today, I believe that the ceramic artists with the greatest imaginative power, who have contributed most profoundly to the medium as we start the 21st century in a Post-Modern condition, are the ceramic

Stephen de Staebler; American; *Standing Woman, Standing Man*; 1975

Steven Montgomery; American; *Engine Block*; 1995

sculptors whose work searches for meaning from the past either by suggesting a concern for the organic origins of life or by making references to memorable icons or symbols of the world's art history.

Why ceramic sculpture? Because it is made of a fundamental material, perhaps best suited to the more fundamentalist atmosphere now prevalent around the world and as an antidote to our increasingly high-tech environment.

Ceramics itself is undoubtedly the most plastic, versatile, direct and potent medium for depicting the human form in three dimensions.

The glorious Koran (in a reference to clay similar to that in the venerable Bible) reports God as proclaiming to Mohammed (Chapter 26), 'verily we created man of potter's clay of black mud altered (27) and the Jinn (spirit) did we create the aforetime of essential fire (28) and (remember) when the Lord said unto the angels: Lo! I am creating a mortal out of potter's clay of black mud altered.'

Clay is the most natural, realistic and poignant medium for presenting ideas or images of the earth itself. It is in fact its essential material, at least on its surface. The earth, the origin and source of life, is a subject for art of greater significance today perhaps as we view the earth more objectively as a limited resource, one that we desperately need to sustain for living organisms in general and for human beings in particular.

Many current events reflect artists' intuitional motives in art. For instance, clues to the origins of life have recently been found in the depths of the Pacific Ocean in a strange microbe that belongs to an ancient kingdom of organisms known as Archea, living in an extreme environment such as a hot spring or deep sea vent of an underwater volcano. Another example recently showed stronger evidence than ever before of past microbial life on Mars when fossilised organisms were discovered in a meteorite by scientists. Molecules found in this rock, which left Mars some 15 million years ago, show fossil traces of past biological activity.

Takako Araki; Japanese; *Bible of the Degeneration*; 1980

Carmen Dionyse; Belgian; *Euridike*; 1991

Therefore, I see the most seriously engaging, imaginative artists (ceramic sculptors) at this point in time – characterised as a relatively reactionary age except for science – gripped with an interest in either the distant origins of life or in the past in references to historical symbols or forms or cultures. On the one hand I see artists such as Yo Akiyama and Ayumi Shigematsu (of Japan), Claudi Casanovas (of Spain), Gary Erickson and Elena Karina (of the USA), Torbjorn Kvasbo (of Norway), Chen Cheng-Hsun (of Taiwan) as exemplifying an interest in primordial, bimorphic, geologic or organic visions of life, and on the other hand artists such as Stephen De Staebler and Steven Montgomery (USA), Jean-Pierre Larocque (Canada), Takako Araki (Japan), Carmen Dionyse (Belgium), Maria Kucznska (Poland), Laszlo Fekete (Hungary) and George Jeanclos (France) as manifesting a kind of elegiac expressionism, an interest in ruinated objects, reliquary figures, the ancient or archaic detritus of civilisation, containing a pathos for what is lost.

Questing for meaning, their art relates to a reflective, meditative time rather than to a very adventurous or futuristic one. These artists, obsessed with echoes of the past in one form or another, may also relate to the plethora of literature of late declaring the end of everything as reflected in these recent book titles: *The End of Science, The End of Sovereignty, The Death of Economics, The End of Nature, The End of History and the Last Man, The End of Education, The End of Work, The End of Bureaucracy, The End of Marriage, The End of Post Modernism* – just a few of the books published in the final decade of the 20th century, envisioning endings rather than beginnings, terminations rather than visions of the future. And, so it

seems, it is the focus for much in art today, at least from artists over 40 years of age. Does the past explain the present? Does our attention to the past mean that we are more comfortable now and that we do not fear the past, as we may fear the future? Is our current interest in the past of the world comparable to the interest of the Renaissance in the arts of Greece and Rome or the late 19th century's eclecticism and historical revivals? The virtual rage for disaster films in the cinematic arts may also indicate a general universal foreboding as we begin the 21st century. Clear ideas about the future appear scarce except for those of technocrats and marketers of software and computers! The two most popular movies of the past decade have been undoubtedly – the nostalgic disaster film, *Titanic*, and the primordially obsessive, *Jurassic Park*. In fact, could we have reached a certain lull for the moment in the progress of humans as we finished the 20th century?

In an article in the *New York Times* entitled, 'The Future Came Faster in the Old Days', Robert C. Post,

Laszlo Fekeke; Hungarian; *Time Machine*; ceramic; 23½"x19"; 1996; Courtesy Garth Clark Gallery

President of the Society for the History of Technology is quoted as saying:

> Swift as the pace of modern innovation may seem to those in its midst, the present rate of technological change pales compared to the period from the late 1850s to 1903 – the steel making process, the light bulb, the phonograph, the telephone, the radio, the automobile, rapid transit, subways, the diesel engine, mechanical refrigeration and the airplane. The late 19th century was the greatest period of technological change in terms of things that affected huge numbers of peoples' lives in basic ways – much more so than today.

As for the heightened contemporary interest in the archaeological past I've noted how all the major known archaeological sites in Mexico and Greece are inundated by tourists constantly. And the *National Geographic Magazine*, always up to date with current archaeological discoveries and scientific breakthroughs, printed two

Maria Kucznska; Polish; *Column*; 1992

Graham Marks; American; *Untitled*; 1992

articles in a recent edition which to me were indicative of some ceramic artists' current concerns and sources of subject matter. One, called 'The Most Ancient Americans' discussed the recent discovery of a site called Monte Verde in Chile that sets back the date for the first human habitation in the Americas from 12,000 years ago to possibly 33,000 years ago by virtue of radio-carbon testing of materials found there.

And as for artists' inspiration and interest in the even more distant origins of life on earth, the other article in the same issue of the magazine, richly accompanied by vivid colour photographs, was called 'Parasites – looking for a free lunch'. In it a growing number of scientists were reported as seeing parasites as subtle organisms, complex creatures, admirable in their own way and much more powerful than anyone ever imagined. Parasites, it was reported, have profoundly shaped life for billions of years determining many of the traits we see in plants and animals which evolved in response to their presence. They may have given the zebra its stripes, shaped the behaviour of animals, from crickets to horses, and even changed human genes.

Unlike the early 20th century which had its futuris-tic and revolutionary visions in cubism, futurism, abstraction, surrealism and a machine age aesthetic for instance, present art concerns itself more with inherited forms, nostalgia, melancholy, ruination, pathos and a sense of the remoteness of things formerly valued, medi-tations on forgotten fragmentary markings of a life or of a place. There seems to be a preoccupation with the beauty of fragility, impermanence, or apocalypse in art in general and in ceramics in particular and appropriately often a romance with the shard or the fragment – in essence I observe a profoundly elegiac art in the works I so admire of Stephen De Staebler, Takako Araki, Jean-Pierre Larocque, Steven Montgomery, Carmen Dionyse, Laszlo Fekete, George Jeanclos and others.

And then with yet another large number of clay artists of a somewhat different perspective there exists a curiosity about where and how life began in the very dis-tant past on earth. It is to these admired artists I would ascribe an interest in the primordial – such as the artists aforementioned, Yō Akiyama, Claudi Casanovas, Chen Cheng-Hsun, Gary Erickson, Torbjorn Kvasbo and Elena

Karina and Ayumi Shigematsu – representative of artists on at least three different continents.

Finally, I believe that the best ceramic artists of our day grasp these significant themes of the elegiac and the primordial and express them in a multitude of profound forms and individualistic expressions. Ceramics in its malleability, textural possibilities and array of glaze dimensions is the quintessential medium for expressing both the old, the fragile, the ruinated and fragmented, man-made or of nature. It is also eminently suitable for manifesting sensuous forms which suggest the origins of life, as clay is indeed the skin of the earth and slip or glaze covering surfaces (often with colour) best suggests living organisms of ancient or even extraterrestrial origins. The very down to earth yet inherently mysterious woodfiring process experiencing a revival of sorts in so many places today far from the origins of the anagama kiln in Japan, is indicative I think of the prevalent fascination and desire of ceramic artists to be in closer touch with the essential forces of nature - in this case consciously collaborating with fire.

As we start this new millennium it appears to me that the most creative clay artists among us are searching either the past in history or in nature for inspiration and answers to our present condition on this time-obsessed planet – some striving to remind us of what we have lost and may still remember and yet others suggesting the beauty of revealing visions, with great tactility, of the sources of life and secrets of nature.

COPYRIGHT © 2002 RONALD KUCHTA.

9 • SITE-SPECIFIC METALWORK: AN ARCHITECTURAL DIALOGUE

Albert Paley

IN this chapter my goal is to focus on the role of the architectural arena in the re-definition of the traditional applied arts disciplines, more specifically, with metal as an architectural element bringing focus and accent to architectural space in functional and site-specific works.

Architectural ornamentation, which embraced the majority of traditional craft disciplines during the 19th century, was all but eliminated with the advent of Modernism after 1900. It was within Post-Modern philosophy that architectural theory and practice revisited the role of ornamentation as an integral element in the vernacular of architectural expression, its prior lineage and continuum broken only by the Modernist doctrine. The dialogue in the Post-Modern and Deconstructivist movements in redefining ornamentation and decorative sculpture is a reassertion of concerns, attitudes and theories that existed at the end of the 19th century. Rather than these historical precedents being too far removed to be relevant to our current discussion, they are in fact the linkage of the art and architecture continuum. In contemporary expression there are aspects of theory and application that can only be understood and thus put into context by the re-examination of these severed relationships. However, problems reside in this reassessment due to the fact that the vocabulary which defined and explained the Fine and Applied Arts has lost most of its original shared meaning and reference. Therefore, instead of getting mired in the tedium of semantics in re-definition, my aim is to focus on the contemporary application of architectural elements made manifest through the medium of metal, specifically related to personal expression in the plastic arts now regarded as an art form within the architectural context. Historical precedence, although imprecise, will be referenced as a point of linkage to an object continuum rather than to a style or philosophical construct.

The categorisation and distinctions of the Fine and Applied Arts were precise and formalised endeavours in the 19th century. Intellectual, social, political and aesthetic institutions of the era provided the underpinning that supported and perpetuated a hierarchical system of artistic activities since the Renaissance. The guild system, with its division of labour, education and social application established the criteria for all of the arts. In Fine Art, pure sculpture was defined as distinct and separate from architectural or decorative sculpture. In addition, there were subdivisions within the field of metalworking disciplines. Rather than disparate, unrelated endeavours they were unified under architecture. Architecture afforded context. It expressed the idealism, morality and formal structure of organised society. This shared vision of unity and stabilised order was international in application yet competitive in national interpretation. The international art expositions of the era bore witness to this dynamic interchange. This all changed with Loos' declaration that ornamentation was a crime, tying the moral dimension to the reductivist theory. This was not solely a sytlistic realignment in the visual arts but a moral and political restructuring of perception attempting to re-order society within a rational, intellectual construct. Due to the fact that the main function of ornament is to solicit emotion through the senses, the visual richness and anti-rational dimension of architectural ornamentation was an impediment to the Modernist process. The application of ornamentation, and symbolism via ornament, found its swan song in the symbolic Art Deco skyscrapers of the 1920s. The integration of visual richness, design pattern and ornamentation was not to be seen again on that scale or application.

Albert Paley; American; *Portal Gates*; Smithsonian Institution; forged and fabricated steel, brass and copper; 1974

As Modernism became more established, embracing mechanisation and the machine aesthetic, the traditional crafts, primarily founded in disciplined manual skills, were eliminated either by the inability to transform the skills and ethics of craftsmanship into the new aesthetic or the inability financially to compete with machine efficiency. The guild system's division of labour that had perpetuated the traditional crafts within architecture became irrelevant and was removed from the context of the architectural arena.

Concurrent with Modernism, as is the nature in all movements, there are co-existing, reactionary and counter-movements. The socialistic philosophies of John Ruskin and William Morris led ultimately to the formation of the Arts and Crafts Movement. They advocated a return to a mediaeval guild structure. At the same time, there were other nationalistic movements that attempted to define a national profile via traditional folk art imagery. These movements felt that the humanistic dimension of the hand-made object was significant and afforded traditional crafts an arena of expression and activity outside the architectural realm thus sustaining

the intimacy of personal expression through a dialogue of maker and material. Having been disengaged from architecture, the traditional craft disciplines, which resided in the Arts and Crafts Movement, evolved into the studio arts movement. The Arts and Crafts Movement, as well, became the foundation for Art Nouveau, the first truly international style. Art Nouveau attempted to unify all the creative endeavours stylistically, thus breaking down the separation between disciplines and application. Artist, architect and artisan could now work in unison to create integrated harmonious environments. Interestingly enough, it was a movement based in the visual sensuality of form and materials embraced within an emotional context. Art Nouveau was the counterbalance to the then developing machine aesthetic of Modernism. It was significant to the decorative arts in several ways. It eliminated historicism. It embraced commercialism and elevated the crafts. The form context of Art Nouveau embraced symbolism, expressionism and the cult of the avant-garde. Although this era was short-lived it energised and transformed the studio art movement. Its momentum kept many skills, disciplines and attitudes of craftsmanship alive. The individual practitioners of this lineage made their way into academia or existed in isolated studio activities. Through this period, while disengaged from architecture, they became object-oriented.

The poetic dimension of the arts associated with the hand-made object can be viewed as one of the strands of humanism that re-occurs and is made manifest at various periods in the culture. The flourishing of the arts in the 1920s after the First World War, as well as after the Second World War, was in part a reaction against the destructive consequences of the war years. The personal intimacy of the craft object reflected a poetic and human dimension to these periods of artistic resurgence. As a result, the post-war youth culture of the 1960s, which championed creativity and self-expression, utilised the arts as a means and a process of redefining society. Artistic expression (which had hibernated in the studio environment) and academia were now finding expression and public context. This was expressed in tile, mosaics, stained-glass windows, interior and exterior applications and throughout the fabric of architecture. This was the period of re-engagement symbolised by the slow reintegration of professional art disciplines into the architectural arena. In academia, universities had developed art programmes integrating theory and practice, skilled not just in material understanding and technique, but in the philosophy of aesthetics founded in

Albert Paley; American; *Stairway Sculptures*; Wortham Center, Houston, Texas; forged and fabricated steel; polychrome; 1987

creativity and self-expression. The Bauhaus philosophy of art education internationally influenced the majority of these programmes thus engaging the individual with the skills and disciplines of making, coupled with the skills of artistic self-expression and perception. This educational process encouraged individuals to function not as isolated practitioners within a studio but rather to work in team situations unified by a central vision. These teams of individuals, although united in a new

vision of the future, had a similarity of reference to the studio movement of Morris and Ruskin. However, in this era the momentum was to engage the architectural process and to become a participant in the manifestation of the personal expression and aesthetic goals within the architectural arena. This direction was a reaction to the anonymity of mass production, which was the malaise of the period. The Bauhaus' educational restructuring in part was aimed at combating the disillusionment and

alienation of the urban psyche through the art experience. University programmes aligning art and architecture by teaching them as inter-related disciplines had the effect of redefining the professions and the objects produced. The design of a gate could be developed by the industrial designer, artist, architect or craftsman. These professional crossovers thereby changed the dominance or exclusivity of object development. Another important element in this distinction in the late 1960s and early 1970s was the structure of government funding for the arts, as well as the desire of many corporations to be reflected within a cultural dimension. Therefore, with governmental and corporate funding, coupled with the professionalism of the art and architecture community there was a willingness of urban planning boards to engage in creative solutions in the reconfiguration of urban spaces. It was within this confluence and vitality that the arts and architecture reconfigured an integration that had not been seen since the Art Deco period.

The dialogue of large-scale and site-specific projects within present day architectural practice is the result of numerous factors and conditions. Some of these are in reference to 19th century predecessors while others are specific to this era. To discuss contemporary issues relating to architectural practice and theory today it is not quite so simple to make reference to historical application to show a linkage in the continuum and thus project such a relationship into the future. The reason for this is that the social, political, technological and aesthetic revolution which occurred at the end of the 19th century interrupted and reconfigured the historical progression. The social fabric had changed, the practitioners and means of developing the works changed, the architectural relevance for the works changed and the intellectual understanding, significance and perception of these works changed as well. Therefore, to speak of these activities in the present tense can be misleading and misunderstood. One must realise in the understanding and evaluation of these practices in the contemporary context, what, for instance, was considered craftsmanship in the 19th century. It is now completely different. The aspect of creativity, design sensibility, use of material, appropriateness and functioning within a cultural context has changed. The practice and professions within the arts have evolved

Albert Paley; American; *Synergy*; Museum Towers, Philadelphia, Pa.; forged and fabricated steel, polychrome; 1987

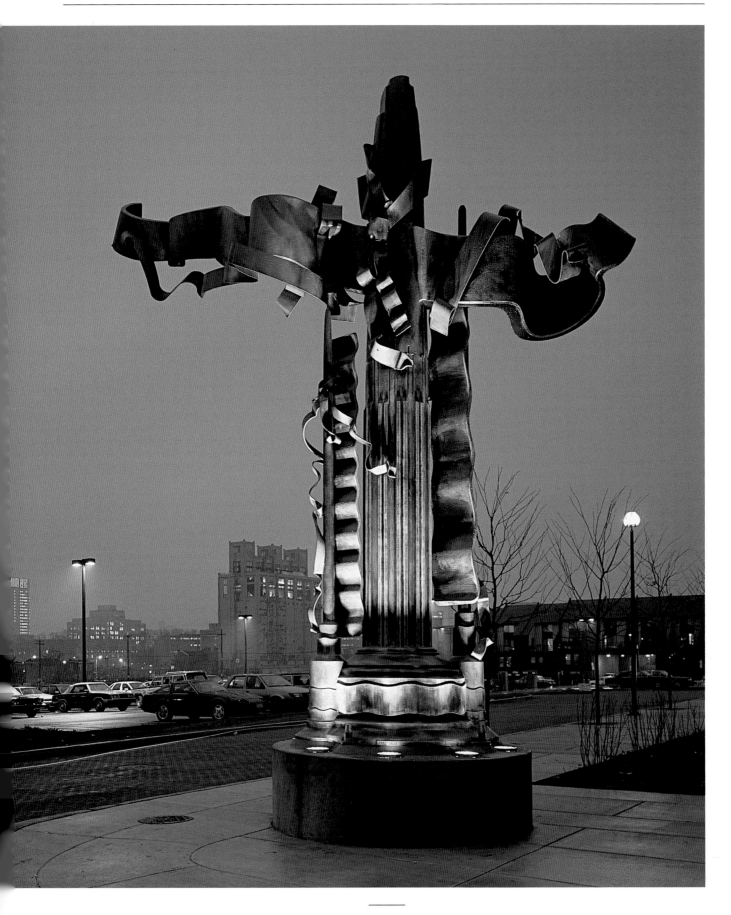

into a new structure of activities and inter-relationships over the past hundred years. These new configurations show little relationship to the previous endeavours.

Prior to the 20th century, architecture was considered the 'Mother of the Arts' and was at the top of a hierarchy. The architect developed structure, dimensions, organised space and controlled process. When the Bauhaus became established, with its philosophic imperative for integration of all disciplines, the original architectural hierarchy was restructured. Another contributor to this restructuring through the influence of the Bauhaus was the creation of the field of Industrial Design. Problem solving and form development became the foundation of a separate profession. The appropriateness of form in reference to material, structure and application, once defined by the guild system, was now centred in a totally new profession that embraced the challenge of machine technology and in turn interfaced with architectural practice. The Bauhaus philosophy was influential and formed the foundation for programme development in the universities, trade schools and design centres. Art, architecture, design and crafts were no longer taught in an isolated manner but shared mutual concerns and issues in the development of perception and understanding of form via the various professions. A specific activity was no longer defined exclusively by a given profession. The architect could give form to a chair as could the industrial designer or craftsman. Their perceptions, based upon material usage and techniques, formal problems of functionalism and personal expression through the process of determination, could be exercised independently or through collaboration. Whether a chair is hand crafted in wood, bronze, mechanically stamped out of aluminium on a hydraulic press or made in some other way, the fact remains that the realm of chair development, which used to reside within the decorative arts criteria alone, is now an interconnected and shared discipline.

At this point, stereotyping an object coming out of a specific tradition is fallacious and has little bearing on the final result of a work in reference to cultural expression. Traditionally, the craftsman as a furniture maker, for example, would cut the tree, cure the wood, hand form the elements, design and execute, mix the varnishes and finish the piece. The new reconfiguration of form development now defines the division of labour, commercialism, mass marketing and the democratisation of information. Activities of a given genre have become inter-related, responding to contemporary sensibilities and issues. The plywood used by the designer, craftsman,

architect or artist is an anonymous, industrially-developed material that conforms to the desires and perceptions of the individuals who use it. Another difference is that the majority of practitioners in the traditional craft fields are now highly mechanised as are other professionals, utilising the same industrial services through subcontractors and supply houses, and interfacing with teams of various professions to develop an object pursuant to their specific vision or inclination. This crossover of professions and integration of professional disciplines has now existed for several decades. However, the perpetuation and persistence of stereotyping continues. These perceptions, whether romantic, holistic, idealistic or humanistic, have little or no relevance in the determination of a specific work. They do, however, distort the cultural significance of a work. It seems relevant to state that an object is the manifestation of a culture. Within this context it brings into focus various contemporary issues, disciplines and concerns. These aspects are significant predeterminants to the realisation of a work, but in fact, few of these deal with the art of making. Making of the work is the by-product or result of cultural issues concerning value and significance.

I would now like to bring into focus some of the dimensions in the process of making an object and describe various forces that allow a work to exist. This will reference the interconnectedness of the various groups that come into play in the overall scheme. An entrance gate might be a good example. If a gate is for a significant architectural project it is designated by the architect as an architectural element and must be appropriate and integrated into the entire architectural concept. The significance of the gate may be deemed important to the client for its symbolic presence, thus functioning as a major statement of a cultural dimension related to the project. The client, being a corporation, developer, university or museum, may desire the entrance gate in order to enhance and define the profile of the complex. To afford the best possible solution for the design of such a work, they draw on the expertise of individuals from various fields that could engage in such an effort, which usually results in a limited or open competition. This competition may seek expertise from many fields including the architect, designer, artist, artisan, computer programmer or independent design teams. This selection process includes individuals to be considered (sometimes in the hundreds) coupled with review boards, cultural agencies and art consultants. Foundation representatives who evaluate and recommend the selection of individuals are sometimes included thereby bringing an institutional

Albert Paley; American; *Portal Gates*; Naples Museum of Art, Florida; formed and fabricated steel, stainless; 2000; Photograph by Carl J. Thorne

Albert Paley; American; *Rotunda Gates*; San Francisco Civic Court House; formed and fabricated stainless steel; 1997

architectural process, a facilitator of the project, working closely with the architect, would also take part. In addition, consultants for the contractor would be included. Despite this, one would hope that the aesthetics would be the driving force for such a selection process, but as you can see, the predominance of such a commission is based on a wide range of concerns from a diverse group with only a small percentage trained in aesthetic evaluation and education. Within the last decade issues of political correctness, social biases, gender and race considerations, environmental impact, regional representation and appropriateness of image related to site have also become part of the equation.

To compete in this process an individual or team must be able to deal with a multiplicity of issues. It is necessary to have the skills to be able to engage within the architectural process and develop a scope of services, detailed budget information, structural analysis and interface systems for shipping and installation. Also included would be legal issues and contract development, liability issues, insurance matters, concerns for handling the work, time lines and related scheduling issues. The individual or team must be able to communicate with the various professions associated with the venture. The exchange of information and schedule monitoring is important. The selection process of large architectural projects usually takes several months to several years. The finalists develop and present their concept to the committee, usually in the form of drawings, blueprints and/or models. The process of selecting a finalist is a dynamic one. Committees are quite sensitive to and even fearful of public response. Therefore an open forum is sometimes developed whereby work being considered is offered to the community for its opinion in order to solicit response and build consensus. This dimension of the politicising of the selection process has been the result of projects that have been funded, developed and installed, only to be followed by negative public controversy thus resulting in the removal of the work. Therefore, the designer or design team, in addition to competing in the competition process, must also engage in an educational process of consensus building via the community. This educational process, which can be lengthy, may include presenting lectures, articles or displays prior to and/or throughout the presentation of the proposed work. Putting these complexities aside, fundamentally the final forms of a commissioned work are the result of the design process. The design approach defines the parameters of the problems and needs specific to the project. These issues are resolved in conjunction with a building or landscape plan.

dimension into the process. The evaluation of individuals or groups of individuals who will ultimately receive the commission for the work is evaluated by a project review board. Even though the object, in this case a gate, is dealing with aesthetics and appropriateness to site, there is a wide diversity of individuals on the committee who influence the process. The standard composition of a project review board could be an architect, urban planner, representative for the client (a Board or Trustee member), president or corporate head with an associated financial advisor or consultant. Due to the fact that large-scale projects receive some part of their funding through public money, governmental representation is often present, either in the form of a council member or government representative. These projects are usually defined as cultural projects thus engaging professionals from the art community such as museum directors, appointed art review members or art critics. If the project has structural implications on the building complex and thus interacts in the

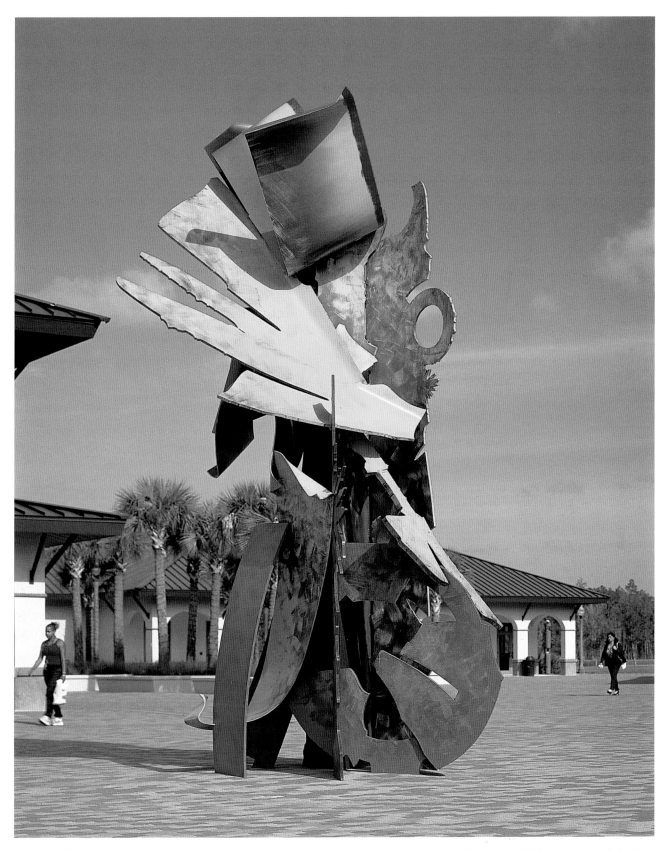

Albert Paley; American; *Cross Currents*; Florida Gulf Coast University, Fort Myers, FL; formed and fabricated steel; 2001; Photograph by Carl J. Thorne

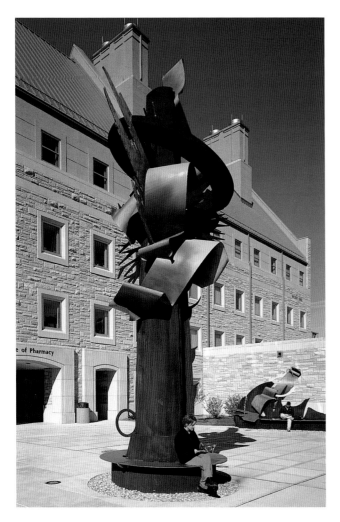

Albert Paley; American; *Symbion*; University of Toledo, Toledo, Ohio; formed and fabricated, stainless steel, polychrome; 1998; Photograph by David Lamb

The visualisation of form is presented in the final proposal. The initial conceptual stage is usually in concert with the architect because of the shared concern of how a large-scale work will impact upon the architectural relationships of space. The artwork has the ability to bring focus and accent to that space thereby visually amplifying spatial relationships. In a site-specific setting this focus might afford an identity to the space: function as a transitional element to unify an architectural progression; and/or engage pedestrians in a more intimate relationship with the architectural experience. If the work is to exist within a landscape plan it might function as a visual sentinel to strengthen sight lines; articulate major architectural axes; add contour and balance; or act as a foil to integrate or inter-relate the building with its setting. In a dialogue with architecture it is important that the object interacts with and affects

space. Artwork, through its symbolic content, has the ability to enhance the ambience or the identity of a space. Therefore, if one were creating a work for a sports complex the approach would be markedly different than designing for a contemplative, religious setting. A major strength of an artwork lies in its ability to convey symbolic content either implied or perceived. Contemporary art, although not as literal as that of the 19th century, does define identity of place and manifest cultural concerns.

Scale plays an important role in the dialogue with architectural space. A larger-scale work, site-specifically designed, must draw its proportional relationships from the architecture. In addition, it must address the pedestrian reality. The pedestrian or human scale is engaged by accenting elements or details that are observed only upon close proximity, therefore, as one approaches and experiences the artwork, details of the form are revealed. These experiences, primarily visual and tactile, have the ability to humanise the architectural experience. In addition to defining proportion, the architectural context gives reference to profile, silhouette, complexity of composition and light and shade articulation.

Large-scale metalwork engages a broad spectrum of technical applications. This area of diverse expertise focusing on the development of an artwork can be quite extensive. The ability to develop large-scale work resides in utilisation of materials and technologies appropriate to structure and form development as well as the organisational skills for exchange of information with other professionals. In order to bring a design concept into physical realisation there are two basic approaches. One is to control the means of production via a self-contained workshop or studio that includes tools and equipment and the necessary skilled labour. The other approach is to subcontract various services through commercial or industrial job shops. At times, the studio environment and the industrial environment might appear the same, having the same type of tools, equipment and facility. The difference resides primarily in the perspective and attitude in approaching the work. This does not involve issues of technique but of attitude, drawing from a different sensibility.

When the decision is made to utilise subcontractors, the artist/designer becomes a co-ordinator and facilitator of services such as ordering and shipping of materials, forming processes, assemblage and finishing processes culminating with the installation of the work. The artist/designer must have knowledge of these sub-

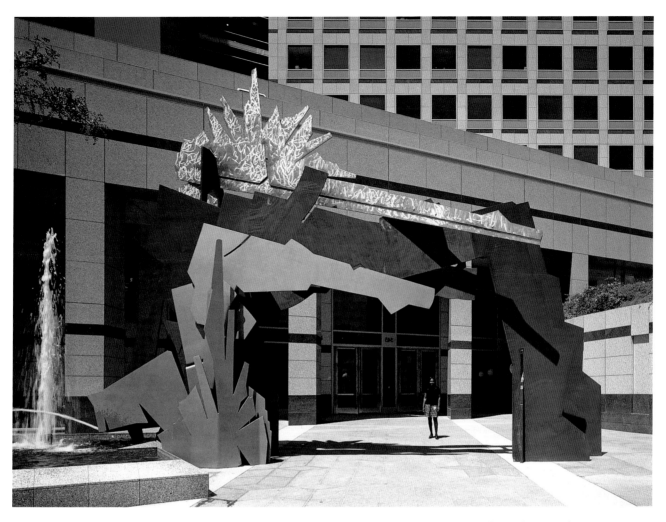

Albert Paley; American; *Horizon*; Adobe Systems Inc., San Jose, CA; formed and fabricated stainless steel; 1998; Photograph by Winston Swift Boyer

contracted professions in order to create a seamless integration of the working process. The means of communication in such a process relies on working drawings and scope of service documents. Due to the fact that various processes are carried out by different firms, the supervisory aspect is usually the responsibility of the designer.

Whether the work is developed in a studio environment or through industrial application, the legal responsibilities related to art in public places are specified by code requirements to insure the well-being of public safety. The work must be certified by a structural engineering firm as well as having various inspections so that the artwork conforms to necessary code requirements.

The documentation process is a significant part of any project. This archival information provides an educational dimension to the work. Publication and publicity whether through photographs, computer disks or video are a necessary component and professional discipline that must accompany the creation of a work. Also, within the information age, copyrighting of a design or image is a security aspect in safeguarding the uniqueness of a work to ensure that an object is not compromised or diminished by reproductions or alterations to the original concept.

The above information outlines the fundamental process of bringing site-specific works into realisation. With each project, however, a different set of variables come into play. I would like to go into depth on three of the illustrated projects. The first project was the result of a government commission for gates for the Renwick Gallery of the Smithsonian Institution in Washington DC. As part of the restoration of the museum a limited competition was developed for entrance gates into a gallery area. Designated as an art project the gates fulfilled two criteria. First, they would add symbolic

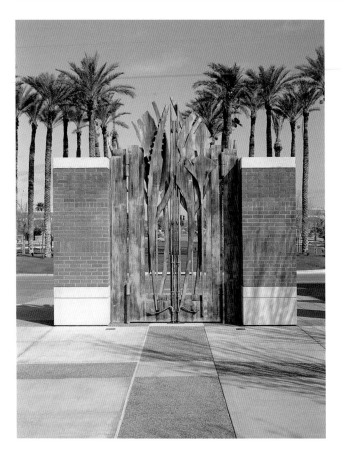

Albert Paley; American; *Ceremonial Gate*; Arizona State University, Phoenix; formed and fabricated steel, polychrome; 1991

dimension to the museum in reference to the design and craft collection, and second, they would fulfil functional security requirements. The design concern was to relate a contemporary design sensibility within a historic building of cultural significance. Complexity of design, attention to detail and refinement of form were aligned to the sensibilities of the architectural space and the museum's identity. The design construct was meant to integrate ornamentation and structural concerns into one unified composition. The individual design elements were structurally triangulated for rigidity. The integration of bronze and copper with the forged iron elements added contrast and emphasis to the composition. All of the mechanical details such as hinges, locks and handles were integral to the design. The gates, intimate in scale, were sensitive to human proportion and interaction. They employed a high level of craftsmanship in their execution. Although a contemporary design, the means of form development was based on the forged aesthetic. The gate was made through the traditional hand skills of forged metal within a studio environment. The execu-

tion of these gates took two people a year to complete.

The second project was a commission for the Wortham Center for Performing Arts in Houston, Texas. It consisted of eight sentinel sculptures flanking a grand staircase in the atrium area of the opera house. The sculptures were designed to bring focus and accent to the main axis of the building and to emphasise the grand staircase and the pedestrian act of passage. The polychromed sculptures afford a visual and emotional counterbalance within the expansive, austere geometric interior. They are meant to provide an exuberant and celebratory ambience to this public arena. The progressional nature of the sculptures, in both scale and colour articulation, aligns with the symbolic act of passage. In addition to the sculptures, exterior and interior bronze door handles created a unified design concept throughout the complex. This project was executed in a studio environment employing eight skilled craftsmen. The duration of the project was three years, with eight months in the design phase, fifteen months in the approval and legal contractual phase and thirteen months for the fabrication and finishing. The individual sculptures integrated hand-formed elements, industrially-contoured plate and modified industrial materials. These welded structures were industrially sandblasted then returned to the studio where the polychromed finish was applied by hand. Shipping, rigging and final installation was subcontracted and supervised by the studio. The prototypes for ornamental bronze handles were forged and fabricated steel, developed in the studio. Moulds were made and cast in bronze at an art foundry. (See p.95.)

The third project, entitled *Genesee Passage*, was a commission from the Bausch and Lomb Corporation in Rochester, New York. This commission was the result of a limited competition. The sculpture was developed as a major element in a newly-constructed corporate headquarters. Seventy-five feet in height, this visual urban sentinel makes reference to the landscape plan and aligns with the main axis of the building. The sculpture defines an elliptical urban plaza that interacts with the concave facade of the complex. The symmetry and dynamism of the sculpture's composition is in visual contrast to the rational nature of the building. Due to the monumental scale of the sculpture, the logistics and co-ordination became quite difficult. Individual component parts were developed in the studio environment then shipped to an industrial complex that could accommodate the height and weight of the sculpture. Structural engineering was a necessary component due to the weight and the wind loads on the structure. Individual geometric elements

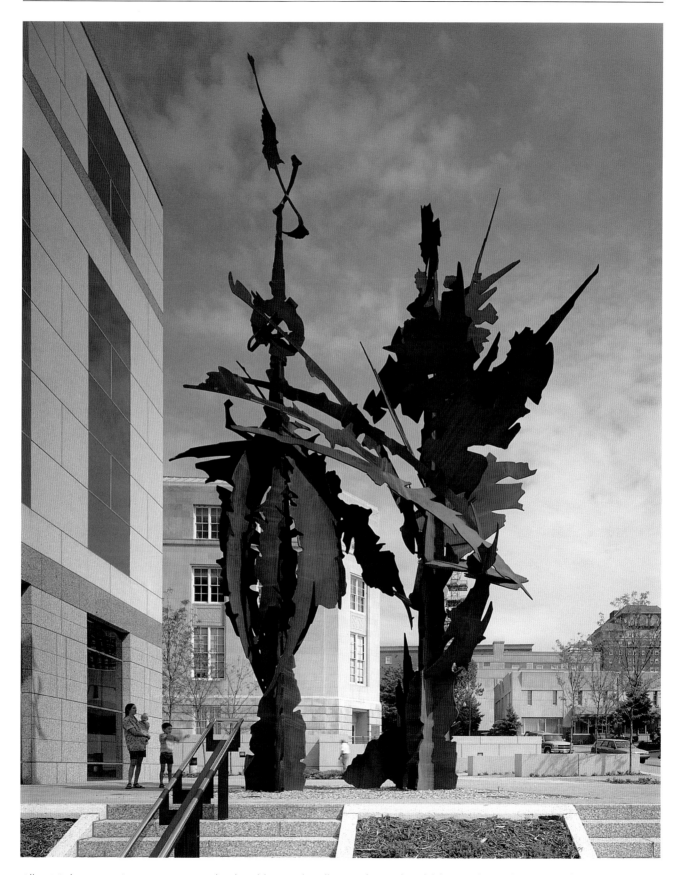

Albert Paley; American; *Passage*; Federal Building, Asheville, NC; formed and fabricated weathering steel; 1995

were predetermined and industrially cut and formed by subcontractors to be assembled by craftsmen. The larger curvilinear banner forms were created by heating and bending by hand processes. In addition to fitting, adjusting and welding the component parts the final detailing, even at this scale, was accomplished by skilled craftsmen. Due to logistics and scale, the piece was assembled horizontally and cranes were used to rotate the work periodically for accessibility. Upon completion of fabrication the sculpture was sandblasted to develop a uniform finish. Because of air pollution standards a temporary enclosed structure was built to house the piece and contain contaminants during this process. A one-hundred-foot truck was used for transportation. Traffic permits were needed to stop traffic, close roads, and provide police escort. Bridges and on/off ramps had to be structurally evaluated prior to moving to ensure weight capacities. The final placement of the sculpture, although on street level, was over an underground parking garage. Therefore, the road surface could not accommodate the weight of the sculpture and the crane during installation. A specialised 250 ton crane had to be ordered to work in conjunction with two other cranes to position and set the sculpture.

The nature of these projects shows the dynamism of the arts within architecture. Site-specific art projects are now vehicles for diverse, cultural expressions functioning in a symbolic context that was unrelated to their historic predecessors. I feel that unique, monumental works will have greater significance in the future than in the past several decades. The social relevance of the creative process experienced through an artwork expresses an aspect of the human dimension that other forums do not. The sole aspect of being unique becomes amplified due to the overwhelming environment of commercialism, uniformity and mass production. The more scientific and rational a society becomes the greater the need for a humanistic counterbalance. Whether this resides in an area of aesthetics or spirituality, it is a fundamental need to be acknowledged, experienced and shared.

COPYRIGHT © 2002 ALBERT PALEY.

10 · STUDIO JEWELLERY: MAPPING THE ABSENT BODY

Linda Sandino

RECENT critical debates and visual practices have focused on the body as a subject/object for exploring a range of preoccupations in contemporary culture. Jewellery, typically seen as an accessory to fashion and a victim of taste, is as much a part of the visual rhetoric of the meanings of the body, as the more overt manifestations in Fine Arts and popular culture. In her seminal book *Natural Symbols*,[1] the anthropologist Mary Douglas suggested that 'the social body constrains the way the physical body is perceived'. Jewellery is a cultural symbol that stands for the private body as well as the social one, its personal links even more profoundly intimate than clothing, while its symbolism extends into the drama of public display.

While many jewellers acknowledge the body as referent, the 'implied' body is revealing of attitudes to the corporeal, begging the question, 'whose (or which) body' is invoked by this particular form of adornment? Jewellery as ornament proliferates as one of the many signals in everyday life but its production and consumption is complex – from factory to studio, from 'chain' store to gallery. Consequently, the work of certain jewellers can be read as engaging with definitions and critiques of the body which reinvigorates the possibility of the applied arts as a critical practice, rather than merely a supplementary, decorative one. In the context of the issues discussed here, one can cite, for example, the cultural shifts in attitudes to gender which can be detected in contemporary work. This chapter, therefore, will explore how studio jewellers have engaged with the body/bodies, extending our understanding of the role of ornament in its relation to the body.

Two regimes of signification are held in place by studio jewellery – gender and 'craft'. For jewellers, especially those who are women, the body and space

function as specific contexts, but how they are used has altered within the last two decades. Different conceptions of what constitutes the 'body' within Modernism, are now challenged by jewellers for whom decoration and the body do not carry ambivalent, negative connotations. Notwithstanding these shifts, the issues remain as Peter Wollen has stated them:

> The problem in the end ... is to how to find ways to disentangle and deconstruct the cascade of antinomies that constituted the identity of modernism: functional/decorative, useful/wasteful, natural/artificial, machine/body, masculine/feminine.[2]

British-based Swiss jeweller, Christoph Zellweger's recent work has explored the relationship of jewellery with medical technologies, such as implants. He sees the link between the beauty and skilled precision of such objects and their role in enhancing the body, with jewellery as cosmetic 'surgery'.[3] *Body Piece IE4* (1997) simulates the valves and arteries of a new world medicine, an image reinforced by the use of artificial materials – expanded polystyrene and nylon tubing. The photographic image of *Commodity Chain E66* (1997) (see p.108), seems to present a microscopic view of valiant white cells multiplying ad infinitum, organic reproduction and commodification hand in hand, the inescapable capitalist and 'natural' cycle. The implied referent here is the abstracted medical body of scientific objectification. These works also mark an externalisation of the inner body, of that abjection which has formerly been hidden in the applied arts; the secret body which has finally emerged.

One of the striking facts about the 'radical' crafts of the 1980s was their insistence on being taken for art, which was evident in jewellery by references to early

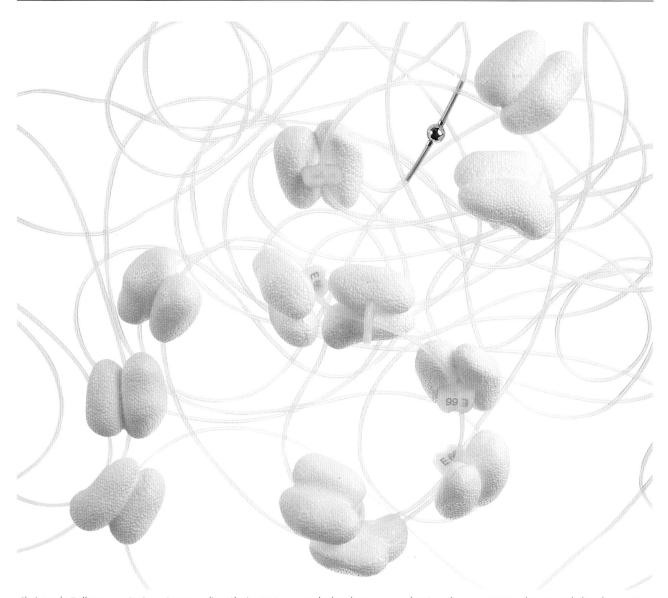

Christoph Zellweger; Swiss; *Commodity Chain E66*; expanded polystyrene, plastic, silicone; 1997; Photograph by the Artist

20th century Modernism, wherein attitudes to female corporeality were fundamentally controlling and repressive, or at least veiled. Moreover, the Western Enlightenment privileging of the mind created an ideology of an idealised body that shuns corporeal realities such as dirt and sex. In Britain, David Watkins' work perfectly exemplifies the purist machine aesthetic, overturning the notion of jewellery as frivolous and gaudy display, the work of laborious craftsmanship. The paradox identified by Le Corbusier that 'modern decorative art is not decorated' is finally resolved, nevertheless raising (the inversion of) another contradiction – 'making decorative art out of tools'.[4]

However, Modernism's impact surfaced in a variety of ways and one can detect national differences. Dutch jewellers, especially the work of Gijs Bakker and Emmy van Leersum of the 1970s such as *Clothing Suggestions*, and Bakker's later *Invisible Jewellery* (1973), offered witty and perceptive explorations of gendered boundaries and body markings.[5]

> Libidinal intensifications of bodily parts are surface effects ... These effects, however, are not simply superficial, for they generate an interior, underlying depth, an individuality of consciousness.[6]

Jewellery is one of the primary 'surface effects', acting as a visual signifier which, nevertheless is not solely for visual consumption but, is as Australian philosopher Elizabeth Grosz points out in her comment above,

evidence of an interior subjectivity. Hans Stofer's *Comfort for boys: Comfort for Girls* (1998) is specific and egalitarian in its gendered references. It wittily expresses Freud's theory that the mother's breast is 'the child's first erotic object' and 'the prototype of all later love-relations – for both sexes',[7] making explicit jewellery as fetish, as erotic fixation and its link to the 'private' body.

It is the declaration by Adolf Loos that 'All art is erotic',[8] from his (in)famous essay on ornament, that makes the paradigmatic case for decoration as the decadent expression of women and primitives. The significance of this turn of events is crucial to understanding studio jewellery in the second half of the 20th century since it forms the conceptual and formalist background within which, and against which, work was and is still, mostly conceived. Furthermore, jewellery dominates as evidence of conspicuous consumption and display, marking it out as an almost 'pure' bourgeois commodity, in the process commodifying the wearer, traditionally the woman, already an object of visual commodification.

In the late 1970s, reaching its most dramatic heights in the early 1980s, jewellery became the focus of critical

Hans Stofer; Swiss; *Comfort for boys: Comfort for girls*; steel (white), stainless steel and rubber; 1997

exploration and analysis. Self-fulfilment and anti-establishment economic values played an important part in supporting work with the aim of rethinking the world of objects.[9] The symbolic function of materials and skills provided an ideal arena for social critique, for the assault was on several fronts: the commodified female body, the cult of the unique precious 'bourgeois bibelot' and its intensive detailed craftsmanship, the confined de-intellectualised space traditionally inhabited by the decorative arts.

In the early 1980s two exhibitions were held in London that presented the 'new' jewellery to the public, *Jewellery Redefined* (1982) and *The Jewellery Project* (1983), both bitterly attacked by the critic Peter Fuller.[10] His diatribe focused principally on the materials used (cinema tickets, paper, plastic), and the lack of skills displayed. 'It lacks intricacy, workmanship, sense of beauty or mystery, celebration of nature, or affirmation of tradition.'

Tellingly, he concludes, 'indeed, it is not really jewellery at all'. As well as being outraged by the language used to describe the work and its avant-gardist aims, it was its 'dissolving into dance, or clothes design' or '... arid proclamations about bodily functions and structures', which he found especially offensive and inappropriate.' Nevertheless, it is significant that the work was evidence of the two strategies to which the 'Redefiners' (my term) resorted – non-traditional materials, the ready-made, the multiple, and, a colonising of new spaces, on and around the body.

Hal Foster has proposed that the turn to the techniques of dada and constructivism within late 20th century art, which are present in the recourse to the readymade and its subversive intents,' offered two historical alternatives to the modernist model',[11] platonic ideal forms were not the only ideal paradigms available.

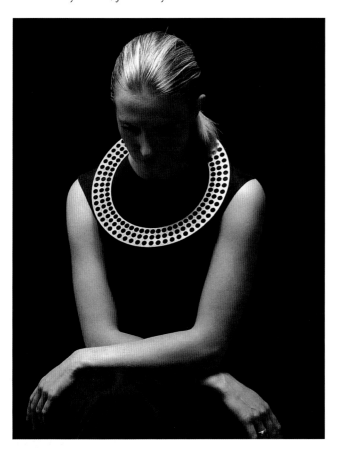

David Watkins; British; *Torus 280 (B1)*; 1989; gilded brass; Photograph by the Artist

That the debate at the time focused on methods and materials also reveals the stranglehold of a distinguishing craft ideology, as well as the grip of the Modernist paradigm of avant-gardism and self-criticism. In Clement Greenberg's famous phrase,

> Each art had to determine, through the preoccupations peculiar to itself, the effects peculiar and exclusive to itself.[12]

In the applied arts, the 'effect' was in the 'craft' of materials. Despite references to punk and fashion[13] their impact on the work in Britain was/is formalist rather than social or political, the embracing of popular culture and kitsch, tentative despite some forays into 'funky' accessible pieces. Insofar as it acted as a critique for the 'redefiners', it engaged with the reformist, democratic ideals of international avant-gardism.

It was in the 'implied' body, however, that the problem of essentialism seemed endemic. Whereas in textiles women artists articulated various arguments[14] about femininity, domesticity and the crafts, these debates seem to be absent from any discussion of the 'redefiners' despite their increasing use of textiles. In a review of the work of her peers, Susanna Heron traced the influential exhibitions which had, in her opinion, defined (or redefined) jewellery. All the exhibitions were specific to jewellery. No mention was made of any overtly feminist art exhibition such as the seminal Hayward annual of 1978. The repression of any feminist agenda is significant. Whereas 'women's art' was to explore the visceral and abject body, the crafts-as-art clung to the Modernist cleanliness of that which stays outside the body – clothing, jewellery.

The psychic implications can best be explained by the concept of disavowal, which 'inscribes a form of self-articulation', wherein 'something is affirmed in the same gesture that it is denied'.[15] Elizabeth Bronfen continues,

> ... a tension is created between conscious and unconscious: for the unconscious negation does not exist. There is an ambivalent relationship between a subject and a given desire ... [the] subject is placed in a dilemma of choice between mutually exclusive desires.[16]

Consequently, disavowal becomes the symptomatic mark of this work with the body and with decoration because of their negative connotations within Modernism. 'Unisex', the denial of gender difference,

also serves as a resolution for this dilemma, in which the body is taken as a generic form.

Photography has played an instrumental representational role in circulating meanings. Much of the photography by which studio jewellery was disseminated to the public, has not included bodies but celebrates the formal, abstract qualities of the pieces reinforcing their value as sculpture-in-miniature. However, David Ward's images allowed for a return of the repressed body but its feminine characteristics were suppressed . In a strange inversion of the body/mannequin opposition, it is in fact a photograph by David Cripps of a tufty necklace by Caroline Broadhead worn around a naked mannequin's waist, that alludes more directly to the fetishist, woman-centred aspect of jewellery. However, the role of a body was crucial for Ward. In his introduction to the Knapp collection he stated that the human body was the

> fundamental key to the scale and size of the works ... objects tend to be conceived in relation to the body and not separately from it.[17]

The abstraction evident in the images is part of the displacement which enabled the work to be presented as body ornament without drawing attention to the traditional offering up of a woman's body to public, voyeuristic consumption. In addition, drawing on precedents from the early part of the 20th century, such as the theatre workshop at the Bauhaus or the designs of the Russian avant-garde, the work was firmly placed within the Modernist tradition.

Rather than succumbing to the customary forms and sites of jewellery, the new work expanded the literal space to be occupied. Thus, performance and dance began to emerge as influential contexts. As Janet Wolff has observed, however, dance colludes in the preservation of the classical body, emphasising in its commitment to line, weightlessness, lift, and extension, and ethereal presence rather than real corporeality. In addition, the strict limits on body size and shape for girls and women dancers reinforce a denial of the female body. ...[18]

The redefinition of jewellery as clothing, as 'wearable', was a significant way for women artist/jewellers of negotiating the representation of women's bodies. Tellingly, Caroline Broadhead has explored shadows in recent work, another tracing of an insubstantial body. The silhouette, like the dress forms she uses, consists of a bodice, a skirt and short sleeves which echo the armless torsos of female classical ideals such as the Venus de

Milo; while the skirt is that gendered signifier which hides the site of sexual difference.

The shift from jewellery to clothing marks a radical investment in the 'real' body, the drive to explore the representability of a female body, subject to scrutiny but, here presented, metonymically. Although the clothing may be worn, it stands as an index and a trace, its links still not to a specific body but a generalised feminity that is not essentialised, nevertheless presenting a 'zero image' of the feminine.

Much has been made of the return to decoration within the late 20th-century aesthetic, a situation which has benefitted the applied arts. A feature of the crafts is their secure footing in a neo-conservatism of tradition and bourgeois values. One of the difficulties for contemporary applied artists is the problem of managing these features rather than being bound by them without necessarily abandoning a radical social and aesthetic agenda. Despite the compromise with the market, the applied arts can testify to a 'conceptual investment'[19] traditionally reserved for the Fine Arts. Stereotypical definitions of the feminine body, and its subjugation, need to be continually addressed in order to emancipate it; 'unisex' was one solution, but one that disavowed rather than embraced gender diversity and ambiguity, both psychic and physical.

The practice of making jewellery 'proper', but as objects which act as more than the common denominator of their genre or their function, is significant and continues. This work acknowledges its marking of a specific body which does not repudiate auto-eroticism, or sexuality. Its status as fetish is even celebrated. For women jewellers this has created a situation where the body can be liberated as a site for the control of looking and meaning, although the repertoire of images could be said to be limited to those already in place – traditional versions of the feminine implicated in a reductionist narcissism.

Lesley Waddell, a recent graduate and student of Caroline Broadhead's, abandons the structural oppositions of a dominant Modernism, and her work presents a 'real', ornamented body that draws on its history of fascination, control and mostly feminine representation, although gender ambiguity is also present. The pieces are only legible when seen 'locked' on to a specific body part. The relationship is not supplementary; it is integrally a part of the body which needs to maintain rigid control, or is controlled, by the piece. The references are not just to the negative aspects of body control but to the positive sides of body contortion which in *Foot Brace* (1998) is the yoga position necessary to hold it in place . It also alludes

Caroline Broadhead; British; *22 in 1*; cotton, nylon; 1984; Photograph by David Ward

to the ways in which initial suffering (for the sake of beauty) becomes less severe over time. 'Women must reclaim beauty, somehow, as something that is their choice and their judgement.'[20] The intricacy and delicacy associated with lace, its essentialist feminine character, is here celebrated but at the same time subverted by the use of severe, sharp metal exquisitely worked into decorative torture. Ornament as 'crime' is the injury to different ideas about beauty, and how one can use decoration to open up the closed, hegemonic definitions of what is acceptable as a beautiful 'ideal' body.

If disavowal marks out the Modernist jeweller's work, irony, which is also a reconciliation of incompatible beliefs is, in many ways, an ideal trope for the applied artist. Significantly, irony acknowledges and signals its control of the medium. As Donna Harraway has remarked,

> Irony is ... about the tension of holding incompatible things together because both or all are necessary and true.[21]

One of the problems for the feminine in the context of Modernism, including its 'Post-', has been the reconciling of political [egalitarian] rights and, at the same time, 'its commitment to "difference" and diversity'.[22] How that difference and diversity can be both represented and presented in the public sphere becomes, therefore,

as much a question for studio jewellers now as at any other time. Freud's discovery of the unconscious revealed the breaks in a unified subjectivity, hence the 'masquerade' of gender and the manipulation of signs becomes a crucial component in the drama of public life and the presentation of self.[23] Jewellery therefore acts as much more than simply a prop but as a sign of a particular form of knowledge but one which cannot be presumed to be common to all. Nevertheless, popular culture provides readymade forms which artists can employ to deconstruct, or make explicit, or play with, dominant cultural norms.[24]

Mah Rana's work focuses on and expresses a subjectivity that also draws on feminine experience but is grounded within the familiar aesthetic territory of the readymade and the found object, but transformed into 'jewels' that condense, rather than abstract, aspects of (feminine, though not necessarily always) experience. The use of a familiar pop lyric as a title, *I never promised*

Mah Rana; British; *In Love Again*; fabricated gold and found chair; 1998; Photograph by Gary MacNamara

you a rose garden (1996) acts as the 'mass-produced' *objet trouvé*. The work could be accused of essentialising women's experience but that would be to miss the way in which this work functions theoretically by quoting from and exposing the 'readymade' discourse of lovers.

The irony in the work is not merely in the titles but in the materials. Mah Rana's use of second-hand wedding rings is extremely significant, the material itself is resonant of that binding idealistic union which, nevertheless, historically, has positioned women as both subject and object. It alludes to the commodification of the bride and her subservience, while at the same time it evokes the romance and commitment of the marriage vows. This 'circle' of allusions is then transformed and 'staged', a still-life that refers directly to lives lived and experienced. The *mise en scène* of *Have You Ever Dreamt That Your Teeth Had Fallen Out?* (1998) underlines the domestic context with its use of patterned wallpaper, hairbrush and table. Like the toothless comb, the other objects in this 'room' also act as potent signifiers. The wallpaper is a neat, diffident but generic pattern, ahistorical, not 'fashionable' – a 'zero image' room – as is the table. They both act as contextual props to the pairing of the brush and comb with their particular evocations – phallic, sexual, and the anxieties of attraction, vanity and ageing. The very fullness of the bristles of the brush and the absence of 'teeth'/power in the comb, are brought into a different dialectic by the gold of the comb, which glistens and stands for the values of the wedding ring of which it is made.

In Love Again, also combines the use of a 'mass-produced' ready-made symbol, the heart, set within a domestic tableau which speaks of absent bodies like the use of wedding rings. The heart can be worn (one of its curves resting on the neck), but its first life as a wedding band, brings to the fore all the conflicting emotions and facts of 'being in love'. The use of a chair as the 'pedestal', itself a sign of the body and support, on the back of which the work hangs, is a visual reference to the thrown-off clothes of lovers where the 'necklace' acts as an index of the dressed body. The 'found', unexceptional old piece of furniture, like the material of the heart, is given new life and retrieved from abandonment, and neglect.

Presenting the circular drama of love and loss, is one of the aspects of subjective experience which Mah Rana's work explores, and which has particular implications if the work is read as 'feminine'. If one looks at male artists working in this field, the jewellery evokes another set of connotations with interesting implications in the debate concerning gender, experience and the mapping of the

Gerd Rothmann; German; *From Him to Her*; gold; 1991;
Photograph by the Artist

Gerd Rothmann; German; *Father and Two Sons*; silver; 1996;
Photograph by the Artist

body. If, for women jewellers, the body is inscribed via the strategies of abstraction, both aesthetic and narrative, the inscription adopted by the Swiss artist Hans Stofer, working in London, is immediate and unambiguous.

Inscriptions mark the surface of the body, dividing it into zones of intensified or de-intensified sensation, spreading a libidinal concentrattion unevenly over the written-and-erotic living surface.[25]

If You Can't Wear It, Eat It: Jewellery is a Matter of Taste (1998) is an entirely found, ready-made but organic piece: a tomato. To wear the piece, one must place the tomato close to the heart, where it can be squashed and consumed. The body, either male or female, becomes erotically inscribed by the burst fruit, red, the colour of passion and danger. Furthermore, the conventional associations of jewellery with financial investment value is completely undermined. *Passion* (1998) continues the theme of erotic possession and fetishism. Combining the allusion to a scene of passionate intensity with the button and torn silk tied to the ring, reinvesting the ring form with all the intensity that the conventional engagement ring absolutely lacks. Although this is not the place to argue the gendered shortfalls of Freud's theory of fetishism which described the 'perversion' as exclusively male, Stofer's work reintroduces a fetishised, libidinous relationship to the corporeal that celebrates the intimacy of desire and attraction. Just as the fetishist focuses on the

object, at the expense of the 'real', so these works speak of the emotion, rather than the representation and reference to a specific body. It is the relationship to the beloved's body, necessarily fetishistic if that body is 'absent', that is invoked in these pieces.

From Him to Her (1991) by the German jeweller and goldsmith, Gerd Rothmann, is a gold cast of a male wrist to be worn by the woman for whom it was made: the gift of his body to her, his wrist to encircle hers. The Australian literary theorist John Frow, discusses the gift economy and its concomitant idea of 'personhood', vital for interpreting the gift as 'disinterested':

> The post-Romantic opposition of the organic, free, disinterested, self-fulfilling work of art to the mechnical, inorganic and interested product of mass – or industrial – culture can be and often is recast in terms of an opposition of an aesthetic of the gift to an aesthetic of the commodity – where the concept of the 'gift' is equated with the authenticity and generosity that are thought to constitute the central core of the person.[26]

Symbolised in the gold wedding band, the giving of jewels by men to women has been a direct reference to an obligation, historically to 'love, honour and obey', as well as 'belong'. Here, however, Rothmann conveys the complex-

113

ity of the modern gift economy by the signified (exchange) value of gold, at the same time as the symbolic value of lovers' gifts which are, as in Stofer's work, fetishistic. They are archetypical examples of the ways in which artwork can, in fact, move in and out of the commodity system. If the art can be seen as embodying 'the exemplary form of the gift', Rothmann's skin and body casts invest a double value of 'personhood'/gift into these works. The random little children's thumbprints linked in with their father's presented in the necklace *Father and Two Sons* (1996), like all the skin-casts, offer a signature of the unique, authentic, original subject as embodied in their skin/body which, as Frow points out in his analysis of the Western definitions of 'person', is that 'inalienable possession' which should not be commodified .

Working in Munich, the Swiss artist, Otto Künzli, has also explored the intimate binding of desire in his *Ring For Two* (1980) which tellingly is presented worn by a couple whose dress bespeaks of their balanced democratic union; both are wearing denim, their gender differentiated by her skirt and his trousers (although in one cropping of the image, gender is not foregrounded). The piece is made of steel, a material that stands as a

Otto Künzli; Swiss; *Centifolia*; wallpaper on hard foam; 1983; Photograph by the Artist

metaphor of strength, and unbending commitment and of great power. Wearing the ring(s) can be extremely painful if the wearers are not completely in harmony; if one turns, the other experiences great pain. If one falls, the other too is devastated.

Künzli's work has also involved specific individuals, making the wearer explicit in representations of his work but not as ciphers of an abstract body, as prop for the work. *The Beauty Gallery* (1984) presents six portraits of women wearing heavy picture frames as necklaces which Künzli has compared to symbolic laurel wreaths. The artist and writer Laurie Palmer has pointed to the ambiguity of the images, how the necklace/frame both celebrates and traps the beauties.[27] The attention and sensitivity to gender is also considered in relation to the experience of men, who have also been the subject of a photographic series. *Centifolia* (1983) portrays a friend of Künzli's rose-patterned wallpaper, that signifier of traditional domestic decoration; the flower itself, of course, a constant in the repertoire of jewellery motifs. The work in itself is not gender-specific but just as Ward's images circulated a context for British work, so these images present a notion of jewellery as expressive, personal and experiential; the brooch sits awkwardly but intentionally and with humour worn by a real individual. The ironic double-coding here, however, is specifically gendered ('man wears jewellery'), as well as genre specific ('a wallpaper box brooch').

Otto Künzli; Swiss; *The Beauty Gallery*; wood; 1984; Photograph by the Artist

Another series, the Pendulum pieces, hang down pointing to the groin, expanding the gender-specific context. A Latin quotation, discovered in a novel, encapsulated for Künzli the meaning of these works: *Narnque non dominae tuae ipsae obtulist mentulae coronas,* ('It is not your lady, but your genitals you wreathed in garlands'). One of these consists of a golden ball (*Il Tempo Passa*), marking, as the wearer walks, the passage and measurement of time, but inevitably, visually, the delicate, significant area of male masculinity and virility. Literally translated pendulum means 'a free-hanging body', underlining, linguistically, the greater social freedom traditionally enjoyed by men, unlike the 'celebrated and trapped' beauties.

Künzli's work displays both the conceptual and expressive investment which is the mark of great work – art and craft. Essentially, it is jewellery's physical engagement that gives it a significance which underlines the 'notion that the postmodern sensibility involves a shift of emphasis from epistemology to ontology, ... to be understood as a deprivileging shift from knowledge to experience ..., from mind to body ...'.[28] Gerd Rothmann rarely makes brooches since they are pinned onto clothing unlike rings, bracelets and necklaces which are worn next to the skin. He also feels that when a person wears the piece he has made for them constantly, his work has succeeded in that 'it belongs to the person like a pair of glasses'.[29]

In Italy, Bruno Martinazzi's work drew on the universality of a classical heritage to comment on the human condition, rather than specifying a diverse gendered experience. His *Eye* (1971) is also a comment on the privileging of the visual over the tactile in Western culture. Despite the increasing return to an 'embodied experience', the importance of images and their consumption,

Gijs Bakker; Dutch; *Holysport, Praha der Star;* silver, computer manipulated photograph, plexiglass; 1998; Photograph by Rien Bazen

their representation of 'ideals', is still a central cultural dominant. Gijs Bakker's *Holysport* series (1998) draws out the 'new mythology' in which '... the worn-out relic of the church [blends] in with the mass adoration of the sports hero. Christ's loincloth finds its match in the sweaty shirt of our new Redeemer.'[30]

Bakker's use of images and photographic techniques draws on a form of reproduction that stands in connotative contrast to Rothmann's casts, another form of reproduction, and to Zellweger's moulded, electroformed, multiple 'cells'. Notwithstanding their differences, the mechanical and the handmade, they reveal the extent of the conceptual complexity of studio jewellery, and its relation to the gendered body, as image, as object, and as 'made'. It is, of course, principally women who have had to negotiate the social and ideological territory of the decorative and this has had significant consequences for the work of women artist/jewellers discussed above. However, in studio jewellery generally, pieces can be created which contain the 'conceptual investment' that is the mark of a 'decorative' art applied to objects that are changed with intricate symbolic values. As Mary Douglas suggested in her other key text *Purity and Danger*, 'The more personal and intimate the source of ritual symbolism, the more telling its message'.[31]

Bruno Martinazzi; Italian; *Eye brooch;* white and yellow metal; *c.*1971; Collection the Worshipful Company of Goldsmiths

Copyright © 2002 Linda Sandino.

NOTES

[1] Mary Douglas, *Purity and Danger: as Analysis of Concepts of Pollution and Taboo*, London, Routledge & Kegan Paul, 1966; *Natural Symbols*, New York, Vintage, 1973.

[2] *Raiding the Icebox*, p.29.

[3] See Christoph Zellweger (catalogue), Sheffield, 1999.

[4] *Le Corbusier The Decorative Art of Today* (1925), trans. J.I. Dunnett, London, Architectural Association, 1987.

[5] See Caroline Broadhead, *The New Tradition: the Evolution of Jewllery 1966–1985*, London, British Crafts Centre, 1985.

[6] Elizabeth Grosz, *Space, Time and Perversion: Essays on the Politics of Bodies*, London, Routledge, 1995, p.34.

[7] Quoted in M. Yalom, *A History of the Breast*, London, Pandora, 1988, p.150.

[8] Adolf Loos, 'Ornament and crime' (1908).

[9] See A. Bruce & P. Filmer, *Working in the Crafts*, London, Crafts Council, 1983 and C. Ashwin, A. Channon, J. Darracott, *Education for Crafts*, London, Crafts Council 1988.

[10] See *Crafts* No.63 July/August 1983, pp.46–7. See also David Ward's letter of reply in the same issue (p.8).

[11] H. Foster, *The Return of the Real: The Avant-Garde at the end of the Century*, Cambridge, Mass., MIT Press, 1966, p.5.

[12] *Art and Literature*, no.4, Spring 1965, p.193.

[13] See Susannah Heron in 'Jewellery Undefined' (op.cit.) and Caroline Broadhead in *New Tradition: the Evolution of Jewellery 1966–1985*, London, British Crafts Centre, 1985. See also D. Ward (op.cit.).

[14] See R. Parker, *The Subversive Stitch: Embroidery and the Making of the Feminine*, London: The Women's Press, 1996; R. Parker & G. Pollock *Old Mistresses: Women, Art and Ideology*, London, Pandora Press, 1986 (see 'Crafty Women').

[15] See *Feminism and Psychoanalysis: a Critical Dictionary* (ed) E. Wright, Oxford, Basil Blackwell, 1992, pp.70–71.

[16] Ibid.

[17] *The Jewellery Project*, London, Crafts Council, 1983, p.7.

[18] J. Wolff, *Feminine Sentences: Essays on Women & Culture*, Cambridge: Polity Press 1990; see 'Reinstating Corporeality: Feminism and Body Politics', p.136.

[19] The phrase comes from Jon Erickson, *The Fate of the Object: From Modern Object to Postmodern Sign in Performance, Art, and Poetry*, Ann Arbor, University of Michigan Press, 1995, pp.26–9. His use of the term refers to the use of the ready-made as opposed to the 'expressive labor' of expressionist art. Craft embodies both but, for the purpose of the argument here, 'conceptual investment' is foregrounded.

[20] T. Lakoff & R.L. Scherr, *Face Value – the Politics of Beauty* (1984) quoted in F. Pacteau, *The Symptom of Beauty*, London, Reaktion Books, 1994.

[21] Quoted in Naomi Schor, 'Fetishism and its Ironies' in E. Apter & W. Pietz (eds) *Fetishism as Cultural Discourse*, Ithaca, Cornell University Press, 1993, p.99.

[22] B.L. Marshall quoted in A. Brooks, *Postfeminisms: Feminism, cultural theory and cultural forms*, London, Routledge, 1997.

[23] See Joan Riviere, 'Womanliness as masquerade' (1929), in V. Burgin, J. Donald & C. Kaplan (eds), *Formations of Fantasy*, London, Methuen, 1986.

[24] J. Wolf, *Feminine Sentences* (see 'Postmodern Theory and Feminist Art Practice').

[25] Ibid.

[26] J. Frow, 'The Signature: Three Arguments About the Commodity Form' in *Aesthesia and the Economy of the Senses*, H. Grace (ed.), University of Western Sydney, Australia, 1996. Frow's expands on Lewis Hyde's seminal *The Gift: Imagination and the Erotic Life of Property*, (1983), and George Bataille's notion of '*depense*'. Frow's essay is immensely suggestive and crucial to my thoughts on jewellery as commodity and gift, to be expanded on elsewhere.

[27] L. Palmer in Otto Künzli: *Everything goes to Pieces* (cat.), Rezac Gallery, Chicago, Ill., n.d.

[28] R. Boyne, 'The Art of the Body in the Discourse of Postmodernity' in M. Featherston, M. Hepworth and B. Turner (eds), *The Body: Social Process and Cultural Theory*, London, Sage Publications, 1993.

[29] Quoted in a letter from Gerd Rothmann to the author, 8 Mar 1999.

[30] See Gijs Bakker: *holysport/shot* (cat.), text Yvonne Brentjens, Amsterdam, 1998.

[31] Mary Douglas, *Purity and Danger*, see Note 1.

11 · POOR MATERIALS IMAGINATIVELY APPLIED: NEW APPROACHES TO FURNITURE

Joellen Secondo

A RECENT walk through the galleries of the Museum of Fine Arts, Boston, put me in front of Paul Gauguin's powerful philosophical painting *D'où venon-nous? Que sommes-nous? Où allons-nous?* (Where Do We Come From? What Are We? Where Are We Going?). While Gauguin was referring to the life-cycle of humankind, to me, this inscription, which appears on the painting, seemed pertinent to the discussions on the current state of craft. In order for craft to remain relevant as a cultural practice, writers, critics, historians, and craftspeople alike exhort the need for this concept to evolve. Given the enormity of the technological revolution accompanying the last few decades, it is appropriate now to reassess what craft is, and where it is going.

Andrew J. King asserts that the multifarious definitions of the term 'craft' in general use today are inherited to some extent from the Arts and Crafts ideology that set itself in opposition to the effects of the Industrial Revolution. A new concept of 'craft' was developed as a response to what John Ruskin referred to in his essay 'On the Nature of Gothic' as the monotonous, machine-like activities of the factory worker and the dissolution of the self-direction of individuals within the organisation of labour. As such, King sees the modern term 'craft' as a political construct and not the prescription for materials and processes it is often viewed as today.[1] Much of the confusion surrounding the term today is the result of this late 19th-century formulation being erroneously imposed on craft practice of the pre-industrial era, when craft was simply the existing technology and industry, a way of making things.

Thus to look back and label pre-industrial processes

as 'craft' processes is to ignore the fact that we are using a modern term designed to describe a modern practice. These earlier processes are 'craft' only in the sense that they predate the capitalist industrial model. In fact they are simply the industrial technologies of the period, and could and did contain many features of the organisation of the workshop and of the work which also appear in industrial capitalism – and vice versa. To label them 'craft' is to romanticise them with the rose-tinted filter of a special term created in the last 150 years specifically to signify all that was not production under a regime of detail and intellectual division of labour.[2]

Just as a modern term should not be used to describe the practices of an earlier, pre-industrial era, it is wrong-headed to allow this concept of 'craft' as developed in the late 19th century to persist unchanged into our post-industrial era. Rather, we should formulate an expanded concept that encompasses the synthesis and symbiosis of craft and industry characteristic of our Post-Modern age.

Craft and industry were part of the same path until the late 19th century, when the ideology of the Arts and Crafts Movement created a fork in the road. Since then they have followed separate paths, with occasional bridges spanning the chasm. This essay will argue that this politically- and socially-motivated division is now artificially imposed on the concepts of craft and industry. Conventional thinking asserts that crafts are the result of the goals and intentions of the maker, while design (the product of industry) exists in answer to the needs and desires of the consumer. In fact, many of the incentives and realities of designers and craftspeople –

personal satisfaction, limited output, working method, interest in materials, the wish to communicate ideas with others to name just a few – are the same. I have chosen to discuss these ideas in regard to furniture-making because it is a traditional craft with a pre-industrial history and, therefore, is part of a historical continuum. In addition, it is a non-material-based craft category (unlike ceramics and glass), one that has traditionally entailed the use of a variety of tools, and as such, its classification is particularly susceptible to uncertainty.

In countries that were influenced by the Arts and Crafts Movement and adopted the ideology of the crafts established by its proponents, a craftsperson working today incorporates the role of designer (who plans structure and appearance) and artisan (who is skilled in working a particular material). In Italy, however, the pre-industrial concept of craft as a skilled trade has dominated.

'DesigningCraft' is the name of an annual competition and exhibition organised by the Chamber of Commerce of Turin, Italy. Its mission is the promotion of the economic development of the region; crafts are one of five sectors under its aegis. Italy has always relied, culturally and economically, on its image as a producer of traditional crafts as well as sophisticated design. The Piedmont is the most industrialised area of Italy, best known as home of the car industry, yet, the region of Turin alone is the site of over two thousand small artisan workshops specialising in ceramics, metalwork, woodworking and other materials. In 1997, young designers were invited to submit projects suitable for production by Piedmontese artisans. Two hundred and sixty-five makers agreed to create prototypes of the winning projects. While there are artist-craftpersons creating original works, most artisans in Italy use their skills to reproduce historical styles. The collaboration instigated by this competition was seen as a way of exposing the artisans to new ideas in order to invigorate their practice, and of giving designers the opportunity to explore a different method of manufacture.

Discussion among the international jury (on which I served) revealed a consensus regarding desirable qualities of the winning entries: symbolism or expressiveness, new typology, practicality, assistance in an existing activity or suggestion of a new activity, ecological motivations, and congruity of form and material. These were characteristics sought in objects which one used in daily life, not 'crafted objects' or 'designed objects' *per se*. Once the prototypes were made, which one of these kinds of objects would they be?

The manufacturing systems of Italy have been premised on the idea of small- and medium-sized artisan-based enterprises that can respond quickly to updating or altering their production, and the integration of craftsmanship and advanced mechanisation. Many furniture workshops specialise in small runs and making prototypes for industry. Italy does not have a tradition of studio craft, however, in the post-war period the crafts were a vehicle for expression by artists.

Italy produces more architects than are employable, so many turn to furniture and product design. In Italy's post-war period of modernisation, collaboration between freelance designers, artisans, and industry was responsible for launching the modern Italian design movement. In recent years, influential architects and designers, such as Ugo La Pietra, have rallied for the support and patronisation of artisan workshops in an effort to preserve traditional craft skills and 'modernise their products', much as was done in the 1940s and 1950s.[3]

This scheme to merge craft and industry also exists in the rest of Europe and the United States. Many young designers, (initially, mostly those who were unable to find jobs in industry) have followed the 'long route' advocated by British designer Jasper Morrison.

There are now two routes for a designer to take, a short and a long one. The short route solves a design problem set by a fixed brief provided by a manufacturer to enable him to use his existing machinery and skills to increase his sales. Although this route secures the manufacturer's immediate future, in the long run it merely fossilises his technology. Moreover, it provides the designer with little satisfaction other than cashing in his royalty cheques. The longer route occurs to the designer with foresight: he builds his own factory, not with bricks, but from the sprawling backstreets teeming with services and processes for materials both common and uncommon to his trade Design by the longer route offers an approach with an almost limitless range of materials and ways of treating them ... the new designer or (indeed) the new manufacturer, taking advantage of the multiplicity of skills available, can design and produce with a versatility that cannot be matched by a single factory.[4]

In this way Morrison produced his *Wingnut* chair, in collaboration with a manufacturer of laundry baskets.

This 'multiplicity of skills' includes craft skills. Jan Nimeiek and Michal Fronik make up the design team

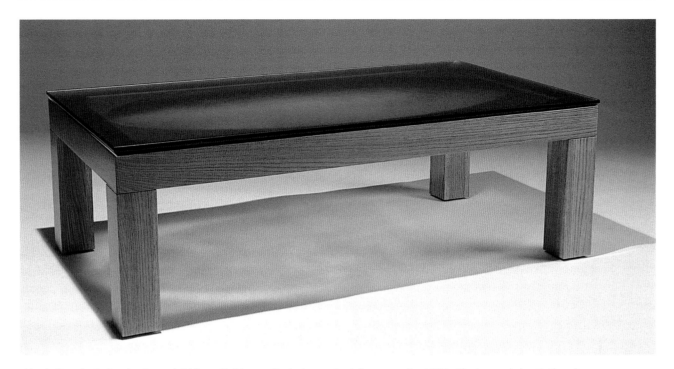

Olgoj Chorchoj; Czech; *Round Oblong Table;* melted glass, steel frame, oak, 1997; Photograph by F. Slapal

Olgoj Chorchoj based in Prague. The transformation to capitalism has prompted young Czech designers, like Nimeiek and Fronik, to find ways to help their country to compete in the world market by restoring the quality of exports to what they were between the wars. Olgoj Chorchoj designs furniture and objects and seeks out appropriate manufacturers – from artisan workshops with just a few employees to large factories, such as Skoda Plzen, which produces cars – for each project.

Nimeiek and Fronik were trained as designers at the Academy of Applied Art in Prague and are both skilled craftsmen. Their studio takes advantage of the traditionally high level of craft skills in the Czech Republic. Some of their work incorporates glass using the 'tavenice' process (melted or cold cast glass). The Czech Republic, where the technique was invented, is now one of only two countries that can still fashion glass in this manner. Nimeiek and Fronik recognise that, by utilising a uniquely Czech craft, their furniture can offer to an international market something that cannot be found elsewhere, and that they are assisting in the preservation of local craft skills.

Another mode of production, one that unites the role of designer and artisan within one person (as with the craftsperson) is that of designers who work primarily outside industry – designing, manufacturing, and marketing their own work. These individuals were formerly known as 'designer-makers', however, most with

whom I spoke prefer the designation of simply 'designer,' so this is how I shall refer to them. Unlike previous generations, they are choosing to work on their own. They attempt to balance materials, construction, aesthetic and consumer concerns, and form an alliance with the design world where systems of promotion and marketing are more extensive and, possibly, more effective. This mode of practice has produced such innovative furniture (some of which is now mass-produced) that many Italian architects are urging young designers in Italy to emulate this model. The hybrid nature of their practices has been recognised. They are often classified with a qualifier, i.e., 'a designer using craft techniques' or 'a craftsperson incorporating industrial materials'. This is the site of the grey area, the 'twilight zone'[5] where the motivations and modes of production of self-professed 'designers' can and do reveal similarities and/or equivalencies to craft practice.

Their enterprises can take various forms: working alone, or with a small team; making furniture entirely by themselves, or sub-contracting certain components for which they do not have (or want) the manufacturing capabilities. Their working methods duplicate those traditionally assigned to craftspeople. Most produce work in small batches, limited by available resources, demand, or the designer's desire to move on to new work. One-offs are also made, as commissions, a way to investigate an idea, or as exhibition pieces that display their talents.

Simon Maidment; British; *Baby Tambour Chair*; birch ply, plastic laminate; 1993

They make functional objects, and have control over production from conception to completion. There is a keen interest in materials, often chosen for their expressive, tactile and visual qualities. Traditional materials and techniques too are employed, but in original ways.

Simon Maidment, a London-based designer, devised an innovative usage of a traditional British cabinet-making technique, the tambour, which is conventionally used as a decorative screen. Maidment conceived the *Baby Tambour* chair, a piece of storage and seating furniture, while attending the Royal College of Art in London. In this chair, the positive and negative curves of the tambour relate to the human lumbar curve, and provide the unprecedented function of seating support. His rationale for its form:

> If you are going to do a piece that has a duality of function – seating and storage – then somehow you've got to communicate that. This has an archetypal, simplified chair profile and a carcass construction that becomes the storage element. The idea of a roll-top desk is something everybody knows. Any over-elaborate, over-development would make the communication that much more difficult. I wanted it to be very clear and pure in what it was saying, very uncomplicated.[6]

Discouraged by college instructors and tambour manufacturers who declared that this design – at that point, only on paper and as a card model – would never work, Maidment set the design aside. While working in the studio of Tom Dixon, he was encouraged to realise this design, and then made it himself in his workshop using simple machine tools. Although he confesses to enjoying the making process, his main goal was to actualise his ideas; the *Baby Tambour* chair was 'an exercise for me to express what I know, what I believe in, what I can do'. Maidment, by working on his own, had the freedom to pursue his vision, express what he felt would be recognisable and appealing symbols, and experiment with using an old technique in a new way. In other words, his creations are the result of his own decision to 'express himself,' an attribute usually thought to be the province of the craftsperson. The self-direction of independent designers allows for freedom and creativity, to challenge accepted ways of doing things or, as Maidment observes: 'If something hasn't been done before you get the impression that there must be a very good reason.'

Peter Dormer sums up why craftspeople make things:

> So strong is the urge to make things ... that it seems likely that making will endure in the teeth of its apparent cultural or technological irrelevance. For some people the method of exploring ideas through making is the best route to understanding those ideas or responding to a class of objects that already exist. For others there is the control provided by directing their life through their work and making a living from it.[7]

Profit is not always the motive. For some, they design because they feel compelled to design, they enjoy the process of designing the way a craftsperson enjoys the process of making. Personal satisfaction with the final product and the appreciation of others is the key. Speaking of the work he creates for exhibitions, Ross Menuez, a New York-based designer states 'You are going to publicly take down your drawers. You really want to do something that is contributing to the general family of design. It's the most satisfying and difficult work because you put so much into it.' Maidment concedes, 'I like the design process ... I wonder if I can do this, run around madly for six weeks enjoying myself, then it dawns on me, "What are you going to do with it now? Now you've had all your enjoyment, maybe it should earn you some money".' The comments of these designers echo that of American studio furniture-maker,

Ross Menuez; American; *Caramac* screen; bakelite tubing, aluminium tubing, stainless steel, 1998

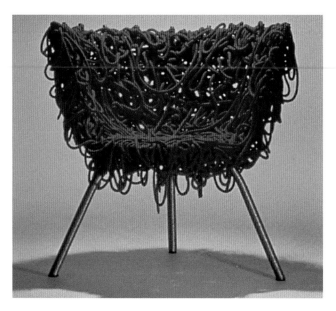

Fernando and Humberto Campana; Brazilian; *Vermelha* chair; stainless steel, cotton rope; 1993

Alphonse Mattia: 'My greatest satisfaction comes from pieces of work, from finishing pieces of work that I feel are really important to me ... I really feel like there is something bigger or better than me in the pieces I make; there's something that might last longer.'[8] Being a designer, like being a craftsperson, is a lifestyle choice, a career that permeates every aspect of one's life.

These designers have participated in the making process as a practical manner of achieving their goals, or as a way of exploration. For Menuez, making is a necessary part of working out his designs. The final colour, patterning and configuration, as well as the basic mechanics, of Caramac, a phenolic (bakelite), aluminium, and stainless steel screen by Menuez were arrived at during the making process. (see p.121). Segments of bakelite tubes, generally used in industrial applications, encase aluminium tubes. Double-ringed stainless steel gaskets encircle adjoining aluminum tubes, holding them together and allowing for free movement between each of the vertical members. The screen contains fourteen hundred of these steel hinges; they not only form a decorative stringcourse, but allow the screen to be rolled up like a carpet. Menuez states 'This screen was not what I started out to make. Its construction was just the hinge of another screen. The only thing I liked was the hinge.' Hence, the resultant piece is formed from a series of hinges. The variation in colour of the bakelite tube segments was also the result of unforeseen circumstances – they were purchased from different manufacturers, as no single manufacturer had enough stock to supply Menuez.

By baking the tubes and exposing them to sunlight, Menuez was able to darken their colour and, in the end, through considered arranging attained an effect he describes as 'that vibration you get when your eye can't focus because the values are different'.

Maidment and Menuez identify themselves as 'designers'. The descriptions of some of their goals and production methods indicate that they might not be able to escape the charge of being craftspeople, since from the outside, most of their activities are indistinguishable from those of craftspeople. It is in the self-perception and intention that differences are evident. Their goal is also to design for mass production. But even then, as Menuez states, 'you always want to be able to make your own prototypes. Be able to play around.' Are they, therefore, designers, and not craftspeople, because of this aspiration? Or are they designers because of certain constrictions that they feel come with the term 'craftperson'?

The practice of Brazilian brothers Humberto and Fernando Campana is perhaps a paradigm of this 'grey area', thoroughly merging art, design, and craft. Trained as a lawyer and an architect respectively, Humberto and Fernando set up Campana Objectos for the design and production of furniture. Although their output is now part of an international sphere, the manner in which the Campana brothers work, and the furniture they produce, utilise Brazil's cultural resources and draw on its dissonant identities. Their practice is truly Post-Modernistic in its juxtapositions of 'high' and 'low' styles, vernacular and global outlooks, and high and low technologies.

The Campanas comb the industrial areas of São Paolo for unusual materials. Once discovered, they explore the properties and potential of these materials to create forms. They began experimenting with metals, moved on to natural materials such as wicker, bamboo, and recycled paper, then – using the same repertoire of techniques – synthetic materials. Their choice of low technology and low budget materials reflects the surrounding culture, one 'based on poverty'. Within the vernacular of this culture, humble materials that are easily found and inexpensive to acquire are combined with natural materials to form objects of spiritual or social significance. According to Fernando, 'Our motto is do things within all of our limitations. We bring something new out of long-forgotten raw materials and we give them a new function. It is important to use these everyday materials without hiding their origin, but, rather, giving them new value.'[9]

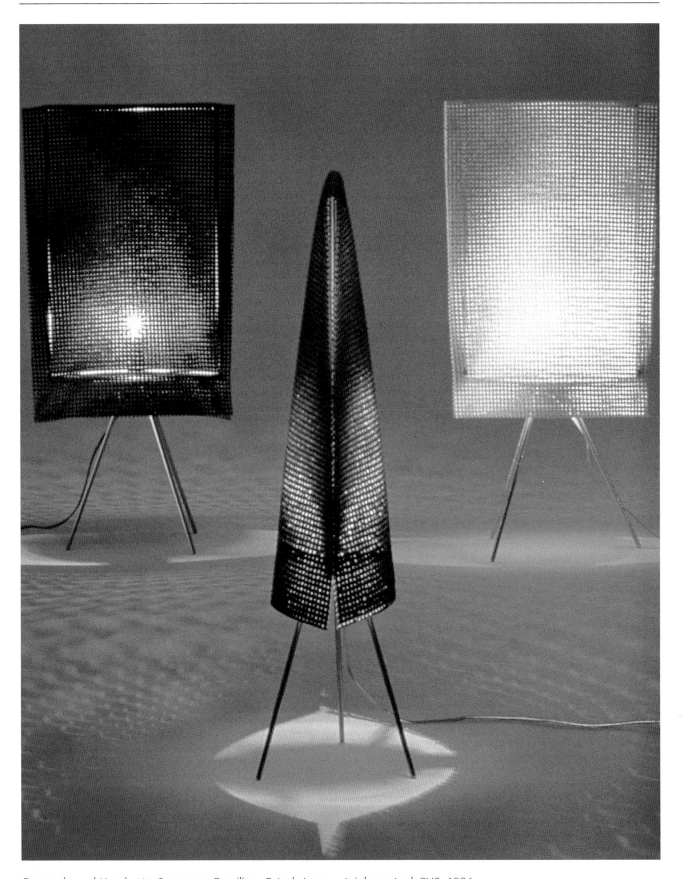

Fernando and Humberto Campana; Brazilian; *Estrela* Lamp; stainless steel, PVC; 1996

These common materials are usually combined with locally-produced industrial components, and worked using 'techniques borrowed from the world of crafts'. Aluminium rods or plastic string are treated as though they are part of the tradition of fibre crafts of Brazil. These non-traditional materials, by the foreign-ness of their surfaces and textures, invite the senses to investigate. Reminiscent of the handcraft aesthetic are the unevenness of finishes and forms and the imperfections that, either occur in the material, or as a result of the making process. 'We have also learned that it is not always possible to achieve the results you imagined. In Brazil, for example, it is not possible to make perfect objects, without flaws and irregularities. So you have to try to transform these errors into poetry'.[10] The *Estrela* lamp was originally produced by the Campanas in their studio using a Brazilian-made rubber and PVC mat intended as a non-skid backing for rugs. When the design was taken up by the Italian firm O Luce, the irregularities and texture of the Brazilian backing were admired, but could not be found elsewhere. Ironically, the raw material had to be imported from Brazil. The lamps are produced on an industrial scale in Italy, and then they are distributed to an international market.

Fernando and Humberto believe that experimentation and knowledge of materials and processes is important for designers. They do not create preliminary studies or drawings; they rely on the spontaneous discoveries that happen in the making process. *Vermelha* is a chair that incorporates a stainless steel frame and red cotton cord (see p.122). The cord is loosely woven by hand in and out of the frame until it takes shape as the body of the chair. The Campanas first made this design in small batches in their studio. The chair is now made at the Italian furniture factory of Edra Mazzei where the workers – trained by the Campanas – use the same hand-weaving techniques. Was the Vermelha chair 'craft' when it was handwoven in the Campanas' studio and made in limited numbers? Now that it is made in a factory, is it 'design'? Can craft be mass produced? This is an instance, perhaps, that exemplifies the closure of the space between craft and design.

The trend towards specialisation is characteristic of Post-Modernist design. An important concept, in opposition to Modernism, is that objects should have meaningful or referential functions and 'speak' to limited segments of the consumer population; there is no longer such a thing as a truly 'mass' audience. Previously a hallmark of craft production, industry is making smaller runs, testing the market before investing in tooling machinery for mass production. New technologies are enabling companies to market to individuals. It verges on the ironic that computer automation permits mass customisation, greater flexibility, and hence, greater variation in production. Industrial design is not always mass produced. Vitra, the Swiss furniture company, issued its Editions series in small numbers for a limited period of time. The aim of this series was 'to provide increased opportunity for experimentation in furniture design' and to 'offer designers, architects and artists more scope to create objects using new materials and technologies'.[11]

This individualisation of mass production is exemplified in the work of the New York-based designer Gaetano Pesce. For Pesce, hands-on experimentation is integral to the design process; he conceived and realised the idea of a 'diversified series' in his studio with the Pratt series of chairs. Pesce's *543 Broadway* chair for the Italian manufacturer Bernini S.p.A. could, paradoxically, be called a unique mass-produced chair. Each multi-hued epoxy resin seat and back is different; when the resin is poured into the moulds, the workers add the colour at their own discretion. In this way, individuals in a factory setting have a degree of autonomy regarding the final appearance of each piece on which they work, an important aspect of craft as defined by the Arts and Crafts Movement. The aim of Pesce and the manufacturer was to offer furniture that did not have a standardised, impersonal quality, but to give consumers a chair that was theirs, and theirs alone.

There were antecedents for this 'designing' and making' system a generation ago (e.g., Danny Lane, Ron Arad and Tom Dixon in Great Britain) by those intent on challenging the aesthetic norms and traditions for the construction and design of furniture – a more avant-garde approach. An economic recession in the early 1990s made such limited function furniture with art-market prices less appealing. These younger designers (under age 40) are pragmatic in their approach and take greater advantage of more varied and complex technologies, particularly information technology, for production and marketing. They carefully balance their desire to create something new and personal with marketability. They recognise that the two most important attributes consumers desire in any objects they purchase are uniqueness and quality.[12] Some view it is a challenge, not a compromise. By either filling a gap in the market and producing on demand – as in the case of Maidment's Baby Tambour chair or, by dividing their time between creative work

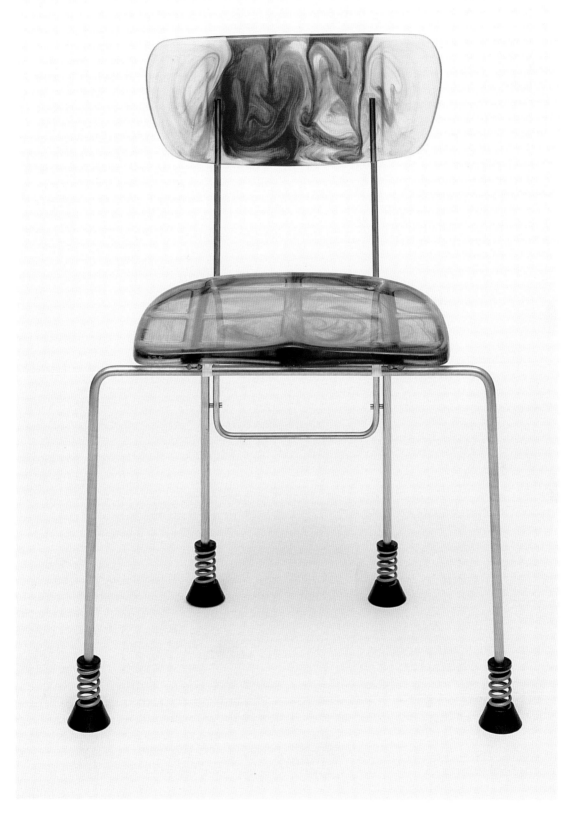

Gaetano Pesce; Italian; *543 Broadway* chair; stainless steel, epoxy resin, nylon; 1993; Courtesy Museum of Fine Arts, Boston

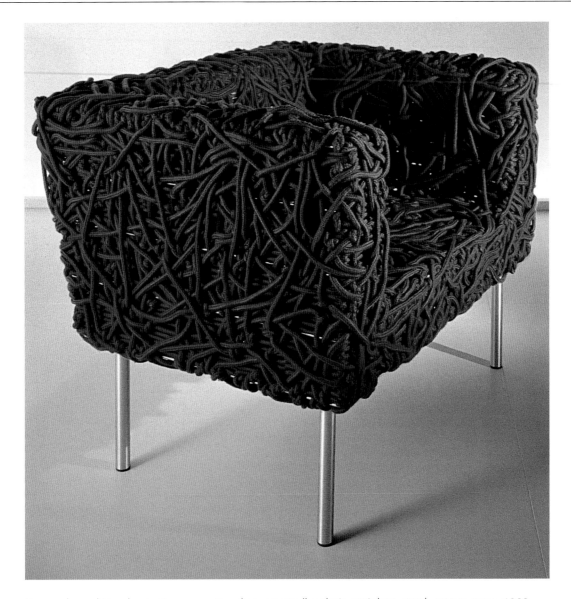

Fernando and Humberto Campana; Brazilian; *Vermelha* chair; stainless steel, cotton rope; 1993

and more profitable activities, for example, Menuez has a display fabrication business – they can earn a living.

Mass communication and information technology are leading to the globalisation of society. In the face of immediate and pervasive contact between diverse cultures, many designers feel that it is important to maintain their individual, and sometimes, national, voices. The personal connection between maker and user/consumer often touted as the special reserve of craft can be approximated through 'virtual' connections. The work of many contemporary designers can be viewed on the Internet and direct contact can be established through e-mail. Numerous design organisations, designers, galleries, and museums have created their own websites. In fact, I interviewed Humberto and Fernando Campana in São Paolo and Jan Nimeiek and Michal Fronik of Olgoj Chorchoj in Prague for this essay via e-mail. The Internet democratises; it gives power, in terms of exposure and marketing – that was formerly the domain of corporations – to individuals.

Is the ultimate aim that craft skills and traditions do not disappear from existence? Designers like Maidment, Menuez and the Campana brothers may eventually abandon all making with the exception of prototypes. If so, how can craft skills be preserved? Individuals will always make things. But the concerted effort of designers to continue designing for craft production and patronising those who still possess these skills can provide the assurance that they will not become obsolete,

that they will continue to create anew and to preserve what skills and knowledge of materials and techniques they already have. In 1984 Charlotte Perriand remarked:

> I think we can anticipate a return to a more primitive form of craftsmanship – not in the sense of going back to the techniques of the past, but a return to smaller scales of operation, making use of all the potential offered by present and future technology. There may still be a need for manufacture on a large scale to meet some needs, but more and more will be produced by individuals, by artisans. The impact on creativity could be enormous, each individual could diversify ...[13]

The essential point in Perriand's statement is the relationship of craft practice to creativity. The advancements in industry in this regard do not yet, and may never, supersede the experimental, knowing-through-making, more open-ended creativity, inherent in 'craft' as I wish to define it. In this way 'craft' as a concept relies more on the attitude of those involved in form-giving than to any prescribed materials or techniques. When faced with the inevitable progression of technology, the best way to preserve creativity is to foster those individuals who are not slaves to any particular method of production and who create useful forms that can be defined as both craft and design. To say that this talent should only be used for the creation of unique objects is to deny its benefits to most people.

The present term 'craft' has been subjected to the semantics of Humpty Dumpty ('When I use a word,' Humpty Dumpty said in a rather scornful tone, 'it means just what I choose it to mean – neither more nor less.')[14] Therefore, the confusion surrounding this term and the perpetration of stereotypes in the discussion of 'craft' and 'design' have maintained certain conceptions that, although they may have been true at one point, are no longer valid after the lessons of Post-Modernism. One wonders if possibly the overlap between craft and design is so great that these two concepts may in fact be the same thing. Perhaps, in the 21st century, craft and design will be distinctions without a difference.

COPYRIGHT © 2002 JOELLEN SECONDO.

NOTES

[1] Andrew J. King, 'The Lost Continent of Craft: historical myth or vision of the future?' In Tanya Harrod (ed.), *Obscure objects of desire: Reviewing the crafts in the twentieth century*, London, Crafts Council, 1997, p. 177.

[2] Ibid., p. 182.

[3] Penny Spark, 'The Straw Donkey: Craft and Design in Post-War Italy', ibid., pp. 153–6.

[4] Quoted in Peter Dormer, *The New Furniture: Trends + Traditions* London, Thames & Hudson, 1987, pp. 137–8.

[5] Jeremy Myerson, 'Squaring the Circle: Four Young Furniture Makers are Finding New Ways of Combining Art and Commerce', *Crafts*, July/August 1994, p. 23.

[6] Unless otherwise indicated, all quotes are from interviews between S.M. and the author.

[7] Peter Dormer, 'Craft and the Turing Test for practical thinking', *The Culture of Craft*, Manchester and New York, Manchester University Press, 1997, p. 157.

[8] Quoted in Joan Jeffri (ed.), *The Craftsperson Speaks*, New York, Greenwood Press, 1992, pp. 114–15.

[9] Quoted in Adélia Borges, 'Irmãos Campana brasileiros e universais', *Board Magazine*, August 1998, pp. 48, 50.

[10] Quoted in Enrico Morteo, 'Brasile: Humberto e Fernando Campana', *Interni* 482, July/August 1998, p. 78.

[11] Vitra website – www.vitra.com

[12] Craig Kellogg, 'Should Oprah Promote Design?', *Metropolis*, October 1998, p. 121.

[13] Quoted in Dormer, *The New Furniture*, see Note 4, p. 136.

[14] Lewis Carroll, *Through the Looking-Glass, and What Alice Found There*, New York, A.A. Knopf, 1984, p. 124.

12 · THE TRANSFORMATION OF TEXTILE ART: A JAPANESE CASE STUDY

Yoko Imai

In 1996 news of the ending of the International Tapestry Biennale in Lausanne was carried in the periodical *Europe Textile Network* and even now, six years later, there appears to be no sign of its return. In effect, the 16th exhibition held in 1995 marked the end of the 30 year history of this Biennale.

The Biennale attracted a variety of responses, some negative, but undoubtedly many artists made their names through it and it was valuable in focusing interest on the various forms of expression within the field of textiles. New names emerged for categories of work previously omitted from traditional definitions – *Nouvel Tapestry – Art Fabric – Textile Art – Fibre Work*, etc. The very existence of the Biennale acted as a stimulus for the metamorphosis into New Tapestry. Instead of becoming fixed, the various names contributed to change and evolved in a way which was rarely seen in other crafts. The judges in their selection did not present a unified view as promoters, but rather acted as a barometer of the state of contemporary tapestry, observing and recording in accordance with the policy of the Biennale laid down by its founder Jean Lurçat.

But in fact the judges themselves were probably more surprised at the speed of change in various aspects of textiles. With every Biennale, the work submitted seemed to have undergone a transformation – figurative to abstract, two-dimensional to sculptural, wall pieces to freestanding pieces. Eventually there even seemed to be confusion amongst the judges and by the time of the 15th Biennale in 1992 (delayed for one year) the word 'tapestry' had disappeared and the name had changed from International Biennale of Tapestry to International Biennale in Lausanne, Contemporary Textile Art.[1] This change of name had highlighted the confusion felt by many visitors and by the promoters who had encouraged the artists' originality but now felt slightly at its mercy.

As a result of this re-naming there was not only a change in the consciousness of the artists who entered but also fundamental developments in the work. There was a deeper understanding of materials with a freer and more sophisticated technical ability; artists appeared who did not spin or weave. It is possible that they had exhausted their thorough knowledge of the nature of the materials. They gave up on techniques previously used and began to cut and pile up ready-made fabric, stiffen materials into sculptural forms, create spaces by drawing lines with thread which drooped under its own weight. And around this time, the artists themselves began to feel that rather than be a part of the craft world they should actually be associated more closely with the fine arts. This seemed even more relevant when artists admitted that 'I really wanted to be a sculptor from the start'.[2] From the position of the promoters this new type of art, which had developed out of the careful nurturing environment of the craft world, had unexpectedly flown the nest like a baby cuckoo and left behind an element of confusion.

So is craft something which you really have to go beyond? 'The distinction between the crafts maker and the true artist is precisely that the former knows what he can do and the latter pursues the unknown.'[3] Can this be said?

To pursue the idea further I would like to introduce representative work of ten artists which should give an idea of the conceptual development that has taken place. In selecting the artists I had one basic criterion: there should be a close relationship between their creative world and the materials and methods of textiles. There are some who call themselves textile artists but use a fairly loose definition and have distanced themselves

from these qualities. I have also chosen only Japanese artists because Japan has a rich textile tradition in the context of a craft world which has always been accorded great importance. Even in the modern era, Western ideas have been absorbed and of influence but rather than painting or sculpture it is the textile world which has been home to some of the most creative artists. Particularly in dyeing, Japanese artists have drawn on their rich tradition and developed a creative co-existence with the demands of the contemporary world. This combination of old and new is extremely well represented in Japan.

Japan has had a very long tradition in dyeing on which contemporary artists can draw. Tapestry on the other hand, which grew out of weaving, was introduced to Japan from the West. But despite a relatively short history, the formative but non-utilitarian possibilities of expression have been fully grasped and explored. In dyeing, the tradition is so strong that it is impossible to ignore and in some cases actually becomes a defining position. Dyeing is broadly classified by the point at which it takes place in the process; if the thread is dyed it is *sakizome* (pre-woven dyeing) and if the fabric is dyed it is *atozome* (post-woven dyeing), this latter category being divided into plain and decorated. Japan has shown particular progress in the field of decorated dyeing.

Artists not only created new motifs but also began to move the technique towards a two-dimensional format perhaps because of the dimensions used, coming very close to painting. Even with the excitement of the advent of the new era at the end of the Second World War and the fresh mixing of illustration and painting, in the selection of motifs, the trend towards traditional styles was still strong.

Toichi Motono (1916–1996) was one of the first artists to establish his creative identity in the confused world of textiles in the 1950s. He proposed abstraction as a possible form of expression within textiles but this wasn't just an echo of what was happening at the time in painting and sculpture. Using a technique of wax resist he evolved a style of working on fabric developed from literary and natural influences which reached great artistic heights. By moving the resist wax before it set and by dyeing and painting resist repeatedly, he achieved a mixture of depth and transparency on the fabric without altering its thickness at all and brought order to the freedom usual within asymmetrical work. In *Communication-3* (1995) having fixed the centre of a piece of white fabric with a blue-dyed square, he covered the whole piece with resist and then added pale grey. In places the resist was warmed and

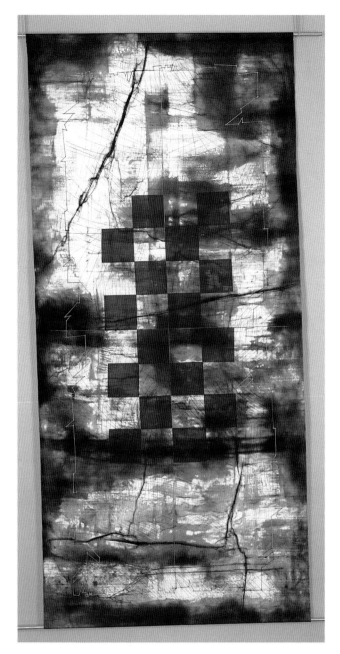

Toichi Motono; Japanese; *Communication-3*; cotton, wax-resist dyeing; 1995

thinned slightly, the cloth was folded and the controlled penetration of the colour created a quiet transparency using dyeing effects.

It is only really within the last 50 years that what one can call a vanguard has emerged in Japan in the textile world – artists who freely use both figurative and abstract means of expression. Harumi Yahata (1956–) bases her work around the traditional Japanese beauties of nature but adds a hint of contemporary influence to broaden the expressive possibilities and to create her

Yasumasa Komiya; Japanese; Kimono cloth, *Lattice with square pattern crest*; silk, stencil-dyeing; 1989

There is an artist within the category of traditional crafts who in his work has consistently explored the single piece of fabric. Yasumasa Komiya (b.1956) is the son and grandson of National Treasures and is following in their footsteps in his work using Edo Komon (Edo fine patterns). He takes the fabric which is intended for use as kimono and explores the beauty of the material itself. This was an approach which was already visible in his father Yasutaka's era.[5] Edo Komon was originally developed as a motif and technique for the decoration of kimonos for the samurai class and became almost impossibly fine and complex. The nature of Edo Komon is more or less decided at the stage when the rice paste is laid down, and in Komiya's method, by using fine motifs cut from paper, he manages to realise a particularly sharp transfer on the cloth. Rubbing the rice paste on the stencil is one stage, and then applying (not completely freely) the liquid dye is another, and the combination ensures that there is a gap between realisation and intent. With the collapse of the system of court rank, the Edo Komon method of motif dyeing became more or less redundant. Komiya however has built upon the research of his ancestors and with his own enthusiasm and the help of the paper sculptor Masui Ippei he has moved on from the past and found a new lattice-like motif.

The reasons for the success of both Motono and Komiya in their respective modes of expression are to be found in both their careful exploration of the materials and in their thorough knowledge and reappraisal of traditional methods. Amongst textile artists recently there has been a trend towards emphasis on the physical characteristics of the technique. For those involved in the creative process using these techniques, the 'what' of expression and the 'how' have become indivisible. With the 'how' and 'what' as one, these artists have grasped the possibilities of the concept and have opened up a new path.

Shigeki Fukumoto (b.1946) initially explored the meaning of the Japanese word '*some*' (dyeing) and the history of the techniques behind it. He then moved on to the hidden heart of Japanese culture and became concerned not just with the surface of the cloth but also with the dyed colours emerging from within.[6] In his resist technique he shakes a brush dipped in wax over the fabric, sprinkling the surface with tiny particles of set wax and then adds shapes cut in masking tape applied directly to the fabric. As a result of the resist of the reactive dye he achieves a complex but delicate effect, almost as if the work is sparkling (see p.132). It is as if he has skilfully illuminated a certain area with a glittering light – not a flashy effect, rather a blurred glow

own style of work.[4] There is a difference in approach between Harumi Yahata and earlier generations in the way that they work. Formerly a new motif would be created and then introduced and added in balance with the composition and that would be the end. Now, the decorative element is the main subject and the work is made up of it alone. In the work illustrated here the motif is derived from creased paper or swept up leaves. It is repeated energetically across the work in pale colours. This treatment can be seen as not just decorative but as a sophisticated and worthy successor in the line of the Rinpa tradition. But having reached this level, Yahata has not stayed still. Recently she has turned her interest to exploring the existence of the single piece of fabric itself as a starting point. By going beyond just expressing a literary appreciation of nature and by mixing various colours and shapes, she appeals directly and strongly to the sensibilities of the viewer.

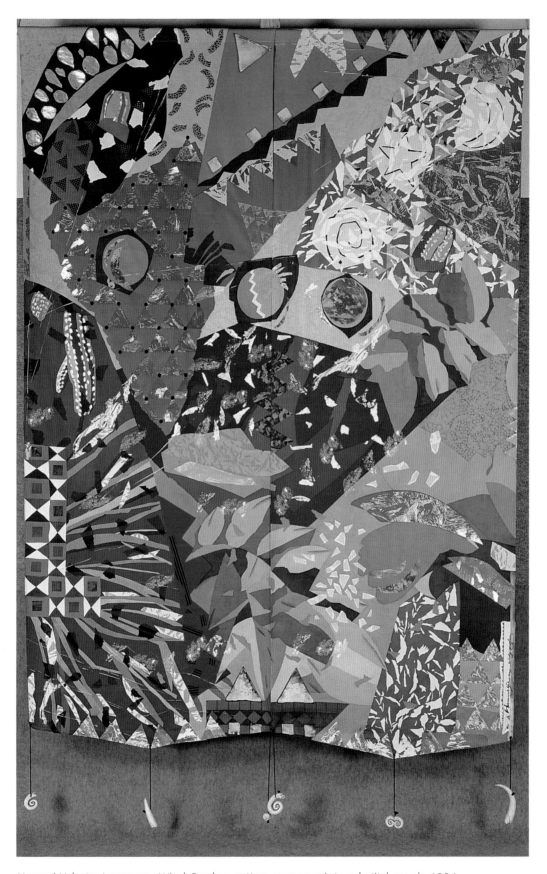

Harumi Yahata; Japanese; *Wind Garden*; cotton, screen-print and stitch work; 1994

Shigeki Fukumoto; Japanese; *Flower, Truth, Wind'91-A*; cotton, wax resist dyeing; 1991

from deep within the fabric. And in the surrounding areas, by skilled and controlled dyeing and the juxtaposition of colours, the eye is led deep into the shadows creating a further level within the work.

An artist once said that weaving is like a never-ending repeated spiral.[7] Weaving is a very systematic activity with rules decided at the very beginning and impossible to change or abandon halfway through. The rather slow, heteronomous quality of weaving is essential to the real nature of the technique. Within the following examples I would like to explore the structural fundamentals of weaving which are very different from dyeing which is more the art of controlling liquid.

'A scale so enormous that people walking under the grove are dwarfed, it is emphasised by the full-intensity red colour. The delineation of fingernails provides the only relief.'[8] This is a reference to the humorous work of Yoichi Onagi (b.1931) though it would be wrong to dismiss it simply as a joke or a prank. There is a kind of

despair at the root of his creative ideas. It is probably a slight exaggeration, but his despair is like a confrontation between the nature of the yarn and the technique and the resulting softness. And there is a complete indivisibility of the method of weaving and the production. It is not possible to dominate the material exactly as you want by sheer force. Allowing for the limits inherent within the materials, he follows the path to his destination and even if the work fails to progress, the piece becomes the art object as it is. Having abandoned the formation of hanging weaving, his challenge was then to move on to giving independence to the piece. He is not the only artist to devise floor pieces using fibre or fabric. Onagi stiffens his woven pieces with rice paste and then installs them rather than piles them up, relying on the action of the weaving itself to make them stand. Since exploring the concepts of 'hanging' and 'standing' his work has moved on from colourful, figurative hands, feet and breasts to plain-coloured abstract pieces which purely express his

sculptural concepts.[9] Having given his work free-standing independence, he then moved through 180 degrees and turned the work on its head. Recently he has again turned through 90 degrees and gone back to using the wall. Rather than sagging hands or breasts he makes boxes, cakes and even pyramids. The pieces are imbued with a strong feeling of passive resistance as the woven sculptural forms hang rather loosely off the walls.

Normally when we see an object, just how much do we consider the world which surrounds it? What attracts us about a chair or an apple, for example, is the essence of the object itself. It is unusual to go on to think about the existence of the object and its relationship with the environment. Toshiko Horiuchi (b.1940) once remarked as follows about one experience of the possibilities for interpretation: 'Looking at Giacometti's work, I first looked at the sculpture itself but then I felt my eyes being drawn to the space around it – complete nothingness. I was almost trembling with emotion.' Her work shows a strong interest in the hints of connection

Toshiko Horiuchi; Japanese; *Atmosphere of the Floating Cube*; ramie, metallic thread, knitting; 1977

between objects. Cut loose from free-will and without sanctification, she herself finds expression for the non-space – using thread she invokes images of air and light-filled space. This is made possible using knitting/weaving techniques. The thread is not packed in but rather allowed to flow loosely in a line creating a flexible surface full of holes. As the air-filled elastic cloth sags forming an elegant curvy line, the gentle trembling movement heightens the feeling of boundless airiness.

Shigeo Kubota's (b.1947) work starts with his choice of sisal as a material. The unequalled strength, firmness and tension of the material certainly influenced the direction of his work. One metre lengths of sisal, slightly thicker than hair are tied in bundles and used as the woof thread, woven into long narrow strips which are then simply assembled into the work. The special characteristic of this yarn is that there is no need to join it or twist it to make long thin pieces, rather like a growing plant it naturally becomes stiff and strong. Without twisting against the tough, resistant quality of the material, and without failing to use its true nature, Kubota makes the most of the weaving process. Afterwards he just adds a stitch to hold the outside edges at obi width. The stiffness and hardness to the touch of the woven piece is composed of tension and flexibility and in the way he builds up the piece he changes it into a sewn form and succeeds in transforming it into another material. As in the illustration, the obilike widths are formed

Yoichi Onagi; Japanese; *Yellow pyramid on the wall V*; jute, wool, double weaving; 1998

Shigeo Kubota; Japanese; *The Wave Space V*; hemp, flat weaving and sewing; 1997

Yuko Ohte; Japanese; *Close to Cloth '92*; cotton, jute, double weaving, kasuri; 1992

into cylinders or parallelograms which hang down from the ceiling fresh to the eye. The balance between the flexibility and the construction of the piece and the possibilities of the form are held briefly in the moment of the act of hanging it. Using lighting, the shadows on the surrounding walls and floor play with the piece and amplify the diagonally joined forms. The particular shine of the sisal is highlighted by the folded edges and becomes one with the gradated colours from the pre-dyed thread. The effect in the exhibition space of the lighting is to strengthen further the light and dark and to reinforce the sense of being in the work.

Yuko Ohte (b.1960) is one of several artists known for working in double-layered weaving. Some artists use woven pieces to build a three-dimensional form, but she first became known for showing double-woven pieces of fabric. In *Close to Cloth '92* she showed a piece made from woven fabric, again folded in half and then suspended from the ceiling with a pipe, showing both the back and

Fukumi Shimura; Japanese; Kimono, *Lingering Snow*; silk, tsumugi

Michiko Uehara; Japanese; *Agezuba*; silk flat weaving

front of the cloth. The presentation of the piece seemed simple, but a very skilful use of the double-layer weaving technique and the contrast between colours resulted in a more than usually complex effect. The flexibility of the twisted cloth as it fell produced soft curved lines, and the five pieces hung as one group moved and played with the focal point and suggested infinity. Mostly, double weaving *kasuri* (resisted yarn dyeing) is used lifting the warp thread to produce a vibrating visual effect which is to some extent beyond the control of the weaver.

Being made a National Treasure was no doubt in some respects a major stimulus for Fukumi Shimura (b.1924). She did not just follow a traditional technique without changing anything but brought a new approach and ideas to the field of *tsumugi* weaving. Tsumugi is a type of plain weaving, the only variation being the inclusion

of a kasuri motif. Shimura introduced a variety of coloured threads into this basically plain technique building up her own style. Her interpretation is not literal – the weft thread is rather more suggestive of music. The colour is not an addition but is fundamental to the growth of the form. She prefers to use natural colours such as indigo, pink and dark red. It is almost as if she captures the brief life of the plant within her finished work.[10] (See p.135.)

The silk yarn chosen by Michiko Uehara (b.1949) for her work is a very thin 6.4 denier. This is about one third the thickness of thread used for bolts of kimono cloth and one half the thickness limit for mechanical looms. Probably only spider's web comes close to the fineness of this thread.[11] But the thread, as it is natural, actually turns out to be far stronger than it appears or Uehara

first imagined. Having said that though, to actually thread up a loom and weave is extremely difficult. Rather than weaving it is more like subtly combining the finest of threads. Her finished pieces are so delicate that one hesitates to call them 'cloth'. Not perceived by touching, the pieces embody the thin delicacy and existence of cloth only possibly glimpsed and experienced momentarily. This fleeting beauty Uehara calls *agezuba* which is the Okinawan word for dragonfly's wings.

Any artist exploring the free possibilities of sculptural form and the limits of materials and technique will at some point feel a certain despair, but they should not necessarily become desperate. It is possible to know the limit within these idioms, and even within despair to seek after the truth – which can almost be said to be ironic. The very unattainability encourages their creativity. It is also not just restricted to the maker, but is also felt by those of us who are the viewers. In the two techniques, the combination of almost uncontrollable water and a length of naturally drying cloth and the long hours spent weaving thread by thread to produce a finished piece are not just an externalisation of the self as an object but probably the expression of the internal self. This is maybe because before the artists even start to work, they have a sense of the future and a feeling for the direction in which they intend to travel.

COPYRIGHT © 2002 YOKO IMAI. TRANSLATION COPYRIGHT ©2002 REBECCA SALTER

NOTES

[1] Rene Berger, 'Tapestry in Question', exhibition Catalogue, CITAM, Biennale Internationale de la Tapisserie, Lausanne, 1973.

[2] Interviews with Magdalena Abakanowicz in July and September 1992, in Kenji Kaneko, *Abakanowicz – the Studio Crafts Movement – Masayuki Hashimoto: Development and overcoming of the material relativism*, pp.77–80.

[3] Mildred Constantine and Jack Lenor Larsen, *The Art Fabric: Mainstream*, New York, Van Nostrand Reinhold, 1981, p.8.

[4] Harumi Yahata, Kyoto University of Plastic Arts (Art and Creativity Series) *Learning Dyeing*, Tokyo, Kadokawashoten, 1998.

[5] 'Fine-Patterned shark – an attempted expression of boundless beauty', (Stencil dyeing), *Japanese Arts*, Vol. 12, No. 343, p.89.

[6] Shigeki Fukumoto, *The Culture of Dyeing*, 1996, p.22.

[7] Quotation from weaving artist, Masako Hayashibe, at a seminar at her exhibition 'Vessels for Appetite VII' at Gallery Isogaya, Tokyo, 1992, 21 Nov 1998.

[8] See Note 3.

[9] Yusuke Nakahara, *Dyeing, Weaving, New Art Theory. This Side Up – Yoichi Onagi's Work* (1981, Kyoto, Senshoku – Senshoku and Seikatsisha) Vol. 3, p.79. In this publication, Nakahara Yusuke says the following about the changes in external appearance: 'The re-appearance of the human form is not because of physical support but rather conceptual reasons within the work. Furthermore it could be said that it is the independence of the work which has removed this support. Here Onagi has removed all physical support and allowed the work to stand free on the floor. Physical free standing can be seen as a metaphor for conceptual free standing.'

[10] Fukumi Shimura, *One Colour, One Life*, Tokyo, Kyuryudo, 1982.

[11] Yasuko Tomita, *Transparent Reality 'Agezuba': The search for Form and a Look – Concerning Art and Crafts*, Kawasaki City Central Foundation, 1994, p.64.

13 · NEO-TRADITION: A NORDIC CASE STUDY

Widar Halén

Distant and primitive cultures were a strong source of inspiration for the development of Modernism in the West, but only a few artists worked with their own cultural traditions. This was still the situation in the 1970s, but with the manifestation of Post-Modernism in the 1980s and 1990s several craft artists turned toward their own cultures. Regardless of different national distinctions, this was a world-encompassing phenomenon, in which old, traditional and local techniques, were re-adopted and reshaped into a Post-Modern expression.

In Norway, which is my case study, the artists began to see the exotic and extraordinary in their own craft traditions. Art-industry and industrial design still has a rather weak position in Norway, compared to other Northern European countries. Our craft milieu, on the other hand, has remained strong and vibrant and it was natural to turn to the old craft traditions for a renewal of Norwegian arts and crafts.

The Norwegian neo-tradition has been particularly visible in the two craft lines which have been most prevalent over the centuries – woodcarving and the silversmith's art. We shall look at some of the craft-artists who have been classified neo-traditionalist within these two fields in recent decades.

Woodwork has long been a male-dominated art form, but in the years since Norwegian arts and crafts artists formed a union in 1975, several women artists have experimented with this demanding material. Among the most successful are Liv Blåvarp, Lillian Dahle, Elisabeth Engen and Liv Mildred Gjernes who all made their débuts in the 1980s and 1990s. This interest in carving and shaping wood must be viewed in relation to the wave of neo-traditionalism which has been prevalent in Norwegian woodcraft. Craft-artists have recognised the exotic aspects of their own culture. Old local techniques and the use of traditional materials have been revived and transformed into a modern style which today has been refined into art of the highest quality.

In 1982, Lillian Dahle, Elisabeth Engen and Liv Mildred Gjernes formed the free woodwork group *Gullregn* (Golden Rain) and tried to discover 'a way towards recognition of the the great truth in sweet-smelling pine'. Their confession of faith includes the following:

> We believe it is necessary for some people who possess the expertise and power of art and craftsmanship to make wooden furniture and artefacts on an entirely free, uncompromising basis.
>
> Indeed, we believe that people should make exciting furniture, lavish, colourful furniture, mystical, secretive furniture, daring furniture, funny, naivist furniture.
>
> Furniture which bears traces of the fact that a person has designed it and made it – with love or anger, with her own temperament. Furniture and other objects made on the basis of the artist's feelings, surroundings, need to express herself and the times we live in. We call those who work in this way craft-artists, and we want to be like that.
>
> (Kunsthåndverk 11. 1983)

With a conscious feeling for our folk culture and art and craft traditions, these three have managed to renew the art of Norwegian woodwork. The same applies to Liv Blåvarp, who at the same time has been working in her own workshop in her father's old carpentry shop in Toten in south-central Norway. These artists' works are part of a local tradition, but their style is sophisticated and contemporary, making use of neo-tradition combined with subtle techniques and lively colours.

Silverwork has been abundant in Norway since the beginning of time and we have preserved more old silver per inhabitant than any other country in Europe. The quality of the work is generally on a very high level that easily stands comparison with silversmithing in the rest of Europe. At times we have also had leading silversmiths in an international sense, for example, around

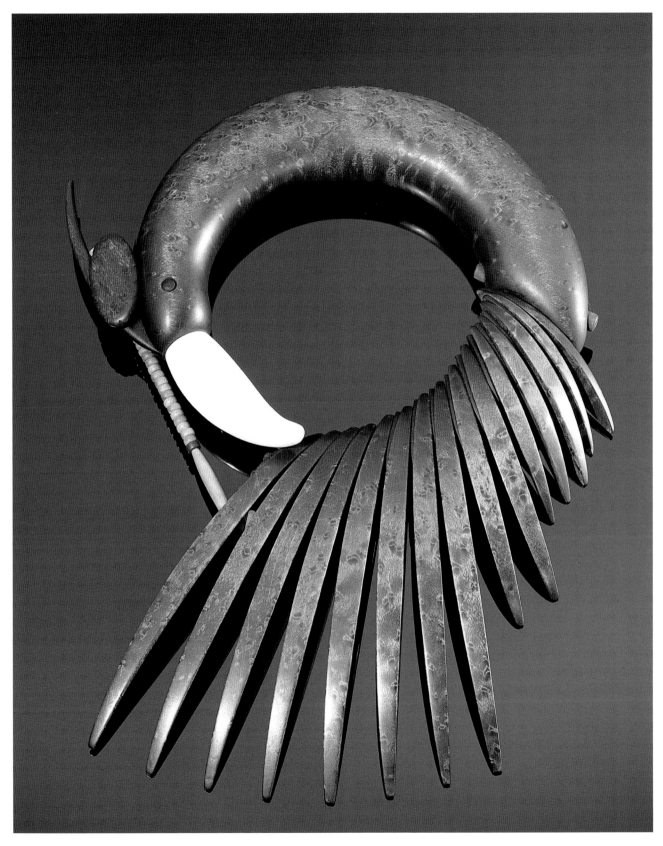

Liv Blåvarp; Norwegian; *Necklace*; birds-eye maple, palisander, satinwood and walrus bone; 1991; Courtesy Kunstindustrimuseet I Oslo; Photograph Teigens Fotoatelier A.S.

Liv Mildred Gjernes; Norwegian; *Heart-lamp*; painted wood and plexiglass; 1996; Photograph Teigens Fotoatelier A.S.

Woodcarving

In 1982-83, the Golden Rain Group, which consisted of the woodcraft artists Dahle, Engen and Gjernes, arranged an exhibition with two other female artists with the informative title *Tre fram, fem frekke friller under Asken Yggdrasil* (Step forward, five fresh females under the Ash, the World Tree), the reference to Norse mythology indicating that these young women regarded themselves as part of the ancient Norwegian woodcarving tradition. However, their art showed that they were also rebelling against the bland mass production of the wood industry, which had dominated Norwegian wood traditions since the Second World War. Their purpose was to create a neo-tradition for wooden artefacts, and now almost twenty years later, they have clearly succeeded.

In the catalogue for the exhibition, Lillian Dahle wrote that she wanted 'to make some of all the things that are not made because they are unsuitable for mass production or because the market is too small – to find some of the solutions you only find when you stand with a plank in your hand and are about to start planing ...'. It was a matter of proximity, soul and artistic nerve, which Lillian Dahle clearly demonstrated in her meticulously joined cupboards, dishes and caskets. They were innovative works, on the borderline between craftsmanship and free sculpture, with finely carved ornaments in high or low relief. There was emphasis on the decorative, on colour and velvet-smooth polishing. This was something new and strange, with clear references to Post-Modernism's unceremonious combinations of materials and styles, past and present. It was no longer a matter of 'form follows function' but 'form follows fantasy', and fantasy, ornaments and colours were precisely what Norwegian furniture and wooden artefacts had lacked in the 1960s and 1970s. The Golden Rain Group and Lillian Dahle's manifesto were clear:

> We were trained during the dying days of the 'Scandinavian Design' movement, when the main emphasis was on neutral, sensible elegance. For us, on the other hand, it is important for furniture to be visible, for it to have character and be a form of expression on a par with pictorial art

Since then, Lillian Dahle has made a significant contribution to the trend in Norwegian crafts towards a more liberal form of artistic expression, although she has always had an eye for the useful aspects of her work. It has taken time to find an audience and win people's

1900 and today our jewellery artists are most impressive with a vitality and originality that is admired worldwide. For centuries we have had a rich and distinctive jewellery tradition connected with the folk costumes. This still provides work for rural silversmiths and inspiration for many contemporary jewellers working within the neo-tradition context.

After the Second World War a number of our silversmiths began to work in their own workshops, independent of the large goldsmith firms. Norwegian jewellery artists have also carried out orders for a more mechanised production, but it is primarily their craft work which holds such a strong position today and has attracted international admiration.

The recent development of jewellery in Norway can be associated with what the English have called 'New Jewellery', which started with studio jewellers in the 1950s and 1960s and grew to an international movement in the 1970s and 1980s. The most vital result of this movement has been a new definition of what a piece of jewellery is and can be, a re-evaluation which has led to giving jewellery the status of art. The most important representatives of 'the new jewellery' are Tone Vigeland, Konrad Mehus and Toril Bjorg, who all established themselves in the 1960s and whose work has frequently been associated with neo-tradition.

trust and interest, but Lillian Dahle has succeeded. She has been commissioned to create decorations for private individuals, schools, hospitals and other public institutions, and in 1993 she made the reception desk in the administration building for the Winter Olympics at Lillehammer. It was a monumental, exciting work with organic shapes and a surface in tones of black and grey which, in the light, conjured up associations with the shining slate mountains of the Lillehammer region.

However, Lillian Dahle is primarily associated with her chests, caskets and dishes – wooden artefacts which, inspite of their imaginative and colourful decoration, have retained their useful and traditional function. In her neo-traditionalist manner she combines the useful with the beautiful and her daring ornaments and colours make us happy and lift us out of our everyday lives, just as good art should. Lillian Dahle's production is immensely demanding – she carves and cuts with a knife – but as a result the surfaces become so subtle and expressive that they bring immense pleasure.

Elisabeth Engen (b. 1957) comes from Tynset, a small community in the deep forests on the border between Norway and Sweden. Here the trees grow tall and majestic, and they still comprise an important element of people's everyday lives and myths. A childhood in this wooded landscape, where most people still live from forestry, has left a deep impression on Elisabeth's artistic consciousness. As soon as she had completed her studies, she became a member of the pioneer *Gold Rain* Group,

which was established in Bergen in 1982. The Group aroused considerable attention in Scandinavia in the 1980s. It was fairly unusual for craft-artists to work in wood at the time, and their work might be said to have filled a vacuum. Furthermore, female woodworkers were still unusual beings, both shocking and provocative to many people. In the course of time, Elisabeth Engen produced cupboards, tables and clocks which challenged our traditional ideas of furniture. In the Post-Modernist style, she used historical references and gradually also pastel colours, challenging the accepted concepts of beauty and function. She said that she primarily wanted to create something expressive and 'almost ugly' because the beautiful was often 'boringly friction-free'.

Elisabeth Engen has also challenged the traditional art of woodcarving in Norway. By using unorthodox methods and tools, she achieves a surface that is entirely unique. She has sometimes pressed the pattern into the wood and used materials as simple as chicken wire to obtain a chequered effect, and she often uses a chain saw and a disc grinder to obtain the rough, daring surfaces that characterise her works. She has reinforced the impression of roughness and immediacy since the 1990s as she increasingly works without precise drawings or preparatory studies, shaping the object and the ornaments as she goes along.

In 1993, Elisabeth made a breakthrough with her more holistic, organic 'floor caskets'. They are often shaped like large troughs with lids, and the shapes are

Lillian Dahle; Norwegian; *Winter* bowl; mahogany and egg shell; 1997; Courtesy Kunstindustrimuseet i Oslo; Photograph Teigens Fotoatelier A.S.

Elisabeth Engen; Norwegian; *Welcome*; wood; 1998

bent to breaking point. It is as if the surface is about to crack, nature itself is at bursting point. The rounded forms are painted in almost sickly, frightening colours, and the surface has growths like warts or rashes. One casket with green patches is entitled *Barn av vår tid* (Child of our Time). Elisabeth has fully converted to the organic, but with an almost frightening physical and natural proximity which arouses associations with current developments in genetic manipulation. In her designs, new mutations and shapes may arise that are entirely unrecognisable in nature. Behind these exciting works lie a deep concern about genetic engineering and pollution, and in this area Elisabeth Engen places herself in an exclusive class with contemporary international furniture designers such as Philip Starck and Marc Newson.

In her most recent works, Elisabeth Engen uses maple, cherry and poplar, and she often uses the natural structure and colour of the wood as an element of her art. In a way, she has distanced herself from the surface and entered into nature itself, as may also be seen in her more controlled designs – simple leaf shapes and larvae. The shapes have become more abstract, but are bursting with intense, exciting sensuality. Elisabeth Engen still has so much that she wants to communicate; it will be exciting to follow her development.

Liv Mildred Gjernes (b. 1960) started out as a rebel in the Norwegian artistic community in the early 1980s when she stated:

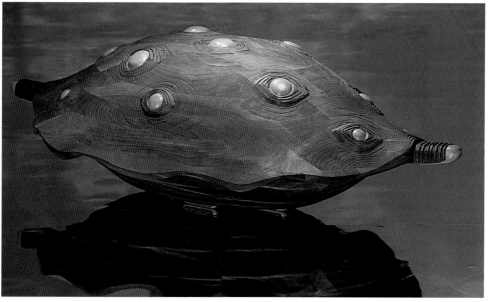

Elisabeth Engen; Norwegian; *Child of Our Time* casket; wood; 1993; Courtesy The West Norway Museum of Decorative Arts, Bergen

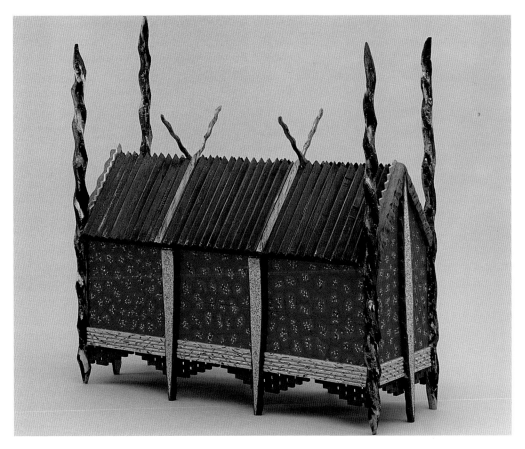

Liv Mildred Gjernes; Norwegian; *Eremitts house for free phantasy*, painted wood; 1989; Courtesy Kunstindustrimuseet I Oslo; Photograph Teigens Fotoatelier A.S.

There is no purpose in working with 'the beautiful', which is the traditional content of the craft I represent. Our surroundings, impulses, thoughts concern many other things. I am strongly against perfection for perfection's sake and aesthetics for aesthetics' sake. My 'furniture' is subordinate to its own language.

Perhaps more than any other contemporary artist working in wood, her expressive chests, cupboards and installations are still 'subordinate to their own language'. They tell us of the artist's difficult balance between the beautiful and the ugly, the perfect and the destructive, the familiar and the frightening. Liv Mildred Gjernes does not conceal the fact that memories and images from her childhood in Telemark emerge when she creates her artefacts. The light wooden rooms and dark lofts at her parents' farm were full of strange old artefacts and provided safe, sound roots for a craftswoman. However, she also found a great deal of inspiration on her travels to the Far East in 1984:

Particularly the first meeting was a cultural shock. Hibiscus flowers and dog turds, an incredible,

intense mixture of beauty and ugliness. A liberating expressiveness, so far from Scandinavia's controlled, anaemic 'design'.

Her chests and cupboards with stupa-like spires are reminiscent of the shapes and decorations of the Orient, but the references to old Norwegian bridal chests and cupboards are perhaps even more apparent. While she is obviously inspired by the cultural heritage of Norway and other countries, Liv Mildred Gjernes' art primarily manifests the magic, myths and tragedies of our own times:

Our era is passing so quickly. Impressions and events rush past. My method is quick, and fairly desperate. So much has to be discovered and there is too little time! Objects – close, necessary, everyday objects – have always been associated with people's lives and history. I am trying to return their intrinsic value; like documentaries, like newspaper articles. I am trying to get these objects to speak – in an age that is overflowing with statements. (Arbeiderbladet 25.8.1986)

Much of the expressiveness of Liv Mildred Gjernes' works lie in her daring way of handling her materials. She hacks a column or a cupboard from a whole log, often allowing the marks left by the tool to remain as decorative patterns. This may seem rough and brutal, but it also has its own beauty which enhances the structure and quality of the material. She increasingly uses these effects in her decorations for schools, churches and prisons, where she can use large formats and enhance sterile modern architecture. Liv Mildred's decorations often contain architectural ornaments and details that used to be visible in our churches and log houses but are now hidden behind fibreboard panels. There are clear parallels with folk art, a closeness and intensity of style and decoration which appeals to the people who use the buildings, to their situation when they are inside them. The colourful column with a capital like a Norwegian bridal crown which she has placed in an anonymous corridor at the Akershus College of Nursing, is entitled *Livets tre* (The Tree of Life). The delicate star-studded wall she has made for Sem Prison is called *Auga i natten* (Eyes in the Night), inspired by a poem with the same title by Tarjei Vesaas: *Står du enno som ein blind under stjerner?* (Do you still stand like a blind man under stars?).

In 1996 Liv Mildred Gjernes presented a new series of works entitled *Ikoner for hjertet* (Icons for the Heart) comprising cupboards and lamps in plexiglas and wood focusing on the heart and the colour red. In the midst of today's restrained surroundings, she wanted to create something heart-warming which might easily have been sentimental and banal but which, in her creative hands, bears witness to genuine, red love.

Jewellery

Liv Blåvarp (b. 1956) has deep roots in Norwegian wood traditions. She more or less grew up in her father's carpentry workshop, which she has now taken over and converted into a studio. We can certainly place Blåvarp among the 'neo-traditionalists', but she has since liberated herself from what is normally associated with the traditional Norwegian style. She works in exotic materials – amaranth, rosewood and lemonwood, for example – and shapes the wood into numerous pieces which she then combines in what she calls 'flexible jewellery'. Liv studied metalwork at the National College of Art and Design and worked in metal for three years before turning to wood, which was more suited to her experimental creativity. Wood was easier to shape and

also cheaper, and she was therefore able to experiment more at less expense. After completing her studies in Oslo in 1983, she spent one year at the Royal College of Art in London, where she found inspiration that had a decisive impact on her career. During this period Blåvarp worked mostly with large pieces of wood laminate, gluing various types of wood together and creating a pattern which permeated the entire piece. This made an exciting, though somewhat solid impression, and since 1988 she has increasingly been working with flexible jewellery composed of many separate elements. Her fixed, almost monumental style has been replaced by jewellery that is lighter, more flexible and malleable. She has finally been able to experiment freely with the variations of shape, volume and size that is so typical of her later production.

The undulating, gracious, sensual shapes, imaginative details and minutely planned joints of Liv Blåvarp's wooden jewellery are a formidable revelation of beauty. With original compositions, exquisite finishes and silky surfaces, her art is uniquely her own. In fact, she cannot be compared with any other contemporary jeweller or woodcarver. Liv Blåvarp stands alone, free and strong, and creates jewellery that not only attracts and speaks to us but captivates and surrounds us in an elevated artistic sphere.

Liv Blåvarp mainly finds her motifs in nature – fruit, birds and exotic animals. She is particularly interested in the spiral shape that constantly recurs throughout the universe. The spiral can be seen in the intricate necklaces with finely-carved sections that create a plastic winding contour and move beautifully on the neck of the wearer. Another favourite motif is the horn of plenty, which she softly surrounds the neck with colourful, flamboyant details. In other works, the patterns and colours of the wood itself provide the artistic texture and composition. We can see this trend in Liv Blåvarp's most recent jewellery, where she often uses exotic woods, allowing them to retain their original colour and structure. The tactile elements now appear to be subordinate to her desire for unity and precision. Her powerful jewellery is good to wear whether it consists of larger elements or small, intricate combinations. Liv Blåvarp has set strict standards for herself and her work which can only be realised through meticulous precision and artistic integrity. She has shown that she fully masters her art, and for this reason, in 1995, she was awarded the Søderberg Prize – often known as the 'Nobel Prize' for Nordic craft-artists and designers. In justifying its decision, the jury stated: 'With her fastidious choice of media and craftsmanship of the highest quality, her innovative contribution to jewellery design is of the greatest artistic merit.'

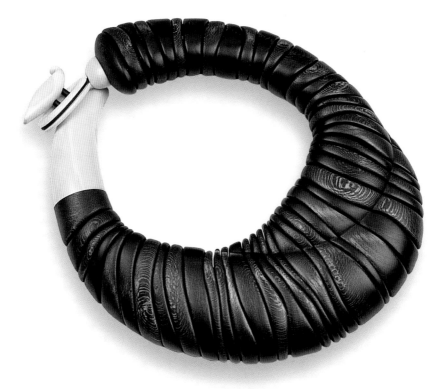

Liv Blåvarp; Norwegian; *Necklace*; plane wood and walrus bone; 1996; © Holgers Foto

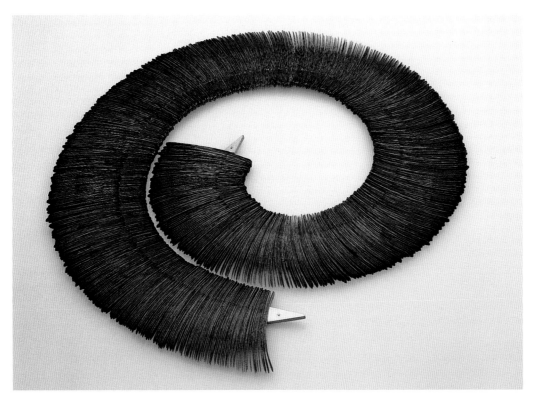

Tone Vigeland; Norwegian; *Necklace*; silver, gold and steel; 1986; Courtesy Kunstindustrimuseet I Oslo; Photograph Teigens Fotoatelier A.S.

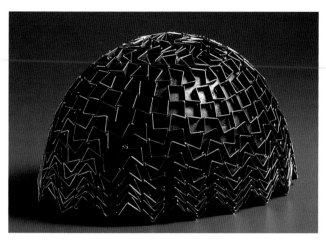

Tone Vigeland; Norwegian; *Evening cap*; oxidised silver; 1993; Courtesy Kunstindustrimuseet I Oslo; Photograph Teigens Fotoatelier A.S.

Tone Vigeland (b.1938) has been a leading spirit in Norwegian and Nordic art jewellery for more than forty years and in recent years she has gained wide international recognition as an important rejuvenator of contemporary art jewellery. In 1992 Robert Lee Morris in the magazine *Metalsmith* expressed the following complimentary words about her:

> I think of her as one of the leaders of art jewellery. Her pieces reflect the spirit and angst of the Viking culture. There is this strong moody image that comes out of every piece that she produces. I believe that some day her work will be in the museums alongside Ellsworth Kelly. (Fall 1993, p.18)

Now, almost a decade later, we can confirm that this has already happened. Vigeland's impressive list of exhibitions, awards and bibliography confirms her status as an artist of international repute. She is represented in most major museums of decorative art around the world, and when the Cooper Hewitt Museum in New York honoured her with a retrospective exhibition, David Revere Macfadden recognised the neo-tradition aspect of her work:

> While contemporary jewelry design is shaped by our understanding and perception of the moment, Tone Vigeland's jewelry tells us about another kind of time – a time grounded in a matrix of ceremony, of ritual theater, and of the power of ceremony.

Macfadden's poetic words summed up the general appraisal of the catalogue:

Through the genius of an artist like Tone Vigeland, we are invited to share her love of the raw, humble, and even overlooked materials. Through her extraordinary choreography of materials, we also revel in a very human love of technical proficiency. We are told about design and craft as a barometer of human inventiveness, awareness of our visual and tactile potential, and about how the personal vision of one artist can be transformed into the personal narrative of the wearer. These qualities engender an atmosphere of respect for material, respect for techniques, respect for tradition, and respect for innovation. Tone Vigeland tells us about time and about ourselves in her work. We are humanized through Tone Vigeland's jewelry, and come away from it enriched in vision, in understanding and in feeling.

Vigeland began her career in the Scandinavian Design movement, but from the time she started her own workshop in 1962 her jewellery has gradually become more complex with a rich and sensual expressiveness. She has always wished to avoid clichés in forming her work and has often showed distaste for the status-seeking and sentimental type of jewellery. In her work she combines precious with non-precious metals without respect and in a supreme technical manner, but always keeps in mind that a piece of jewellery must be in accord with, and beautify, the body of the wearer. Although her works are often monumental, they are still light and never impede the wearer's movements, but function rather when in motion to create new effects in the play and light of the metal. Vigeland's jewellery drapes amazingly lightly and softly around the body, and that makes it a pleasure to wear. In 1980 Vigeland had a breakthrough year with jewellery formed from forged and hammer-flattened nails of iron and steel in combination with silver and gold. The everyday and aggressive nature of the nails was softened by the feather-like jewellery forms. The play of geometric forms, combined with smaller elements of balls, cubes and tubes fastened on silver chain mesh are characteristic qualities of Vigeland's later jewellery, and can be compared to the minimalist trends in international sculpture. Several commentators tend to underline the Norwegian and neo-traditionalist character of her jewellery. This can particularly be seen in her collections from the 1990s with monumental neck pieces and oxidised silver caps reminiscent of chain mail, which brought to mind the ancient armour of the Vikings but also today's piercing and high-tech culture. Although entirely unsentimental, Vigeland's jewellery possesses nonetheless a romantic and neo-

14 · PLURALITY AND NECESSITY: AN ANTIPODEAN CASE STUDY

Janet Mansfield

For many of us involved in the practice of crafts the craft movement proper started in the 1950s and 1960s. It was almost as if we had newly discovered a philosophy of life: working with the dignity of the handmade and with the joy of designing and making a work of one's own individual expression. These precepts held out a promise of a satisfying and interesting life. For a country such as Australia, settled by Europeans not much more than 200 years ago, crafts originally had been a practice of necessity: leather for door straps and hinges; furniture and utensils from empty cans; bits of wood and wire fashioned into handles; and found objects transformed into personal expressions of functional art. The European settlers brought the traditions of their home countries with them and communities of specific national origin endeavoured to create something of their native countries in a totally new and occasionally alien environment. Through their basic functional objects and traditional decorative arts, their appurtenances of daily life reminded them of life in their former countries. A resulting multicultural society, today even more so with its continuing immigration policy, Australia can boast an identity that is international in all of its arts. A similar scenario can be used to describe the development of the crafts in New Zealand though its social establishment and the influences of its landscape and geology gave rise to different artistic expressions.

To gain a clear understanding of the crafts movement in Australia and New Zealand from the 1960s, how it developed and the issues facing it today, a brief background is in order. Australia's original settlers, the Aboriginals, made the first ceramic artefacts that have yet been found. Fashioning stones from clay where no local stones existed, the Aboriginals baked clay balls in the fire for the purpose of cooking. These clay stones are

dated 30,000 BC, no earlier ceramic objects have been discovered anywhere in the world. Aboriginal people, however, are nomadic, and do not wish to carry heavy pottery on walkabouts. Carved wood containers and weapons, basketry and stone implements, painting on the sand and on bark, are all well-known Aboriginal art works of extraordinary cultural significance, as are the carvings and architecture of the Maori in New Zealand. But these forms and patterns were not, morally or ethically, available for the white settlers to use. The descendants of the Europeans had to look to their own ethnic origins or rely on their own interpretations of the new land, its forms and patterns, for an original style of their own. And this has taken time.

Here I am reminded of Shuichi Kato's *Reflections on Japanese Art and Society: Form, Style, Tradition*, where he describes a similarity in the development of style. Kato applies his references to architecture but his study could easily pertain to stylistic changes in Antipodean ceramics or crafts in general. Taking ceramics as a case history, we can see that the early potters of Australia and New Zealand used their cultural traditions to make work that was familiar to them without too much reference to the natural surroundings or the growing new culture around them. A second phase saw the blending of the old and the new when the potters wished to express features of their new homeland, superimposing decorative motifs of native Australian or New Zealand flora and fauna on European forms. At first this resulted in a lack of relationship between traditional forms and applied imagery. What resulted was a compromise rather than a fusion.

The first influences on art in the colonies were, of course, British. Teachers were trained in Britain and it was 'home' for most of the population. Britain was the

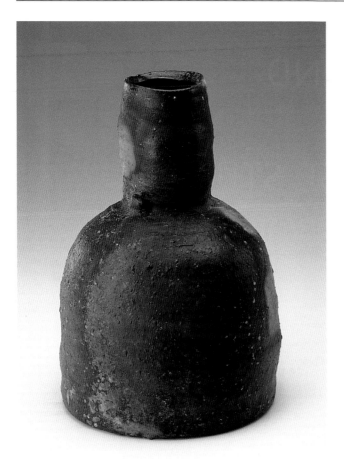

Janet Mansfield; Australian; *Flower vase*; wood-fired stoneware; natural ash glaze; 1996; Photograph by Ian Hobbs

preferred place to travel for further 'overseas experience' and many of the materials for the crafts, particularly in ceramics, were imported, mostly from Stoke-on-Trent. Most of the manufactured goods used in Australia were imported – it was easier and cheaper than to begin a tableware industry. Imported also was the Arts and Crafts Movement; the running of its societies and ideals were close to the British model, and its followers, mostly women, used their skills to provide a kind of emancipation, a small income leading to independence and fulfilment.

Influences from Art Nouveau, the Bauhaus and Art Deco have all left their marks, the inspiration coming from the work and teachings of immigrants and travellers. With technical ability and sensitivity, an Australasian style had some chance of developing. However, Modernism with its attitudes of 'form following function' and a strictness of the unembellished line, became an international movement. This, together with the era of rapid communication between countries, travel of people, of touring exhibitions, of books and

magazines, and now the internet, came into conflict with the push towards regional flavour and national identity. An international style has flourished with a language that deals in universal notions of beauty and reflecting world-wide changes in society. What happens in New York, Tokyo or London has an influence on artists everywhere, at least on the surface. International styles have come to provide the framework in which a craftsperson seeks a personal expression. Yet, within this universality, there remain attitudinal differences which account for individual experiences, personal and regional, and this makes the study of contemporary crafts a vital and valuable one to explore.

Both Australia and New Zealand can be proud of the efforts of their pioneers who won their living from the land against tremendous difficulties. That spirit lives on, not only in country areas, but in many business and artistic pursuits. Those of us who are third or fourth generation colonials, and who have been involved in ceramics for a short 35 years, will remember that there were no traditions that were available, no ceramic suppliers to sell clays, or wheels, or exotic underglaze colours. We dug our own clay, or sieved the brickworks clay; we built our own wheels and kilns from spare parts; and experimented with available minerals for glazes. When the studio pottery movement as we know it today was beginning, it was a time of excitement, of secrets hard won. Few books of any note were there for studying except, of course, Bernard Leach's *A Potter's Book*. Teaching was mostly a private affair with a few colleges offering part-time courses. The establishment of groups of ceramic artists was just beginning with the aims of combined study and promotion. In those few years we have seen the lifestyle of the potter rise and decline: from a time when people queued up to buy from exhibitions and with sell-outs at craft fairs – to today when some potters are finding it hard to survive at all and wondering if what they are doing/making is relevant; from a time when university courses flourished and a vocation in ceramic art seemed possible – to today when cutbacks and economic rationalisation have led to the contraction or amalgamation of ceramics courses into those of sculpture or design or even the closure of some art departments altogether.

Focusing then on ceramics, and taking a leap in time, I believe that references and skills today are singular, belonging to an individual artist and are rarely related to a particular region of the world. While issues may be universal, their expression by artists are presented in a variety of ways influenced by experience and heritage. We can recognise some national characteristics: clean-

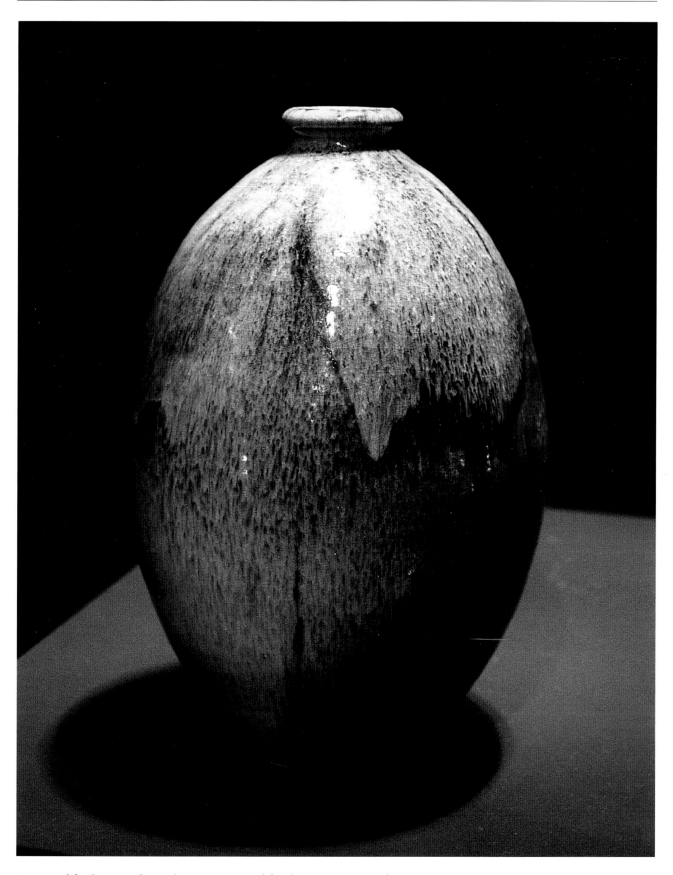

Peter Rushforth; Australian; *Blossom Jar*; wood-fired stoneware, Jun glaze

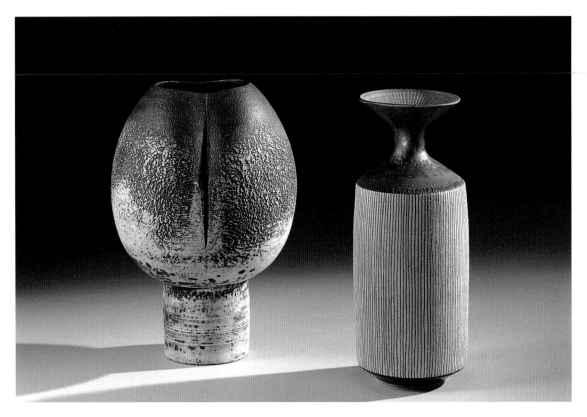

LEFT: Hans Coper; British; *Pot*; stoneware; 1968. RIGHT: Lucie Rie; British; *Bottle*; porcelain; 1959; Courtesy the Trustees of the Victoria and Albert Museum

cut Scandinavian design; the glaze and surface qualities of German pottery; the relevance of history in English ceramics; the asymmetry of Japanese art; colour and scale in the USA; the innovations of the French; typical Italian maiolica; individual domestic functionalism in New Zealand; the architectural forms of contemporary work of Spanish artists; Arabian lustre; the burnished wares of South America; and so on. But we can easily be fooled when trying to establish the provenance of the work. People have moved and taken their heritage and skills with them, and students with an open mind travel around the world to learn.

Today's artists are not concerned with establishing a future heritage for generations of their kinfolk to come. I do not hear of a potter laying down porcelain clays for his grandchildren, or passing on secret glaze recipes to the eldest child for exclusive use in the family pottery. There are no impassable mountains between communities, we can transport ourselves and our materials from one area of the world to another. Our lifestyles and habits are becoming more uniform internationally and we seem no longer to need specific wares for specific uses.

Today, it is the influence of a teacher that has become a dominant factor in a particular region of the world, so we can talk of an area of influence, though this, too, becomes a school of adherence. Bernard Leach's apprentices are spread throughout the world and some of his strongest advocates are in the former British colonies. Michael Cardew, through his work and the work of his students, has spread a philosophy promoting the community role of a potter; the specific shapes of his pots are still made throughout the world, including Africa. Peter Rushforth, through his 27 years of teaching at East Sydney Technical College influenced generations of Australian students to the work ethic and the Anglo-Oriental precepts of beauty. Drawn to Japanese ceramics, Rushforth made study trips to Japan and believed that any potter working in stoneware must acknowledge traditional Oriental ceramic techniques. As a teacher, he stressed the belief that a sound foundation of the techniques of ceramics is essential and that functional pots are the basis of the craft. Now retired from teaching, he has established a pottery studio at Blackheath in the Blue Mountains in New South Wales. He has built kilns fired with wood for natural ash effects, and glazed stoneware. Rushforth, born in New South Wales in 1920, has been making pots continuously since the early 1950s, making wheel-thrown forms

such as bowls, platters, blossom jars and jugs, pots that combine beauty and usefulness.

The interest in Australia's material resources continues to be relevant. Much development has occurred in the procuring and processing of materials for the potter, resulting in commercially available clays and the standardisation of raw materials following McMeekin's *Notes for Potters in Australia*, which gave technical information on both the sources and preparation of Australian materials. McMeekin had a dream that Gulgong in NSW could become a centre for potters using the clays and minerals of the area to make a unique and regional pottery. A student of McMeekin, Gwyn Hanssen Pigott, now living in Queensland, who also studied with Leach and Cardew, is concerned with purity of form, simplicity and the abstract vessel as a sculptural entity. Her inspiration is the painter, Georgio Morandi, whose still lifes create a tension of relationships between similar and disparate forms. In Hanssen Pigott's still-life groups, sometimes numbering up to 26 pieces, the grouping of seemingly simple shapes creates a visually complex image that is both tranquil and compelling. While each form with its sheen of perfect glaze and dusting of wood ash from the firing is minimal in outline, the tight formation of the group demands attention.

When questioned about the influences on their work, artists' answers range from direct sources such as teachers, from travel, or most predictably, from nature. We are all influenced in our work, by cultures, by style, by our environment and social or political situations, by whole traditions. The influence of Japan on contemporary potters in Australia and New Zealand is understandable. We are in close geographical proximity and many of us have made the pilgrimages to the old kiln sites while others have worked in Japan for months or years. Also, in Japan, pottery and function go hand in hand in a tradition that has promoted a specific use of materials and where competition has forced individual aesthetic. And with a skill base that is renowned, avant-garde ceramics in Japan is in the forefront, leading the way and enticing the rest of the world to experiment with ideas and scale. Equally, Italian maiolica, German and British salt-glaze and Persian lustre, all contain whole traditions of forms and surfaces that are available to and influence the practice of the contemporary ceramicist.

The material of ceramics is so abundant, so capable of taking on any form, so variable in its texture and finish. The techniques so easy at first and yet so difficult – when you realise the possibilities – that a lifetime can be spent acquiring them to any degree of satisfaction. Techniques prove a challenge to the experimenter in most of us: that difficult form, that elusive surface, that firing control. Then there is the personalisation of expression – what are we endeavouring to say with our work, is it that we wish to be part of a continuum of ceramic art over the thousands of years of history, making work that fills a need in a community? Are we trying to tell a personal story or the wider narrative of a social group? Is there a particular issue that should be addressed and presented through an artistic medium? Sculptural, architectural, functional or decorative,

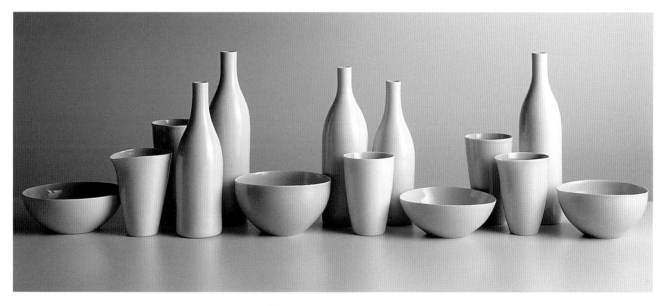

Gwyn Hanssen Pigott; Australian; *Still life*; wood-fired porcelain; 1997; Courtesy Christine Abrahams Gallery

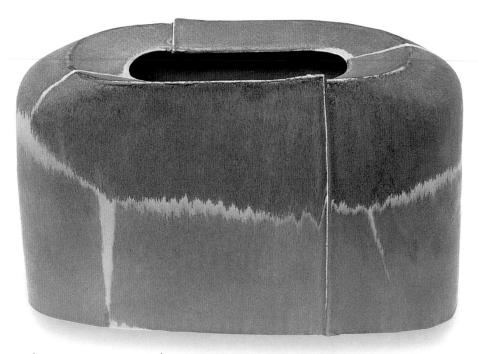

Hiroe Swen; Australian; *Form*; stoneware, glaze; 1996

expression in clay is unlimited. These are the possibilities and the passion. The artistic object has a power that can speak to others.

What are the issues facing the crafts practitioner today? What are his or her needs and how are they resolved? There is pressure on the craftsperson in what has become known as the arts industry. Even the word 'industry' implies a community of allied workers: museum and gallery directors; curators; writers; editors; photographers; and more – all passing judgement, selecting, rejecting, expressing opinions, casting doubts. We all agree that we need quality. Most of us recognise quality, most of us strive for it – from the most sophisticated and urbanised avant-garde works to the pots made in the jungle. We look for quality in ceramic works, in writing, and magazine content, in gallery presentation. We think we know quality and professionalism when we see it, but how do we define it? If it is simply a matter of refinement how do we account for those rough wares that excite the imagination; they are certainly not refined but neither are they poorly made; and what about installations that surround us and totally fill the senses; and works that take scale to another dimension and seem to be overwhelming, dominating our landscape; what they do is to extend our conception of quality and lead us to a broader vision. In a gallery or when it comes to teaching, quality can be seen by the direct results on others. One important need for crafts

today, I see, is one of social and active involvement on the part of practitioners. Attendance at conferences, sending work to competitions, subscribing and contributing to magazines, helping one's fellow travellers, taking an active part. It is up to the craftsperson to take the lead. With today's fast transport and ease of travel, no country is any longer geographically remote, we are all only hours away from the rest of the world.

Diversity of personal expression, imaginative use of materials and a recognisable vigour will be what makes the difference between one artist and the next; one culture and another. An aesthetic of naturalness and simplicity, to which Leach refers as a Japanese sense of beauty related to humility is imaginatively used by Bill Samuels, firing large wood kilns in the Blue Mountains of New South Wales. A former student of Peter Rushforth, he believes in the philosophy of the head, heart and hands, and that by working in a flow of similar shapes, the spirit of the potter can expand; no two forms are ever the same and the pleasures are in the subtleties. Both Samuels and Rushforth have always had a strong conviction that a potter has a role to play in the community, that a creative person can, in many ways, offer an alternative to industrial or mass-produced goods and ideas.

A revival in the art of wood firing is one of the interesting phenomena current in Australian ceramics. To some it is a hark-back to the values that seduced us into

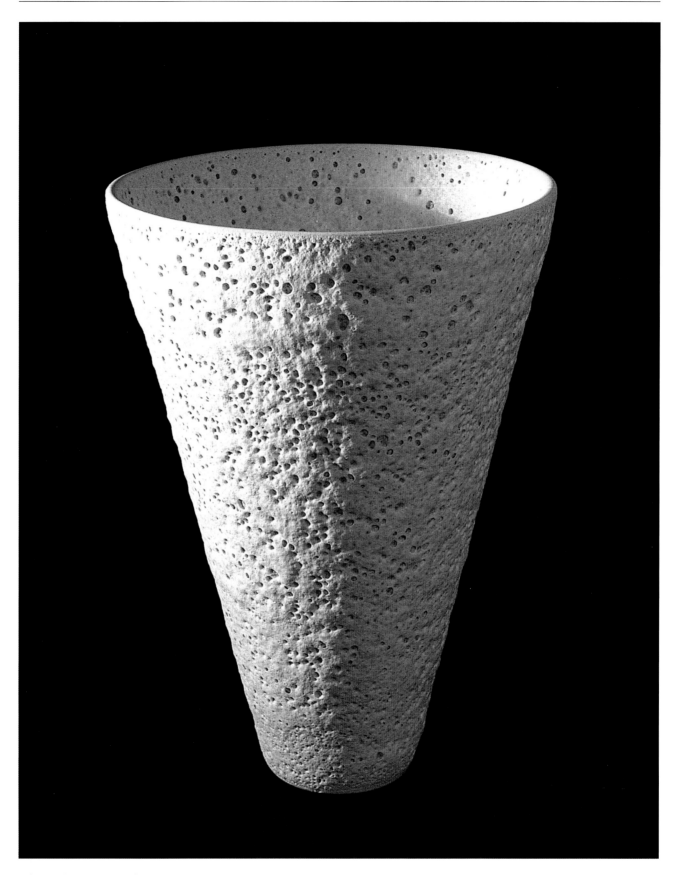

John Parker; New Zealander; *Porcelain form*; 50cm; 1997

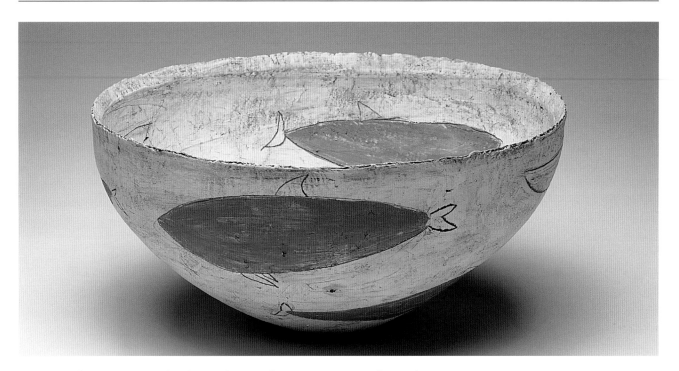

Raewyn Atkinson; New Zealander; *A Change of Heart*; stoneware, slip, oxides; 1997

making pottery in the first place. The complete involvement in all aspects of the making and firing, From planning the forms, winning and mixing the clays and other materials, to forming and finishing the pots using the direct possibilities of vitrifying clay with fire, adds up to a powerful means of expression and satisfying labour. My interest in ceramics began from a practical need to make objects that I wanted and was unable to buy. Then I became intrigued by what challenges the medium could offer to my mind while at the same time allowing for a total involvement of the spirit. That the activity was physically demanding was an added attraction, there was satisfaction in using the body for the purpose of making something worthwhile. My training under the guidance of Peter Rushforth instilled the values of beauty possible in clay utensils. Subsequent studies in Japan reinforced an admiration of Japanese attitudes to work, to the use of local materials for their own qualities, to the technical possibilities and the concept of relating a pot to its use. Firing large wood-burning kilns at rural Gulgong, NSW, my work has concentrated on salt-glaze and wood-firing for the past 20 years. Although salt-glaze is a European tradition rarely practised in the Orient, the work philosophy could be allied to Eastern concepts in the form of the pot, in simplicity, in natural asymmetry and making pottery that aspires to a wholeness and honesty. Also working at Gulgong in the wood-fired aesthetic and fir-

ing large kilns for three to four days is Chester Nealie. Originally from New Zealand, Nealie has settled in Australia where he is researching the medium of clay and fire. A potter since 1964, his sensitivity to form and his ability to create a variety of surfaces have set him at the forefront of the wood-firing movement in Australia. Roswitha Wulff, of German heritage, teacher and wood-firing potter, has built a wood-burning kiln in Sydney to continue exploring the relationship of form and surface, particularly experimenting with felspar glazes.

Raku, a Japanese technique involving low-temperature firing and open clay bodies that can withstand the thermal shock of sudden heating and cooling, has been used by Jeff Mincham to express his personal aesthetic. The essence of Raku, with its spirit of naturalness and chance occurrences, is used to create large forms that no longer have a specific function but are loaded with historical references. Working in South Australia, his vessels are fumed with metallic salts to create rainbow-like hues in reduced earthenware. The salts remain on the surfaces of the clay in a process which Mincham refers to as 'firing and weathering at the same time'.

Numbers of potters from various countries have visited Australia and New Zealand since 1960 giving workshops and adding new dimensions to the knowledge of ceramic art. Antipodean potters have studied overseas, exploring many traditional and contemporary practices. Books and magazines are read widely and

travelling exhibitions have made a considerable impact on the work of practitioners. The works of Lucie Rie and Hans Coper (see p.152) have many admirers among Australian potters. Both Rie and Coper settled in England from Europe and brought to their work a refined sense of form quite different from the Oriental. Rie's work in the early 1950s had a significant impact on British ceramics, her aesthetic reflected the 'new modern look' with clean lines and minimal surface decoration. Coper made original and monumental forms that had fine balance and surfaces that were rich with many layers of clay slips. Their forms were based on functional pottery and they relied on the disciplines of throwing to shape the pieces but the design consciousness, the sharp profiles and the restrained surfaces offered a contrast to the Oriental aesthetic. The influence of both Rie's and Coper's work was reflected in art schools in Britain in the 1960s. The Central School of Art and Craft, opened by followers of William Morris, and the Camberwell School of Art were two British schools dedicated to the teaching of fine crafts. Marea Gazzard studied at the Central School of Arts and Crafts in London during the 1950s. Here she was a contemporary of Ruth Duckworth and others who were more interested in form than glazes and who felt that handbuilding clay forms could offer special and unique qualities. Gazzard's forms have monumental qualities of timelessness and purity. Made by the coil method, these works have a presence that transcends the material. In fact, Gazzard has cast a number of pieces in bronze and has received many important commissions for her cast bronze sculptures.

Also working in pure form is New Zealander, John Parker, influenced by his training at the Royal College in London. (See p.155.) Interested in starkness and purity of line with attention to detail and finish, Parker's work alerted potters to the possibilities of elegant form, primary colour and strict line in ceramics. His work in allied art fields such as set design and exhibition display also reveal his eye for detail and proportion. Virtuosity of style is an international attribute. Merilyn Wiseman is a New Zealand ceramist who enjoys making objects. Clay offers her intimacy with the materials. Working with simple tools and her hands, her shapes have evolved gradually, solving problems of design and technique as she works, yet the results are sure and well resolved. Wiseman's fellow countrywoman, Raewyn Atkinson acknowledges a greater debt to her environment. Her forms and imagery are distinctly connected to the land and sea around her. Social commentary has gradually taken a more dominant theme in some of her large hand-built forms as she has seen where she can take a nudging role in issues of the environment.

Working in off-centred forms and using glazed porcelain and undecorated surfaces is British-born Prue Venables from Melbourne, Victoria. With profiles that could be reminiscent of metalwork, her jugs, cups and bowls have a simplicity of line and are made in a scale that is inviting to pick up, handle and use. Both Prue Venables and Kevin White teach at the Royal Melbourne Institute of Technology and have been at the forefront of a movement to foster the making of fine tableware. White's porcelain vessels, decorated with blue and red, are often off-centre being altered when the clay is still soft; this gives them a lively human quality. Trained in the UK and Japan, his work is not merely functional, it invites ceremony and celebration. The alteration of the form and the dynamic brushwork combine to give each piece character and energy.

Hiroe Swen and Mitsuo Shoji, both Japanese-born Australian resident artists reveal their training in Japan. Hiroe Swen, working and teaching in the Canberra

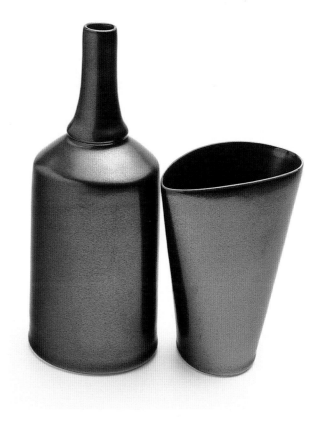

Prue Venables; New Zealander; *Bottle and Jug;*
Photograph by Terence Bogue

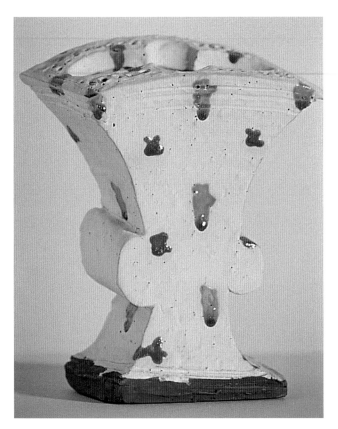

Richard Parker; New Zealander; *Spotted Vase*; terracotta, slops, glaze; 180mm; 1991; Photograph by Julia Blake White

Potter's vessels, the elegant glazes and surface patterns of Greg Daly's jars and plates to the colourful and zany works of Jenny Orchard, personal expression through ceramic art is paramount.

New Zealand ceramist, Richard Parker, from Kaeo, north of Auckland, works with a theme of sculptural representations of classical vases. His roughly-textured amphorae in terracotta clay sometimes take on life-size scale, sometimes are miniatures, but all are works with presence, provocative in their forms with contrastingly vibrant decorative treatment in slips and glazes. Working from personal experience and with an emotive use of colour, John Crawford, from Nelson, New Zealand, works in a narrative style. Some pieces are figurative, some sculptural, his ceramics deal with horses, offerings of food, his self-image and his desires and dreams. Both these artists have exhibited internationally. Christine Thacker is a sculptor in clay. Using coil building, her soft-edged figurative amorphous forms or her harder-edged geometric works take on an installation quality when they are grouped together. Interested in the qualities of clay itself and the shapes, textures and colour tones that can be achieved, her work is influenced by both universal themes and contemporary concerns.

Alan Peascod is an innovative ceramic artist, a leader in technology which he uses in the making of sculptural

region, believes in the ability of ceramics to convey emotions. Working mainly in stoneware, her vessels have a surety of finish. Swen is opposed to ugliness in any form and she seeks to express the joy of life and the best of human qualities. Her pots suggest naturalness, grace and a sensitivity that is calm and serene. (See p.154.) Mitsuo Shoji, living and teaching in Sydney, has gained a reputation as a sculptural ceramist. His innovative concepts, his broad-ranging ideas and his need to address universal issues result in works of multiple elements that are often complex, puzzling and provoking.

While the Oriental influence is evident on the work of a number of potters working in Australia, it is more the inspiration of the spirit of the work than the direct imitation of forms. The search for an Australian identity throughout all the arts has been a source of speculation for more than five decades and much has been written about the environment, the quality of light and the wide open spaces. But the Australian environment is as diverse as its art practice; it is the imagination of its artists that has been predominant. From the sculptural strength of Fiona Murphy's scraped and refined forms, the wildly irregular forms and hectic surfaces of David

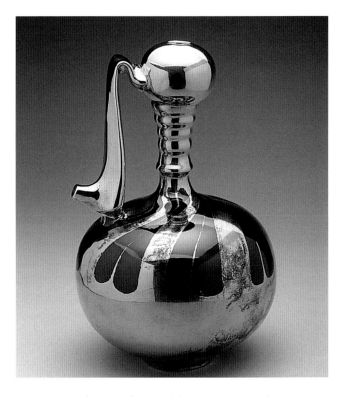

Alan Peascod; Australian; *Gold Jar*; stoneware, lustre

vessels and figurative forms. With his exceptional ability to use clay, minerals and fire, Peascod is self-reliant and self-motivated. His expertise and his experience allow him to fully explore the ceramics aesthetic in a free and unrestrained way making objects that are personal and inimitable. Numbers of his works, made in series, point to deficiencies in our social situations, for example the ego-inflated members of the teaching profession and the plight of their students. Peascod's work contains artistic integrity whether of vessel or sculptural form.

Concerned with social situations and making commentary on universal issues of feminism, Gudrun Klix, American-born Australian resident, works in both vessel and figurative ceramics. Her current work, using the boat form as a metaphor for a woman's body contains layers of meaning and the intention to inform our awareness of the position of women in society. Sandra Taylor, Bronwyn Kemp and Susan Ostling are ceramic artists concerned with portraying personal ideas of domesticity and the environment through sculptural objects. While Taylor looks to provide us with an insight into life in all its pathos through her colourful painted surfaces in high relief, Ostling sets the object in a situation that is remote from its original purpose making us look again at our history and our expectations of normalcy. Bronwyn Kemp has a diverse practice which ranges from the utilitarian to environmental works, using an equally wide range of techniques. All her works, however, have a sculptural quality that is both abstract and attractive in its tactility. Their concern is with the cultural environment, our identity and the references to life both domestic and abstract. Working in multiples, in small groups or in large installations, their work has a message for coping with life in the industrial age. Diogenes Farri, teacher and ceramic artist living in Sydney, works in large-scale pieces, often using coloured terra sigillata marking on the surface of his vessels. These works reflect the culture of his birth place, Chile, while at the same time, being contemporary statements about art, reality, emotion and his personal experience.

Many ceramists are on the internet and use it frequently and specific craft magazines go to most countries in the world. One can read about ceramic artists in distant parts at the turn of a page or the click of the computer mouse. A ceramics global network offers a free listing on the internet to all artists, schools,

Susan Ostling; Australian; *Acts and Experiences,* part of an installation of five pieces; 1995; Photograph by Rod Buchholz

galleries, suppliers, in fact all the makers and their support industry, a kind of telephone book of the ceramic arts. Artists themselves always seem to be on the move, studying here, exhibiting there, competing for prizes and joining workshop experiences in foreign locales. The artists mentioned in this text are working in a range of directions in contemporary ceramics and references to them can be seen in a number of international publications. Their concepts and objects are in balance. That they could practise anywhere in the world and produce the same style of work is perhaps possible but they also show an integration of their materials with their chosen environment. At the same time, these artists make reference to the factors that influence them, and their work demonstrates strong personal aesthetics expressed via the medium of ceramic art. Contemporary Antipodean ceramic artists, in line with their colleagues in the UK, North America, Europe and Japan, are working in an identifiable international yet personal style.

COPYRIGHT © 2002 JANET MANSFIELD.

15 · SHARED TERRITORY AND CONTESTED SPACES: AN ANTHROPOLOGICAL PERSPECTIVE

Carol E. Mayer

MY cultural upbringing taught me that being British was all I needed to know about my ethnicity. Nationalism was better known as unquestioned patriotism, and internationalism or 'advocacy of interest among nations'[1] was uninteresting because during my youth I was never exposed to the other. I emigrated to Canada in 1970. There, people ask me where I am from, and 'England' is not always a sufficient reply, people want to know my ancestral roots. After some research I discovered Irish and French ancestors. These more defined roots seem to satisfy a Canadians' need to situate me within a cultural/historical framework. I begin to understand this need when my son, who was born in Canada, asks what part of him is English. My answers lie in the memories I can pass on to him about his ancestors, and in stories about history and beliefs that I think are culturally important. He will decide what to retain, what to discard, and what to combine with his Canadian identity.

I have chosen to confine this discussion to Canada – because I live here and know it better than other places. Ethnicity and nationalism are zones of complexity, contention and uncertainty. Other 'new' countries, such as Australia and New Zealand, have similar zones where indigenous and immigrant populations are struggling to claim or establish their cultural identity in the post-colonial era. As an anthropologist I recognise that I do not have the right or authority to speak for others and recognise also that the validity of what I might report is dependent on my ability to be objective. Even within the grand anthropological tradition of participation and observation, it cannot be denied that an observer becomes on some level a participant, and participation is seen as analogous with subjectivity. I argue that as long as this participatory role is recognised and recorded it can provide a platform for critical response.

My approach is guided by conversations, the telling of stories, the passing on of oral traditions. In our museums we are yet to realise that material objects and their stories are culturally inseparable, yet we separate them. Life can be told like a story. The objects that we make and keep are the triggers for the narrative that tells us what to believe in, how to behave, what is right and what is wrong. I can show my son the blanket that his English nana knitted and I can tell him stories about her world, how the blanket was passed to my mother and then to me. Without the stories, it is just a fine example of a knitted wool blanket from around 1920. Without the blanket it is a story with no illustration.

This 'story' begins with a description of this place as it is commonly viewed from the outside. Canada is the second largest country in the world – it takes four days by train to travel from west to east, it has enviable natural resources that include one fifth of the world's fresh water. It does not, however, have a huge population – approximately three people per square kilometre (in Britain there are 238 people per square kilometre). Communities and regions are physically isolated, and the population of about 30 million is stretched mainly along the border with the United States, and clumped in the Central Canadian provinces of Ontario and Quebec. The political and legal systems are inherited from Britain. The United Nations Human Development Index cites Canada as the most desirable place in the world to live, and Vancouver the most desirable city. Add to this

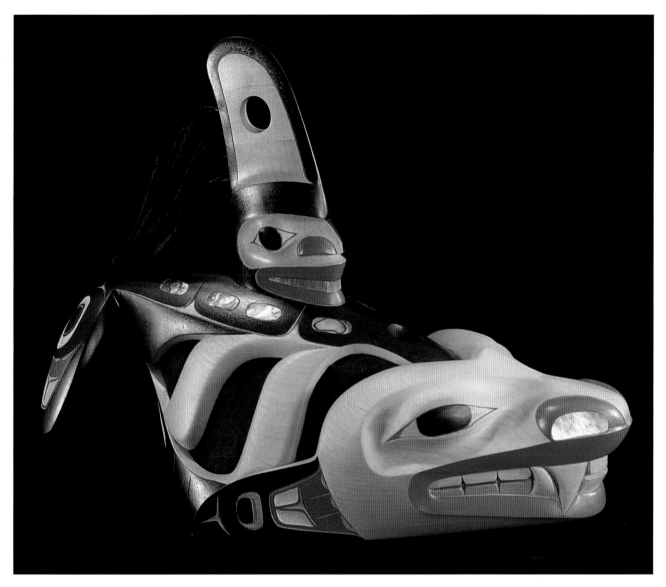

Dempsey Bob; Canadian; *Killer Whale Headdress*; alder wood, abalone; 1987; Courtesy University of British Columbia, Museum of Anthropology; Photograph by Bill McLennan

'Mounties, biculturalism and slightly boring decency'[2] and the external picture is fairly complete. No mention here of contention and uncertainty.

A view from the inside might reveal that Canada can equally be defined by what it is not, that is, it is not European and it is not American. Canada has a diverse population that is known as First Nations, those whose oral history tells them they have always been here, and Second Nations (my term), those who remember coming from other places. Both have contributed to the repertoire of arts and crafts that can be identified as conceptually Canadian – that is they are from and of this place that was named Canada[3] by the Second Nations. They have separate and shared histories, and have very different ideas about ethnicity, nationalism or internationalism. I chose to read about, and whenever possible speak to, craftspeople (or artists, if that is how they named themselves) from both 'nations' who, except for one, live in British Columbia.

Obviously this was not to be a pursuit of a universal reality – the American paradigm of the cultural melting pot has not done well here. Consequently, when selecting my language of description I knew the term 'Second Nations' could be viewed as an allusion to post-colonial political correctness. I argue that it is an appropriate term that satisfies those who have been here for many generations and object to being named 'immigrants'. When selecting ten craftspeople I looked for works that

Judson Beaumont; Canadian; *Teah*, maple veneer, fibreboard; 1998; Photograph KM Studios

articulated an awareness of identity that could lead me to perhaps discover evidence of cultural opposition and commonality. The materials used by these ten craftspeople include wood, metal, fibre and clay.

Working primarily in wood Dempsey Bob, Tahltan/Tlingit, creates carvings, such as the Whale headdress illustrated (see p.161), that have a distinctive personal style yet remain recognisably Tahltan/Tlingit. Dempsey Bob lives in Prince Rupert. Judson Beaumont was born in Saskatoon, Saskatchewan. He also works primarily in wood but will use any material that suits his purpose. His cartoon-like furniture illustrated here is playful yet underpinned with a deeply sophisticated sense of craftsmanship. He lives in Burnaby. Richard Sumner, Kwakwaka'wakw, is a maker of bent wood boxes. These steam bent containers are the traditional holders of regalia and wealth and there is nothing playful about them. Making them requires a high level of technical virtuosity, and Richard Sumner is considered one of the best craftspeople working in this area. The box illustrated is incised and meticulously painted with a 'typical' Northwest Coast design. Richard lives on Salt Spring Island.

Lyle Wilson works in wood and metal. He is also an accomplished painter and printmaker. Born in Kitamaat, Lyle is a member of the Haisla Nation and is currently artist in residence at the Museum of Anthropology, Vancouver. Lyle also experiments with different media, his designs have been applied to both ceramics and glass. The images on his silver work are often based on stories that he remembers or is told (see pp.164 and 165). Lyle lives in Vancouver. Jeff de Boer was born in Calgary, Alberta. His many visits to see the Japanese and European armour at the Glenbow museum started his fascination with metal. His workmanship is extremely fine yet can be viewed as playful, and he has been referred to as a poet-craftsman.

Laura Wee Lay Laq, Kwakwaka'wakw/Salish, works with clay. Her hand-built vessels are characterised by a perfection of form that is complemented by painstakingly burnished surfaces (see p.167). She lives in Vancouver. Rachelle Chinnery is also a hand-builder. The environment and her experiences of Northwest Coast art influence the carved surfaces of her clay pieces. The piece illustrated on p.168 also references the influences of the ancient Jomon pottery of Japan.[4] She lives in Vancouver. Paul Mathieu was born in Quebec. He works primarily in clay but will utilise other materials when appropriate. His work challenges existing categories, defies being described within one genre and stands in

opposition to any attempts to be situated within a Canadian context. The piece illustrated (see p.169) effectively 'puns the deification of works of art as receptacles of cultural value'.[5] Paul lives in Vancouver.

Ruth Jones was born in Ottawa. She is an accomplished tapestry artist who works in the Aubusson tradition. As a weaver she feels she has a commonality with all weavers of all nations, especially those of the Northwest Coast who, she says, 'look at me as someone who is practising a craft that is part of their tradition as well'. One of her tapestries is on permanent display at the Museum of Anthropology. The one illustrated on page 170 is her most recent work. Ruth lives in Vancouver. Debra Sparrow and her sister Robyn are Salish weavers who have spent many years reviving the weaving traditions of the First Nation's Musqueam people, lost generations ago. Their pieces are in much demand for ceremonial occasions.[6] Debra and Robyn live on the Musqueam Reserve, Vancouver (see p.171).

In the Northwest Coast, First Nations individuals normally identify themselves by Nation ('I am Haisla') and describe themselves as a member of a community '....from Kitamaat'. This situating of self is a declaration of ethnicity, although the word is not part of First Nations' vocabulary. There are also very few words for art, or craft, because what is made is so integrated with all aspects of life that it should not be separated out for individual inspection. This may happen when pieces are sold on the market and displayed in museums and galleries, but such pieces are viewed as culturally disconnected – they have no ethnicity. In the community, masks and regalia are danced during ceremonial occasions, but only by those who own the rights to do so. The making of Northwest Coast art nearly stopped for a while when colonial administrators forbade the associated ceremonies. The elders kept some of the memories and stories, others were locked into the objects that in turn were locked in museums. The practice of Salish weaving for example virtually ceased for two or three generations. When Debra and Robyn Sparrow decided to revive it they had to go to museums to examine the only surviving examples. Debra Sparrow says: 'At the beginning we had no one to ask but our own inspiration'. After much trial and error Debra and her sister have developed the art of weaving to a high art form. 'What we are doing is still traditional, but it is contemporary ...' It's not art as you know it. It is a lifestyle we know.'[7]

Haisla artist Lyle Wilson grew up in a community where the knowledge of traditional art techniques had not disappeared.

Richard Sumner; Canadian; *Box*; yellow cedar, red cedar base and lid; 1998; Photograph KM Studios

I remember working with wood all the time, chopped wood, sawed wood, smoked wood. I used to watch my grandfather, he used to know how to make things, he had an old knife, he had a wood stove so in order to start a fire he would take a hunk of cedar and shave it until he created these flower shapes used for kindling. I used to watch him and I never forgot it. One year this old guy was making a canoe down at the beach and I used to watch him on the way to school. I did woodwork at high school. [Wood] feels really nice, almost a psychological comfort level – smell, feel, touch, warmth.

This learning from elders is part of the cultural life of the Northwest Coast First Nations. Elders teach the young to respect the family, the land, and the environment, and to share knowledge. Respect for elders is paramount, they hold the stories and keep the memories alive.[8] Richard Sumner was taught by Doug Cranmer, a Kwakwakaw'wakw artist who is now an elder. Doug in turn worked alongside the great Haida artist Bill Reid.[9] Dempsey Bob dedicates his art to the ancestors who influenced him as an artist.

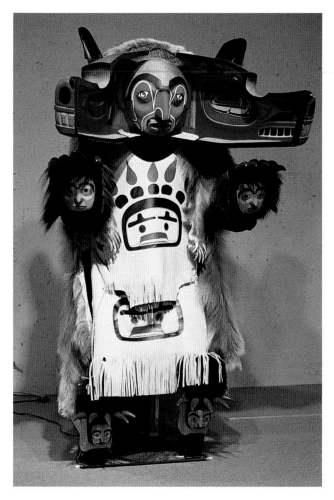

Lyle Wilson; Canadian; *Transforming Grizzly Bear Human*; wood, fur, paint, robotics, h.ca.7'; 1991; Commissioned by the British Columbia Government as part of the B.C. exhibition in the Canada Pavilion for Expo '92, Seville, Spain

My Grandmother's father and mother both had artistic abilities ... My mother, Flossie, and my Grandmother, Julia Carlick, were both beaders and sewers ... My grandmother's uncle was a gold and silversmith as well as an artist. The art has been in my family for generations and will continue to be from my teachings to the young.[10]

There is a mistaken impression that all First Nations artists work within strict traditional limitations – the ethnographic present has not yet departed. I have included Laura Wee Lay Laq not only because her work is excellent but also because she has chosen to work outside the traditional Northwest Coast media and imagery. This does not rob her of any ethnicity. Like many other First Nations artists she works within a powerful spiritual aura that includes a deep respect for the environment.

However, any contemporary First Nations artists producing 'non native' work might find themselves competing for gallery space with established and emerging Second Nations artists. Many in the European-based culture seek a prescribed 'authenticity' in First Nations' art and some have difficulty categorising artists who work outside that authenticity. Others, such as Paul Mathieu, are less concerned. 'I think we have to rethink how we place things. You can look at the limitations of the human desire to categorise and I hope that we move beyond those kinds of things – it might help you understand but it might also prevent you from understanding ...' Images of cultural and environmental abuse by early settlers are frequent in these new works, giving voice to the anger and sense of loss felt by many First Nations' people. These sometimes-difficult images exacerbate a legacy of collective guilt felt by the very market being targeted, especially those constituents who descend from the early settlers. This is art that is difficult to situate in an art world where the only niche available for First Nations' art is taken by works of a 'traditional' nature. Then there are those Second Nations' artists who replicate this 'traditional' First Nations' art. They too enter a contested terrain with fairly well-patrolled borders. Not only are they ignoring issues of ownership, rights and ethnicity but they are also encroaching on a lucrative market. Any reading of Canadian history will leave no doubt about First Nations' concepts of ownership of their own art. 'It's a sensitive subject' says Lyle Wilson. 'It's not just art or the history of settlement. Things happened so fast and most native people feel cheated out of land that has been mapped as theirs. Art is something that should be kept to themselves.' Critiquing of actual works is sometimes affected by an uneasiness about the artists' cultural origins – ethnicities. This shifting and contentious ground is yet to be shared with comfort.

All the Second Nations craftspeople illustrated in this chapter were born in Canada, and attended school in Canada and elsewhere.[11] Their ancestors were European. I wanted to find out whether their Canadian ethnicity was rooted in European cultures or whether they were examples of a new cultural hybridity that could be named Canadian. Any discussion about ethnicity or nationalism is not complete without recognising that separation and separateness are conceptual constants in Canada. The cultures of Canada celebrate their distinctness and worry about their unity. This angst has given rise to self-determination movements, well illustrated by the First Nations Treaty negotiations and the repeated separatist referendums in Quebec. There are

also sovereignty movements that advocate a united Canada. An editorial in the *Financial Times* of London, 1995, said 'If tolerant Canada cannot share power across a linguistic divide, what hope is there for more bitterly riven societies?'[12]

This view from the outside belies the conflict within. Rachelle Chinnery who was born in Quebec says,

> I believe we have an emotional buoyancy, you're never one place or another, you have no particular allegiance yet whenever there's a referendum people get really upset, the whole country is upset that this should even be questioned – are we so afraid that if one piece breaks off then the rest will follow and then we'll have nothing? Maybe that's what binds us.

Quebec is isolated by language and many Francophones[13] know they will not be understood when they leave the province. Those who do leave encounter an Anglophone[14] world that is culturally different, yet also called Canadian. The issues are complex and contentious. Do they affect the work produced by a craftsperson? Paul Mathieu who is from Bouchette in Quebec says:

> The concept of nationalism is to me very uninteresting ... I don't see any national connection or identity in my work at all It is an accident of birth that I was born here. I feel that the traditions of pre-Columbian America or China are mine as much as if I were born there. I can understand those objects and I use those materials. I create forms that are basically very similar that play within the cultural role and it hasn't changed that much – maybe not at all, except stylistically – but that's superficial ... so they're mine.

Ruth Jones says simply, 'I'd like Canada to stay together. I'd like Canada to feel like a Nation.' I looked at the works of Rachelle Chinnery, Ruth Jones and Paul Mathieu and there was a dearth of visual similarities. Paul talked about his association with a few other gay male potters. 'My country is more Leopold (Foulem) and Richard (Milette) I feel more connected to [them] because we share a number of things beyond geography and language.'[15]

This is a specific environment that he has chosen and it informs his work. He creates images that together address serious issues such as sexuality and engenderment, the hierarchies of medium, and the canonisation of works of art as alembics of cultural values. Rachelle

Lyle Wilson; Canadian; *The Lonely Salmon*; silver; 1998; Courtesy University of British Columbia, Museum of Anthropology; Photograph by Bill McLennan

Chinnery's work is a more visually accessible reference to the environment.

> I see [the surfaces on my work] as coming from nature, from the eddies in the water ... the patterns in a tree ... or volcanic patterns in rock ... If you look at the beach you can see where the Haida patterns come from They are obviously influenced by their environment, I was influenced by their environment and so there might be a visual crossover.

Ruth Jones' tapestry *The Golden Spruce: The Fall of the Profit* (see p.170) tells a story that makes an even more specific reference to an environmental issue.

> This piece was inspired by a church in the Queen Charlotte Islands. I was taken by my best friend to see the Golden Spruce that was revered by the Haida Nation, visited by busloads of tourists, and very well known to the local population. A few years after I had visited it and was awed by it I heard that it had been cut down by a man who was making a political statement against the people who revered it. I was immediately struck by the similarity between the crucifixion of Christ and the chopping down of this tree – both being beautiful healing forces in the world that were rejected by the people that they could have helped or healed I say it's Christ and he has a lumberjack tartan around his loins. Some will say it is a logger and the environmental movement is crucifying loggers, and the environmental movement is Christ and the tree was chopped down by a logger, so the environmental movement is being deified because of the power of the

logging industry. My ultimate goal in the piece is to make peace between the powerful expropriative force that has given us all wealth, made us all prosperous, and the quiet volunteer movement of the environmentalists that is waking us up to the fact that if you don't stop now you're all headed towards calamity ...

This tapestry is as much a political statement as it is a supreme example of technical virtuosity, something she may have inherited from her great great uncle Edward Burne-Jones, the Pre-Raphaelite painter and tapestry designer. Laura Wee Lay Laq in a gentler frame of mind refers to the memories of the essence held in 'the tautness of a pod, the soft unfurling of a mountain range'.[16]

Dempsey Bob responded to an oil spill by incorporating black into a panel design, black being the oil on the waters and inside the salmon, symbolising death. He looks to the spiritual world for solutions 'What I thought is that Raven is going to have to come again, and bring the salmon back'.[17]

The shrinking salmon stock affects everybody on the West Coast and is an issue that divides the First and Second Nations' fishers. The story on Lyle Wilson's bracelet *The Lonely Salmon* is illuminating.

The silver bracelet is a sum of a lot of years of life. The idea came to me when I was way out in a seine boat. It's a big boat and takes a lot of money to run. Every set is a huge net and it takes a lot of hours and five guys – so if you don't get a certain number of fish you are losing hand over fist. Once we only caught one fish and the captain said, 'that's a lonely salmon'. Other times all we caught was a lot of water. Each year we got progressively less fishing time and less fish, and I was thinking about this when I decided to make that bracelet. We depend on fish on a personal level. When I grew up I ate fish for breakfast, lunch and supper and yet in a commercial sense, a lot of native people are literally out there destroying what we have depended on for centuries. We are trapped and yet never question what we are doing. So when I started doing the bracelet the words of my captain came out of my mouth, 'lonely salmon'. I wanted it to look decorative yet the message has an edge to it.

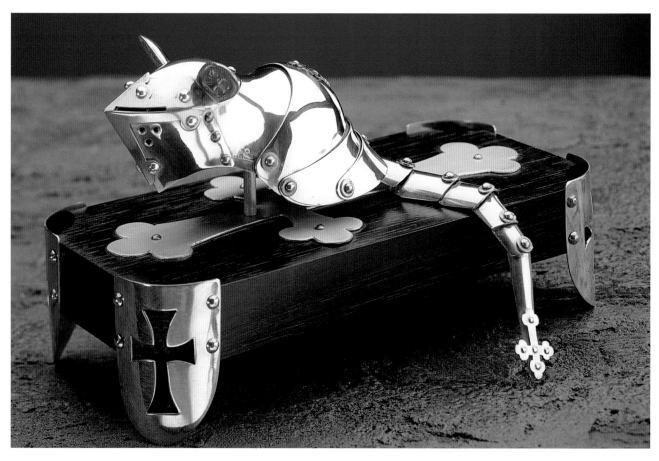

Jeff de Boer; Canadian; *12th Century Knight Templar Mouse*; nickel, brass, aluminium; 1998; Photograph KM Studios

Jeff de Boer spent some of his childhood amongst the antique European and Japanese armour at the Glenbow museum in Calgary.

> I was attracted to the tremendous energy that exists in an armoured structure, this container for some worthy individual or some creature You look at these objects, and even though they're not moving, you automatically respond to them with images and thoughts about what they do or what they might have done.[18]

He started to produce armour for cats and mice – Japanese Samurai for cats and Mediaeval European for mice. The natural aggression between these two became the subject for his cultural artefacts that sport a mantle of humour that lightly conceals ideas about human history, chivalry, vulnerability, courtesy and respect. He is lauded for his superb craftsmanship, and the fact that the armour would function if he could persuade a cat or a mouse to wear it. Function and humour are paramount to furniture maker Judson Beaumont. His inspiration comes from American cartoons that he watched as a child. He has assimilated and reconfigured the images to make them into objects that he has not seen elsewhere. 'Therefore', he says, '...they must be Canadian.' He goes on to say

> I don't think I could be just a painter – I'm amazed to see a guy making a living at painting a picture – it's on a flat surface, on canvas and you mix a bunch of colours and you paint a beautiful picture. Me, I have to make something. I couldn't make a big sculpture without it functioning in some way – I'd put a drawer in it somewhere! I want my stuff to be very functional I do craft.[19]

So is there a shared cultural hybridity that includes humour, environment, functionality? Just as Canadians live with the complex issues relating to Quebec separatist movements and First Nations Treaty negotiations they also enjoy a complex relationship with the United States with whom they share the longest undefended border in the world. The two nations are joined politically, economically, and geographically and some would

Laura Wee Lay Laq; Canadian; *Olla*; earthenware; 1991; Photograph KM Studios

Rachelle Chinnery; Canadian; *Memory of Evolution*; clay; 1998; Photograph KM Studios

is still there but he now chooses not to worry about it too much. '... you have 70-80 years on this earth and so you do what you do to make you happy – I like to carve.'

Those Canadians that I have described as Second Nations keep themselves separate from the United States by an interesting combination of irony and humour. The stereotypical American tourist who expects to encounter igloos, ice and Mounties as soon as the border is crossed amuses them (sort of). This way of seeing reinforces a sense of cultural separateness. However, the lack of critical mass forces Canadian craftspeople to head south to the larger market. When they gain fame in the United States, other Canadians are surprised and Americans think they must be American. Canadians are celebrated in the States in a way they are not celebrated in Canada, and some Canadians are willing to be called American if that's what it takes to succeed. Canadians do not hold their hearts when they sing their National Anthem, or more correctly either of their two official National Anthems (depending on where they might be or what the occasion is). There are a number of inside jokes: Former Ontario premier David Peterson said, 'The thing that keeps this great country together is that everybody hates Ontario; and the thing that keeps Ontario together is that everybody hates Toronto ...'.[20] Others may argue that the glue is supplied by the need to have a unified front against becoming absorbed by America.

A story that seems to put it all in perspective, for Canadians, has been circulating on various e-mail lists. It tells of an exchange that took place off the coast of Newfoundland, Canada, involving a US Navy vessel. This happened, so the story goes, in 1994.

US: Please divert your course 15 degrees to the north to avoid a collision.
CAN: Recommend you divert YOUR course 15 degrees to the south to avoid a collision
US: This is the Captain of a US Navy Ship. I say again, divert your course.
CAN: No. I say again, you divert YOUR course.
US: This is the battleship USS Missouri. WE ARE A LARGE WARSHIP OF THE US NAVY. DIVERT YOUR COURSE NOW.
CAN: This is a lighthouse. Your call.[21]

say culturally. Most First Nations artists do not think about this very much, they are securely focused on their communities and the continuance of their own cultural heritage. Canada and the United States are constructs that exist outside their cultural arena and they do not participate enthusiastically in expressions of nationalism. Lyle Wilson remembers his high school days when some First Nations children would congregate together, refuse to sing or stand for the national anthem, their message being '... we're here but we're not here'. The gulf

Like this lighthouse keeper, craftspeople refuse to be intimidated by the larger American culture. In his book, *Borderlands*, the author William New says, 'Canadian art persists because people desire to hear the plural

voices of their compatriates and celebrate their own social alternatives.'[22]

Arms length financial support for the arts has been available from the Canada Council since 1958. This is a concrete recognition of the cultural value of the arts. New continues:

> I think ... that we do have enough faith in ourselves that we support the arts, for the arts are the enter-prises through which we express, to ourselves and to the world, our insights into our own society, our capacity to criticise and to celebrate, our aspirations and regrets and the meanings we attach to the bor-derlands of what we understand.[23]

The Canada Council did not extend this faith to First Nations' art until recently. There was no category for 'aboriginal art'. It was considered ethnographic and therefore to be funded by the Museum Assistance Programme (MAP). Unfortunately MAP only funded historical projects so the contemporary First Nations' artist was left out of the system. It took lobbying from many artists and their supporters to persuade Canada Council to recognise that its concept of the art world needed to be adjusted, it was time to embrace First Nations' art.

Robert Joseph, Kwakwaka'wakw elder, talks about the world as a place that 'breaks down into four realms – the Sky World, the Undersea World, the Mortal World and the Spirit World. Ancient voices ...' he says, '... spoke of a time when the world was one, indicating absolute acknowledgment of the interconnections between those four dimensions.'[24]

This is a world of established realms, a conceptual world that exists alongside one of contested borders. Communication technology enables us to ignore these borders and absorb, borrow, take ownership of what was once not accessible. 'Everything in the world is becoming the same – there's always a McDonalds' says Lyle Wilson. 'Yet ... if you come to British Columbia ... there is some-thing that is tangibly from [here] and you won't find it anywhere else in the world ... the Northwest Coast look is unique and I haven't seen it anywhere. ...' Certainly the works of Richard Sumner and Dempsey Bob could never be presumed to be from elsewhere – they enter the inter-national scene secure in their identity. However some Northwest Coast artists do see similarities between elements of their work and other sculptural styles. Lyle Wilson can look at an ovoid eye form on a carving and wonder '... is that a Byzantine eyeball I see?' Debra

Paul Mathieu; Canadian; *Soil/Flower Vase*; ceramics, bronze, steel; 1998; Photograph KM Studios

Ruth Jones; Canadian; *The Golden Spruce: Descending from the Profit*; tapestry, wool, silk; 1999; Photograph KM Studios

Sparrow when choosing an object for a recent exhibition surprised the curator by choosing a Ketongan slit gong drum from Western Indonesia.[25]

> ... I chose this piece for its visual beauty, its spirit and its similarity to Coast Salish designs. This piece verifies for me what I have always thought – that design is universal. I believe that where the spirit is moved, the creative process follows.[26]

Rachelle Chinnery, influenced by the forms and surface decorations of the early Jomon pottery of Japan, sees similarities between their surface patterns and the natural patterns found in the trailings on the beaches of British Columbia. She finds the same patterns in Haida art. 'Maybe it's because they both live on coasts, both by the water – perhaps a shared perception of isolation.' Yet she says her pieces have 'no belonging' because they are a unification of cultural, geographical, physical and spiritual influences from many places. Paul Mathieu takes a broader stance. He refers to '... Paul Greenhalgh [who coined the phrase] "conceptual constant". That is, when you make a bowl, you are not making anything new – your bowl is conceptually identical to a bowl made 10,000 years ago, the idea hasn't changed, it always remains the same.' He argues that any bowl he may make is therefore connected to all the bowls that have ever been made. Perhaps it is these references that link crafts together, perhaps there are conceptual constants that exist in materials other than ceramics. Is this what Ruth Jones is referring to when she says '... if I go to Romania I am greeted with open arms by anybody who is working with traditional crafts and they see me as one of their own ... because I've found something that any culture can relate to, and I can storytell in a language that anyone can relate to ...'

There is certainly good reason to suppose that Judson Beaumont's furniture has an international flavour – it is influenced by American cartoons such as Bugs Bunny and Roger Rabbit, available wherever there is a television set. 'When I show my work up here everybody says "that's very amusing Judd" it puts a smile on their faces. Down in the States they're thinking "I can make money off this guy." Right away they're thinking business.' Americans, he says, are very surprised to find out that he comes from Canada, and that he also sells his work in Mexico. He detects a shared sense of humour between his work and Jeff de Boer's: 'Well we both do fun stuff! I can see playful things that are amusing and beautifully made.' Jeff de Boer has the last word. 'I opened up my eyes and looked at the world and realized it was all one

Debra and Robyn Sparrow; Canadian; *Weaving*; wool; 1992; Courtesy University of British Columbia, Museum of Anthropology; Photograph by Bill McLennan

thing. The whole world is one thing – and I had found my one equation – enlightenment. The equation was 1+1=3. And that was 1986. I made my first mouse.'

Conversations, memories and stories are at the heart of how First and Second Nations craftspeople construct their notions of ethnicity, nationalism and internationalism. John Gray, a Vancouver-based playwright and critic calls Canada '... an internally generated vision, a collective work of art ... an existential fable, a poem, packed with personal questions.'[27]

I look at the craftspeople that occupy this place called Canada as constituents of a cultural hybridity in process. They simultaneously share and contest the same space, they visually influence each other by 'vaulting across categories structured in language'.[28]

They are separate, yet influences show up as partial communication. Their work underlines an ongoing negotiation of different histories and ethnicities that will continue to inform our present and construct our future – like nana's blanket.

COPYRIGHT © 2002 CAROLE MAYER.

NOTES

1. *Oxford Dictionary of Current English*

2. *Financial Times*, 1995. Quoted in Olive D., 'Canada Inside Out', p.222.

3. The name Canada originates from the Huron-Iroquois word 'kanata' meaning 'village' or 'settlement.'

4. Jomon pottery dates from 11,000 BC to 300 BC. It is typically handbuilt, unglazed, narrow at the base and wide at the rim. The rim is sometimes carved into elaborate natural forms that resemble the flames of a fire.

5. Quoted by B.H. Russell, *The Pottery of Mathieu*, p.4

6. Weavings by Debra and Robyn Sparrow are also held in collections at the UBC Museum of Anthropology.

7. Quoted by Grant Arnold in *Topographies: Aspects of Recent B.C. Art*, p.119

8. As described by Thomas Berger in Marjorie Halpin's book *Jack Shadbolt and the Coastal Indian Image*

9. Richard Sumner was greatly honoured to be asked to make Bill Reid's burial box. Bill Reid died in 1997.

10. Quoted in the exhibition catalogue *Dempsey Bob: Tahltan-Tlingit Carver of the Wolf Clan*, n.d., p.3

11. Jeff de Boer went to the Alberta School of Art, Calgary, Judson Beaumont attended the Emily Carr Institute of Art and Design, Vancouver, Ruth Jones attended the Aubusson School of Tapestry, France, Rachelle Chinnery studied in Japan and at the Emily Carr Institute of Art and Design, Paul Mathieu studied at schools in Montreal, Calgary, Banff, Stoke-on-Trent (England), Los Angeles and San Francisco.

12. In Olive, p.222.

13. In Canada people who view French as their primary language are called Francophones.

14. People who view English as their primary language are called Anglophones.

15. Leopold Foulem and Richard Milette are gay men who embrace clay as 'a medium denigrated as effete and superficial ... [they] explore their own social status as gay men and as artists in contestation of received social roles', B.H. Russell p.4., op.cit.

16. Quoted in C.E. Mayer, *The Potter's Art*, 1997, p.134.

17. Quoted in P. Vernon, *Dempsey Bob: A Portrait of a Contemporary Native Artist*, p.7.

18. Quoted by Carol Sheehan in *Articulation* (no page numbers).

19. Judson Beaumont wants to make his work more accessible and affordable. His limited editions are available to those who can afford them, but he is also now working with furniture manufacturers to design and produce a line of children's furniture that will be more affordable and widely available.

20. Quoted in David Olive, *Canada Inside Out*, 1996, p.86.

21. Quoted in William New, *Borderlands*, p.68

22. Quoted in W. New, ibid., p.49.

23. Quoted in W. New, ibid., pp.101-102

24. Quoted in Peter Macnair, *Down from the Shimmering Sky: Masks of the Northwest Coast*, p.18.

25. First Nations' artists and friends were asked to select an object from the Museum of Anthropology's collection for the exhibition 'Exhibit A: Objects of Intrigue'. All the other First Nations' people chose objects from their own cultures.

26. Quoted in J. Webb, 1999. p.37.

27. Quoted in W. New, ibid., p.68.

28. Allison Glenn, *Speaking in Circles, Throwing in a Straight Line*, unpublished paper presented at Fireworks '94 conference. 1994, p.6.

16 · INTELLECTUAL COLONIALISM: POST-WAR AVANT-GARDE JEWELLERY

Simon Fraser

IN order to discuss the idea of an avant-garde in contemporary jewellery over the years, it is important to look at some of the ideas that surround the making of self-consciously 'modern ornaments'.

These include the relationship of Modernism to ornament as a framework for the creation of objects to decorate the body.

If artists in an avant-garde lead a cultural field and impact widely upon it, then one has to question if individuals could be seen to be occupying such a position in jewellery, given the understated impact of self-consciously 'modern' jewellers on the wider practice of traditionally inspired jewellery. This is especially true as the latter is predicated around precious materials and the uninterrupted historical and internationally recognised languages relating to that.

One could perhaps argue that the entire studio jewellery project still represents an avant-garde in its own right or conversely just a cul-de-sac! Certainly if the consumption of outsider ideas as exciting to a larger mainstream audience spells the end of an avant-garde, then this has not happened. If, perhaps, 'studio jewellery was made for the liberal intellectual fringe of the American and European middle classes',[1] this tight focus on one value system might explain its failure to broaden its appeal to others ...Yet!

It would seem to the casual onlooker that the period 1967 to 1987 showed an immense flowering of such work. I will seek to show that the roots of such activity lay in an adaptation of ideas and frameworks from Modernist architects and fine artists and also from the 19th century interest in ethnography and ethnic artifacts embraced by 20th century fine artists. With the breaking free from their original 19th century meanings the words 'primitive' and 'fetish' were to become adaptable inspirations for many 20th century makers.

In Europe certainly, the Modernist 'tradition'[2] allowed objects called jewellery to describe and invent new physical languages and expressions. Strongly to the forefront was a rejection of traditional jewellery materials, iconography and even modes of wearing. I was as enthusiastic as others, and expressed my enthusiasm through the exploration of nylon as a material for jewellery. I became more preoccupied as the 1980s progressed with how much we were afraid to approach and appropriate the historical symbols of jewellery. Although many contemporary makers viewed these as redundant during the 1970s and 1980s, they are in fact at the core of most occidental peoples' understanding of the word 'jewellery'. How were we ever to change these things if we didn't engage with them? Clearly, it seemed time to engage with crowns and collars, to be unafraid and to remake them in our own images and for our own purposes.

It was, and still is, interesting to me to make objects where cultural redundancy is used to recreate the structure of an object and to make a new item from this. What I mean by culturally redundant objects, are objects which have served their purpose, superseded by time and innovation, but still have an emotionally potent place within a culture.

For me, diamonds or saints' relics are such. If one takes royalty as a value system, who actually wears a crown today and is aware of the object ritually and emotionally as when historically worn? Then, it was the physical manifestation of royal status both publicly and personally for those who wore it. Now, however hard one tries to believe it, in a modern constituted state, power resides elsewhere, no longer in the object. It has become 'drag' in the widest sense of that term, both heterosexual and gay. It seems interesting to me that

within the milieu of contemporary jewellers that the serious exploration of cultural icons such as crowns has been seen as retrogressive, even as simple minded.[3] Perhaps to make such items suggested a lack of contemporary identity?

It is always difficult to make items in a field where objects have been made for millennia and still exist. Hence, museum collections of Egyptian jewellery can still exert a powerful hold through a formalised set of cultural values apart from the material value of the gold and gems that embody them.

As Modernist thinking helped to examine new ways of creating objects to wear and new ways to locate them on the body, there was also interest in what materials could achieve. It was this interest which led to the examination of the role of precious materials. Although this led to an examination of gold, it was and is still, apparently acceptable to use the material with all its cultural baggage to make objects representative of our time. During the high Modernist period the remaking of the cultural icons of jewellery history was not open for examination.

In an analogous way to clothing, jewellery is, in its own way, unique as a repository of cultural ideas and fashions. Curiously it is this afterlife as far as a maker is concerned which has been the least self-consciously examined by jewellery artists.

Alchemy with a Piano was a jewellery performance at the ICA (the Institute of Contemporary Arts, London) which I staged in 1991. During it, a piano was taken apart into its constituent elements, which were then used, over a period of 24 hours, to compose pieces of jewellery. As an investigation of the multiple relationships between jewellery and performance, it was a deliberate 'act' to occupy theatrical space with the performance itself. In a similar form, during the 1980s an explosion of creativity occurred under the framework of 'physical theatre', particularly in Britain, good examples would be *Theater de Complicite* or *Rose English*.

I was always interested to watch how simple familiar props were transformed into exciting imaginary objects. The task of transformation, perhaps even transmutation, is something which jewellers achieve with their familiar metal and other materials every working day. I became interested in occupying theatrical space with 'real' (in a jeweller's definition) objects and using a theatrical time-scale to structure and examine the process of making objects for people to wear. I needed a beginning and a material source which had strong cultural resonance and yet provided a multitude of making possibilities. The upright domestic piano provided the perfect object with its multitude of crafted elements and redundant cultural associations of family singsongs, desperate good taste and cultural guilt. I also like the way that pianos have a sense of the body about them. It makes immediate sense to talk about the carcass of a piano.

Jewellers are always working with, on, around or against the sculptural form of the body. It is our arena. There is in many art forms an attempt to exclude the audience or consumer from the actual event of making. From this point, the creation of jewellery is no different with its historical guilds promising to 'uphold the mysteries of the craft' i.e., don't show or tell! Paradoxically, I remain convinced that to show what we actually do makes us stronger. We have moved as a culture from the position of one where the artist dictates and the audience's job is to accept unquestioningly to one where there is accepted cognisant participation on the part of the viewer. Consequently, during *Alchemy* improvisation and experimentation on the part of the 'performers', Peter Fountain, Gillian Salmon and myself joined with input from our audiences' actions and interactions. This is a welcome part of the process. Although there were many jewellers in the audience over the 24 hours many other professionally creative people took part alongside others who had no formal or technical training or history of making.

Tracing modern jewellery, an idea which detonated in America in the 1930s before the impetus moved across to Europe and the Netherlands in particular, means we are looking at a wide range of pieces of jewellery. There are, however, within this body of work key items which illustrate a genuine development of new objects in relationship to ornament. They do not all represent the same train of thought and indeed some are oppositional in their relationship. I am loath to state that these are key objects but they are informative in relation to this text. Much of this work is made from non-precious materials, consciously and deliberately. It is this choice which made the fundamental difference.

'Modern, and I know how contentious that word can be, but for the sake of this jewellery work I assume means non-traditional in form and the use of materials having no permanent value other than the work of the designer'[4] says Sarah Osborne, framing a purist view of the modernist jewellery project. She adds: 'Modern jewellery has so many ways to succeed or fail: as a shape, colour, material as the wearer's public expression of status/interests/taste/fashion; as consumer goods to be made, bought and sold by jewellers shops and galleries, living off it or through it as the final evidence of the jeweller's day to day, year to year work.'[5] This could be

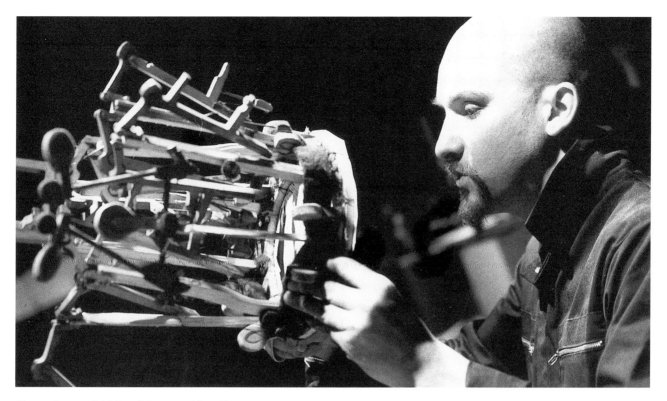

Simon Fraser; British; *Alchemy with a Piano*; 1991

accorded as a list to creators of any sort of contemporary wearables. The decision to avoid precious materials is framed by some of the arguments above but even beyond to earlier notions of luxury, difference and beauty.

The notion of beauty in European cultural history has been subject to endless changes by 'discoveries', a procedure taken for granted and perceived as natural among the inhabitants of Western societies post-Renaissance.

Particularly in jewellery but also in other mediums patterns from elsewhere were consumed and subsumed under the overarching framework of classical forms. The 19th century in Jewellery, beyond gold and historically precious materials, offered us a rich diversity of materials including contemporary substitutes. One was the use of pressed glass to substitute for the fashionable jet, but predominantly it offers us non-precious materials framed or decorated with traces of gold, for example, tortoise-shell filigreed with gold wire – the 'exotic' held in check by classicism. This 'civilised' the material and drew it, suitably codified, safely into the heart of European empires.

Contrary to this in wider intellectual life, the ideas and meanings of 'primitivism' and ethnicity were also under construction at this time with their roots interestingly close to 'fetish'. To make clear how this adoption and adaptation of ideas from other cultures went onto function in the 20th century, I would like to look at the words primitive, fetish, and ethnic in their late 19th century context.

Anne McClintoch discusses the various meanings of the word fetish and the primitive as being derived largely from theoretical constructions – notably Marxism and psychoanalysis – evolved at the beginning of the century.[6] She discusses how the ordering of religion (time and transcendence), money (economies) and sexuality (the body) arrange themselves around the social idea of racial fetishism, displacing what the modern imagination could not incorporate onto the invented domain of the primitive.

Enlightenment thinking and scientific rationalism allowed the separation of holistic frameworks into intellectual scales of cultural material values. Practices that Lucy Lippard notes are continuous in other frameworks: 'Only in Western culture are these things separated from each other, because many traditional cultures emphasise process over production while Western capitalism emphasises the commodity produced.'[7]

These fractures were one element that allowed the development of the rationalist modernism as a movement interested in the ideal of purity. Secretly, meanwhile, 'imperialism returned to haunt the enterprise of modernity as its concealed and central logic'.

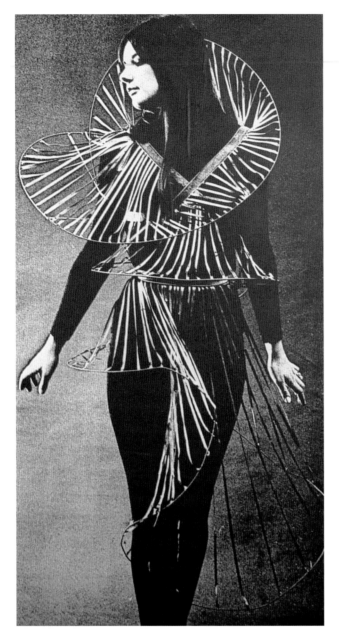

Susanna Heron, British; *Untitled*; legal ribbon and wire; 1969; life size

McClintoch discusses William Pietze's unpublished ideas about the historical semantics of fetishism which includes passages about the development of the word fetish. She notes that in the 15th century: 'Portuguese explorers along the coast of Africa used the word *feitico* to describe the mysterious amulets and ritual objects favoured by the African peoples (encountered) on their voyages.'[8] She goes on, 'The colonial fetish was thus neither proper to West African or European culture'.[9] Rather the fetish 'was a hybrid object which sprang from the abrupt encounter of racially heterogeneous cultures

during the era of mercantile capitalism and slavery'.[10] The change of identity of an object as it moves from one culture to another is important to my argument. When an object is allowed to float with a lack of contextual information and perceived cultural value to the recipient culture, it occupies a 'between' position. Whilst this space in reality can be the hold of a boat or a packing crate on a plane, the object effectively rids itself of its original meanings and becomes 'available' – witness the consumption of 'All-American' Coca-Cola in strongly Muslim countries.

The development of ethnographic collections as part of the great 19th century documentation drive has been part of the process and has had a lasting influence on makers wherever they place themselves in this culture. As a process, the reconfiguring of meaning for objects gained through trade or the interfacing or actions of empires is vital to the growth of the visual arts through adoption or assimilation. These gaps in sequential continuity are read as a given whole by Western eyes and it is in that seamlessness that ethnic jewellery becomes so fascinating to our jewellers. We read a picture of creative possibilities and lines of development, not the uniform, the requisite indication of identity, which such apparel is to the indigenous wearer. Hidden within the attractiveness of the ethnic and the primitive is also, for Western makers, a nostalgic longing for social certainty and the reflection of that in strong jewellery objects, countered by their casting as creative rebels within, of course, discrete bourgeois frameworks. This leaves the great museum collections, the greatest collations of cultures ever assembled, still available for consumption, just waiting for creative adoption of their possibilities.

Amongst the items on display, the amulet became the great tease to 20th century jewellers, largely separated as they were by non-belief from religious artifacts. Their interest became displaced outwards from the artifacts' content onto the body as a sculptural form and into a focus of making objects which occupied the spaces on or around such a form. This can be clearly be identified in Susanna Heron's piece from 1967 which alludes to both Tatlin's tower and the theatre pieces of Oscar Schlemmer during his time with the Bauhaus. Heron's work continued into pieces that she explains came out of her purely rationalist experiments. 'They were based on my discovery at Art College that a rigid circle can sit quite flat from the back of the neck, between the collar bone and shoulder to the chest.'[11]

This search for sculptural spaces to occupy on the body and how one might do that is helped enormously

by ethnography with its multi-cultural multi-disciplinary displays of just what can fit where.

H. Cunliffe-Charlesworth[12] has shown how foreign objects are perceived as rare and exotic, and which give us qualities of beauty. This can be seen, for example, in the adoption of Japanese art by many Post-Impressionist artists and of the sculptural planes of Fang and Pende masks used by Picasso in 'Les Demoiselles D'Avignon'. Access to such sources was facilitated by French imperial conquest.

These occupy an especially secure niche as practitioners of the Fine Arts swooped 'down' to embellish the lustre of the 'minor' arts. Nevertheless, although Calder's enthusiasm and work in America went on to inspire jewellers such as Earl Okin, Calder himself was quick to point out that 'the very styles of Modernist jewellery were indebted to the conventions of high art'.[13] 'Although American Modernist jewellers worked separately ... they used ... a distillation of Cubism, Constructivism, Surrealism, Dada, Abstract expressionism.'[14] Margaret de Patta who trained under Moholy Nagy at the 'American' Bauhaus, clearly broke the mould with her experiments at 'catching stones in the air' and her uses of stone cuts and rutiles inside quartzes.

The American jewellery movement was powerfully represented by an exhibition in 1954 showcasing the new work, and as a group dealt with many themes and materials that would continue to develop and be revisited by other artists throughout the century. Key elements were the use of simple techniques and 'frequently incorporating valueless organic and inorganic substances such as wood, pebbles, glass, ceramic shards'.

Amongst the texts of interviews with such makers, we come across sentences such as 'Earl Pardon made Primitivism his guiding force in the 1950s. He was enamoured by primitive art *per se*, he collected it and studied it'[15] and 'Sam Kramer's metalsmithing techniques were rudimentary and were inspired by Native American jewellery, which he collected'.[16]

Such interests paralleled those of international American Modernists such as Charles and Ray Eames whose version of Modernism is once again influential. Their close friend and collaborator in Herman Miller Inc. (the furniture company), Alexandro 'Sancho' Girard, collected 120,000 pieces of primitive/ethnic art which now forms a wing of the Museum of International Folk Art in New Mexico.

'Together Charles and Sancho sought out the sources of folk art and it was Charles' camera which most sensitively captured the spirit of Girard's installations.'[17]

Margaret de Patta; American; *Pair of Earrings*; c. 1955; silver, rutilated quartz, white gold; 6.7 x 2.4 x 2 cm; Collection Liliane and David M. Stewart

Girard was nostalgic for what he called the 'vanishing handcraft civilisation'. However he believed that the value of his collection was 'not as a pattern for sentimental imitation but as nourishment for the creative spirit of the present so that we too may evolve customs and shape objects of equivalent value in our own time ...'[18] This is an acknowledgement of the role such objects played in American Modernism.

Studio jewellers in Britain seemed to be still defined by the Arts & Crafts Movement and were locked within its definition of craft and historical values. Paul Derez describes most post-war jewellers' lot in his notes on Dutch jewellers: 'There was a shortage of material and equipment. Contacts between smiths and jewellers were scarce and there were no galleries exhibiting free work yet.'[19] He goes on to describe precious metalsmithing more positively:

In the second half of the sixties, the artists (started) using their work to express what they were con-

Emmy Van Leersum; Dutch; *Collar, double (112) series*; 1980/1982; nylon; Collection Het Kruithuis, Stedelijk Museum voor Hedendaagse Kunst; Photograph Boudewijn Neuteboom

cerned about. An idea or a theme becomes the starting point and sketches and experiments are used to look at the form which best represents this idea or theme. The artists do not know before hand what material will be used or how the jewel will be made.[20]

As a working method this is a valuable analogy to understanding many of the objects to come and is still a framework important for radical designers today. However, Derez goes on to describe the introduction of morality: 'Analogous to developments in society, a need for democratisation made itself felt in jewellery design as well.'[21] This introduced a train of thought which was to spiral outwards, affecting material choice, marketing and perceived clients. In the same paragraph he heralds the point where jewellers, searching for the way to make affordable democratic jewellery, slip over into industrial design. 'Non-precious materials were used and machines and serial production introduced which kept prices relatively low.'[22] In the work of Van Nieuwen Borg, Wegman ans Van Eyben's 'large-scale production methods were used for the first time'.[23] Well, perhaps in this genre of work they were but jewellery has always had an affinity for mass production of elements, casting for example facilitates exactly that.

Two jewellers, Gijs Bakker and Emmy van Leersum, made a significant impact with their work at this point.

Forming one of the most powerful of the 20th century jewellery partnerships, they used aluminum – then associated with aircraft manufacture – to frame large mirrored collars. Both dramatic and futuristic, this was an idea that collides/combines the Bauhaus with the history of Dutch dress, the mirrored surfaces revealing startling views of the wearer's head. Their later work had resonance beyond jewellery, as it participated in the late 1960's couture experiments in Paris. The work developed to become 'more introvert' and to create 'jewels made to wear in harmony with the body but that were interesting to wear in their own right, objects to wear'.[24]

Here the Modernist jewellery project reached a point where objects were diametrically opposed to traditional jewellery in materials and techniques but the traditional object's value in material terms had been substituted by the Western Fine Art practice of the *sole auteur* as valuable – keeping multiples or editions like prints. Van Leersum's work was, for a while, involved with the exploration of plastics. Here her metals-based practical understanding of cutting forms and volumes, allied to the use of nylon, led to a range of objects which unified the themes of body as sculptural object surrounded by space and the jewellery object as concomitant to that. The pieces *Worn-forms* were defined by the volume inside them, allowing the objects to occupy sculptural space. That this space was defined by the linear nature of

the pieces makes them more rather than less interesting.

The late 1970s and early 1980s saw a period of development by such makers as Caroline Broadhead, Susanna Heron, Paul Derez and latterly, Louise Slater, Jane Adam, Alison Findlay, myself and many others, influenced by the interest in new or unconventional materials in the work of the European Modernists. The political climate of the time and its anti-traditionalist value system encouraged the development of collections of non-precious jewellery. This neatly dovetailed with the wider embedding of feminist thought into wearables and importantly the development of a market place to support such work. Many women started to buy such work for themselves.

Highly influential at this period was the angry, critical, yet methodical, practice of Otto Künzli. (See pp.114-115.) Trained with Herman Junger at the Munich Academie, Künzli remains sceptical about the values that much jewellery promotes and sees the value of jewellery as a critical vehicle of status and regimes. From the wearable brick objects of the early 1980s to his examination of the 'evil empire' through the character of Mickey Mouse, his work imposes its suspicion on jewellery practice.

The radicalism of work during the 1980s shifted focus under the pressure of resurgent monetarist values and increasingly, wearability became important, although it was an ostentatious wearability as fashion collided with the nascent jewellery scene. Although Modernism in the form of the jewellery experiment reached an apogee with the much maligned 1982 *Jewellery Redefined* exhibition, explorations in jewellery were, it seemed, more acceptable under the banner of British fashion week. Jeweller, stylist and *fashionista* Judy Blame drew upon a number of what one could call modern 'fine art' jewellery traditions, found objects from 'mudlarking' on the banks of the Thames, collages of rusty or corroded objects, and objects assembled from multiple and commercially mass-produced elements. Influenced by the badge making connected to the music biz scenes, he started also using stamped badges (or 'buttons') to create a 'detritus ethnicity' which allowed the re-utilisation of overly familiar objects. They had a bravura spirit which some of the more considered pieces of the period had not, and this in turn allowed a pleasurable and more familiar wearability. Perhaps more interestingly, Blame also mined something of British post-war youth culture, treating its 'tribalisms' with the same carelessness. The badges finally developed into Stephen Brennan's influential collage pieces, most famously worn by 'Boy' George O'Dowd.

Emmy van Leerseum; Dutch; *Collar with fastening/dress*; 1967; aluminium; Collection Het Kruithisi, Stedelijk Museum voor Hedenaagse Kunst; Photograph Boudewijn Neuteboom

Susanna Heron; British; *Neck Curve*; opal acrylic with painted edge; 1979; Collection The Crafts Council; Photograph by David Ward

Simon Costin, a contemporary of Blame, was to use Dada spiced with 'Gothic Shock Horror' tactics and underpinned by taxidermy techniques in fish head brooches and chicken's feet pendants. The effectiveness of Costin's work lay in the visceral reaction his objects produced. Ironically, his Sperm Necklace phials which resulted in mass press coverage and notoriety lack the immediate theatrical bravura and nostalgic Victorian feel of his more decorative objects. As Costin moved into sculptural objects, producing large canvasses covered with feathers, his 'tribalist debts' became more apparent. The theatrical strand of his gothic-inspired work was to surface in the mid 1990s as he directed a run of catwalk shows for Alexander McQueen, then working for Parisian couture house Givenchy.

Pierre Degan; British; *Large Loop*; 1982; carbon fibre/nylon/steel; Photograph by David Ward

A bridge to these practitioners can be located in the work of Pierre Degen. In a 1992 show entitled 'new work', he explored the fullest extent of jewellery objects. He enlarged the scale of his previous bracelets to form bouncing circles on and around the body. Tensioning by two cords allowed the circular frame to bounce from one angle to another and then back again, thus synthesising the delight of mobiles with the movement of the body. Enlarged to body scale and worn across from shoulder to hip, the items created a motion that helped develop a different style of walking, the wearer responding to the swinging framework. Successful on all scales, the relationship with the body allowed not only the energy to enliven the object but also allowed a different identity to be created with each change of scale. This gave simple clear jewellery items of immense ambiguity.

Artifacts, hand-held staffs and poles with a neo-shamanistic air, hotly debated at the time, now reveal an indication of the obsession with neo-tribalism that was to legitimise the fetishism of ethnicity.

There was in the 1990s, a wave of exploration in areas which are not traditionally associated with jewellery. Inspired by a confident group of individuals and pictures collected from the photographs in *National Geographic Magazine*, the advent of body piercing as a 1990s phenomenon has been well-documented.

The roots of this interest in non-Western decoration can be traced back through the interests of a group of practitioners in America and Europe: Jim Ward, who went on to found Gauntlet, the global piercing business; Sailor Sid, a well-known American tattooist; and Alan Oversby, AKA Mr. Sebastian, a tattooist and innovatory piercer. Millionaire Doug Malloy helped to support and fund them.

Working with friends, lovers and clients across the sexual demi-monde, which persisted up until the mid-1970s, these men (with the help of their male and female clients) were responsible for the development of techniques, which moved from sexual experimentation to gay sub-culture and on to wider social acceptance. It was the 1980s interest in 'Tribalism', a passionate enthusiasm for all things connected with smaller ethnic groupings with distinctive body decorations, which frames this time period. Tattoo artists such as Leo Zueleto and Ed Hardy explored Poly- and Micronesian tattoo heritages and reproduced them as a form of body decoration which gave tattoos 'a spiritual meaning accessible to the wearer through the sacred marking of the body that is tattooing'. This neo-tribalism provided

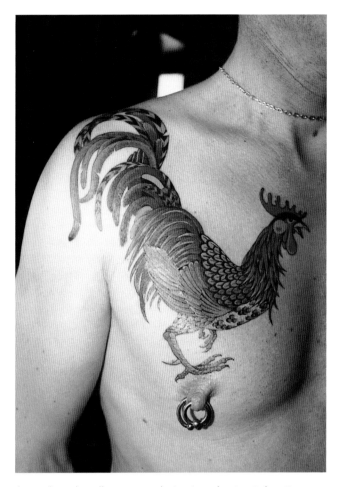

'Peter'; cockerell tattoo and piercings by Mr Sebastian; from late 1970s; Collection The Mr Sebastian Archive, London

a bold strong flowing series of lines, reminiscent to occidental eyes, of Art Nouveau and undoubtedly striking when on the three-dimensional canvas of the body. The subject becomes more complex when viewed from the perspective of say a New Zealand Maori who meets an East London teenager decorated with a sacred pattern belonging to that tribal family. So close is this cultural appropriation, so explicit the expectations that these cultural manifestations are 'ours' for the taking, that tempers can and do get frayed.

The jewellery that is most closely associated with neo-tribalism is the stainless steel ball closure ring. A simple stainless steel wire with a drilled ball tension set into it. Appearing very early on in the development of occidental body piercing it has become one of the great jewellery icons of the 20th century and is likely to remain so in retrospect. Originally it was designed to provide a smooth and seamless closed ring which was easy to exchange for a larger one and would not catch,

Simon Fraser; British; *Purple: Dermagraphic Drawing 1*;
raised skin drawing; 1992; Photograph by Lola Flash

income their work generates. Jewellery items have become smaller as a result, perhaps in reaction to the excesses of 1980s costume jewellery but also as a result of the level of financial investment small concerns were able to make. Interest elsewhere turned to exploring issues around HIV and Aids as some jewellers started to use their personal and artistic voices in combination.

Purple, an installation of 42 pieces of jewellery in the form of a maze, was a piece I constructed in response to a commission by Martijn Van Oostrom who worked closely with Paul Derez at Gallerie Ra in Amsterdam. Within the framework of a Shakespearean quote 'first milk white then purple with loves wound,' the installation was concerned with Karposi's Sarcoma a particularly visual cancer affecting people with HIV+. The jewellery looked at the effect of decoration, wearables and pattern making, it was concerned particularly with information one saw and understood but didn't want to acknowledge. For example, rings were cast using the surfaces and forms from Hickman lines, a small plastic port of entry for syringe needles, normally placed on the chest for repeat drug dosaging in the case of serious illness. Often they are placed just where a conventional brooch would be situated.

Keith Lewis from the USA was also responding to his involvement in the area with a large necklace composed of many smaller ones, each a portrait of a lost friend. The end result is a tension between the visual interest and attraction of the pendant elements; one struggles to read them and so gets involved. There are a lot of pieces and it is an elaborate necklace. Owing something to his mentor Bruce Metcalf, Lewis uses the American decorative and narrative tradition for his own ends. However the identity of the piece interestingly undermines its wearability, making it hard in reality to wear the tokens of so many deaths. The interest in the body manifest in piercing, tattooing and illnesses associated with it have combined with gothic to form a more pungent strand of viscerally aesthetic jewellery.

It will be this interplay between above and below the surface of the body; between appearance and disappearance, playing with light and the electrical and chemical possibilities of our physical selves, where exciting jewellery objects are likely to appear in the future as the next industrial revolution truly arrives. All of this will influence the way we will decorate ourselves.

COPYRIGHT © 2002 SIMON FRASER.

snag, or interfere with physical action. It can be seen located in almost all body parts where there is sufficient flesh to pinch but not in areas where multi-directional stretching is likely to disturb healing. Perhaps it is one of the few pieces of 20th century jewellery to escape the avant-garde to become an immediately recognisable global symbol. By its nature, although it is extensively handmade, the maker is always anonymous.

During the 1990s the investigation of jewellery possibilities switched direction to some extent. After the upheavals of the previous two decades, there was a resurgence of interest in the possibilities of traditional and precious materials. Partly in response to the recession, the market for non-precious materials has slowed and most jewellers are concerned about the level of

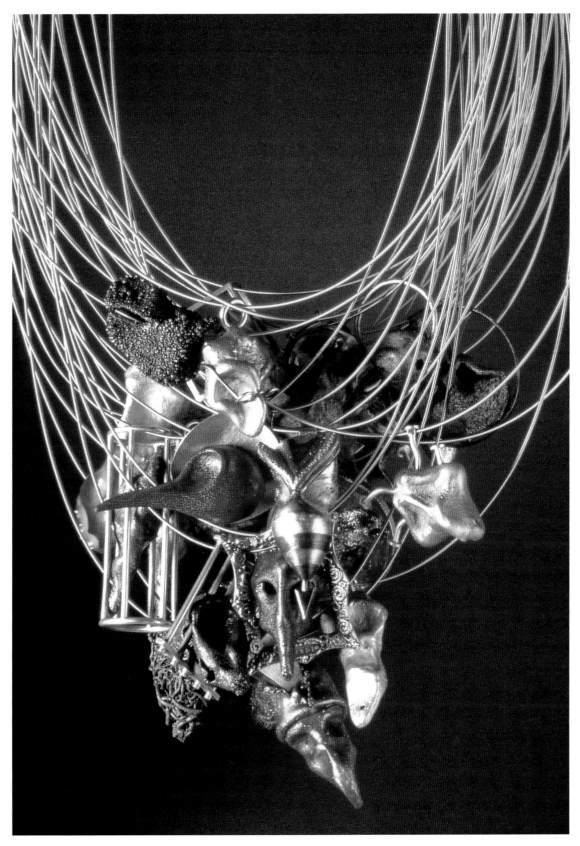

Keith Lewis; American; *35 Dead Souls;* 36 pennants of assorted sizes and materials; 1992/93; Photograph by Keith Lewis; Courtesy Don + Heide Endemann Collection

NOTES

[1] Toni Greenbaum, *Messengers of Modernism, American Studio Jewellery, 1940-1960*, Paris/New York, Montreal Museum of Decorative Arts/Flammarion.

[2] Peter Dormer and Ralph Turner, *New Trends & Traditions*, London, Thames & Hudson.

[3] Ralph Turner, 'Review', *Crafts Magazine*, 1991.

[4] Sarah Osborne, *Body Works*, catalogue of Susana Heron exhibition, Crafts Council, 1978.

[5] Ibid.

[6] Anne McClintoch, 'The return of fetishism and the fiction of the phallus,' *New Formations, Perversity*, number 19, Spring 1993.

[7] Lucy Lippard, 'Give & Take, Towards a Cross Cultural Consciousness', *The Eloquent Object*, Manhardt & Manhart (eds), Tulsa Pilbrook Museum, 1987.

[8] McClintoch, op. cit.

[9] Ibid.

[10] Ibid.

[11] Osborne, op. cit.

[12] Cunliffe Charlesworth, H., 'Us & Them, Present & Past,' *Other Bodies, the Representations of Beauty cross Cultures*, Association of Art Historians' conference, Great Britain, 1996.

[13] Greenbaum, op. cit.

[14] Ibid.

[15] Ibid.

[16] Ibid.

[17] Jack Lenor Larsen, 'A Celebration of the Senses,' *Folk Art of the Global Village*, Santa Fe Museum of New Mexico Press, 1995.

[18] Ibid.

[19] Paul Derez, *Dutch Jewellery 1945-1987*, a retrospective, exhibition catalogue, Amsterdam, Gallerie Ra, Amsterdam.

[20] Ibid.

[21] Ibid.

[22] Ibid.

[23] Ibid.

[24] Ibid.

17 · ALTOGETHER ELSEWHERE: THE FIGURING OF ETHNICITY

Edmund de Waal

The ability of anthropologists to get us to take what they say seriously has less to do with either a factual look or an air of conceptual elegance than it has with their capacity to convince us that what they say is a result of their having actually penetrated (or, if you prefer, been penetrated by) another form of life, of having, one way, or another, truly 'been there'.

Clifford Geertz, *Works and Lives*
The Anthropologist as Author, Stanford, 1988, p.45

1. Over There: The Craftsman as Ethnographer

Iᴛ is an extraordinary image, an old white man dressed in baggy shorts and a singlet playing the recorder surrounded by smiling Australian Aboriginal children: Michael Cardew, an Oxonian Marlow alone in the Bush in 1968, sent out to introduce a non-ceramic culture to the wonders of stoneware pottery. Even amongst the images of a century of curious cultural encounters between artist-craftsmen, and occasionally crafts-women, from the West and makers of objects from other societies variously thought of as primitive, tribal, traditional, folk or ethnic (think of Bernard Leach in rural Japan, Ethel Mairet with weavers in Ceylon, Shoji Hamada with the vernacular potters of Devon or Soetsu Yanagi meeting Maria Martinez in New Mexico), this is an encounter that stands out. The majority of these encounters share common charecterstics. They are between members of a Patrician class of craft pioneers, the inheritors of a Ruskinian world-view as to the value of unmediated, non-industrial traditions of hand work-manship whether found abroad or in rural communities in their home society, and makers of a considerably lower economic, social or literate grouping. In either place, these encounters lead us towards the image of the Western craftsman as ethnographer, the gatherer of data as to the processes of making, the interviewer and recorder of conversations. And these images are often coupled with the role of the collector of artefacts, the art historian and more often than not, the extrapolator of social and moral meanings.

This is ethnography of a very particular kind. It is based on the positioning of the Western craftsman-ethnographer as both 'the man apart', the dispassionate onlooker able to observe the goings-on rationally and impartially, and also to be the intuitive, instinctual colleague of the peasant craftsman, to crouch next to the loom or wheel and enact the pantomime of shared skills. This is the taxing position of the colonial encounter with authentic craft, the problem of 'being there'.

Authenticity is a pre-lapsarian condition. It is a condition discernible in other groups that have not yet experienced the rift that Ruskin defined between maker and object within industrial society. Authenticity occurs elsewhere, noticed only by the anxiously inauthentic. Thus in the most obvious of ways it is 'a form of cultural discrimination projected onto objects', and, of course, onto people. I would like to explore four particular manifestations recognisable for the traces and markers of an authentic object, or authentic maker of those objects, delineated in the writings of these pioneer ethnographer-craftsmen.

The first marker for authenticity is that the maker of the object must not be self-aware, must be unconscious of the possibility of inauthenticity in making. Therefore the process of making must be consuming, even self-abnegating, thereby allowing little of the destructive self-consciousness that has infected the West. Consider

this charecterstic piece of aesthetic ethnography by Soetsu Yanagi, the theroetician of the Japanese Folkcraft Movement and interlocutor of Bernard Leach, writing about the Kizaemon teabowl, a bowl that a poor man would use everyday:

> ...a typical thing for his use; costing next to nothing; made by a poor man; an article without the flavour of personality; used carelessly by its owner; bought without pride; something anyone could have bought anywhere and everywhere. That is the nature of this bowl. The clay has been dug from the hill at the back of the house; the glaze was made with the ash from the hearth; the potter's wheel had been irregular. The shape revealed no particular thought: it was one of many. The work had been fast; the turning was rough, done with dirty hands; the throwing slipshod; the glaze had run over the foot. The throwing room had been dark. The thrower could not read. The kiln was a wretched affair; the firing careless. Sand had stuck to the pot but no one had minded; no one invested the thing with any dreams. It is enough to make one give up working as a potter ... The plain and unagitated, the uncalculated, the harmless, the straightforward, the natural, the innocent, the humble, the modest: where does beauty lie if not in these qualities? ... Only a commonplace practicality can guarantee health in something made.[1]

Yanagi's Korean potter, healthily illiterate, naturally aesthetic, too busy to be self-conscious is a vivid example of 'homo orientalis ... by nature mystical and concerned with great ideas',[2] the peasant craftsman who underpins the creation of Leach's authentic Orient. By extension this kind of making can also be found in children, as Leach iterates when writing on the feeling of glazes to the touch: 'Unconsciously our fingers are invited to play over the contours, thereby experiencing pleasure through the most primitive and objective means. Children play with pebbles with a similar awakening of perception, and orientals have lost touch with the fresh wonder of childhood less than we have.'[3] Authenticity is indeed pre-lapsarian. And the Edenic fall into self-consciousness is particularly dangerous for the Korean bowl maker, or the young Japanese potters counselled by Leach who wanted to escape their traditional roles:

> A young 'individual' potter protested that our advice to stick to good old traditions was cramping, Yanagi and I, each in our own way, replied: 'Be modest, these results of wild experiment show indigestion, launch out into new only as you can understand it and feel it, in any case only a few have this natural creative capacity in my country.[4]

The quotation marks that frame the word 'individual' say much about where authenticity is sited and where it is held to be absent in this encounter. For the second marker for authenticity is that of tradition. An easily identified and extensive tradition is a safeguard against the novel. If a chair-bodger (such as the one encountered by Shoji Hamada in the woods near High Wycombe in 1929) or a teapot decorator (such as Masu Minagawa of Mashiko as described by Leach[5]) can be situated in such a tradition that, *ipso facto*, defines the status of the object through the clear acceptance of the social status of the maker. Tradition means knowing your place. For the ethnographer-craftsman it means knowing their place.

The third trace for the authentic object is that it should be made in quantity, preferably for quotidian local living. As we have seen this was a principal definition for Yanagi, as it was for Cardew in West Africa. Quantity protects the object from the possibility of transformation into a self-conscious art-object. This transmutation is only permissable by that object's assimilation into a collection: the valuing or endowing it with aesthetic meaning is the province of the collector not the original maker. It is the Japanese Tea Master who aestheticises the Korean teabowl. This may be the reason that there is such anxiety about objects made for display or with a super abundance of decoration: such objects extend the possibility of the original maker's intentions in making beyond the site of authenticity. Making merely for local everyday life rules out the dangers of transgression into complex trade relations, delimits the obvious commoditisation of the craft object. Making in this way also reinforces the possibility of the craft-ethnographer aestheticising the whole culture in which the object is made. As Cardew wrote:

> In West Africa, art has not yet been separated from ordinary life; it is still the air that everyone unconsciously breathes. Every man and woman is by nature a poet, a stylist, an aesthete, though outsiders like ourselves may sometimes disagree with or disapprove of the ways in which it is expressed. West Africans do not need to make a cult of art – still less, of what we call 'good taste' – because they live with it all the time, and, unlike ourselves, have not made the mistake of treating it as a separate department.[6]

Michael Cardew and Clement Kofi Athey at Alajo in 1943

Finally, the authenticity discerned must be capable of being transferred in easily communicable ways. When Ezra Pound published his versions of Chinese poetry in 1916 entitled 'Cathay', the exotic or 'Other', nature of the original Chinese verse was always apparent. They always seemed Chinese even in translation. This was a tendency vividly remarked on by George Steiner: 'the more removed the linguistic and cultural source, the easier it is to achieve summary penetration and a transfer of stylized, codified markers.'[7] These are the codified markers of authenticity, and the markers of having 'been there' in ethnographic terms. Thus Clifford Geertz writing on the seductive stylistic fluency of the patrician British ethnographer Sir Edward Evan Evans-Pritchard, 'assured, limpid, measured, equanimous, effortless, superior, conversational', and further noting the 'constant row of promulgatory declarations' identified this transference. Geertz continues that: 'The outstanding characterstic of E-P's approach [sic] to ethnographic exposition and the main source of his persuasive power is his enormous capacity to construct visualizable representations of cultural phenomena – anthropological transparencies.' This kind of flashing-up of 'magic-lantern images' demonstrates that 'the established frames of social perception, those upon which we ourselves instinctively rely, are fully adequate to whatever oddities the transparencies may turn out to picture'.[8] That is to say, the 'stylized markers' are both easily identifiable as strange, exotic and 'other', but, crucially, their difference from us, however dramatic, does not finally count for much. When we read Cardew, Mairet or Leach, in their limpid and assured prose, the summary, repeated flashing-up of a few images of the authentically exotic in their encounters is always without the mediation of any surprise, astonishment, wonder or bewilderment at what they see. It is as if they had already been there. In some ways, they had: what they see fits in with what they want to see and with what they went to see. But it is also important to register that it is the nature of 'magic lantern images' of ethnography to fragment a culture into digestable morsels: 'the artfulness of the ethnographic

object is an art of excision, of detachment, an art of the excerpt. ... Like the ruin, the ethnographic fragment is informed by a poetics of detachment. Detachment refers not only to the physical act of producing fragments, but also to the detached attitude that makes the fragmentation and its appreciation possible.'[9] That is, as readers of this particular craft-ethnography, we give ourselves up to the authorial decision about the removal of particular objects from complex material cultures and their re-presentation to us as 'craft objects'.

Authentic ethnic craft validates the critical abilities of those who have spotted it, just as Sir Edward Evan Evans-Pitchard's fieldwork acts as a bulwark for his ethnographic insight. But it also points up our own inauthenticity: it suggests both a 'more strenuous moral experience than sincerity does, a more exigent sense of the self, and what being true to it consists of,[10] and also, crucially, a way to overcome this. 'Losing one's tail' is how Leach put it, the passage through self-consciousness back into child-like transparent making: the strenuous moral experience, the elective submersion into repetition and process. The exhausting of self, whether in the studio or in the case of Cardew (and Conrad's Marlow) in the Bush, is the hallmark of the Western craftsman after his encounter with the authentic. One of the more fanciful early etymologies of 'authentic', after all, is that of perpetrator, murderer and suicide: the destruction of self lies deep within its cultural meaning.[11] Cardew even called the large stoneware oil jar he made at Abuja in Nigeria in 1959 *Heart of Darkness* (see p.190). This jar was a composite of West African decorative repeat incising into the clay under an Oriental mottled tenmoku glaze. It stands as a hybrid of authentic markers, symptomatic of the confusion that the transfer of coded meanings leads towards.

2. Being Here: The Moralised Geography of Home

> Samuel Rockall is not a businessman; I doubt whether he has ever heard of the joint-stock methods of getting all you can out of Nature by means of accountancy, machines and dope. He is of no account to the modern world, though he represents that English tradition which produced Shakespeare and Lincoln Cathedral.
>
> 'Samuel Rockall, Wood-Bodger' in *The English Countryman: A Study of the English Tradition* by H.J.Massingham, 1942, p. 59-62

Ethnography can begin at home. The strangeness and otherness of 'over there' can also be present within the communities of craftsmen and craftswomen of one's own culture. Many of the tropes of authenticity are as present in the 'discovery' of domestic vernacular crafts as in those of abroad. But there are questions as to how these traditions are mediated and incorporated: what is the relationship between craft practice and ideas of nationhood and of craft practice and individualism? As we have seen through the discussion on the nature of the ethnographic fragment as a way of locating, fixing and translating the image of the authentic, it is the isolation of either the craft object or the craftsman or woman from complexities of material culture that allows them to be used. This process is similar within the approach to the craft of 'here': the crafts that have been susceptible to this kind of treatment share a status of being 'traditional', 'common' and 'non-individualistic'. The wood bodger that Massingham quotes with such approval is such a figure. Working by himself he is self-contained and thus far from the modern economic processes of 'getting all you can out of Nature', in fact he is identified so closely with his environment that he becomes 'natural' himself, just as Yanagi's Korean peasant potter is seen as part of the geography that surrounds his workshop. Samuel Rockall (his name is a pleasing conjunction of Biblical cadence and geological gravitas) is also 'not a businessman' and also 'of no account to the modern world': that is, he does not function, and by implication is not capable of functioning, within the complex parameters of the life of the writer-ethnographer. Finally Rockall is placed as a representative within his tradition: one that is characterised by two icons of art and architecture, Shakespeare and Lincoln Cathedral. Thus the tradition is humanised as being democratic (a simple man alongside the Bard), whilst the amount of difference that might have been found in Samuel Rockall and his chairs is simultaneously rendered nugatory. And notice the time of writing: Massingham, an elegiac chronicler of rusticity, is also an exponent of the Englishness of craft at a time of crisis. As Tanya Harrod has pointed out, this kind of writing about the rural crafts can be allied to the other manifestations of the analysis of national character, such as J.B.Priestley's 'Postscript' radio talks, and Kenneth Clark's Recording England project, designed to give work to artists and frequently the patron of images of 'popular art and craft traditions as something to defend'.[12]

Defending your culture through the defence of your traditional crafts has been a strong part of the recent

Hamada; Japanese; *Chairs*

cultural history of both Japan and of England. In both these countries it can be seen as the creation of a moralised geography: a way of mapping nationhood through the mapping of craft practice. For this to happen there has to be a sense of regionalism, of different kinds of practice in different areas: authentic crafts are not homogenous but specific to their own areas – they

are 'grounded'. Thus the mapping of vernacular chair production in the centre of England from High Wycombe to the Cotswolds produces a complex family tree of different approaches to design and making similar, perhaps, to the way in which a folk song collected by the pioneer musicologist Cecil Sharp might differ from village to village. 'What is done by one man in one way

Michael Cardew; British; *Heart of Darkness*; ceramic jar; 1959

support for *volkish* crafts. Regionality was crucial to this: '... forms and materials were chosen which stressed *Handwerk* skills of the German craftsman, and designs were historicist and conservative in taste. For interior decorative schemes the wish to employ indigeneous raw materials saw, for example, an abundance of wrought ironwork and woven materials featuring heraldic or folk patterns.'[14] If taste is this historicist then the implications for the status of the craftsmen and women is clear.

And secondly it allows for the construction of a craft nationalism: one capable of export as an image of vital, vigorous national identity as well as for home-consumption. At the height of the Second World War it was decided by the British Council to send an exhibition of 'Modern British Crafts' to America. The objects sent spanned both the surviving rural crafts (including hand-knitted fishermen's jerseys and hand-carved wooden spoons) and the work of those who made furniture, textiles or pottery in the vernacular tradition, including Edward Barnsley and Edward Gardiner, Ethel Mairet, Michael Cardew and Bernard Leach. Room settings were created to give a sense of wholesome and harmonious living, of contemporary English life spanning the whole spectrum of the country. Its inclusiveness was brilliantly stage-managed to suggest a commonality within all the different traditions of making. The British Council continues to send exhibitions of British craft work abroad. An example from the 1990s is that of a ceramic teapot exhibition, *Time for Tea*. It came with a small catalogue bound in Edward Bawden designed covers, a detail that, no doubt unintentionally, brought back images of Bawden's inclusion in the wartime exhibition.

In looking for the home-consumption of the 'Englishness' of craft it is this combination of prolixity of regional variations that map 'essential' national charecterstics that is present in the rise of domestic tourism. The 1930s saw a dramatic increase in this and in the popular guidebooks series published by Batsford, Methuen and Shell, the crafts played a significant part. Tourist wares and souvenirs, craft objects that were made and sold to express fragments of authentic regional identity, also show this process of commoditisation of this 'moralised geography.' Whether in the form of Bernard Leach's galena ware made in St Ives with Cornish sayings or images inscribed on it ('the Mermaid of Zennor', for instance), or in the hugely popular Goss tourist wares where heraldic shields and crests were applied to traditional forms from historic towns (a Honiton lace bobbin or a Chipping Camden chair) owning Englishness became focussed on this sense of locality

in one place may be done quite differently elsewhere. Therefore ... the reader should realise how very widely usages differ in this small island ... I want everyone to appreciate the work done by country people. Not for its commercial value, but because the work is done by independent people, and the character of these few independent people is as strong as the goods they make. It is these country men and women who are of the utmost value to England.'[13]

This mapping does two quite specific things. Firstly it reinforces the idea of a natural geography of craftsmanship into which both makers and their objects fit as unchangeable constants, with all that this implies for the impossibility of change within craft practice. Local materials, often the mantra of the studio pottery movement, plays an important role here: it is as if becoming part of a locality confers value on the pots made. As part of the ideology of nationhood of the Third Reich in Germany from 1933 to 1945 there was a clear policy of

... This process continues unabated in the pages of *This England* magazine now.

In a parallel way the map of 'Traditional Rural Potteries in Present Japan' issued by the Mingeikwan, Tokyo in MCMLII [sic], the Folk Crafts Museum in 1952 presents us at first glance with a simple anatomising of all the different potteries then current. That it excludes any urban potteries might raise questions (the possibility of the incorporation of urban craft into authentic practice has always been problematic). That it is in English, in a medievalised sub-Gothic script in red and black, printed on handmade paper to be mounted on a scroll raises questions about its audience. We might consider that those Westerners interested in Japanese Folk Crafts in 1952 might well be the occupying American forces; that the creation of a decorative map of authentic Japanese ceramics serves to preserve a recidivist sense of continuity at a time of cultural anxiety. Compare this map with one from the late 1930s also created by Yanagi Soetsu but at a time of political imperial expansion for Japan, and the constituents of Japanese crafts are markedly different. Bluntly, Japan here extends to include the Korean peninsula and Manchuria: the moralised geography of craft here is centred on ideas of essential Japanese-ness that can be found in diffusion. And if you go into a Japanese Tourist Information Bureau now and ask for a map of the traditional crafts of Japan and it will have yet another view of the sites of proper ethnic craft. In a similar way to the British Council, the Japanese Folkcraft Museum has initiated exhibitions. 'Mingei: the Living Art of Japan' for example, that are structured round the idea of an inclusive, culturally-conservative, tradition.

Edward Bawden; British; cover for teapot exhibition catalogue; 1997

3. Elsewhere: Making Ethnicity Now

In the mid 1990s the English potter Richard Slee embarked on a series of contemporary Toby jugs. The Toby jug is a vernacular English decorative tankard of a bluff, pink cheeked, Henry Fielding country squire. Toby is also a red-faced, myopic, jingoist Little Englander, a barroom politician. With Slee Toby underwent a series of transmogrifications: Toby as Harpie, poised in mid denunciation, a Roast Beef Toby and a Fizzy Toby with eaten away features. At the highwater mark of a particularly strongly inflected political nostalgia for a kind of Englishness based on values of continuity, tradition and

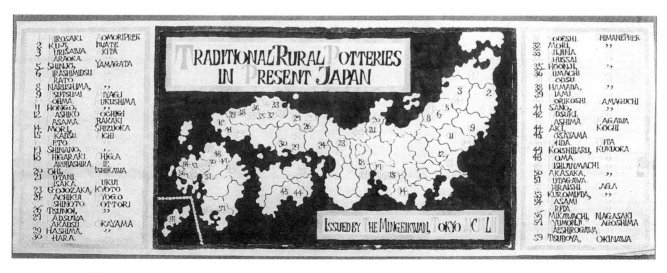

Map of Mingei kilns; 1952

community, Toby became in effect the carrier of a whole series of inversions of Englishness. The image of an Englishman with his side of beef changes in an age of the disease BSE, just as a stalwart Englishman happy in his cups inflects differently when violent drunken English youth is the most forceful image of the English abroad. Toby as a figure elides with the other iconic figure of Mr Punch, another cross between comic jocularity and frightening violence. It is as if there are common sites within cultural life which are particularly susceptible to this opening up of their 'otherness': the interest of Slee's work lies not just in his use of the vernacular in a politicised way to explore ideas of ethnicity but in the way that he makes this commentary on his own cultural matrix. As the anthropologist James Clifford has said: '[What] has become irreducibly curious is no longer the other, but cultural description itself.'[15] That is, by dealing with the 'matter of Englishness' by taking as his theme the iconic Toby jug, Slee automatically puts himself into the arena of intense speculation on ethnicity. Slee is his own ethnographer.

Richard Slee; British; *Acid Toby*; handbuilt earthenware glazed with enamels 1994; Photograph by Zul Mukhida

A comparison can be made with the work of the Japanese ceramicist Nakamura Kinpei. Nakamura was brought up in Kanazawa, a centre of rarified craft traditions, spent a year in the United States as a Rockefeller Foundation Fellow in 1969-70 and now teaches at Tama University of the Arts in Tokyo. He is a heterodox figure within Japanese ceramics, a maker of ceramic sculpture that acts as a commentary on the foundations of the 'authenticity' of accepted taste, holding in 1988 an exhibition entitled 'An Exploration of Japanese Taste'. In 'Even Stones have Sap' we see a bricolage of disparate man-made industrial and craft objects assembled on a gilded rock promontory. It is difficult to read: are these bizarre objects malign growths or benign decorations? From a metallic angle of pipe sprouts a twig, embedded in the rock is an open cube of Shinto scarlet. Nakamura helps in decoding this deeply coded sculpture, this palimpsest of Japanese cultural motifs, by introducing the notion of kitsch: '... the constant reworking of traditional ceramic styles by artists living in an age with different priorities from those obtaining at the time the original works were made, leads to products that cannot fail to degenerate into 'mere kitsch replicas'.[16] It is his embracing of kitsch as a significant cultural manifestation, as a cultural practice as significant as the pursuit of authenticity that is so richly present in his work. Consider the place of the rock and the branch within Japanese aesthetics as an integer for the carefully mediated placing of the natural within Tea Ceremony and Zen gardens. This austere aestheticising of the natural is not so much parodied by its transformation into fired clay cloaked in metallic glazes as intensified by it. This is not mockery of tradition but a fierce concentration of both the subject and ways of approaching it within the same piece. For here the rock and branch which should in normative Japanese aesthetics be isolated and cordoned off into the safe places where beauty is allowed to perform its role, have to act within a welter of discursive images of modernity. Japan is like this, Nakamura seems to be implying: the structures that have allowed the distancing of confused everyday urban living and the objects of fetishised cultural attention have fragmented. Everything within the piece carries the same visual weight and significance: this is the maker as obsessive ethnographer and obsessive collector of data, the maker at large in the modern city. But just as Slee cannot be said to be an ironic ceramist (the impulse behind his series of Toby jugs is both celebratory and critical), so Nakamura is engaged with 'cultural description' and not prescription.

Kinpei Nakamura; Japanese; *Introduction to Japanese Taste*; ceramics; 1988; Collection The National Museum of Modern Art, Tokyo

The supposition is that in a Post-Modern world the figuring of ethnicity within craft practice must de facto lead to a mass of 'airport art', a term that sums up the neatly packaged and commoditised fragments of a country's craft styles.[17] This is hard to refute. Certainly many of the strategies for the support of traditional craft are still centred on their continuity as authentic manifestations of a culture, whilst overlooking the places where these objects are sold and to whom they are sold. The reality that the 'biography of an object' to use Igor Koptyoff's phrase is radically altered by the changes of approach to their making does not sit happily with the kinds of development project so happily espoused.[18] If the kinds of object that are regarded as acceptable manifestations of a culture are not open to transformation then the danger is that authenticity will become a kind of captive breeding programme for craft, fed and watered by curators, collectors, anthropologists and, of course, craftsmen and women from other, more affluent countries. Certainly if

you examine the programmes for the plethora of International Ceramic Festivals with their demonstrators provided by colourful extras from Nigeria, Colombia or Korea, it is hard not to be reminded of the 19th century World Fairs. Just as the Family of Man exhibition of photographs in the 1960s managed to elide cultural difference into a few tropes of laughter, grief and family feeling, so the Family of Craft celebrates survival, whilst averting the gaze from the racks of books on 'Living with Ethnic Textiles' and the galleries promoting Ethnic Art.[19] The speed with which commoditisation now occurs can be seen in the way in which the 'beauty, skill and ingenuity of makers [with] these very specific materials',[20] namely Indian craftsmen recycling tins into objects of both utility and decoration, has moved from being on the outskirts of interest to being the subject of exhibitions, critical monographs and even artists' books. This is partly because this kind of object (and it includes the toys made by children in South African townships) can be

read as authentic objects made in quantity for a locality whilst simultaneously being overtly textually complex, with the original wording of the tins still legible. They are, like Nakamura's ceramic sculpture, palimpsests. In this way they appeal to the Western collector who wants to be able to read the ethnicity of an object without too much difficulty.

Perhaps with Western cultures, increasingly for both the consumers and the manufacturers of normative ideas of ethnicity abroad, what is required is, to borrow Trilling's phrase, 'a more exigent sense of self'. For if our own understanding of the creation of our own markers of authentic ethnicity is greater then we might be less presumptious elsewhere.

COPYRIGHT © 2002 EDMUND DE WAAL.

NOTES

[1] Soetsu Yanagi ,'The Kizaemon Teabowl' from *The Unknown Craftsman*, Kodansha International, 1972.

[2] Brian Spooner, 'Weavers and dealers: the authenticity of an oriental carpet', in Arjun Appadurai(ed.), *The Social Life of Things*, Cambridge, 1986, p. 211. See also Edmund de Waal, 'Homo Orientalis: Bernard Leach and the Image of the Japanese Craftsman', in *Journal of Design History*, Vol.10, No.4, pp. 355-62.

[3] Bernard Leach, *A Potter's Book*, London, 1940, p. 37.

[4] Bernard Leach, *A Potter in Japan*, London, 1960, p. 88.

[5] Bernard Leach, *Hamada Potter*, Kodansha International, 1975, p. 193.

[6] Michael Cardew, *A Pioneer Potter*, London, 1988, p. 203.

[7] George Steiner, *After Babel*, Oxford, 1975, p.361.

[8] Clifford Geertz, *Works and Lives The Anthropologist as Author*, Stanford, 1988, pp. 62-4.

[9] Barbara Kirshenblatt-Gimblett, 'Objects of Ethnography' in *Exhibiting Cultures The Poetics and Politics of Museum Display* ed. by Ivan Karp and Steven D. Lavine ,Wahington,1990, p. 388.

[10] Lionel Trilling, *Sincerity and Authenticity*, Oxford, 1971, p.11.

[11] Op. cit., p.131.

[12] Tanya Harrod, *The Crafts in Britain in the 20th Century*, Yale,1999, pp. 193-8.

[13] Dorothy Hartley, *Made in England*, London, 1939, pp. IX-X.

[14] Jeremy Aynsley, *Nationalism and Internationalism*, Victoria and Albert Museum, 1993, pp. 45-7. See also John Heskett, Modernism and Archaicism in Design in The Third Reich', in *The Nazification of Art*, ed. by Brandon Taylor and Wilfried Van Der Will, Winchester, 1990, pp. 110-27.

[15] On the relationship between the Japanese Folkcraft Movement and nationalism see Yuko Kikuchi, 'The Oriental Orientalism of Yanagi Soetsu and *mingei* theory.' in *Obscure Objects of Desire*, ed. by Tanya Harrod, UEA, pp.73–80.

[16] James Clifford quoted in Geertz, op. cit., p.133.

[17] Nakamura Kinpei quoted in Rupert Faulkner, *Japanese Studio Crafts tradition and the Avant-Garde*, Lawrence King, 1995, pp. 76-9.

[18] cf *Ethnic and Tourist Art*, N.H.Graburn.

[19] Igor Koptyoff, The cultural biography of things:commoditization as process' in *The Social Life Of Things*, ed. by Arjun Appadurai, pp. 64-91.

[20] Tony Hayward, *Made in India*, London 1997, np. See also Hayward's review of 'Handmade in India', an exhibition held in London in 1998 in *Crafts*, No.153, July/August 1998, pp. 53-4.

18 · COMPLEXITY

Paul Greenhalgh

When viewed from close up, the universe is an over-whelming and unimaginable number of particles dancing to a melody of fundamental forces. All about us and within us, molecules and atoms collide, vibrate and spin. Gusts of nitrogen and oxygen mole-cules are drawn into our lungs with each breath we take. Lattices of atoms shake and jostle within the grains of sand between our toes ... Yet we think of the universe as a single harmonious system or cosmos, as the Greeks called it. Now a new branch of science is attempting to demonstrate why the whole universe is greater than the sum of its many parts, and how all its components come together to produce overarch-ing patterns. This effort to divine order in a chaotic cosmos is the new science of complexity.

Peter Coveney and Roger Highfield, 1961

WE are swimming in a sea of stuff that we have made. This stuff responds to thousands of codes, contexts and consciousnesses and fires in a million directions. These can appear to be arbitrary but they are not. In this concluding chapter I wish to make a plea for the crafts not as a worthy (separate) entity within a (separate) art world, but as a set of material discourses within a far bigger and ultimately more important uni-verse. More specifically, I will be arguing that all cultural produce is generated through a complex structured sys-tem, or infrastructure, and that this infrastructure is the key to the future of all cultural produce. The infrastruc-ture is never static, but at this time, it is in process of significant change.

As one flicks through the chapters of this volume, one could be forgiven for wondering what on earth all this stuff is about. I don't especially mean what craft is about (though this is not an issue to trifle with) but rather how exactly the whole realm of visual culture, and beyond this cultural practice generally, got to be in the condition it is. It is safe to assume in late modern culture that we can usually arrive at a social and political con-sensus that the arts are worthwhile, though we collectively rarely agree to fund them appropriately. It is

also important to note that we are at this stage wholly globalised. As textured and knotty as the cultural fabric is, we are essentially now dealing with the same set of phenomena. No one doubts, albeit begrudgingly, that the visual arts have a collective symbolic and hierarchi-cal dimension to them that makes them important. But it is surprisingly difficult, from the eclectic heights of the professional art world, to say why it all looks as it does (why it looks oddly cohesive) and why we actually bother. This is partly because we are all profoundly institutionalised, and partly because we are living in a genuinely complicated period.

It is a time of big questions and answers, and the answers to the two big questions posed (why is it like that? and why bother?) are simultaneously simple and indescribably complex. It all looks as it does because it functions within a single but highly complex structure; we bother to make and consume all this stuff because we have no choice. Both answers refer to the fact that cul-tural activity is part of our intrinsic condition.

The next phase of modernity will be to do with inter-disciplinarity. This is because the next phase of intellectual growth, which has been underway for sever-al decades but is only just coming into full effectiveness, is premised on relational rather than reductive visions of life. Interdisciplinarity does not imply a lessening of the specialised intense knowledges that make the various visual arts what they are, but rather the recognition that their interaction, and additionally the development of new approaches premised on interaction, is the key to the next phase of modernity. It is all to do with a coming together of lateral and vertical modes of creativity.

More exciting still, the sciences and arts finally appear to be capable of ending the 'two cultures' syn-drome that has dogged and undermined industrialised culture for several centuries. At the level of training and research, the gap between the arts and sciences grew so wide during the 20th century, the age of subject special-isation, that scientists and artists understood each other principally through caricature. This situation has been steadily changing, as the literatures of the two worlds

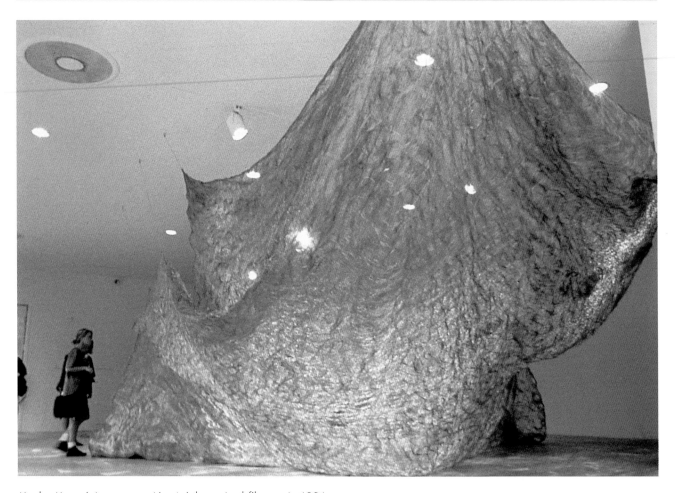

Kyoko Kumai; Japanese; *Air*; stainless steel filaments;1991

begin to reveal common threads, and new technology and new art begin to meet and meld on the streets of the world's industrial conurbations.

Patterns. Complexity theory is all to do with patterns. Theoretical physics, astrophysics, biology and mathematics have developed, over the past two decades, an explanation of the functioning of the universe. This new theory is the natural successor to Chaos theory and recognises that the immense complication of such things as the eco-system or the human brain cannot be explained in terms of linear evolution, that the sophistication of such things could only come to exist through a process of emergence, whereby simpler systems fuse and develop to an infinite degree beyond their original components. Research scientist John H Holland explains that

A small number of rules or laws can generate systems of surprising complexity. Moreover, this complexity is not just the complexity of random patterns. Recognisable features exist, as in a pointillist painting. In addition, the systems are animated – dynamic; they change over time. Though the laws are invariant, the things they govern change.[2]

Complexity acknowledges that the world cannot be described through reductive means, by breaking things down to component, self-explanatory or self-evident elements. The meaning is actually in the pattern formation, in the combination of elements that becomes so layered as to acquire infinite depth and width. Patterns are fractal, non-repeating and yet ordered. At crucial points, patterns become structuring and insistent, yet never directional nor in any limited sense 'logical'. Complexity has only been able to emerge as a way of seeing the world since the rise of the computer, which has allowed hundreds of millions of components to be related and understood so that patterns may be seen. Prior to computerisation, it was not so much a matter of not seeing the wood for the trees, as seeing the trees but being unaware that the wood existed.

By 'pattern' two things are implied. First, and quite literally, patterns are the basic visual constituency of the

Rebecca Earley; British; *Scattered Pins*; heat photogram printed; 1997; Courtesy the Trustees of the Victoria and Albert Museum

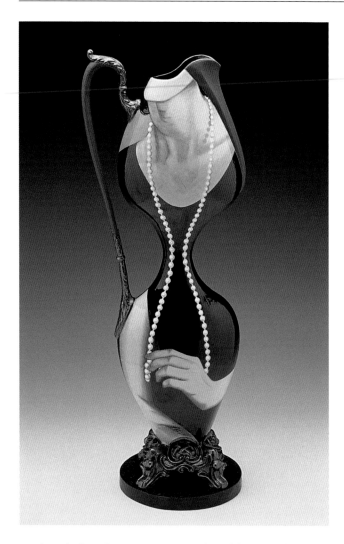

Cindy Kolodziejski; American; *Pearl Necklace*; earthenware; 1999

Perhaps most interesting and important is the fact that complexity, which had its origins in particle physics, mathematics and genetics, is being used as synonym rather than analogue; the fundamentals of pattern formation, it is being suggested, follow the same structural principles in the social, cultural and political spheres as they do in the scientific realm.

Such approaches to understanding are of great relevance to the visual arts. It could be said that the entire realm of visual creativity, of which the crafts are a major component, is essentially to do with pattern formation. More precisely, visual culture gains its forms and meanings from the intertwining of a number of ordered systems. Like an enormous rope, the totality of the system of visual culture is a taut combination of structured, intertwining threads, which depend on each other for their consistency and meaning. A number of structures accumulating into one, highly complex fractal matrix, full of internal tensions and oppositions but nevertheless an interdependent, functioning whole. A non-repeating pattern, dynamic rather than static, simultaneously machine and machination, unfolding through time and society and mediating everything the individual and collective retina picks up.

To return to the two big questions I posed earlier. I have asserted that the reason that cultural produce looks as it does in any one period or place is because it functions within a single highly complex structure. This needs elaboration.

Imagine the totality of the processes that go into the creation of all visual cultural produce as a single complex system or infrastructure. Infrastructure refers to the multifarious fabric of communication in the art world: makers, writers, dealers, manufacturers, curators, institutions, markets, publications; the repositories of culture that store, project, promote, sell and exploit the arts. It enables objects to be conceived, made, seen, recorded, sold and consumed. Imagine infrastructure as a giant machine in a literal and metaphoric sense. It creates, processes, transports, presents and conserves art objects. The machine brings into existence machination, the concepts, emotional impulses and ideological networks that wire performer with performer and performer with audience. Machine and machination are interdependent, material and cerebral, relational and causal: they ensure the simultaneous coming into being of art objects and their meanings.

The notion of infrastructure is dependent on the acceptance of the idea that all stages in the creative process, from the maker engaging with abstract ideas

visual arts. The ability to decorate the world using pattern forms of various types is the oldest and most obvious signifier of humanity. Second, human behaviour is structured in patterns. The 'pattern of life' refers to the way we construct society and our collective role within it. It is the second concept of pattern I am concerned with here.

One of the most interesting aspects of complexity theory is its potential as a tool for analysis and description away from the hard edge of quantum mechanics. Over the last decade, it has been used at the legendary Santa Fe Institute, for example, to explore the nature of third world economy, traffic flow in cities, the stock exchange and the design of industrial products.[3] In fact, in any instance where millions of individual units form larger, collective systems, complexity is of use. This move over into the social sphere raises fascinating questions.

and raw materials, through to the consumer coveting the object, relate to each other. This relational model of culture is not restrictive or prescriptive. The work of art is not to be understood as physical object (or text or set of sounds). The work of art is a relationship. It is the relationship between the viewer and the object and both these are elements in its creation. Infrastructure, therefore, merely describes the structure of processes that must occur so that works of art, these relationships, can happen.[4]

This model of interdependence of process and consumption has equivalents in other disciplines that directly relate to the cultural sphere. Two recently developed examples are especially pertinent: *extelligence* and *machinofacture*. The first of these stems from the worlds of neurology, evolutionary studies and socio-biology; the second arose from the new history of technology.

Extelligence is in some ways the most far reaching of the two concepts. For some time now, one of the central areas of concern among historians and theoreticians of science has been the social context in which scientific development occurs. Serious and often acrimonious debate has surrounded the objectivity of science in relation to cultural context. Without caricaturing the debates, it is possible to discern deep-seated antagonism between Post-Modern thinkers welling from the humanities and the empirically-based science community. The former have been positioned somewhat as the watchdogs of the latter, and as watchdogs they have claimed, to a considerable extent, that the social context that scientific discovery is made in affects the nature of the discovery itself. In other words, science is not simply to do with objective empirical experimentation and technical advance. It is changed by the socio-cultural dispositions of the individuals who do the experiments and the environments they live in. For their part, the scientists – while often accepting that society does have an effect on science – have nevertheless tended to insist on the objectivity of the scientific ethos. A grand climax of the contextual-empirical debate came with the notorious Sokal affair. In 1996 physicist Alan Sokal submitted an article to the journal *Social Text*, which frequently carries critical (contextual) analysis of science and technology. The article was a deliberate parody filled with bogus data and absurd philosophical positions. It passed the journal's academic reviewers and was published. The incident polarised the communities involved.[5]

The intensity of the debate accepted, some scientists have powerfully argued that the space between the

Peter Aldridge; British; *A Moment in Time*; glass; 1998; Courtesy the Trustees of the Victoria and Albert Museum

Yō Akiyama; Japanese; *Oscillation III*; ceramics; 1995; Photograph by Gakuji Tanaka

empirical and contextual worlds is not only a spurious but a false one. Mathematician Ian Stewart and biologist Jack Cohen, for example, have developed a socio-biological worldview that deliberately lives in both spheres. Extelligence, the model they have developed, is dependent on this cohabitation. Extelligence is an integrative, developmental process which describes the manner in which human society functions and evolves:

> Extelligence is the invention that not only allowed humans to change themselves into the type of animal they now are, but made it very difficult for them to avoid doing so. What is the origin of extelligence? Did we invent it or did it invent us?
> Both.
> Two things characterise our species. One is an enormously exaggerated concern for children of any kind ... The other is language. We maintain that these two apparently very different characteristics are actually linked, by the medium of cultural privilege, and that together they created the possibility of extelligence.[6]

To take the second of these first, an ongoing argument in evolutionary circles has concerned the growth of intelligence in relation to language. Two central and conflicting versions dominate the discussion, the first positing that a development in intelligence allowed language to develop, the other that language is a prerequisite for intellectual growth. Stewart and Cohen resolve the debate by asserting that 'It seems very plausible indeed that both of these theories are true, with each driving the other in a complicit process of interactive co-evolution'.[7]

This co-evolution allows for a consolidation of knowledge and its constant representation to successive generations, which is where, for them, the significance of child nurturing comes in.

The collective experiences of the tribe become a cultural lexicon stored in the people that surround each child. This cultural context for each child can then grow, as successive generations accumulate further knowledge, and new discoveries can be transmitted very rapidly to all individuals who have the aptitude to use them.[8]

Extelligence, then, is the shared, cumulative intelligence of a society, made available in multiple ways to successive generations of children. Extelligence is in constant flux, it has no universal prescribed shape or agenda, these changing from context to context. But what doesn't change for Stewart and Cohen is the framework, the pattern. Extelligence is a structured constant, an animated pattern form which surrounds individuals in a community. They are constantly, and often unconsciously, fed by the pattern, and they also choose elements within the pattern that they wish to utilise for themselves. They are to a considerable extent invented by the pattern, but their dynamic interaction with it means that

Kagari Miyoshi; Japanese; *Le Soir*; Lacquer box; 1991

they simultaneously invent it. Thus the relationship between intelligence and extelligence is vital, as this represents the tie between the individual and the collective.

The metaphysical fabric that holds together and mediates a community has been variously identified and explained in the humanities throughout the 20th century, following a long and ancient tradition of explication. Perhaps the most important of these is ideology. Defined broadly, ideology is an idea or body of ideas that become naturalised into the consciousnesses of a community, so much so that they are accepted without question. Individuals think, act and accept the premises of the ideology without analysing it. The term is often used in the political sphere and therefore has gathered a pejorative dimension. Related to ideology is the idea of zeitgeist, or spirit of the age. Particularly important in the first half of the century, zeitgeist was used by numerous cultural thinkers to explain the prevailing mood of a community. More substantial but ultimately no more scientifically tangible is the Jungian idea of collective unconscious. Self-explanatory as an idea, collective unconscious was a

means of explaining psychological and cultural phenomena that are apparently universally shared.

Ideology, zeitgeist and collective unconscious all attempt to explain the relationship of the individual to society, and insofar as they do this they exist in the same conceptual terrain as Cohen and Stewart's extelligence. However, as parts of the grand attempt by early Modernists to explain the material and mental workings of society, they appear now oddly limited and somewhat dependent on unprovable and even mystical conceptions of the mind. Recent developments in neurology have shown conclusively that psychoanalysis and 'spirits' no longer map onto the known geography of the brain.[9] The interdisciplinary nature of extelligence is able to bridge the space between the physical and mental worlds, and between cultural and scientific spheres. It describes the biological-cultural matrix within which human society resides and evolves.

Second, the concept of machinofacture has been used to explain the role and position of technology and industry in society. The concept has been most fully developed

Piet Stockmans; Dutch; *Installation*; porcelain; 1999

Neil Forrest; Canadian; *Architectural screen*; ceramic, 1999

by historian of technology Ian Inkster.[10] The issue has been addressed as to why and how some nations successfully industrialise and achieve the economic status of first world nations, and maintain that position. The historical record has demonstrated with devastating clarity that the injection of industrial investment and technology into a national economy alone does not guarantee the development of sustained socio-economic prosperity. A nation needs machinofacture. Machinofacture does not simply imply technological hardware, but a wider network of socio-economic development. It implies the myriad companies, retailers and investors which constantly adapt to ongoing conditions in the world. It suggests that a national economy is not a limited number of corporations putting into practice a finite number of inventions, but a mass of interdependent companies and individuals, a massively complex vortex of active bodies, making and consuming the stuff of the world.

In isolation technology transforms nothing permanently and triggers little into life beyond itself. Any society that embraces it must also change socio-cultural systems relating to education, consumption and the lifestyles of the population. The ever-changing products of technology demand an ever-changing, self-aware society to feed into. Machinofacture therefore also refers to the lifestyles of the millions who engage everyday with the products of technology. In the 20th century, centralised – that is, simplified – economies have failed, as have attempts to stimulate productivity in nations through the construction of showpiece city centres, motorways and model factories. Successful economies consist of the semi-orchestrated vortex of a million vested interests.

As many utopian experiments have demonstrated, beyond a certain size societies cannot be governed politically, economically and intellectually from a centralised point. Too much has to be destroyed in order to maintain control of the system. Even generous delegation ultimately fails. Any economy is a dynamic tension between centred and de-centred, and public and private sectors. If these four are not present and operating relative to one another, the economy will fail. Ironically therefore, too simple a pattern, when imposed, leads to no pattern at all. Complexity theory tells us that simple

Paul Mathieu; Canadian; *Afternoon Sun* (after P. Cavafy); front; porcelain; l.150cm; 2000

units can combine and develop immensely complex pattern forms. Some of the more extreme social experimentation of the 20th century advocated exactly the opposite: the deliberate simplification of complex social systems.

As phenomena, machinofacture, extelligence and infrastructure clearly belong to the same conceptual family. They are systems within the structure of particular aspects of humanity. They are mechanisms for the generation of non-repeating patterns; they are dynamic not static; they function through constant adaptation of individual units within a larger whole; they evolve developmental processes through cumulative pattern formations. Simple elements come together in the right conditions and establish a growth pattern. This gains in complexity and sophistication to the point at which the phenomena being created become effectively self-determining. Once the process has established itself, it speeds up exponentially and can resist degradation with remarkable tenacity.[11]

Infrastructure dictates how things are going to look. Most important in this context, it is responsible for that most complex of phenomena: style. At any one time and in any one place cultural produce tends to be visually and intellectually cohesive. The stuff we make settles into styles. Classically defined, style is the generic appearance of a wide range of cultural objects produced in any one time or place. This appearance is not arbitrary; it is the visual manifestation of underlying structures and ideas. Styles lend society stability, they record our memories, identify our gods and give us hedonistic pleasure.

Styles can prove surprisingly resilient. Nations might be represented by them for centuries, and once the civilisation that created it has disappeared, it can come to stand for particular values. Several styles often thrive concurrently in a single place; styles merge to form complex variations of their constituent parts. They become endlessly nuanced without losing the public nature of their language. Having said this, styles can emerge with astounding rapidity and disappear at the same speed in a given space of time.

The relationship of the individual to style is complex. Individuals participate in the collectivity that is style, decorating themselves and their environments in such a way as to attach themselves symbolically to those around them. In this way style is a device we have invented for cohering as social groups. It holds the memories and ideas of communities and transmits them on. At the same time, in an interestingly dialectical manner, individuals can deliberately defy predominant style, combining or subverting its tenets in order to differentiate themselves. Style is also surprisingly difficult to generate artificially. Individuals and groups can declare themselves to be in a certain 'style' at any one time, but there is no guarantee that their declaration will result in a wider, generically naturalised phenomenon. Style is only partly deliberate. At a certain moment, it gains its own volition and escapes the control of the forces that initially created it.

Paul Mathieu; back

From the later part of the 19th century, thinkers have pondered on the origins of style. How exactly an ethnic group arrived as they did at the specific approaches to visual culture was explained in one of several ways. It was seen by some as a result of the particular technologies and materials they used; it was identified as a corollary to language; it was associated with the physical and geographic characteristics of the land where it was created; it was identified as part of the complexity of evolutionary theory; and it was identified as welling out of the collective temperament, or 'zeitgeist' of the peoples who created it.[12] At the end of the century the idea developed that style was a result of none of these things, but rather was created by individual geniuses who were then copied by others until the 'look' became naturalised into the society. This, the so-called 'trickle-down' theory, held sway for much of the 20th century.

Vociferous as many of the debates were, in reality there is no reason why all of these explanations cannot be true. As a pattern a community creates to identify itself, style is a principal means of cohering individuals. It is not under the control of any one element at any one time, but rather it is a complex mediation. It can be forced into an hegemonic structure that allocates it specific roles and meanings, but it does have to be forced, and with considerable tenacity.

A style as a collective expression of a society is intimately bound up with the phenomenon of consumption. Commodity types are endlessly adjusted and modified over periods of time as people continually shift and refine their needs and tastes. At the same time, their needs and tastes are shifted by commodities. The totality of the physical and cerebral landscape comes to bear on the process. Given the dynamic, on-going nature of the process, contemporary style is usually difficult to discern. Once a style is part of the past, it is static and therefore identifiable.

Style is a sophisticated and eclectic combination of visual and mnemonic impulses that gives visual cohesion and identity to societies. Style is generated through infrastructure. Infrastructure is a machinery developed by societies (it ultimately develops itself following the logic of complexity theory) for the production of cultural artefacts. Style is a visual representation of infrastructure and infrastructure is simultaneously analogue and synonym of society.

The timbre and balance of the infrastructure, its position with regard to the social, economic and political patterns of the larger world, will dictate how important the arts will be, who will consume them and what they will look like. It is important that we find our place within the infrastructure. The processes of Modernity are entirely bound up in it and these will continue on relentlessly in the coming decades. And modernity in itself it not a value-laden thing. In the first instance it is not good or bad: it just is. It is well capable of becoming a nightmare force or a vehicle to the sublime. By adjusting and developing the infrastructure, the systems of creation, distribution and display that are its

Léopold L. Foulem; Canadian; *Empire Style Flower Vase with Bouquet of Red Poppies*; ceramic; 2001-2002;
Photograph by Pierre Gauvin

constituency, we change the shape of the visual culture around us. Several types of intervention suggest themselves for the next period of years.

First, we should not abandon or even dilute the intense specialisms we have developed over generations. Tragically, our systems of training, dissemination and display in the visual arts are not necessarily improving in terms of specialist excellence. Some nations have guarded these skills more successfully than others, but it could easily be argued that we are interpreting populism and interdisciplinarity – the two vital concepts – as being vehicles for the achievement of a less differentiated, bland, generalist culture. Quality can only be achieved through the obsessive engagement of large numbers of singularly committed individuals on specific tasks. Ultimately, art is judged by the quality of individual productions. There are signs that we are no longer prepared to invest the time and resource to maintain the painful intensity of specialisation. This is an issue of politics and economics. We can lie to ourselves about cultural production and use relativist sophistry to mask the decline, or we can determine not to do this.

Second, we need to move laterally through the layers of the infrastructure and keep it in a state of constant communication and dissemination. The idea of orchestration is key. Catalysts need to move through our systems, connecting, binding and positioning what they find. This is how specialist skills improve themselves, develop new aspects and become widely available. Third, infrastructure needs to liaise with other systems within the totality of culture. The compartmentalisation of the 20th century has to be dispensed with. The tragic myth that economy, technology, politics or philosophy, for example, are not centrally relevant to the visual arts, has been isolating and destructive. However, engagement on the micro-level will not necessarily change much. Interaction of infrastructure with its equivalent systems in these other fields will be the key to development.

The crafts as a consortium of genres sit in the middle of the infrastructure, a loosely cohesive group of practices that acquired whatever logic they have during the course of the 20th century. They have been economically marginalised, and pushed to numerous peripheral borders. But they have managed to maintain, through their powerful sense of individuation, a distinct skill-base. The 20th century is over. The time has come to use this skill-base – to develop, enlarge and to re-position it. It is time that this consortium of practices fully understood its own importance.

With regard to my second and third points, we have always liaised within the infrastructure of the visual arts with modest success, usually on an informal basis. The last twenty years has seen great strides in the area of orchestration of collaborations between disciplines and functions. But we have a long way to go in order to make the infrastructure into a fully adaptive, flexible system of production and consumption. Large parts of the infrastructure, not least as it relates to the crafts, are dormant and under-used. The third idea we have dreamt about but never achieved. Appropriate liaison between infrastructure and its equivalents in other fields will be the task of the next several decades. If we do not address the issue of the 'two cultures' of sciences and arts, for example, and push toward the concept of one culture, then it is difficult to imagine satisfactory solutions to myriad crippling social and economic problems. Arguably, we are less accomplished in the art of interdisciplinarity than our 19th century forebears.

The best products of the next decades will be the result of a reconciliation of what have previously been understood to be oppositions: specialisation and generalisation; the individual and the collective; globality and locality; the avant-garde and the popular. Everything relates to everything. Accepting this without losing ourselves or sacrificing the quality of the things we make will be the great challenge.

The constantly unfolding fabric of culture complicates and re-complicates itself with increasing rapidity, as communication speeds up and technical facilities that were formerly beyond our imagination become commonplace. Those cultural practices that do not engage with Modernity, which will speed and grow exponentially from now on, will be peripheral. The crafts, if they are to have a role in the next phase of Modernity, need to be core to the process of complication. They need to flow with and simultaneously create the pattern.

We are swimming in a sea of stuff we have made. We need to continually remind ourselves why it looks like it does and why we do it. And we must be careful not to drown in it.

COPYRIGHT © 2002 PAUL GREENHALGH.

NOTES

[1] Peter Coveney and Roger Highfield, *Frontiers of Complexity*, London, Faber & Faber, 1996, p.5.

[2] J.H. Holland, *Emergence from Chaos to Order*, Oxford, OUP, 1998.

[3] The following publications give a reasonable grasp of the scope of the field. Holland, see Note 2 and Coveney and Highfield, see note 1; John L Casti, *Searching for Certainty: What Science can Know about the Future*, London, Scribners, 1992; David Pines, *Emerging Syntheses in Science*, New York, Addison-Wesley, 1988; Stuart Kauffman, *The Origins of Order*, Oxford, OUP, 1992; M. Mitchell Waldrop, *Complexity: The Emerging Science at the Edge of Order and Chaos*, New York, Simon & Schuster, 1992; J. Cohen and I Stewart, *The Collapse of Chaos*, London, Pan, 1992; Roger Lewin, *Complexity, Life on the Edge of Chaos*, London, Phoenix, 1993.

[4] See W. Ray Crozier and P. Greenhalgh, 'The Empathy Principle: Towards a Model for the Psychology of Art', *Journal for the Theory of Social Behaviour*, Vol. 22, No. 1, March 1992.

[5] Noretta Koertge (ed.), *A House Built on Sand: Exposing Post-Modern Myths about Science*, Oxford, OUP, 1998.

[6] Ian Stewart and Jack Cohen, *Figments of Reality: The Evolution of the Curious Mind*, Cambridge, OUP, 1997, p.244.

[7] Ibid., p.245.

[8] Ibid., p.245.

[9] Zeki Semir, *Inner Vision: An exploration of Art and the Brain*, Oxford, OUP, 1999.

[10] See, for example, Ian Inkster, *Science and Technology in History: An approach to industrial development*, London, MacMillan, 1991; Ian Inkster, 'Technology Transfer in the Great Climacteric: Machinofacture and International Patenting in World Development Circa 1850–1914', *Journal of the History of Technology*, Vol. 21, 1999, pp.87–106.

[11] See Ray Kurzweil, *The Age of Spiritual Machines*, London, Pheonix, 1999.

[12] See, for example, Paul Greenhalgh, '"A Great Seriousness": Art Nouveau and the Status of Style', *Apollo*, May 2000, pp.3–10 and Paul Greenhalgh (ed.), *Quotations and Sources from Design and the Decorative Arts 1800–1990*, Manchester, MUP, 1993, chapter 1.

BIBLIOGRAPHY

Books

No bibliography is ever complete. The one below reflects two things: the condition of the field of contemporary craft scholarship, and my own eccentricities. The aim has been to give the reader a solid introduction to the field and to provide the most important contextual material. I apologise in advance for omissions, but am confident that the bibliographies contained within the listed texts will finish the incomplete picture I provide here.

GENERAL
These texts include classic studies of the crafts as a whole.

Bebe, Miles, *Designing with Natural Materials*, 1975, New York, Van Nostrand.

Carter, Sam et al., *A Treasury of Canadian Craft*, 1992, Vancouver, Canadian Craft Museum.

Carter, Sam, *Side By Side*, 1999, Vancouver, Canadian Craft Museum.

Causey, Andrew (ed.), *Sculpture Since 1945*, 1998, Oxford, OUP.

Coatts, Margot (ed.), *Pioneers of Modern Craft*, 1996, Manchester, MUP.

Coleman, Roger, *The Art of Work: An Epitaph to Skill*, 1988, London, Pluto.

Collingwood, R.G., *The Principles of Art*, 1938, Oxford.

Day, Peter; Lewis, Linda, *Art in Everyday Life: Observations on Contemporary Canadian Craft*, 1988, Toronto, Summerhill.

Dormer, Peter (ed.), *The Culture of Craft: status and future*, 1997, Manchester and New York, Manchester University Press.

Dormer, Peter, *The Art of the Maker*, 1994, London, Thames and Hudson.

Dormer, Peter, *Arts and crafts to avant-garde: essays on the crafts from 1880 to the present*, 1992, London, South Bank Centre.

Doordan, Dennis, *Design History: An Anthology*, 1995, MIT Press.

Doyon, Carol; Falk, Lorne; Weir, Jean, *Restless legacies: contemporary craft practice in Canada*, 1988, Calgary, Olympic Arts Festival.

Elinor, Gillian; Richardson, Scott; Thomas, Angharad; Walker, Kate, *Women and Craft*, 1987, London, Virago Press Ltd.

Faulkner, Rupert, *Japanese Studio Crafts: Tradition and the Avant-Garde*, 1995, Lawrence King.

Forty, Adrian, *Objects of Desire, Design and Society 1750-1980*, 1986, London, Thames and Hudson.

Fuller, Peter, *Images of God*, 1982, London, Chatto and Windus.

Gibson, William et al., *Articulation, Muttart*, 1994, Calgary, Public Art Gallery.

Grant, Arnold; Gagnon, Monika Kin; Jensen, Doreen, *Topographies: aspects of recent B.C. art*, 1996, Vancouver, British Colombia, Douglas & McIntyre Ltd.

Greenhalgh, Paul, *Looking Forward: New Views of the Craft Object*, 2000, Toronto, Ontario Crafts Council.

Greenhalgh, Paul (ed.), *Modernism in Design*, 1990, London, Reaktion.

Greenhalgh, Paul, *Quotations and Sources from Design and Decorative Arts 1800-1990*, 1993, Manchester, MUP.

Greg, Andrew, (ed.), *Primavera: pioneering craft and design 1945-1995*, 1995, Newcastle upon Tyne, Tyne and Wear Museum.

Greystone, *The Greystone Encyclopaedia of the Crafts*, 1975, New York, The Greystone Press.

Halpin, Marjorie, *Jack Shadbolt and the Coast Indian Image*, 1986, University of British Columbia Press.

Harrod, Tanya, (ed.), *Obscure Objects of Desire: reviewing the crafts in the twentieth century*, 1997, London, Crafts Council.

Harrod, Tanya, *The Crafts in Britain in the 20th Century*, 1999, New Haven and London, Yale University Press.

Hartley, Dorothy, *Made in England*, 1939, London.

Hayward, Tony, *Made in India*, 1997, London.

Hickey, Gloria, A., *Making and metaphor: a discussion of meaning in contemporary craft*, 1994, Hull, Quebec, Canadian Museum of Civilization with the Institute for Contemporary Canadian Craft.

Huston, John, (ed.), *Craft Classics Since the 1940's*, 1988, London, Crafts Council.

Ioannou, Noris, *Craft in Society*, 1992, Fremantle Arts Centre Press.

Ioannou, Noris, *Masters of their Craft: Tradition and Innovation in the Australian Contemporary Decorative Arts*, 1997, Sydney, Craftsman House.

Jeffri, Joan, (ed.), *The Craftsperson Speaks*, 1992, New York, Greenwood Press.

Jencks, Charles, *The Language of Post Modern Architecture*, 1977, London Academy.

John Hansard Gallery, *Craft matters: 3 attitudes to contemporary craft*, 1985, Southampton.

Johnson, Pamela, *Ideas in the Making: practice in theory*, 1998, London, Crafts Council.

Kangas, Matthew, *Breaking barriers: recent American craft*, 1995, New York, American Craft Museum.

Kato, Shuichi, *Reflections on Japanese Art and Society: Form, Style, Tradition*, Japan, Kodansha.

Lucie Smith, Edward, *The Story of Craft: The Craftsman's Role in Society*, London.

Knott, C.A., *Crafts in the 1990s*, 1994, London, Crafts Council.

Macnair, Peter L.; Hoover, Alan; Neary, Kevin, *The Legacy: Continuing Traditions of Canadian Northwest Coast Indian Art*, 1980, Victoria, British Columbia Provincial Museum.

Macnair, Peter L.; Joseph, Robert; Grenville, Bruce, *Down from the Shimmering Sky: Masks of the Northwest Coast*, 1998, Vancouver, Douglas & McIntyre.

Manhart, Marcia and Tom (eds), *The Eloquent Object*, 1987, Tulsa, Philbrook Museum of Art.

Margetts, Martina (ed.), *International Crafts*, 1991, London, Thames and Hudson.

Margetts, Martina, *Classic Crafts: A Practical Compendium of Practical Skills*, 1989, London, Octopus.

Mattil, Edward, *Meaning in Craft*, 1965, New Jersey, Prentice Hall.

Metcalfe, Robin; Abbott, Adriane, *Studio Rally*, 1999, Halifax, Studio Rally.

Moseley, Spencer, *Crafts Design: An Illustrated Guide*, 1966, Belmont, Calif, Wadsworth.

Needleman, Carla, *The work of craft: an inquiry into the nature of crafts and craftsmanship*, 1993, New York and London, Kodansha International.

New, William H., *Borderlands: How we talk about Canada*, 1998, University of British Columbia Press.

Nordness, Lee, *Objects: USA*, 1971, New York.

Northern Centre of Contemporary Art, *2D/ 3D: Art and Craft Made and Designed for the Twentieth Century*, 1987, Sunderland, Crafts Council.

Olive, David, *Canada Inside Out*, 1996, Toronto, Doubleday Canada Limited.

Pearson, Richard, *Image and Life: 50,000 Years of Japanese Prehistory*, 1978, University of British Columbia, Museum of Anthropology.

Pye, David, *The Nature of Design*, 1964, London, Studio Vista.

Pye, David, *The Nature and Art of Workmanship*, London, Herbert Press, 1995

Richards, M.C., *Centering*, 1962, New York, Wesleyan.

Rowley, Sue (ed.), *Craft and Contemporary Theory*, 1997, St. Leonard's, New South Wales, Allen & Unwin.

Schoeser, Mary, *Influential Europeans in British Craft and Design*, 1992, London, Crafts Council and Mary Schoeser.

Smithsonian Institution, *Skilled work: American craft in the Renwick Gallery*, 1998, Washington and London, Smithsonian Institution Press.

Sparke, Penny, *An Introduction to Design and Culture in the Twentieth Century*, 1986, London, Allen and Unwin.

Thackera, John, *Design After Modernism*, 1988, London, Thames and Hudson.

Townsend, Peter (ed.), *Art within reach: artists and craft workers, architects and patrons in the making of public art*, 1984, London, Thames and Hudson.

Turner, W.J. (ed.), *British Craftsmanship*, 1948, London, Collins.

Vernon, Phil, Dempsey Bob: *A Portrait of a Contemporary Native Artist*, 1991, Unpublished paper.

Webb, Jennifer (ed.), *Objects and Expressions*, 1999, University of British Columbia Museum of Anthropology.

Woodham, Jonathan, *20th Century Design*, 1997, Oxford, OUP.

Woodham, Jonathan, *Twentieth Century Ornament*, 1990, London, Thames & Hudson

Wyatt, Gary, *Spirit Faces: Contemporary Masks of the Northwest Coast*, 1994, Vancouver, Douglas & McIntyre.

Wymer, Norman, *English Country Crafts: a Survey from their Origins to the Present Day*, 1946, London, Batsford.

Yanagi, Soetsu, *The Unknown Craftsman*, 1972, Tokyo, Kodanska International.

GENERAL:
Historical, Theoretical, Technological, Contextual

There could have been limitless entries here, and in some respects this list is eccentric. It reflects the wide range of issues raised by the authors in this volume, and indicates those areas that the editor believes to be of importance in the crafts at this time. Historical texts are included where they directly outline the prehistory of the current situation. Biographies of individuals have been avoided except where wider issues are implied. The theoretical texts explain themselves, but the reader will note a significant number of works not normally associated with the crafts. The field is widening as well as deepening.

Anscombe and Gere, *The Arts and Crafts in Britain and America*, 1978, London, Academy.

Appadurai, Arjun, *The Social Life of Things: Commodities in Cultural Perspective*, 1988, Chicago, Chicago, U.P.

Appadurai, Arjun, *Modernity at Large: Cultural Dimensions of Globalisation*, 1996, Chicago, Chicago, U.P.

Aynsley, Jeremy, *Nationalism and Internationalism*, 1993, London, Victoria and Albert Museum.

Bourdieu, Pierre, *Distinction: A Social Critique of the Judgment of Taste*, 1979, London, RKP.

Buchanan, Richard; Margolin, Victor, *The Idea of Design*, 1995, MIT Press.

Causey, Andrew, Burty, Philippe, *Chefs d'Oeuvres of the Industrial Arts*, 1869, London, Chapman and Hall.

Castells, Manuel, *The Rise of Network Society*, 1996, Oxford, Blackwells.

Coveny, Peter; Highfield, Roger, *Frontiers of Complexity*, 1995, London, Faber.

Clunas, Craig, *Art in China*, 1997, Oxford, OUP.

Crane, Walter, *Ideals in Art*, 1905, London: George Bell & Sons.

Crawford, Alan C.R., *Ashbee: architect, designer and romantic socialist*, 1985, New Haven and London Yale University Press.

Crozier, W. Ray, *Manufactured Pleasures: Psychological Responses to Design*, 1992, Manchester, MUP.

Cumming, Elizabeth: Kaplan, Wendy, *The Arts and Crafts Movement*, 1991, London, Thames and Hudson.

Dews, Peter, *Habermas: A Critical Reader*, 1999, Oxford, Blackwells.

Dodd, Nigel, *Social Theory and Modernity*, 1999, Cambridge, Polity Press.

Dresser, Christopher, *The Principles of Decorative Design*, 1873, London, reissued 1973 Academy Editions.

Eagleton, Terrence, *The Idea of Culture*, 2000, Oxford, Blackwell.

Foster, Hal, *The Return of the Real: The Avant-Garde at the end of the Century*, 1996, Cambridge, Massachusetts, MIT Press.

Gage, John, *Colour and Culture*, 1993, London, Thames and Hudson.

Geertz, Clifford, *Works and Lives: The Anthropologist as Author*, 1988, Stanford.

Gleick, James, *The Best American Science Writings 2000*, 2000, New York, Ecco.

Goudsblom, Johan; Mennell, Stephen, *The Norbert Elias Reader*, 1998, Oxford, Blackwell.

Greenberg, Clement, *Art and Culture*, 1961, Boston, Beacon.

Greenberg, Reesa; Ferguson, Bruce; Naine, Sandy, *Thinking About Exhibitions*, 1996, London, Routledge.

Greenhalgh, Paul (ed.), *Art Nouveau 1890-1914*, 2000, London and New York, V&A and Abrams.

Horgan, John, *The End of Science*, 1996, London, Abacus.

Hutchinson, Tam; Smith, Antony, *Ethnicity*, 1996, Oxford, OUP.

Jameson, Fredric; Miyoshi, Masao, *The Cultures of Globalization*, 1998, Durham and London, Duke University Press.

Jervis, John, *Exploring the Modern*, 1998, Oxford, Blackwells.

Jones, Owen, *The Grammar of Ornament*, 1856, London, reissued 1986, London, Studio Editions.

Karp, Ivan; Lavine, Steven D. (eds.), *Exhibiting Cultures: The Poetics and Politics of Museum Display*, 1990, Washington.

Kaku, Michio, *Visions: How Science will Revolutionize the 21st Century and Beyond*, 1998, Oxford, OUP.

Kracauer, Siegfried, *The Mass Ornament*, 1995, Boston, Harvard UP.

Kristellar, Oscar, Paul, 'The Modern System of the Arts', *Journal of the History of Ideas*, 1951, p.p. 496-527.

Lash, Scott, *Another Modernity A Different Rationality*, 1999, Oxford, OUP.

Le Rider, Jacques, *Modernity and Crises of Identity*, 1993, New York, Continuum.

Lumley, Robert, *The Museum Time Machine*, 1988, London, Routledge.

Marcuse, Herbert, *The Aesthetic Dimension*, 1977, London, MacMillan.

McEwen, Indra, Kagis, *Socrates Ancestor: An Essay On Architectural Beginnings*, 1993, Chicago, M.I.T.

Mumford, Lewis, *Art and Technics*, 1952, Oxford, OUP.

Naylor, Gillian, *The Arts and Crafts Movement: A Study of its Sources, Ideals and Influence of Design Theory*, 1970, London, Studio Vista.

Papenek, Victor, *The Green Imperative*, 1987, Thames and Hudson.

Pavitt, Jane, *Brand New, 2000*, London, Victoria and Albert Museum.

Racinet, A, *The Encyclopedia of Ornament*, 1873, London, reissued 1873, London, Studio Editions.

Sanders, Barry, *The Craftsman: An Anthology*, 1978, Salt Lake City, Peregrine Smith.

Shusterman, Richard, *Bourdieu: A Critical Reader*, 1999, Oxford, Blackwell.

Stewart, Ian; Cohen, Jack, *Figments of Reality*, 1997, Cambridge, CUP.

Thomas, Lewis, *The Fragile Species*, 1992, New York, Scribener.

Tokyo, National Museum of Modern Art, *Japonisme in the Crafts*, 1998, Tokyo, Tokyo, National Museum of Modern Art.

Wilson, Edward. *On Human Nature*. 1978, Boston, Harvard UP.

Wittkower, Rudolf, *The Artist and the Liberal Arts: An Inaugeral Lecture*, January 1950, London, UCL.

Wittkower, Rudolf, *Sculpture: Processes and Practices*, London.

Zeki, Semir, *Inner Vision: An Exploration of Art and the Brain*, 1999, Oxford, OUP.

CERAMICS

Adlin, Jane, *Contemporary Ceramics: Selections from the Collection of the Metropolitan Museum of Art*, 1998, New York, Metropolitan Museum of Art.

Anderson, Duane; Vigil, Lonnie, *All That Glitters: The Emergence of Native American Micaceous Art Pottery in Northern New Mexico*, 1999, School of American Research Press.

Andrews, Tim, *Hitec-Lotec*, 2000, Crafts for Now.

Andrews, Tim, *Raku: a Review of Contemporary Works*, 1994, London, A&C Black.

Australian Ceramics, Shepparton Art Gallery.

Bardos, Carolyn M., *Earthen Wonders: Hungarian Ceramics Today*, 2000, Lake House Books.

Berger, Guy; Schiffer, Nancy, *Pueblo and Navajo Contemporary Pottery and Directory of Artists*, 2000, Schiffer Publishing.

Cardew, Michael, *A Pioneer Potter*, 1988, London.

Charleston, Robert, *World Ceramics*, 1981, London, Hamlyn.

Clark, Garth, *American Ceramics: 1876 to the Present*, 1987, New York, Abbeville Press.

Clark, Garth, *The Potter's Art*, 1995, London, Phaidon.

Clark, Garth, *Ceramic Art: Comment and Review 1882-1978*, 1978, New York, Dutton.

Clark, Garth, *A Century of Ceramics in the United States 1878-1978*, 1979, New York, Dutton.

Clark, Garth, *Ceramics and Modernism: Response of the Artist, Designer, Craftsman and Architect*, 1982, Los Angeles, Institute for Ceramic History.

Clark, Garth; Watson, Oliver, *American Potters Today*, 1986, London, V&A.

Danto, Arthur C.; Koplos, Janet, *Choice/America: Modern Ceramics*, 1999, Museum Het Kruithuis.

De Waal, Edmund, 'Homo Orientalis: Bernard Leach and the Image of the Japanese Craftsman' in *Journal of Design History*, Vol.10, No.4, pp. 355-62.

De Waal, Edmund, *Bernard Leach*. 1997, Tate Gallery.

De Waal, Edmund, *New Ceramic Design*, 2000, Writer's Digest.

De Waal, Edmund, *Bernard Leach*, 1997, London, Tate St.Ives.

De Waal, Edmund, *Bernard Leach*, 1998, Tate Gallery, St Ives Artists Series.

Fairbanks, Jonathan L., *The Best of Pottery*, 1996, Writer's Digest Books.

Fairbanks, Jonathan; Fina, Angela; Gustin, Christopher, *The Contemporary Potter: A Collection of the Best Original Work in Earthenware, Porcelain, and Stoneware*, 2000, Rockport Publications.

Fountain Sikes, Toni (ed.), *The Best of New Ceramic Art*, 1997, North Light Books.

Frankel, Cyril, *Modern Pots: Hans Coper, Lucie Rie and their contemporaries: The Lisa Sainsbury Collection*, 2000, London, Thames and Hudson.

French, Neal, *Industrial Ceramics: Tableware*, 1972, Oxford OUP.

Henzke, Lucile, *Art Pottery of America*, 1999, Schiffer.

Hildyard, Robin, *European Ceramics*, 2000, London, V&A.

Hildyard, Robin, *Browne Mugges*, 1989, London, V&A.

Ioannou, Noris, *Ceramics in South Australia 1836-1986: From Folk to Studio Pottery*, 1986, Adelaide, Wakefield Press.

Jefferies, Susan; McPherson, Anne, *White on white [exhibition]: contemporary Canadian ceramics*. 1996, Waterloo, Ontario, Canadian Clay & Glass Gallery.

Kenji, Kaneko et al., *The History of World Ceramics*, 1999, Bijitsu Shuppansha.

Kling, Alice Jane, *America's contemporary craftsmen: a way of work, a way of life*, 1987, Washington, George Washington University.

Kohyama, Yasuhisa; Tanaka, Chiyoko, *Sand and Silk: contemporary ceramics and textile art from Japan*, 1992, Hamburg, Museum für Kunst und Gewerbe Hamburg.

Koplos, Janet (ed.), *The Unexpected: Artists' Ceramics of the 20th Century: The Kruithuis Museums Collection*, 1999, Museum Het Kruithuis.

Lane, Peter, *Studio Ceramics*, 1983, London, Collins.

Lane, Arthur, *Style in Pottery*, 1948, London, Faber and Faber.

Lauria, Jo; Adkins, Gretchen; Clark, Garth; Niederlander, Rebecca; Peterson, Susan; Selz, Peter, *Color and Fire: Defining Moments in Studio Ceramics, 1950-2000*, 2000, Rizzoli International.

Leach, Bernard, *A Potter in Japan*, 1960, London.

Leach, Bernard, *A Potter's Book*, 1940, London, Faber and Faber.

Leach, Bernard, *Hamada Potter*, 1975, Kodansha International.

MacNaughton, Mary Davis (ed.), *Revolution in Clay: The Marer Collection of Contemporary Ceramics*, 1994, University of Washington Press.

Mansfield, Janet, *Contemporary Ceramics in Australia and New Zealand*, 1993, Craftsman House.

Mansfield, Janet, *Modern Australian Ceramics*, 1988, Craftsman House.

Mansfield, Janet, *Salt-glaze Ceramics*, 1992, London, A&C Black.

Mayer, Carol E. (ed.), *The Potter's Art: Contributions to the study of the Koerner Collection of Ceramics*, 1997, University of British Columbia Press.

Mayer, Carol E., *Made of Clay: Ceramics of British Columbia*, 1998, Vancouver, Potters Guild of British Columbia.

Moeran, Brian, *Folk Art Potters of Japan: Beyond an Anthropology of Aesthetics*, 1998, Hawaii, University of Hawaii Press.

Museum of Contemporary Crafts, *Clayworks: 20 Americans*, 1971, New York, MCC.

Osterman, Matthias, *The New Maiolica: Contemporary Approaches to Colour and Technique*, 1999, A&C Black/University of Pennsylvania Press.

Opie, Jennifer, *Scandinavia: Ceramics and Glass in the 20th Century*, 1986, London, V&A.

Opie, Jennifer, *The Poole Potteries*, London.

Perry, Barbara (ed), *American Ceramics: The Collection of the Everson Museum of Art*, 1989, New York, Rizzoli.

Peterson, Susan, *Contemporary Ceramics*, 2000, Watson-Guptill.

Rago, David, *American Art Pottery*, 1997, Knickerbocker Press.

Rice, Paul, *British Studio Ceramics in the 20th Century*, 1989, London, Barrie & Jenkins.

Rich, Chris (ed.), *The ceramic design book: a gallery of contemporary work*, 1998, Asheville, NC, Lark Books.

Roberts, Ann (ed.), *A Question of Identity: Ceramics at the End of the*

Twentieth Century, 1998, Waterloo, The Canadian Clay and Glass Gallery.

Russell, Bruce H., *The Pottery of Mathieu: Suite Serpentin*, 1998, Ontario, Burlington Art Centre.

Selz, Peter, *Funk Art*, 1967, Berkeley, University of California Art Museum.

Slivka, Rose; Tsujimoto, Karen, *The Art of Peter Voulkos*, 1995, Kodansha.

Vincencelli, Moira, *Gendered Vessels: Women and Ceramics*, 2000, Manchester, MUP.

Watson, Oliver, *Studio Pottery: Twentieth Century British Ceramics in the Victoria and Albert Museum Collection*, 1993, Oxford, Phaidon Christie's.

Wilcox, Timothy (ed.), *Shoji Hamada: Master Potter*, 1998, Lund Humphries.

Yanagi, Soetsu, 'The Kizaemon Teabowl' in *The Unknown Craftsman*, 1972, Kodansha International.

Zakin, Richard, *Ceramics: Ways of Creation : An Exploration of 36 Contemporary Ceramic Artists & Their Work*, 1999, Krause Publications.

FURNITURE

Bogle, Michael; Landman, Peta, *Modern Australian Furniture*, 1989, Sydney, Craftsman House.

Cabra, Raul (ed.), *American Contemporary Furniture*, 2000, Universe.

Cabra, Raul; Ngo, Dung (eds.), *Contemporary American Furniture*, 2000, Laurence King.

Cerver, Francisco Asensio, *The New Modern Furniture Design*, 1998, Whitney Library of Design.

Clunas, Craig, *Chinese Furniture: A Concise History* (1993, London, V&A)

Dormer, Peter, *Furniture Today: its design & craft*, 1995, London, Crafts Council.

Dormer, Peter, *The New Furniture: Trends + Traditions*, 1987, London, Thames and Hudson.

Edwards, Clive, *An Encyclopedia of Furniture Materials, Trades and Techniques*, 2000, London, Scolar.

Edwards, Clive, *Twentieth Century Furniture: Materials, Manufacturers and Markets*, 1994, Manchester, MUP.

Edwards, Clive, *Victorian Furniture: Technology and Design*, 1993, Manchester, MUP.

Herbert, Martin, Key, Joan, Herber-Percy, Paul, *Furniture*, 2000, Richard Salmon.

Lucie Smith, Edward, *Furniture: A Concise History*. 1985, London, Thames and Hudson.

McDermott, Catherine; Dewing, David, *Matthew Hilton: Furniture for our time*, 2000, Lund Humphries.

Myerson, Jeremy, *Makepeace: A Spirit of Adventure in Craft and Design*, 1995, Conran Octopus Ltd.

Purvis, Cynthia M. (ed.), *New American Furniture: The second generation of studio*, 2000, MFA Publications.

Ramakers, Renny; Bakker, Gijs (eds.), *Droog design: spirit of the nineties*, 1998, Rotterdam, 010 Publishers.

Sembach, Klaus-Jürgen (ed.), *Contemporary furniture: an international review of modern furniture, 1950 to the present*, 1982, New York: Architectural Book Pub. Co.

Stone, Michael A., *Contemporary American Woodworkers*, 1986, Layton, UT, Gibbs M. Smith, Inc.

Sudjic, Deyan, *Ron Arad: Restless Furniture*, 1989, Fourth Estate.

Vernon, P., *Dempsey Bob: A Portrait of a Contemporary Native Artist*.

GLASS

Arwas, Victor, *Glass: Art Nouveau to Art Deco*, 1987, London, Academy.

Bray, Charles, *A Dictionary of Glass*, 1995, London, A&C Black.

Chambers, Karen S., *Clearly inspired: contemporary glass and its origins*, 1999, San Francisco, Tampa Museum of Art

Charleston, Robert J., *Masterpieces of Glass*, 1990, New York, Abrams.

Corning Museum of Glass, *New Glass: A Worldwide Survey*, 1979, New York, Corning.

Chihuly, Dale, *The Chihuly Projects*, 2000, Seattle.

Dorigato, Attilia; Klein, Dan, *Venezia Aperto Vetro: International New Glass*, 1996, Venice, Italy, Arsenale Editrice.

Duncan, Alastair, *Louis Comfort Tiffany*, 1992, New York, H.N.Abrams in association with the National Museum of American Art, Smithsonian Institution.

Fairbanks, Jonathan L.; Warner, Pat, *Glass Today by American Studio Artists*, 1997, Boston, Museum of Fine Arts.

Frantz, Susanne K., *Contemporary Glass: A world survey from the Corning Museum of Glass*, 1989, New York, Abrams.

Frantz, Susanne, *Contemporary Glass*, 1988, New York, Corning Museum.

Garner, Phillippe, *Emile Gallé*, 1990, 2nd edition, London, Academy Editions.

Grover, Ray and Lee, *Contemporary Art Glass*, 1975, New York: Crown Publishers.

Hajdamach, Charles, *British Glass 1800-1914*, 1991, Suffolk, Antique Collectors Guild.

Hawley, Henry H., *Glass Today: American Studio Glass from Cleveland Collections*, 1997, Cleveland, OH: Cleveland Museum of Art.

Ioannou, Noris, *Australian Studio Glass*, 1995, New South Wales, Craftsman House.

Klein, Dan, *Glass: A Contemporary Art*, 1989, London, Collins.

Kuspit, Donald, *Chihuly*, 1997, New York, Harry N. Abrams.

Kyoto National Museum of Modern Art, *Contemporary Studio Glass*, 1982, Weatherhill.

Layton, Peter, *Glass Art*, 1996, London, A&C Black.

Littleton, Harvey, *Glassblowing: A Search for Form*, 1971, New York, Van Nostrand-Reinhold.

Lynn, M.D., *Masters of Contemporary Glass*, 1997, Indiana University Press.

Polak, Ada, *Glass – Its Makers and its Public*, 1975, London, Weidenfeld and Nicholson.

Sparke, Penny (ed.), *Contemporary British Glass*, 1993, London, Crafts Council.

Stuhr, Joanne, *Calido!: Contemporary Warm Glass*, 1998, Seattle, University of Washington Press.

Tait, Hugh (ed.), *Five Thousand Years of Glass*, 1991, London, British Museum.

Yoshimizu, Tsuneo, *The Survey of Glass in the World*, 1992, Tokyo, Kyuryodo.

JEWELLERY

Anderson, Patricia, *Contemporary Jewellery – The Australian Experience, 1977-1987*, 1988, Sydney, Millennium.

Anderson, Patricia, *Contemporary Jewellery in Australia and New Zealand*, 1997, Craftsman House.

Baxter, William Thomas, *Jewelry, Gem Cutting and Metal Craft*, 1942, New York, McGraw Hill.

Bradley, Alexandra; Fernandez, Gavin (eds), *Un-clasped*, 1997, Black Dog.

Cartlidge, Barbara, *Twentieth Century Jewelry*, 1985, New York, Harry N. Abrams.

Dormer, Peter; Turner, Ralph, *The New Jewelry*, 1994, London, Thames and Hudson.

Dormer, Peter; Turner, Ralph, *The New Jewelry: trends and traditions*, 1985, London, Thames and Hudson.

Drucker, Janet, *Georg Jensen: a tradition of splendid silver*, 1997, Schiffer Publishing.

Drutt English, Helen; Dormer, Peter, *Jewellery of Our Time: Art, Ornament and Obsession*, 1995, London, Thames and Hudson.

Fitch, Janet, *The Art and Craft of Jewelry*, 1992, London, Reed International Books.

Grosz, E., Space, *Time and Perversion: Essays on the Politics of the Body*, 1995, London, Routledge.

Hinks, Peter, *Twentieth Century British Jewellery, 1900-1980*, 1983, London, Faber.

Houston, John, *Caroline Broadhead: Jewellery in Studio*, 1990, London, Bellew Publishing.

Hughes, Graham, *The Art of Jewelry: a Survey of Craft and Creation*, 1972, New York: The Viking Press.

Johnson, Pamela, *Bodyscape: Caroline Broadhead*, 1999, Northern Gallery for Contemporary Art.

Kuhnen, Johannes (ed.), *Directions – Silversmithing*. 1990, Canberra, Crafts Council.

Lewin, Susan Grant, *One of a Kind: American Art Jewelry Today*, 1994, New York, Harry N. Abrams.

Lucie Smith, Edward, *The Art of Albert Paley*, 1996, New York, Harry N. Abrams.

Moss, Kathlyn; Scherer, Alice, *The New Beadwork*, 1988, New York, Harry N. Abrams.

Praddow, Penny; Healy, Debra, *American Jewelry: Glamour and Tradition*, 1987, New York, Rizzoli.

Pullee, C., *20th Century Jewellery*, 1990, London, Quintet.

Thompson, Bob, *Jewellery Australia Now*, 1990, Sydney, Crafts Council of Australia.

Turner, Ralph, *Contemporary Jewellery: A Critical Assessment, 1945-1975*, 1976, London, Studio Vista.

Turner, Ralph, *Jewelry in Europe and America: new times, new thinking*, 1996, London, Thames and Hudson.

Watkins, David, *The Best in Contemporary Jewellery*, 1993, London, Batsford.

West, Janice; Cartlidge, Barbara, *Made to Wear: Creativity in Contemporary Jewellery*, 1998, Lund Humphries.

Wilcox, Donald, J., *Body Jewelry: International Perspectives*, 1973, Chicago, Henry Regnery.

Wilson, Muriel, *All that glitters: new jewellery in Britain*, 1992, London, British Council.

TEXTILES

Bergman, Stephenie, *Fabric and Form: new textile art from Great Britain*, 1982, London, British Council.

Braddock, S.; O'Mahoney, M., *Techno Textiles: Revolutionary Fabrics for Fashion and Design*, 1998, London, Thames and Hudson.

Chamberlain, Marcia, *Beyond Weaving*, 1974, New York, Watson Guptill.

Chandés, Hervé (ed.), *Issey Miyake: making things*, 1999, 1st Scalo ed., Paris, Zurich and New York, Fondation Cartier pour l'art contemporain.

Colchester, Chloe, *The New Textiles*, 1993, Thames and Hudson.

Colchester, Chloe, *The New Textiles: Trends and Tradition*, 1991, London, Thames and Hudson.

Colour into Cloth: A celebration of Britain's finest hand-coloured textiles. 1994, London, Crafts Council.

Constantine, Mildred; Larsen, Jack Lenor, *Beyond Craft: The Art Fabric*, 1981, New York, Van Nostrand Reinhold.

Constantine, Mildred; Larsen, Jack Lenor, *The Art Fabric: Mainstream*, 1981, New York, Van Nostrand Reinhold.

Exhibition Catalogue: CITAM, *Biennale Internationale de la Tapisserie*, Lausanne, 1962, 65, 67, 69, 71, 73, 75, 77, 79, 81, 83, 85, 87, 89. After name change: Biennale de Lausanne, Lausanne, 1992, 1995.

Exhibition Catalogue: Contemporary Stencil Dyeing and Printing: The Repetition of Patterns, 1994, Tokyo, The National Museum of Modern Art.

Farrelly, Liz, *Wear me: fashion and Graphic interaction*, 1995, London, Booth-Clibborn.

Fukumoto, Shigeki, *The Culture of Dyeing* 1996, Kyoto, Tankosha.

Kenji, Kaneko, *The Fundamental Concept of the Lausanne International Biennale of Tapestry and Craftical Formation*, Ethno-Arts, Vol.14, 1986, Tokyo, Kodansha.

Jackson, Anna, *Japanese Textiles in the Collection of the V&A*, 2000, London, V&A.

Johnson, Elizabeth L.; Bernick, Kathryn, *Hands of Our Ancestors: The Revival of Salish Weaving at Musqueam*, 1986, University of British Columbia Museum of Anthropology.

Koumis, Matthew, *Art Textiles of the World: Australia*, 1999, Winchester, Telos.

Koumis, Matthew, *Art Textiles of the World: Japan*, 1997, Winchester, Telos.

Mayer-Thurman, Christa C., *The 20th Century Textile Artist*, 1999, Chicago, Art Institute of Chicago.

McCarty, Cara; McQuaid, Matilda, *Structure and Surface, Contemporary Japanese Textiles*, 1998, New York, Museum of Modern Art.

Minagawa, Makiko; Tahara, Keiichi, *Texture*, 1988, Tokyo, Kodansha.

Nakahara, Yusuke, *Dyeing, Weaving. New Art Theory*, 1981, Kyoto, Senshoku ? Senshoku and Seikatsisha.

Parry, Linda, *Textiles of the Arts and Crafts movement*, 1988, London, Thames and Hudson.

Rowley, Sue (ed.), *Reinventing Textiles, Vol 1: Tradition and Innovation in Contemporary Practice*, 1999, Telos.

Rowley, Sue (ed.), *Tradition and Innovation*, 1999, Winchester, Telos.

Schoeser, Mary (ed.), *International textile design*, 1995, London, Laurence King.

Smith, Barbara Lee, *Celebrating the Stitch: Contemporary Embroidery of North America*, 1991, Taunton Press.

Spooner, Brian, 'Weavers and Dealers: the authenticity of an oriental carpet' in Appudurai, Arjun (ed.), *The Social Life of Things*, 1986, Cambridge.

Suké Suké: The Emperor's New Fabrics, 1997, Tokyo, Nuno Corporation.

Sutton, Ann, *British Craft Textiles*, 1985, London, Collins.

Periodicals, Magazines, Websites

GENERAL

This is an ever-expanding field. Hopefully the selection here will provide a sound insight and lead the reader on to further, unlisted sources.

American Craft, New York: American Craft Council.

American Craft Council http://www.craftcouncil.org/

American Craft Museum http://www.americancraftmuseum.org/

Artifex: journal of the crafts, Newcastle-on-Tyne, Oriel Press.

Arts and CraftsMovement
http://www.gray-cells.com/artsandcrafts/index.html

Asia Art.Net http://www.asoa-art.net/

Aussie Craft on Line http://www.ausiecraft.com.au

Australia Council for the Arts http://www.ozco.gov.au/

Australian Material Culture http://www.decorativeart.co.uk

Craft Arts, 1984-88, Sydney, Craft Art Pty, Ltd.

Craft Arts International, New York, American Craft Council.

Craft Australia, Sydney, Crafts Council of Australia.

Crafts Council, Great Britain http://www.craftscouncil.org.uk/

Crafts Council of Ireland
http://www.ccoi.ie/inet/register.nsf/home?openpage

Craft Studio At Harbourfront Centre Toronto
www.harbourfront.on.ca

Craft Horizons, 1941-1978, New York, American Crafts Council.
Craft Horizons with Craft World, 1978-79, New York, American Crafts Council.
Crafts, London, Crafts Council.
Crafts Review, Tring, England, Action Movement for the Crafts.
Craftwest, Perth, Australia, Holburne Museum & Crafts Study Centre.
Craft Site Australia http://www.craftaus.com.au/
Craft Victoria http://www.craftvic.asn.au/
Danish Decorative Arts Museum http://www.mus.kim.dk
Danish Design and Craft Forum http://www.design.dk/
Danish Handcraft Guild, Copenhagen, Danish Handcraft Guild.
Federation of British Craft Societies Newsletter, London, Federation of British Craft Societies.
Form Function Finland, Helsinki, Finnish Society of Crafts and Design.
Gurasu & to, [Glass & Art], Tokyo, Eik U u.
Haandarbejdets Fremme, Copenhagen.
Kunst + Handwerk, 1957-1991, Hamburg, Ritterbach.
Kunsthandwerk & Design, Frechen, Ritterbach.
New Zealand Crafts, Wellington, Crafts Council of New Zealand.
Object, Sydney, Crafts Council of New South Wales.
The Master Craftsman, U.K., Burgess Hill, The Guild of Master Craftsmen.
The Studio, 1893-1964, London, The Studio Ltd.
Things, London.

CERAMICS
American Ceramics, New York, American Ceramics
American Ceramic Society http://acerswny.org/
Cahiers de la céramique du verre et des arts de feu, 1959-77, Sèvres, Societé des amis du Musée national de céramique.
Canadian ceramics quarterly, Willowdale, Canadian Ceramics Society.
Ceramic Review, London, Craftsmen Potters Association of Great Britain.
Ceramics: Art and Perception, Sydney, Ceramics: Art and Perception Pty. Ltd.
Ceramics: the international journal of ceramics and glass, 1985-7, London, Art Focus.
Ceramics: the International Journal of Ceramics and Glass, 1985-87, London, Art Focus
China Ceramic Art.com www.chinaceramicart.com%2F
Clay World http://www.clayworld.com/
Fusion, Toronto, Ontario Clay & Glass Association,
Japanese Ceramics www.sainsbury-institute.org/mpitelka/ceramics.html
Journal of the Australasian Ceramic Society, Sydney, Australasian Ceramic Society.
Keramik, Triesen.
Kermion Ceramics Museum www.ceramics.de/Keraminn.htm
Museo Archeologico & Della Ceramica Di Montelupo, www.leonet.it/comuni/montemus/montemus.html
London Potters Newsletter, London, London Potters.
Neue keramik: new ceramics, Berlin, Verlag Neue Keramik.
New Zealand Potter, 1958-86, Wellington.
Pottery in Australia, Turramurra, Potters' Society of New South Wales.
Pottery quarterly, 1954-85, Tring, England, Northfields Studio.
Real Pottery, 1987-91, Tring, England, Northfields Studio.
Sixth Biennale Ceramics Festival Andenne Belgium www.keramos.com902Fartecerame
Studio Pottery, Exeter, Paul Vincent.
The Ceramic and Glass Association of New York www.cany.net/
The Potter, Santa Barbara, The Potter Pub. Co.

The Studio Potter, Goffstown, Daniel Clark Foundation.
Traditional Japanese Ceramics Information and Catalogue www.netlaputa.ne.jp/-namazu/index.html
T U ugei no bi: the beauty of fire and earth, 1984-9, Kyoto, Kyoto Shoin.
T U ugei Shiki: Ceramic Art, Tokyo, Gabun-d U u.
T U usetsu, Tokyo.
UK Ceramics Gallery www.ukceramics.org/

FURNITURE
American Woodworker, USA.
Art and Antiques, New York.
Blueprint Magazine, London.
Dwell, New York.
Furniture Meubles Mobili Meubles Mobel www.iserv.net/-plucas/
Furniture Masters .org – New Hampshire Furniture Masters http://www.furnituremasters.org/
Furniture Today http://www.furnituretoday.com
Homes and Gardens, London.
Metropolis, New York.
New furniture, New York, George Wittenborn.
Space and Form, Copenhagen.
The Art Furnishings Show And Artisan Directory http://www.artfurnishings.com/
The Furniture Society www.furniture.org/
Victorian Wood Workers Association http://www.home.vicnet.net.au/-woodlink.htm
Vitra http://www.vitra.com
Wood, London.

GLASS
Ars vitraria, Jablonec nad Nisou, Muzeum skla a bizutérie.
Baltic Sea Glass, Denmark www.balticSeaglass.com
Bullseye Connection: Glass Working Resource Center, Portland www.bullseye-glass.com
Cahiers de la céramique du verre et des arts de feu, 1959-77, Sèvres, Societé des amis du Musée national de céramique.
Centre de Metier du Verre du Quebec Espace Verre, Montreal PQ www.espaceverre.gc.ca
Creative Glass Center of America, NJ www.creativeglasscenter.com
Czechoslovak Glass Review, 1946-67, Prague, Rapid.
Fusion Art Glass Gallery, Panama City Beach, FL www.fusionartglass.com
Gallery Enomoto Co. Ltd. (Contemporary art in glass) Tennoji-Ku, Osaka, Japan www.aianet.jp/-enomoto/
G.A.S. News, Seattle, Glass Art Society.
Glass, New York, New York Experimental Glass Workshop.
Glass Art Society www.glassart.org/
Glass Encyclopedia www.glass.co.nz/encyclopedia/index.html
Glasshouse Tokyo Kokusai Glass Institute (Tokyo International School of Glass Art) www.eikoh.com/glasshouse/
Glass Review, Prague, Rapid.
Journal of the Glass Art Society, Seattle, Glass Art Society.
Marx-Saunders Gallery, Chicago, IL www.marxsaunders.com
Neues Glas, Dusseldorf, Verlagsanstalt Handwerk.
New Glass Review, Corning, NY, Corning Museum of Glass.
New Glass Work, 1987-89, New York, New York Experimental Glass Workshop.
New Work, 1980-87, New York, New York Experimental Glass Workshop.
Niijima Glass Art Center, Tokyo, Japan www.marin.or.jp/niijima
Studio of the Corning Museum of Glass, Corning, NY www.cmog.org

The International Journal of Ceramics and Glass, 1985-87, London, Art Focus.

Vitrea: revue du Centre international du vitrail, Chartres, Centre international du vitrail.

Who's who in contemporary glass art, Munich, J.Waldrich Verlag.

JEWELLERY

ABANA Artist Blacksmith Association of North America www.abana.org/index.html

Adornment: the newsletter of jewellery and related arts, New Rochelle, Adornment.

Alabama Forge Council www.afc.abana-chapter.com/

Anvilfire.com – Blacksmithing and Metalworkers Reference www.anvilfire.com/

Aspects, London, Aspects.

British Artist Blacksmith Association (BABA) www.baba.org.uk/

Castaldo www.castaldo.com/

Creative Metal Arts Guild.

Florida Society of Goldsmiths www.fsg4u.com

Ganoksin.com www.ganoksin.com/

Guild of Metal Smiths www.metalsmith.org

Metal Crafts Australia www.kadina.yp-connect.net/-tcents/metal/

Metal Web News www.metalwebnews.com/

Metalsmith, New York.

National Ornamental Metal Museum www.metalmuseum.org/

Nomma (the National Ornamental and Miscellaneous Metals Association www.nomma.org/

Ornament, Los Angeles, Ornament.

Schmuck, Munich.

Society of American Silversmiths www.silversmithing.com

Society for Midwest Metalsmiths www.midwest-metalsmiths.org/

SNAG – Society of North American Goldsmiths www.snagmetalsmith.org/default.asp

The Artist-Blacksmiths Association of North America (ABANA) www.abana.org

The Jewelry Design Professionals Network.

TEXTILES

Asian Arts – Chinese Textiles http://www.asianart.com/textiles/textile.html

Costume And Textiles At Lacma http://lacma.org/art/perm_col/costumes/costume2.htm

ETN-European Textile Network http://www.etn-net.org/

Fiber Art Museum http://www.geocities.co.jp/Hollywood/3019/

Fiberarts, Asheville, N.C., Fiberarts.

Fiberworks: Symposium on Contemporary Textile Art, 1978, Berkeley, California, Fiberworks.

Hand Weavers Guild of America http://www.weavespindye.org/

International Textiles, Amsterdam and London, International Textiles.

Koelz Textile Collection http://www.umma.isa.umich.edu/orient/koelz/textiles/textiles.html

Kyoto International Contemporary Textile Art Center http://www.kyoto-inet.or.jp/people/kictac/indexen.html

Midwest Weavers Association http://www.home.fuse.net/weavers/

Museum for Textiles (Toronto) http://www.museumfortextiles.on.ca/

National Needlework Association http://www.tnna.org/

Textile Arts of the Islamic World http://www.lib.umich.edu/area/near.east/textiles/textiles.html

Senshoku no Bi. Waido-han, Kyoto, Kyoto Sho-in.

Senshoku no Bi: Textile Art, 1979-84, Kyoto, Kyoto Sho-in.

Textile and text, New York, Fashion Institute of Technology

Text: for the study of textile art, design & history, Macclesfield, Textile Society, Great Britain.

Textile Museum Tilburg Niederlande http://www.textielmuseum.nl/

Textile Museum http://www.textilemuseum.org/

Textile Society of America http://www.textilesociety.org/

Textile Society Magazine, Macclesfield, Textile Society, Great Britain

Textiles Through Time http://www.interlog.com/-gwhite/ttt/tttintro.html

INDEX

Note: The Japanese names in the Index have been inserted in the Western order i.e. last name, first name.

The International Journal of Ceramics and Glass, 1985-87, London, Art Focus.
Vitrea: revue du Centre international du vitrail, Chartres, Centre international du vitrail.
Who's who in contemporary glass art, Munich, J.Waldrich Verlag.

JEWELLERY
ABANA Artist Blacksmith Association of North America www.abana.org/index.html
Adornment: the newsletter of jewellery and related arts, New Rochelle, Adornment.
Alabama Forge Council www.afc.abana-chapter.com/
Anvilfire.com – Blacksmithing and Metalworkers Reference www.anvilfire.com/
Aspects, London, Aspects.
British Artist Blacksmith Association (BABA) www.baba.org.uk/
Castaldo www.castaldo.com/
Creative Metal Arts Guild.
Florida Society of Goldsmiths www.fsg4u.com
Ganoksin.com www.ganoksin.com/
Guild of Metal Smiths www.metalsmith.org
Metal Crafts Australia www.kadina.yp-connect.net/-tcents/metal/
Metal Web News www.metalwebnews.com/
Metalsmith, New York.
National Ornamental Metal Museum www.metalmuseum.org/
Nomma (the National Ornamental and Miscellaneous Metals Association www.nomma.org/
Ornament, Los Angeles, Ornament.
Schmuck, Munich.
Society of American Silversmiths www.silversmithing.com
Society for Midwest Metalsmiths www.midwest-metalsmiths.org/
SNAG – Society of North American Goldsmiths www.snagmetalsmith.org/default.asp
The Artist-Blacksmiths Association of North America (ABANA) www.abana.org
The Jewelry Design Professionals Network.

TEXTILES
Asian Arts – Chinese Textiles http://www.asianart.com/textiles/textile.html
Costume And Textiles At Lacma http://lacma.org/art/perm_col/costumes/costume2.htm
ETN-European Textile Network http://www.etn-net.org/
Fiber Art Museum http://www.geocities.co.jp/Hollywood/3019/
Fiberarts, Asheville, N.C., Fiberarts.
Fiberworks: Symposium on Contemporary Textile Art, 1978, Berkeley, California, Fiberworks.
Hand Weavers Guild of America http://www.weavespindye.org/
International Textiles, Amsterdam and London, International Textiles.
Koelz Textile Collection http://www.umma.isa.umich.edu/orient/koelz/textiles/textiles.html
Kyoto International Contemporary Textile Art Center http://www.kyoto-inet.or.jp/people/kictac/indexen.html
Midwest Weavers Association http://www.home.fuse.net/weavers/
Museum for Textiles (Toronto) http://www.museumfortextiles.on.ca/
National Needlework Association http://www.tnna.org/
Textile Arts of the Islamic World http://www.lib.umich.edu/area/near.east/textiles/textiles.html
Senshoku no Bi. Waido-han, Kyoto, Kyoto Sho-in.
Senshoku no Bi: Textile Art, 1979-84, Kyoto, Kyoto Sho-in.
Textile and text, New York, Fashion Institute of Technology
Text: for the study of textile art, design & history, Macclesfield, Textile Society, Great Britain.
Textile Museum Tilburg Niederlande http://www.textielmuseum.nl/
Textile Museum http://www.textilemuseum.org/
Textile Society of America http://www.textilesociety.org/
Textile Society Magazine, Macclesfield, Textile Society, Great Britain
Textiles Through Time http://www.interlog.com/-gwhite/ttt/tttintro.html

INDEX

Note: The Japanese names in the Index have been inserted in the Western order i.e. last name, first name.